AMERICAN CULTURE

An Anthology of Civilization Texts

Edited by
Anders Breidlid, Fredrik Chr. Brøgger,
Øyvind T. Gulliksen, Torbjorn Sirevag

London and New York

First published 1996
by Routledge
11 New Fetter Lane, London, EC4P 4EE

Simultaneously published in the USA and Canada
by Routledge
29 West 35th Street, New York, NY 10001

Typeset in Baskerville by
J&L Composition Ltd, Filey, North Yorkshire

Printed and bound in Great Britain by
Biddles Ltd, Guildford and King's Lynn

British Library Cataloguing in Publication Data
American Culture: An anthology of civilization texts
I. Breidlid, Anders
973

Library of Congress Cataloging in Publication Data
A catalogue record for this book has been requested

ISBN 0–415–12439–5 (hbk)
ISBN 0–415–12440–9 (pbk)

CONTENTS

List of illustrations	xiii
Acknowledgements	xv
Introduction	1

1 NATIVE AMERICANS

Introduction	6
1 Thomas Jefferson	
"Confidential Message to Congress" (1803)	7
2 Tecumseh	
"We All Belong to One Family" (1810)	10
3 Tecumseh	
"Sell a Country? Why Not Sell the Air?" (1810–11)	12
4 Seattle	
FROM "The Dead are Not Powerless" (1854)	13
5 Helen Hunt Jackson	
"A Tale of the Wrongs" (1881)	16
6 John Collier	
"Full Indian Democracy" (1943)	18
7 Buffy Sainte-Marie	
"My Country" (1971)	20
8 Leslie Silko	
"The Man to Send Rain Clouds" (1969)	22
9 Studs Terkel	
FROM "Girl of the Golden West: Ramona Bennett" (1980)	25

2 IMMIGRATION

Introduction	34
10 Emma Lazarus	
"The New Colossus" (1883)	35
11 Henry James	
FROM "The Inconceivable Alien" (1883)	36

12 *Owen Wister*
FROM "Shall We Let the Cuckoos Crowd Us Out of Our
Nest?" (1921) 38
13 *Madison Grant*
"The Mixture of Two Races" (1917) 40
14 *Arthur M. Schlesinger, Jr.*
"E Pluribus Unum?" (1992) 41
15 *Abraham Cahan*
"The Meeting" (1896) 42
16 *Ole E. Rølvaag*
"The Power of Evil in High Places" (1927) 46
17 *Michael Lee Cohen*
"David" (1993) 59
18 *Joan Morrison and Charlotte Fox Zabusky*
FROM "Premier Nguyen Cao Ky: From South Vietnam, 1975" 62
19 *Al Santoli*
FROM "Mojados (Wetbacks)" (1988) 66

3 AFRICAN AMERICANS

Introduction 72
20 *Moses Grandy*
"The Auction Block" (pre-1860) 73
21 *Joseph Ingraham*
"A Peep into a Slave-Mart" (pre-1860) 74
22 *Sojourner Truth*
"Ain't I a Woman?" (1851) 75
23 *Abraham Lincoln*
Final Emancipation Proclamation (1863) 76
24 *William DuBois*
FROM "Of the Faith of the Fathers" (1903) 77
25 *William DuBois*
"This Double-Consciousness" (1903) 82
26 *Gwendolyn Brooks*
"We Real Cool" (1960) 84
27 *Martin Luther King, Jr.*
"I Have a Dream" (1963) 84
28 *Malcolm X*
FROM "The Ballot or the Bullet" (1965) 88
29 *Malcolm X*
"The Black Man" (1965) 89
30 *US Congress*
The Civil Rights Act of 1964 91

31 Septima Clark
"Teach How Change Comes About" (pre-1987) 93

4 WOMEN IN THE UNITED STATES

Introduction 98
32 Alexis de Tocqueville
"The Young Woman in the Character of a Wife" (1848) 100
33 Thomas R. Dew
FROM "Differences between the Sexes" (1835) 102
34 Seneca Falls Convention
Declaration of Sentiments and Resolutions (1848) 103
35 Kate Chopin
"The Story of an Hour" (1894) 105
36 Charlotte Perkins Gilman
FROM *Women and Economics* (1966) 107
37 Meridel LeSueur
"Women on the Breadlines" (1932) 109
38 Betty Friedan
"That Has No Name" (1963) 115
39 Adrienne Rich
"Think through the Body" (1976) 120
40 Studs Terkel
"Just a Housewife: Therese Carter" (1972) 122
41 Merle Woo
FROM "Letter to Ma" (1980) 126
42 National NOW Times (Editorial)
"Abortion Is Not Immoral" (1989) 129
43 Barbara Newman
FROM "Postmodern Patriarchy Loves Abortion" (1993) 131

5 THE STRUCTURE OF GOVERNMENT

Introduction 134
44 Founding Fathers
FROM The Constitution of the United States (1787) 136
45 James Madison
FROM "How a Republic Will Reduce the Evil of Faction"
(1788) 144
46 E. L. Doctorow
FROM "A Citizen Reads the Constitution" (1987) 147
47 Thomas Jefferson
FROM "The Roots of Democracy" (1816) 151
48 John Marshall
FROM *Marbury* v. *Madison* (1803) 153

49 *Andrew Jackson*
FROM Proclamation to the People of South Carolina (1832) 155
50 *John Kenneth Galbraith*
"The American Presidency: Going the-Way of the
Blacksmith? " (1988) 158

6 PARTIES AND POLITICS

Introduction 162
51 *George Washington Plunkitt*
FROM "Honest Graft and Dishonest Graft" (1905) 164
52 *Joe McGinnis*
FROM *The Selling of the President* (1969) 165
53 *Studs Terkel*
FROM Interview with Congressman Philip M. Crane (1988) 167
54 *Studs Terkel*
FROM Interview with Ex-Congressman Bob Eckhardt (1988) 170
55 *Hedrick Smith*
FROM *The Power Game: How Washington Works* (1988) 172
56 *The Republican Party*
FROM The Republican Party Platform 1992 175
57 *The Democratic Party*
FROM The Democratic Party Platform 1992 178

7 ENTERPRISE

Introduction 184
58 *Benjamin Franklin*
FROM *Autobiography* (1785) 187
59 *Francis Grund*
FROM "To Americans, Business is Everything" (1837) 190
60 *Andrew Carnegie*
FROM *The Gospel of Wealth* (1900) 192
61 *Bruce Barton*
FROM "Christ as a Businessman" (1925) 194
62 *Studs Terkel*
Interview with George Allen, Football Coach (1972) 198
63 *Henry Ford*
FROM *My Life and Work* (1922) 200
64 *Andrew Jackson*
"The Power of the Moneyed Interests" (1837) 203
65 *Franklin D. Roosevelt*
"Organized Money" (1936) 204
66 *Dwight D. Eisenhower*
"The Military-Industrial Complex" (1961) 206

8 CLASS STRUCTURE

Introduction	210
67 *Thomas Jefferson*	
FROM "Property and Natural Right" (1785)	212
68 *William Graham Sumner*	
FROM "The Forgotten Man" (1883)	213
69 *Upton Sinclair*	
FROM *The Jungle* (1906)	215
70 *Sinclair Lewis*	
FROM *Babbitt* (1922)	216
71 *Emily Moore*	
FROM "Marie Haggerty" (Interview with a Nursemaid, 1939)	219
72 *Studs Terkel*	
FROM "Mike Lefevre" (Interview with a Steel Mill Worker, 1974)	221
73 *Lyndon B. Johnson*	
FROM "The War on Poverty" (1964)	223
74 *Steven VanderStaay*	
FROM "Hell" and "Joe" (1992)	224
75 *Peter Baida*	
FROM "Confessions of a Reluctant Yuppie" (1985)	227

9 RELIGION

Introduction	232
76 *Jonathan Edwards*	
FROM "Personal Narrative" (1739?–1742?)	234
77 *Ralph Waldo Emerson*	
FROM "The Manifesto of 1838"	238
78 *James Cardinal Gibbons*	
FROM "The Catholic Church and Labor" (1887)	241
79 *Will Herberg*	
"The Religion of Americans" (1955)	245
80 *Anonymous*	
"Swing Low, Sweet Chariot" and "Go Down, Moses" (pre-1860)	250
81 *Billy Graham*	
"The Unfinished Dream" (1970)	251
82 *Pat Robertson*	
FROM "The New World Order" (1992)	255

CONTENTS

10 EDUCATION

Introduction 264
83 *Robert Coram*
 FROM "The Necessity of Compulsory Primary Education"
 (1791) 266
84 *John Dewey*
 "My Pedagogic Creed" (1897) 269
85 *US Supreme Court*
 The 1954 Supreme Court Decision on Segregation 273
86 *US Congressmen*
 "Protest from the South" (1956) 275
87 *Jonathan Kozol*
 "The Grim Reality of Ghetto Schools" (1967) 277
88 *Peter Schrag*
 "Savage Equalities: The Case Against Jonathan Kozol"
 (1991) 279
89 *Allan Bloom*
 "The Closing of the American Mind" (1987) 282
90 *Elizabeth Loza Newby*
 FROM "An Impossible Dream" (1977) 287
91 *Studs Terkel*
 FROM "Public School Teacher: Rose Hoffman" (1972) 290

11 MASS MEDIA AND POPULAR CULTURE

Introduction 296
92 *New York Herald*
 Review of *Uncle Tom's Cabin* (1853) 298
93 *Bessie Smith*
 "Empty Bed Blues" (1920s?) 301
94 *Woodie Guthrie*
 "This Land is Your Land" (1944) 302
95 *Mikal Gilmore*
 FROM "Bruce Springsteen" (1987) 302
96 *Studs Terkel*
 FROM "Jill Robertson: Fantasia" (1982) 309
97 *Stanley Kauffmann*
 "*Little Big Man*" (1970) 313
98 *Martin Scorsese, Paul Schrader and Robert de Niro*
 FROM "*Taxi Driver*" (1992) 315
99 *Neil Postman*
 FROM "The Age of Show Business" (1985) 318

12 THE UNITED STATES AND THE WORLD

Introduction 324

100 George Washington
FROM Farewell Address (1796) 327

101 James Monroe
FROM "The Monroe Doctrine" (1823) 329

102 Charles A. Beard
FROM "The Case for Isolation" (1940) 332

103 Harry Truman
"The Truman Doctrine" (1947) 335

104 George C. Marshall
"The Marshall Plan" (1947) 337

105 Joseph McCarthy
FROM "The Wheeling Speech" (1950) 339

106 John F. Kennedy
First Inaugural Address (1961) 345

107 Lyndon B. Johnson
"American Policy in Viet-nam" (1965) 349

108 George Bush
"The Launch of Attack on Iraq" (1991) 351

109 E. L. Doctorow
Open Letter to the President (1991) 355

13 IDEOLOGY: DOMINANT BELIEFS AND VALUES

Introduction 361

110 Thomas Jefferson, with Amendments by the Continental Congress
FROM The Declaration of Independence (1776) 364

111 Abraham Lincoln
The Gettysburg Address (1863) 367

112 John Marshall Harlan
FROM Dissenting Opinion in *Plessy* v. *Ferguson* (1896) 368

113 Learned Hand
FROM "The Spirit of Liberty" (1944) 369

114 William James
FROM *Pragmatism* (1907) 370

115 Jane Addams
FROM *Twenty Years at Hull House* (1910) 371

116 Woodrow Wilson
FROM First Inaugural Address (1913) 373

117 William J. Clinton
FROM Address on the State of the Union, 1994 375

CONTENTS

118 Frederick Jackson Turner
FROM "The Significance of the Frontier in American
History" (1893) 376
119 Theodore Roosevelt
FROM "The Strenuous Life" (1899) 377
120 Studs Terkel
FROM "Jay Slabaugh, 48" (Interview with a Corporate
Executive, 1980) 378
121 Ronald Reagan
FROM Address on the State of the Union, 1986 379
122 Rush H. Limbaugh, III
FROM *See, I Told You So* (1993) 380
123 Earnest Elmo Calkins
FROM "Business Has Wings" (1927) 382
124 Dale Carnegie
FROM *How to Win Friends and Influence People* (1936) 385
125 Malvina Reynolds
"Little Boxes" (1962) 386
126 David Watson
"Civilization is Like a Jetliner" (1983) 387

Sources 389
Suggested further reading 399

ILLUSTRATIONS

1.1 Geronimo 15
1.2 Chief Standing Bear of the Poncas 18
1.3 The run into the Cherokee outlet 31
2.1 Immigrants at Ellis Island 36
2.2 The physical examination of immigrants on arrival at
 Ellis Island, *c.* 1912 37
2.3 Cuban refugees disembarking in Key West, Florida,
 August 1994 66
3.1 Martin Luther King at a mass rally in Philadelphia, 1965 85
4.1 Supermodel Cindy Crawford, in 1991 118
4.2 "Supermarket Lady": a lifesize fiberglass sculpture by
 Duane Hanson, 1970 119
4.3 Women at Venice Beach, Santa Monica, Los Angeles 121
4.4 First Lady Hillary Clinton at a press conference on
 health care reform 130
5.1 President Bill Clinton giving his inauguration speech, 1993 160
6.1 Republicans celebrating on the evening of the presidential
 elections, 8 November 1988 176
7.1 Billboard for Camel cigarettes, Times Square, New
 York, 1993 185
8.1 Slum dwellers in Baxter Street Court, New York, *c.* 1888 214
8.2 Homeless on the streets of Washington D.C. 226
9.1 Evangelist Billy Graham preaching at the Upper
 Midwest Crusade, 1973 252
9.2 Evangelist Jim Bakker recording the "People That Love"
 television show, 1986 255
11.1 John Wayne in Paramount's 1969 western *True Grit* 311
11.2 A Coca-Cola bottle 320
11.3 Advertisement for Jordan motor cars, 1924 321
12.1 President John F. Kennedy giving his inauguration
 speech, 1961 346
12.2 US marines near Hoa My, South Vietnam, 1965 348

12.3 US soldiers guarding their encampment in Port-au-Prince,
 Haiti, September 1994 357
13.1 The Declaration of Independence 365
13.2 Ku Klux Klan parade, Washington D.C., 1925 368
13.3 Advertisement for Buick motor cars, 1924 384

ACKNOWLEDGEMENTS

We are grateful to all those who have granted us permission to reproduce the extracts listed below. Many extracts are now in the public domain. Every effort has been made to contact unlisted copyright holders; if there are any we have not succeeded in reaching they are invited to contact Routledge in the first instance.

7 Buffy Sainte-Marie, "My Country"
Reprinted by permission of Grosset & Dunlap from *The Buffy Sainte-Marie Songbook*, copyright © 1971 by Buffy Sainte-Marie.

9 Studs Terkel, "Girl of the Golden West: Ramona Bennett"
From *American Dreams: Lost and Found* by Studs Terkel. Copyright © 1980 by Studs Terkel. Reprinted by permission of Pantheon Books, a division of Random House, Inc.

17 Michael Lee Cohen, "David"
From *The Twenty-Something American Dream* by Michael Cohen. Copyright © 1993 by Michael Cohen. Used by permission of Dutton Signet, a division of Penguin Books USA Inc.

18 Joan Morrison and Charlotte Fox Zabusky, "Premier Nguyen Cao Ky: From South Vietnam, 1975"
From *American Mosaic: The Immigrant Experience in the Words of Those Who Lived It* by Joan Morrison and Charlotte Fox Zabusky. © 1980, 1993. Reprinted by permission of the University of Pittsburgh Press.

19 Al Santoli, "Mojados (Wetbacks)"
From *New Americans: An Oral History* by Al Santoli. Copyright © 1988 by Al Santoli. Used by permission of Viking Penguin, a division of Penguin Books USA Inc.

40 Studs Terkel, "Just a Housewife"
From *Working* by Studs Terkel. Copyright © 1972, 1974 by Studs Terkel. Reprinted by permission of Pantheon Books, a division of Random House, Inc.

41 Merle Woo, "Letter to Ma"
From *This Bridge Called My Back: Writings by Radical Women of Color*, edited by Cherríe Moraga and Gloria Anzaldua © 1983. Reprinted by permission of the author and of Kitchen Table: Women of Color Press, Box 40-4920, Brooklyn NY 11240.

43 Barbara Newman, "Postmodern Patriarchy Loves Abortion"
From *Sisterlife*, 13, No. 1, Winter 1993. Reprinted by permission of Feminists for Life of America, 733 15th Street, NW, Suite 1100, Washington, DC 20005 (202–737–3352).

50 John Kenneth Galbraith, "The American Presidency: Going the Way of the Blacksmith? "
From the *International Herald Tribune*, December 13, 1988. Used by permission of The New York Times Syndication Sales Corporation.

52 Joe McGinnis, *The Selling of the President*, 1969
Used by permission of Andre Deutsch Ltd.

55 Hedrick Smith, *The Power Game: How Washington Works*
Reprinted by permission of HarperCollins Publishers Ltd and David Higham Associates Ltd.

62 Studs Terkel, Interview with George Allen, Football Coach
From *Working* by Studs Terkel. Copyright details as for extract 40 above.

70 Sinclair Lewis, *Babbitt*
Copyright 1922 by Harcourt Brace & Company and renewed 1950 by Sinclair Lewis, reprinted by permission of Harcourt Brace & Company, The Estate of Sinclair Lewis and Jonathan Cape.

72 Studs Terkel, "Mike Lefevre"
From *Working* by Studs Terkel. Copyright details as for extract 40 above.

74 Steven VanderStaay, "Hell" and "Joe"
From *Street Lives: An Oral History of Homeless Americans*, by Steven VanderStaay, ISBN 1-800-333-9093. Copyright © 1992 by Steven VanderStaay. Reprinted by permission of New Society Publishers, 4527 Springfield Avenue, Philadelphia PA 19143.

75 Peter Baida, "Confessions of a Reluctant Yuppie"
Reprinted from *The American Scholar*, Vol. 55, No. 1, Winter 1985/86. Copyright © 1985 by Peter Baida.

79 Will Herberg, "The Religion of Americans"
From *Protestant Catholic Jew* by Will Herberg. Copyright © 1955 by Will Herberg. Used by permission of Doubleday, a division of Bantam Doubleday Dell Publishing Group, Inc.

82 Pat Robertson, "The New World Order"
From *The New World Order*, by Pat Robertson, copyright © 1991, Word, Inc., Dallas, Texas. All rights reserved.

89 Allan Bloom, "The Closing of the American Mind"
From *The Closing of the American Mind*, by Allan Bloom. Copyright © 1987 by Allan Bloom. Reprinted by permission of Simon & Schuster, Inc.

91 Studs Terkel, "Public School Teacher: Rose Hoffman"
From *Working* by Studs Terkel. Copyright details as for extract 40 above.

95 Mikal Gilmore, "Bruce Springsteen"
From *Rolling Stone*, November 5, 1987. Reprinted by permission of Straight Arrow Publishers, Inc., 1987. All Rights Reserved.

96 Studs Terkel, "Jill Robertson: Fantasia"
From *American Dreams: Lost and Found* by Studs Terkel. Copyright details as for extract 9 above.

97 Stanley Kauffman, "Little Big Man"
From *Living Images: Film Comment and Criticism*, New York, Harper & Row, 1975. Copyright © 1975 by Stanley Kauffman. Reprinted by permission of the author.

98 Martin Scorsese, Paul Schrader and Robert de Niro, "*Taxi Driver*"
From the book *Martin Scorsese: A Journey*, by Mary Pat Kelly. Copyright © 1992 by Mary Pat Kelly. Used by permission of the publisher, Thunder's Mouth Press.

99 Neil Postman, "The Age of Show Business"
From *Amusing Ourselves to Death* by Neil Postman. Copyright © 1985 by Neil Postman. Used by permission of Viking Penguin, a division of Penguin Books USA Inc.

113 Learned Hand, "The Spirit of Liberty"
From *The Spirit of Liberty* by Learned Hand, ed. Irving Dilliard. Copyright 1952, 1953, © 1959, 1960 by Alfred A. Knopf Inc. Reprinted by permission of the publisher.

115 Jane Addams, *Twenty Years at Hull House*
Copyright 1910 by Macmillan Publishing Company, renewed 1938 by James W. Linn.

118 Frederick Jackson Turner, "The Significance of the Frontier in American History" (1893)
From *Frederick Jackson Turner: Wisconsin's Historian of the Frontier* edited by Martin Ridge, Madison, State Historical Society of Wisconsin, 1993. Reprinted by permission of the publisher.

120 Studs Terkel, "Jay Slabaugh, 48"
From *American Dreams: Lost and Found* by Studs Terkel. Copyright details as for extract 9 above.

122 Rush H. Limbaugh, III, *See, I Told You So*
Copyright © 1993 by Rush H. Limbaugh, III. Reprinted by permission of Pocket Books, a division of Simon & Schuster, Inc.

123 Earnest Elmo Calkins, "Business Has Wings"
Originally published in the January–June 1927 issue of *The Atlantic Monthly*. Reprinted by permission of the publisher.

125 Malvina Reynolds, "Little Boxes"
Words and music by Malvina Reynolds. Copyright 1962 by Schroder Music Co. (ASCAP). Renewed 1990. Used by permission. All rights reserved.

126 David Watson, "Civilization is Like a Jetliner"
This text was originally written under the pseudonym T. Fulano in the Winter 1983/84 issue of the North American radical journal *Fifth Estate* (4632 Second Avenue, Detroit MI 48201 USA), and later published in *Questioning Technology: Tool, Toy or Tyrant?* (Freedom Press/New Society Publishers). Reprinted by permission of the author.

INTRODUCTION

This anthology of documentary texts is aimed at students of American culture, particularly as a subject taught within the study of English as a foreign language. The study of English at colleges and universities outside of Britain and America usually includes three main disciplines: linguistics, literary study and cultural studies. Within the subject of American cultural studies, there is no dearth of anthologies of scholarly essays *about* American civilization, but there is a great need for a collection of primary sources *of* American culture that can be used for illustration and discussion in class – sources that students themselves analyze as cultural texts. We have tried to find texts that are challenging and suggestive in terms of both their language and their ideological discourse, which would invite students to analyze them from a linguistic as well as a cultural point of view. Although these documentary sources are tailored to students of English, their engaging character should also make them suited for general American studies or American civilization courses.

Considerable care has been taken to include most subject areas that are taught in American civilization courses within the study of English as a foreign language, namely Native Americans, immigration, African Americans, women, government, politics, enterprise, class structure, religion, education, mass media/popular culture, the US and the world, and ideology. Our concern with a historical perspective has furthermore produced a combination of "older" and more recent sources. At the same time a central aim has been to furnish students with a great variety of texts. In addition to standard historical and political documents, our anthology includes essays, articles or parts of chapters, speeches, manifestoes, autobiography, reminiscences, interviews, advertisements, song lyrics, and stories. Such a variety of subjects and texts is intended to encourage multi-cultural and inter-disciplinary approaches to the study of American life.

Our selection of texts for this volume has been guided by a particular conception of American cultural studies. The study of American

1

civilization is seen to involve both a general introduction to different aspects of American history and society and the close study of documentary texts that pertain to these subject areas. By submitting texts to analysis in class, students may themselves discover how cultural beliefs and values are embedded in the very language used in these sources, in the choice of idiom, imagery and register. Through their examination of texts, students learn that the language of people of different groups and periods represents particular ways of looking at the world, engendered by specific social, economic, ethnic, political and/or gender-related circumstances. We hope that students of English, when working with these primary texts, will understand the importance of evolving both a linguistic and a cultural competence. Multi-cultural, multi-topical, multi-textual, and multi-disciplinary, this anthology is intended to make students recognize that language is culture and culture is language, and that the one cannot be understood without some grasp of the other.

There are three major omissions in this anthology that may strike the critical reader immediately: 1) the dearth of texts of Puritan culture, 2) the paucity of texts of imaginative literature, and 3) the extensive use of excerpted passages rather than complete texts. All of these are deliberate, and all three are due to limitations of space. Although Puritan culture is essential for the understanding of a great many aspects of American life, such as its political, religious and ideological features, we have frequently omitted texts of American Puritanism because they are amply represented in any major anthology of American literature that students are required to read, and to which they should be directed. This is also the reason why we have not included more texts of imaginative literature in our volume; and why we have excluded such canonical sources as J. Hector St. John de Crèvecoeur's *Letters from an American Farmer*, since it can be found in most survey editions of American literature. Even with the cultural documents that we actually include, considerations of space have forced us to cut many of them rather heavily. If we had used complete texts, our volume would either have contained a mere fraction of the present number of sources, or it would have run to some twelve to fifteen hundred pages.

Since complete texts give a better impression of the comprehensive interplay of issues at a specific time, our excerptions may sometimes irritate a historian looking for the variety of points brought up, say, in a president's Annual Address on the State of the Union. By using excerpts, however, one wins as well as loses. What one gains is concentration of dominant cultural assumptions. Long documents tend to turn the reader's attention away from the interplay between ideology and language to an extended concern with socio-political specifics. Details that are a must for the specialist historian or social scientist are often of less relevance to the student of English and likely to sidetrack rather than

instruct him or her. Frequently brevity proves to be a great virtue when texts are analyzed for the way in which their language gives expression to cultural values.

This is not to say, of course, that a comprehensive understanding of specific economic and socio-political issues is not required in the study of American life. A course in American cultural studies certainly demands the reading of a general introduction to American history and society. Our anthology is first and foremost intended as a documentary companion to such a study in order to facilitate discussion in class and to turn the students' attention to the close interrelations between culture and language.

1

NATIVE AMERICANS

Introduction 6

1 Thomas Jefferson
"Confidential Message to Congress" (1803) 7

2 Tecumseh
"We All Belong to One Family" (1810) 10

3 Tecumseh
"Sell a Country? Why Not Sell the Air? " (1810–11) 12

4 Seattle
FROM "The Dead are Not Powerless" (1854) 13

5 Helen Hunt Jackson
"A Tale of the Wrongs" (1881) 16

6 John Collier
"Full Indian Democracy" (1943) 18

7 Buffy Sainte-Marie
"My Country" (1971) 20

8 Leslie Silko
"The Man to Send Rain Clouds" (1969) 22

9 Studs Terkel
FROM "Girl of the Golden West: Ramona Bennett" (1980) 25

INTRODUCTION

Although the socio-economic situation of the American Indians varies according to tribal and regional background, statistics clearly show that Indians across the nation, in cities as well as on reservations, are members of one of the most impoverished ethnic groups in the US. In his address to a Senate sub-committee in March 1968 Robert Kennedy warned that "the first American is still the last American in terms of income, employment, health, and education. I believe this to be a national tragedy for all Americans – for we are all in some way responsible."[1]

The dismal situation of the Indians is no new phenomenon. During the nineteenth century many liberal reformers rushed in to defend the Indian cause. Already in his *Notes on the State of Virginia* (1785) Thomas Jefferson admitted that it is "very much to be lamented that we have suffered so many of the Indian tribes already to extinguish."[2] Jefferson's views, as expressed in the opening extract, illustrate a common attitude of guilt, paternalism and admiration for the Indian.

Indian oratory is probably the genre of Native American literature best known to the reading public. Nineteenth-century speeches of Indian leaders contain impassioned pleas for a lost cause. The first speech by Tecumseh in this chapter was given in 1810, three years before he died in battle. It is an attempt to unite various tribes for the purpose of regaining land in the Ohio valley. The same year he protested against previous land sales to settlers and refused to enter the mansion of the governor (extract 3). His last words of warning here (page 13) are from 1811.

Speeches of Tecumseh and Seattle are often referred to by conservationists of today. Seattle's speech (extract 4) was addressed to the governor of Washington Territory in 1854. Black Elk's famous eyewitness report from the Wounded Knee massacre of 1890 from *Black Elk Speaks* (1932) is often anthologized and therefore not used here.

In 1881 Helen Hunt Jackson published *A Century of Dishonor*, a book-length indictment of what she considered to be the government's disastrous neglect of the Indians (see extract 5). Over the last few years, however, Indian writers have focused on their own situation, not so much as victims, but as keepers of a valid tradition within American culture. Among other prominent spokesmen, Vine Deloria, a Standing Rock Sioux, has analyzed the conditions of Indians from the Massacre at Wounded Knee in 1890 to a new generation of activists in the 1970s.

During the 1930s John Collier, a commissioner of Indian Affairs, became the responsible architect behind the Indian New Deal, a major effort by the F. D. Roosevelt administration to improve the situation of the Indians (see extract 6). Deploring the disastrous effects of the General Allotment Act of 1887, in which tribes had been dissolved to turn

Indians into independent farmers, Collier worked indefatigably to re-introduce and strengthen the tribe as the center of Indian life.

In "My Country," the renowned Indian folk-singer, Buffy Sainte-Marie, born in Canada, gives artistic expression to the sentiments of many Indians about their plight during the early 1970s. Less militant in tone, contemporary Native American literature, including such writers as N. Scott Momaday (*House Made of Dawn*, 1969) and Louise Erdrich (*Love Medicine*, 1984), has gained general recognition over the last decades. Thus Leslie Silko's short story captures the tension between two cultures and two religions, "resolved" in this story by tacit compromise. Silko was born in 1948 on the Laguna Reservation in New Mexico.

Traditional Indian values, such as reverence of nature, strong tribal ties, and the importance of storytelling, have also influenced non-Indian writers in the US. The famous Chicago journalist Studs Terkel's interview with an Indian woman in the state of Washington (1980) brings us up to the situation as perceived by several Native Americans of today.

The conflict between the Indians' determination to control their own land or rivers and the attempts of private enterprise to exploit the resources on that land is still a potential powder keg. Indians themselves are in disagreement about the issues of how natural resources on reservations should be used.

Sometimes media focus on reservation life tends to take attention away from the large percentage of Native Americans now living in western and midwestern cities. The contrast between country and city life is a continuing factor in Indian culture. Relocation (of Indians to the cities) and termination (of reservations as a federal responsibility) have been key political terms since the 1950s. The recent federal relocation program for the Navajo and Hopi Indians is just one case in point.

1 Quoted in Helle H. Høyrup and Inger N. Madsen, *Red Indians: The First Americans*, Copenhagen, Munksgaard, 1974, p. 5
2 Thomas Jefferson, "Query XI: Aborigines, Original Condition and Origin," *Notes on the State of Virginia*, excerpted in *The Heath Anthology of American Literature*, Vol. 1, Lexington, Mass. D.C. Heath and Co., 1990, p. 970

1 THOMAS JEFFERSON

"Confidential Message to Congress" (1803)

Gentlemen of the Senate, and of the House of Representatives:

As the continuance of the act for establishing trading houses with the Indian tribes will be under the consideration of the legislature at its present session, I think it my duty to communicate the views which have guided me in the execution of that act, in order that you may decide on

the policy of continuing it, in the present or any other form, or discontinue it altogether, if that shall, on the whole, seem most for the public good.

The Indian tribes residing within the limits of the United States have, for a considerable time, been growing more and more uneasy at the constant diminution of the territory they occupy, although effected by their own voluntary sales. And the policy has long been gaining strength with them of refusing absolutely all further sale, on any conditions; insomuch that, at this time, it hazards their friendship, and excites dangerous jealousies and perturbations in their minds to make any overture for the purchase of the smallest portions of their land.

A very few tribes only are not yet obstinately in these dispositions. In order, peaceably, to counteract this policy of theirs, and to provide an extension of territory which the rapid increase of our numbers will call for, two measures are deemed expedient. First, to encourage them to abandon hunting, to apply to the raising stock, to agriculture, and domestic manufacture, and thereby prove to themselves that less land and labor will maintain them in this better than in their former mode of living. The extensive forests necessary in the hunting life, will then become useless, and they will see advantage in exchanging them for the means of improving their farms, and of increasing their domestic comforts. Second, to multiply trading houses among them, and place within their reach those things which will contribute more to their domestic comfort than the possession of extensive, but uncultivated wilds. Experience and reflection will develop to them the wisdom of exchanging what they can spare and we want, for what we can spare and they want. In leading them to agriculture, to manufactures, and civilization; in bringing together their and our settlements, and in preparing them ultimately to participate in the benefits of our governments, I trust and believe we are acting for their greatest good.

At these trading houses we have pursued the principles of the act of Congress which directs that the commerce shall be carried on liberally, and requires only that the capital stock shall not be diminished. We, consequently, undersell private traders, foreign and domestic, drive them from the competition; and, thus, with the goodwill of the Indians, rid ourselves of a description of men who are constantly endeavoring to excite in the Indian mind suspicions, fears, and irritations toward us. A letter now enclosed shows the effect of our competition on the operations of the traders, while the Indians, perceiving the advantage of purchasing from us, are soliciting, generally, our establishment of trading houses among them. In one quarter this is particularly interesting.

The legislature, reflecting on the late occurrences on the Mississippi, must be sensible how desirable it is to possess a respectable breadth of country on that river, from our southern limit to the Illinois, at least, so

that we may present as firm a front on that as on our eastern border. We possess what is below the Yazoo, and can probably acquire a certain breadth from the Illinois and Wabash to the Ohio; but, between the Ohio and Yazoo, the country all belongs to the Chickasaws, the most friendly tribe within our limits, but the most decided against the alienation of lands. The portion of their country most important for us is exactly that which they do not inhabit. Their settlements are not on the Mississippi but in the interior country. They have lately shown a desire to become agricultural; and this leads to the desire of buying implements and comforts. In the strengthening and gratifying of these wants, I see the only prospect of planting on the Mississippi itself the means of its own safety.

Duty has required me to submit these views to the judgment of the legislature; but as their disclosure might embarrass and defeat their effect, they are committed to the special confidence of the two houses.

While the extension of the public commerce among the Indian tribes may deprive of that source of profit such of our citizens as are engaged in it, it might be worthy the attention of Congress, in their care of individual as well as of the general interest, to point in another direction the enterprise of these citizens, as profitably for themselves and more usefully for the public.

The River Missouri, and the Indians inhabiting it, are not as well known as is rendered desirable by their connection with the Mississippi, and consequently with us. It is, however, understood that the country on that river is inhabited by numerous tribes, who furnish great supplies of furs and peltry to the trade of another nation, carried on in a high latitude, through an infinite number of portages and lakes shut up by ice through a long season. The commerce on that line could bear no competition with that of the Missouri, traversing a moderate climate, offering, according to the best accounts, a continued navigation from its source, and possibly with a single portage, from the western ocean, and finding to the Atlantic a choice of channels through the Illinois or Wabash, the lakes and Hudson, through the Ohio and Susquehanna, or Potomac or James rivers, and through the Tennessee and Savannah rivers.

An intelligent officer, with ten or twelve chosen men, fit for the enterprise and willing to undertake it, taken from our posts, where they may be spared without inconvenience, might explore the whole line, even to the western ocean; have conferences with the natives on the subject of commercial intercourse; get admission among them for our traders; as others are admitted, agree on convenient deposits for an interchange of articles; and return with the information acquired, in the course of two summers. Their arms and accoutrements, some instruments of observation, and light and cheap presents for the Indians

would be all the apparatus they could carry, and, with an expectation of a soldier's portion of land on their return, would constitute the whole expense. Their pay would be going on, whether here or there. While other civilized nations have encountered great expense to enlarge the boundaries of knowledge by undertaking voyages of discovery and for other literary purposes, in various parts and directions, our nation seems to owe to the same object, as well as to its own interests, to explore this, the only line of easy communication across the continent, and so directly traversing our own part of it.

The interests of commerce place the principal object within the constitutional powers and care of Congress, and that it should incidentally advance the geographical knowledge of our own continent cannot be but an additional gratification. The nation claiming the territory, regarding this as a literary pursuit, which is in the habit of permitting within its dominions, would not be disposed to view it with jealousy, even if the expiring state of its intersts there did not render it a matter of indifference. The appropriation of $2,500, "for the purpose of extending the external commerce of the United States," while understood and considered by the executive as giving the legislative sanction, would cover the undertaking from notice, and prevent the obstructions which interested individuals might otherwise previously prepare in its way.

2 TECUMSEH

"We All Belong to One Family" (1810)

Brothers – We all belong to one family; we are all children of the Great Spirit; we walk in the same path; slake our thirst at the same spring; and now affairs of the greatest concern lead us to smoke the pipe around the same council fire!

Brothers – We are friends; we must assist each other to bear our burdens. The blood of many of our fathers has run like water on the ground, to satisfy the avarice of the white men. We, ourselves, are threatened with a great evil; nothing will pacify them but the destruction of all the red men.

Brothers – When the white men first set foot on our grounds, they were hungry; they had no place on which to spread their blankets, or to kindle their fires. They were feeble; they could do nothing for themselves. Our fathers commiserated their distress, and shared freely with them whatever the Great Spirit had given his red children. They gave them food when hungry, medicine when sick, spread skins for them to sleep on, and gave grounds, that they might hunt and raise corn.

Brothers – The white people are like poisonous serpents: when chilled,

10

they are feeble, and harmless, but invigorate them with warmth, and they sting their benefactors to death.

The white people came among us feeble; and now we have made them strong, they wish to kill us, or drive us back, as they would wolves and panthers.

Brothers – The white men are not friends to the Indians: at first, they only asked for land sufficient for a wigwam; now, nothing will satisfy them but the whole of our hunting grounds, from the rising to the setting sun.

Brothers – The white men want more than our hunting grounds; they wish to kill our warriors; they would even kill our old men, women, and little ones.

Brothers – Many winters ago, there was no land; the sun did not rise and set: all was darkness. The Great Spirit made all things. He gave the white people a home beyond the great waters. He supplied these grounds with game, and gave them to his red children; and he gave them strength and courage to defend them.

Brothers – My people wish for peace; the red men all wish for peace; but where the white people are, there is no peace for them, except it be on the bosom of our mother.

Brothers – The white men despise and cheat the Indians; they abuse and insult them; they do not think the red men sufficiently good to live.

The red men have borne many and great injuries; they ought to suffer them no longer. My people will not; they are determined on vengeance; they have taken up the tomahawk; they will make it fat with blood; they will drink the blood of the white people.

Brothers – My people are brave and numerous; but the white people are too strong for them alone. I wish you to take up the tomahawk with them. If we all unite, we will cause the rivers to stain the great waters with their blood.

Brothers – If you do not unite with us, they will first destroy us, and then you will fall an easy prey to them. They have destroyed many nations of red men because they were not united, because they were not friends to each other.

Brothers – The white people send runners amongst us; they wish to make us enemies, that they may sweep over and desolate our hunting grounds, like devastating winds, or rushing waters.

Brothers – Our Great Father[1] over the great waters is angry with the white people, our enemies. He will send his brave warriors against them; he will send us rifles, and whatever else we want – he is our friend, and we are his children.

Brothers – Who are the white people that we should fear them? They cannot run fast, and are good marks to shoot at: they are only men; our

fathers have killed many of them; we are not squaws, and we will stain the earth red with their blood.

Brothers – The Great Spirit is angry with our enemies; he speaks in thunder, and the earth swallows up villages, and drinks up the Mississippi. The great waters will cover their lowlands; their corn cannot grow; and the Great Spirit will sweep those who escape to the hills from the earth with his terrible breath.

Brothers – We must be united; we must smoke the same pipe; we must fight each other's battles; and more than all, we must love the Great Spirit; he is for us; he will destroy our enemies, and make his red children happy.

1 i.e., King George III of England (1760–1820).

3 TECUMSEH

"Sell a Country? Why Not Sell the Air?" (1810–11)

1810

Houses are built for you to hold councils in; Indians hold theirs in the open air. I am a Shawnee. My forefathers were warriors. Their son is a warrior. From them I take my only existence. From my tribe I take nothing. I have made myself what I am. And I would that I could make the red people as great as the conceptions of my own mind, when I think of the Great Spirit that rules over us all. . . . I would not then come to Governor Harrison to ask him to tear up the treaty. But I would say to him, "Brother, you have the liberty to return to your own country."

You wish to prevent the Indians from doing as we wish them, to unite and let them consider their lands as the common property of the whole. You take the tribes aside and advise them not to come into this measure. . . . You want by your distinctions of Indian tribes, in allotting to each a particular, to make them war with each other. You never see an Indian endeavor to make the white people do this. You are continually driving the red people, when at last you will drive them onto the great lake, where they can neither stand nor work.

Since my residence at Tippecanoe, we have endeavored to level all distinctions, to destroy village chiefs, by whom all mischiefs are done. It is they who sell the land to the Americns. Brother, this land that was sold, and the goods that was given for it, was only done by a few. . . . In the future we are prepared to punish those who propose to sell land to the Americans. If you continue to purchase them, it will make war among the different tribes, and, at last I do not know what will be the con-

sequences among the white people. Brother, I wish you would take pity on the red people and do as I have requested. If you will not give up the land and do cross the boundary of our present settlement, it will be very hard, and produce great trouble between us.

The way, the only way to stop this evil is for the red men to unite in claiming a common and equal right in the land, as it was at first, and should be now – for it was never divided, but belongs to all. No tribe has the right to sell, even to each other, much less to strangers. . . . *Sell a country! Why not sell the air, the great sea, as well as the earth?* Did not the Great Spirit make them all for the use of his children?

How can we have confidence in the white people?

When Jesus Christ came upon the earth you killed Him and nailed Him to the cross. You thought He was dead, and you were mistaken. You have Shakers among you and you laugh and make light of their worship.

Everything I have told you is the truth. The Great Spirit has inspired me.

1811

Where today are the Pequot? Where are the Narragansett, the Mohican, the Pocanet, and other powerful tribes of our people? They have vanished before the avarice and oppression of the white man, as snow before the summer sun. . . . Will we let ourselves be destroyed in our turn, without making an effort worthy of our race? Shall we, without a struggle, give up our homes, our lands, bequeathed to us by the Great Spirit? The graves of our dead and everything that is dear and sacred to us? . . . I know you will say with me, Never! Never! . . .

Sleep not longer, O Choctaws and Chickasaws, in false security and delusive hopes. . . . Will not the bones of our dead be plowed up, and their graves turned into plowed fields?

4 SEATTLE

FROM "The Dead are Not Powerless" (1854)

Yonder sky that has wept tears of compassion upon my people for centuries untold, and which to us appears changeless and eternal, may change. Today is fair. Tomorrow it may be overcast with clouds. My words are like the stars that never change. Whatever Seattle says the great chief at Washington can rely upon with as much certainty as he can upon the return of the sun or the seasons. The White Chief says that Big Chief at Washington sends us greetings of friendship and goodwill. That is kind of him for we know he has little need of our friendship in return. His people are many. They are like the grass that covers vast prairies. My

people are few. They resemble the scattering trees of a storm-swept plain. . . . I will not dwell on, nor mourn over, our untimely decay, nor reproach our paleface brothers with hastening it, as we too may have been somewhat to blame. . . .

Your God is not our God. Your God loves your people and hates mine. He folds his strong and protecting arms lovingly about the paleface and leads him by the hand as a father leads his infant son – but He has forsaken His red children – if they really are His. Our God, the Great Spirit, seems also to have forsaken us. Your God makes your people strong every day. Soon they will fill the land. Our people are ebbing away like a rapidly receding tide that will never return. The white man's God cannot love our people or He would protect them. They seem to be orphans who can look nowhere for help. How then can we be brothers? . . . We are two distinct races with separate origins and separate destinies. There is little in common between us.

To us the ashes of our ancestors are sacred and their resting place is hallowed ground. You wander far from the graves of your ancestors and seemingly without regret. Your religion was written upon tables of stone by the iron finger of your God so that you could not forget. The Red Man could never comprehend nor remember it. Our religion is the traditions of our ancestors – the dreams of our old men, given them in solemn hours of night by the Great Spirit; and the visions of our sachems; and it is written in the hearts of our people.

Your dead cease to love you and the land of their nativity as soon as they pass the portals of the tomb and wander way beyond the stars. They are soon forgotten and never return. Our dead never forget the beautiful world that gave them being.

Day and night cannot dwell together. The Red Man has ever fled the approach of the White Man, as the morning mist flees before the morning sun. However, your proposition seems fair and I think that my people will accept it and will retire to the reservation you offer them. Then we will dwell apart in peace. . . . It matters little where we pass the remnant of our days. They will not be many. A few more moons; a few more winters – and not one of the descendants of the mighty hosts that once moved over this broad land or lived in happy homes, protected by the Great Spirit, will remain to mourn over the graves of a people once more powerful and hopeful than yours. But why should I mourn at the untimely fate of my people? Tribe follows tribe, and nation follows nation, like the waves of the sea. It is the order of nature, and regret is useless. Your time of decay may be distant, but it will surely come, for even the White Man whose God walked and talked with him as friend with friend, cannot be exempt from the common destiny. We may be brothers after all. We will see. . . .

Every part of this soil is sacred in the estimation of my people. Every

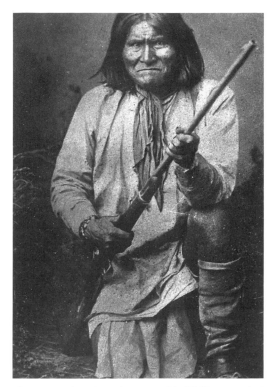

Figure 1.1 "Geronimo, captive Apache war chief." By permission of Oklahoma Historical Society

hillside, every valley, every plain and grove, has been hallowed by some sad or happy event in days long vanished. The very dust upon which you now stand responds more lovingly to their footsteps than to yours, because it is rich with the blood of our ancestors and our bare feet are conscious of the sympathetic touch. Even the little children who lived here and rejoiced here for a brief season will love these somber solitudes and at eventide they greet shadowy returning spirits. And when the last Red Man shall have perished, and the memory of my tribe shall have become a myth among the White Men, these shores will swarm with the invisible dead of my tribe, and when your children's children think themselves alone in the field, the store, the shop, upon the highway, or in the silence of the pathless woods, they will not be alone. At night when the streets of your cities and villages are silent and you think them deserted, they will throng with the returning hosts that once filled and still love this beautiful land. The White Man will never be alone.

Let him be just and deal kindly with my people, for the dead are not powerless. Dead, did I say? There is no death, only a change of worlds.

15

5 HELEN HUNT JACKSON

"A Tale of the Wrongs" (1881)

There is not among these three hundred bands of Indians [in the United States] one which has not suffered cruelly at the hands either of the Government or of white settlers. The poorer, the more insignificant, the more helpless the band, the more certain the cruelty and outrage to which they have been subjected. This is especially true of the bands on the Pacific slopes. These Indians found themselves of a sudden surrounded by and caught up in the great influx of gold-seeking settlers, as helpless creatures on a shore are caught up in a tidal wave. There was not time for the Government to make treaties; not even time for communities to make laws. The tale of the wrongs, the oppressions, the murders of the Pacific-slope Indians in the last thirty years would be a volume by itself, and is too monstrous to be believed.

It makes little difference, however, where one opens the record of the history of the Indians; every page and every year has its dark stain. The story of one tribe is the story of all, varied only by differences of time and place; but neither time nor place makes any difference in the main facts. Colorado is as greedy and unjust in 1880 as was Georgia in 1830, and Ohio in 1795; and the United States Government breaks promises now as deftly as then, and with added ingenuity from long practice.

One of its strongest supports in so doing is the wide-spread sentiment among the people of dislike to the Indian, of impatience with his presence as a "barrier to civilization," and distrust of it as a possible danger. The old tales of the frontier life, with its horrors of Indian warfare, have gradually, by two or three generations' telling, produced in the average mind something like an hereditary instinct of unquestioning and unreasoning aversion which it is almost impossible to dislodge or soften.

There are hundreds of pages of unimpeachable testimony on the side of the Indian; but it goes for nothing, is set down as sentimentalism or partisanship, tossed aside and forgotten.

President after president has appointed commission after commission to inquire into and report upon Indian affairs, and to make suggestions as to the best methods of managing them. The reports are filled with eloquent statements of wrongs done to the Indians, of perfidies on the part of the Government; they counsel, as earnestly as words can, a trial of the simple and unperplexing expedients of telling truth, keeping promises, making fair bargains, dealing justly in all ways and all things. These reports are bound up with the Government's Annual Reports, and that is the end of them. It would probably be no exaggeration to say that not one American citizen out of ten thousand ever sees

16

them or knows that they exist, and yet any one of them, circulated throughout the country, read by the right-thinking, right-feeling men and women of this land, would be of itself a "campaign document" that would initiate a revolution which would not subside until the Indians' wrongs were, so far as is now left possible, righted.

In 1869 President Grant appointed a commission of nine men, representing the influence and philanthropy of six leading States, to visit the different Indian reservations, and to "examine all matters appertaining to Indian affairs."

In the report of this commission are such paragraphs as the following: "To assert that 'the Indian will not work' is as true as it would be to say that the white man will not work.

"Why should the Indian be expected to plant corn, fence lands, build houses, or do anything but get food from day to day, when experience has taught him that the product of his labor will be seized by the white man to-morrow? The most industrious white man would become a drone under similar circumstances. Nevertheless, many of the Indians" (the commissioners might more forcibly have said 130,000 of the Indians) "are already at work, and furnish ample refutation of the assertion that 'the Indian will not work.' There is no escape from the inexorable logic of facts.

"The history of the Government connections with the Indians is a shameful record of broken treaties and unfulfilled promises. The history of the border, white man's connection with the Indians is a sickening record of murder, outrage, robbery, and wrongs committed by the former, as the rule, and occasional savage outbreaks and unspeakably barbarous deeds of retaliation by the latter, as the exception.

"Taught by the Government that they had rights entitled to respect, when those rights have been assailed by the rapacity of the white man, the arm which should have been raised to protect them has ever been ready to sustain the aggressor.

"The testimony of some of the highest military officers of the United States is on record to the effect that, in our Indian wars, almost without exception, the first aggressions have been made by the white man, and the assertion is supported by every civilian of reputation who has studied the subject. In addition to the class of robbers and outlaws who find impunity in their nefarious pursuits on the frontiers, there is a large class of professedly reputable men who use every means in their power to bring on Indian wars for the sake of the profit to be realized from the presence of troops and the expenditures of Government funds in their midst. They proclaim death to the Indians at all times in words and publications, making no distinction between the innocent and the guilty. They irate the lowest class of men to the perpetration of the darkest deeds against their victims, and as judges and jurymen shield them from

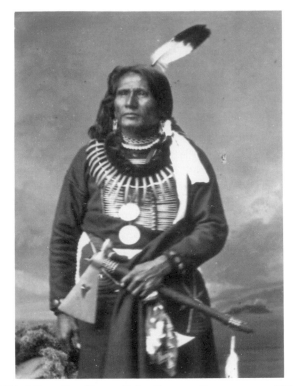

Figure 1.2 Chief Standing Bear of the Poncas. By courtesy of Nebraska State Historical Society

the justice due to their crimes. Every crime committed by a white man against an Indian is concealed or palliated. Every offence committed by an Indian against a white man is borne on the wings of the post or the telegraph to the remotest corner of the land, clothed with all the horrors which the reality or imagination can throw around it. Against such influences as these the people of the United States need to be warned."

6 JOHN COLLIER

"Full Indian Democracy" (1943)

I see the broad function of Indian policy and Indian administration to be the development of Indian democracy and equality within the framework of American and world democracy. . . .

The most significant clue to achieving full Indian democracy within and as a part of American democracy, is the continued survival, through all historical change and disaster, of the Indian tribal group, both as a

real entity and as a legal entity. I suspect the reason we do not always give this fact the recognition it deserves is that we do not want to recognize it. Indian "tribalism" seems to be foreign to our American way of life. It seems to block individual development. We do not know how to deal with it. Consciously or unconsciously, we ignore it or try to eliminate it. Remove the tribe, rehabilitate the individual, and our problem is solved – so runs our instinctive thinking. . . .

We can discard everything else if we wish, and think of the tribe merely as a fact of law. At the minimum, the tribe is a legally recognized holding corporation – a holder of property and a holder of tangible rights granted by treaty or statue, by virtue of which a member enjoys valuable privileges which as a non-member he could not have. Through court decisions – many of them Supreme Court decisions – an important body of legal doctrine has grown up about the concept of the tribal entity. This fact of law is an enormously important, persistent, stubborn, living reality. . . .

Now this fact of law was greatly clarified and strengthened by the Indian Reorganization Act, which converted the tribe from a static to a dynamic concept. Congress, through the Indian Reorganization Act, invoked the tribe as a democratic operational mechanism. It reaffirmed the powers inherent in Indian tribes and set those powers to work for modern community development. In doing so, Congress recognized that most Indians were excluded from local civic government and that no human beings can prosper, or even survive, in a vacuum. If we strip the word tribe of its primitive and atavistic connotations, and consider tribes merely as primary or somewhat localized human groups, we can see that Indian tribal government, for most Indians, is the only presently feasible type of local civic self-government they can share in and use for their advancement. We can divest ourselves of the lingering fear that tribalism is a regression, and we can look upon it as a most important single step in assimilating Indians to modern democratic life. . . .

I cannot predict how long tribal government will endure. I imagine it will be variable in duration. I can imagine some tribes will remain cohesive social units for a very long time; others will more or less rapidly diffuse themselves among the rest of the population. It is not our policy to force this issue. Indians have the right of self-determination. And cultural diversity is by no means inimical to national unity, as the magnificent war effort of the Indians proves. . . .

During this transitional period (however short or long it may prove to be) the federal government is forced both by the fact of law and the fact of self-interest to continue to give a friendly guiding and protective hand to Indian advancement. As to law: there is a large body of treaties and statutes to be interpreted and enforced; Indian property must continue to be protected against unfair practices by the dominant group; Indians

must be assisted in attaining self-subsistence and full citizenship. As to government self-interest: the complete withdrawal of this protection would merely substitute a more difficult problem in place of the one that is on the way to solution. It would create a permanently dispossessed and impoverished group that will either have to live on the dole or become one more sore spot in the body politic. . . .

The government's relationship to Indians is itself in a transition period. The Indian Reorganization Act made that inevitable. The Indian office is moving from guardian to advisor, from administrator to friend in court. In this transition, many powers hitherto exercised by the Indian service have been transferred to the organized tribes; many more such powers will be transferred. As Indians advance in self-government, they will begin to provide many of their own technical and social services or will depend more and more on the services ordinarily provided to American communities. I think we can agree, however, that federal advisory supervision ought not to be withdrawn until Indians have attained a fair political, economic, and cultural activity.

7 BUFFY SAINTE-MARIE

"My Country" (1971)

Now that your big eyes are finally opened,
Now that you're wond'ring "how must they feel? "
Meaning them that you've chased 'cross America's movie screens.
Now that you're wond'ring "how can it be real,"
That the ones you've called colorful, noble and proud
In your school propaganda – they starve in their splendor!
You've asked for my comment. I simply will render:
My country, 'tis of thy people you're dying!

Now that the long houses "breed superstition"
You force us to send our toddlers away
To your schools where they're taught to despise their traditions;
Forbid them their languages, then further say
That American history really began
When Columbus set sail out of Europe! And stress
That the nation of leeches that's conquered this land
Are the biggest and bravest and boldest and best!
And yet where in your history books is the tale
Of the genocide basic to this country's birth?
Of the preachers who lied? how the Bill of Rights failed?
How a nation of patriots returned to their earth?

And where will it tell of the liberty bell
As it rang with a thud over Kinzua mud?
And of brave Uncle Sam in Alaska this year?
My country, 'tis of thy people you're dying!

Hear how the bargain was made for the West,
With her shivering children in zero degrees,
"Blankets for your land", so the treaties attest.
Oh, well, blankets for land is a bargain indeed . . .
But the blankets were those Uncle Sam had collected,
From smallpox diseased dying soldiers that day,
And the tribes were wiped out and the history books censored!
A hundred years of your statesmen have felt it's better this way,
Yet a few of the conquered have somehow survived . . .
Their blood runs the redder though genes have been paled,
From the Grand Canyon's caverns to Craven's sad hills,
The wounded, the losers, the robbed sing their tale,
From Los Angeles County to upstate New York,
The white nation fattens while others grow lean.
Oh the tricked and evicted, they know what I mean;
My country, 'tis of thy people you're dying!

The past it just crumbled: the future just threatens;
Our life blood's shut up in your chemical tanks.
And now here you come, bill of sale in your hand,
And surprise in your eyes that we're lacking in thanks,
For the blessings of civilization you've brought us,
The lessons you've taught us, the ruin you've wrought us!
Oh see what our trust in America's brought us!
My country, 'tis of thy people you're dying!

Now that the pride of the sires receive charity,
Now that we're harmless and safe behind laws,
Now that my life's to be known as your heritage,
Now that even the graves have been robbed,
Now that our own chosen way is your novelty,
Hands on our hearts, we salute you your victory,
Choke on your blue, white and scarlet hypocrisy,
Pitying the blindness that you've never seen,
That the eagles of war whose wings lent you glory,
They were never no more than carrion crows;
Pushed the wrens from their nest, stole their eggs, changed their story,
The mockingbird sings it . . . it's all that she knows,
"Ah what can I do? " say a powerless few,
With a lump in your throat and a tear in your eye,

21

Can't you see that their poverty's profiting you?
My country, 'tis of thy people you're dying!

8 LESLIE SILKO

"The Man to Send Rain Clouds" (1969)

One

They found him under a big cottonwood tree. His Levi jacket and pants were faded light-blue so that he had been easy to find. The big cottonwood tree stood apart from a small grove of winterbare cottonwoods which grew in the wide, sandy arroyo. He had been dead for a day or more, and the sheep had wandered and scattered up and down the arroyo. Leon and his brother-in-law, Ken, gathered the sheep and left them in the pen at the sheep camp before they returned to the cottonwood tree. Leon waited under the tree while Ken drove the truck through the deep sand to the edge of the arroyo. He squinted up at the sun and unzipped his jacket – it sure was hot for this time of year. But high and northwest the blue mountains were still deep in snow. Ken came sliding below the low, crumbling bank about fifty yards down, and he was bringing the red blanket.

Before they wrapped the old man, Leon took a piece of string out of his pocket and tied a small gray feather in the old man's long white hair. Ken gave him the paint. Across the brown wrinkled forehead he drew a streak of white and along the high cheekbones he drew a strip of blue paint. He paused and watched Ken throw pinches of corn meal and pollen into the wind that fluttered the small gray feather. Then Leon painted with yellow under the old man's broad nose, and finally, when he had painted green across the chin, he smiled.

"Send us rain clouds, Grandfather." They laid the bundle in the back of the pickup and covered it with a heavy tarp before they started back to the pueblo.

They turned off the highway onto the sandy pueblo road. Not long after they passed the store and post office they saw Father Paul's car coming toward them. When he recognized their faces he slowed his car and waved for them to stop. The young priest rolled down the car window.

"Did you find old Teofilo? " he asked loudly.

Leon stopped the truck. "Good morning, Father. We were just out to the sheep camp. Everything is OK now."

"Thank God for that. Teofilo is a very old man. You really shouldn't allow him to stay at the sheep camp alone."

"No, he won't do that any more now."

"Well, I'm glad you understand. I hope I'll be seeing you at Mass this week – we missed you last Sunday. See if you can get old Teofilo to come with you." The priest smiled and waved at them as they drove away.

Two

Louise and Teresa were waiting. The table was set for lunch, and the coffee was boiling on the black iron stove. Leon looked at Louise and then at Teresa.

"We found him under a cottonwood tree in the big arroyo near sheep camp. I guess he sat down to rest in the shade and never got up again." Leon walked toward the old man's bed. The red plaid shawl had been shaken and spread carefully over the bed, and a new brown flannel shirt and pair of stiff new Levis were arranged neatly beside the pillow. Louise held the screen door open while Leon and Ken carried in the red blanket. He looked small and shriveled, and after they dressed him in the new shirt and pants he seemed more shrunken.

It was noontime now because the church bells rang the Angelus. They ate the beans with hot bread, and nobody said anything until after Teresa poured the coffee.

Ken stood up and put on his jacket. "I'll see about the gravediggers. Only the top layer of soil is frozen. I think it can be ready before dark."

Leon nodded his head and finished his coffee. After Ken had been gone for a while, the neighbors and clanspeople came quietly to embrace Teofilo's family and to leave food on the table because the gravediggers would come to eat when they were finished.

Three

The sky in the west was full of pale-yellow light. Louise stood outside with her hands in the pockets of Leon's green army jacket that was too big for her. The funeral was over, and the old men had taken their candles and medicine bags and were gone. She waited until the body was laid into the pickup before she said anything to Leon. She touched his arm, and he noticed that her hands were still dusty from the corn meal that she had sprinkled around the old man. When she spoke, Leon could not hear her.

"What did you say? I didn't hear you."

"I said that I had been thinking about something."

"About what? "

"About the priest sprinkling holy water for Grandpa. So he won't be thirsty."

Leon stared at the new moccasins that Teofilo had made for the ceremonial dances in the summer. They were nearly hidden by the

red blanket. It was getting colder, and the wind pushed gray dust down the narrow pueblo road. The sun was approaching the long mesa where it disappeared during the winter. Louise stood there shivering and watching his face. Then he zipped up his jacket and opened the truck door. "I'll see if he's there."

Four

Ken stopped the pickup at the church, and Leon got out; and then Ken drove down the hill to the graveyard where people were waiting. Leon knocked at the old carved door with its symbols of the Lamb. While he waited he looked up at the twin bells from the king of Spain with the last sunlight pouring around them in their tower.

The priest opened the door and smiled when he saw who it was. "Come in! What brings you here this evening?"

The priest walked toward the kitchen, and Leon stood with his cap in his hand, playing with the earflaps and examining the living room – the brown sofa, the green armchair, and the brass lamp that hung down from the ceiling by links of chain. The priest dragged a chair out of the kitchen and offered it to Leon.

"No thank you, Father. I only came to ask you if you would bring your holy water to the graveyard."

The priest turned away from Leon and looked out the window at the patio full of shadows and the dining-room windows of the nuns' cloister across the patio. The curtains were heavy, and the light from within faintly penetrated; it was impossible to see the nuns inside eating supper. "Why didn't you tell me he was dead? I could have brought the Last Rites anyway."

Leon smiled. "It wasn't necessary, Father."

The priest stared down at his scuffed brown loafers and the worn hem of his cassock. "For a Christian burial it was necessary."

His voice was distant, and Leon thought that his blue eyes looked tired.

"It's OK Father, we just want him to have plenty of water."

The priest sank down into the green chair and picked up a glossy missionary magazine. He turned the colored pages full of lepers and pagans without looking at them.

"You know I can't do that, Leon. There should have been the Last Rites and a funeral Mass at the very least."

Leon put on his green cap and pulled the flaps down over his ears. "It's getting late, Father. I've got to go."

When Leon opened the door Father Paul stood up and said, "Wait." He left the room and came back wearing a long brown overcoat. He followed Leon out the door and across the dim churchyard to the adobe

steps in front of the church. They both stooped to fit through the low adobe entrance. And when they started down the hill to the graveyard only half of the sun was visible above the mesa.

The priest approached the grave slowly, wondering how they had managed to dig into the frozen ground; and then he remembered that this was New Mexico, and saw the pile of cold loose sand beside the hole. The people stood close to each other with little clouds of steam puffing from their faces. The priest looked at them and saw a pile of jackets, gloves, and scarves in the yellow, dry tumbleweeds that grew in the graveyard. He looked at the red blanket, not sure that Teofilo was so small, wondering if it wasn't some perverse Indian trick – something they did in March to ensure a good harvest – wondering if maybe old Teofilo was actually at sheep camp corraling the sheep for the night. But there he was, facing into a cold dry wind and squinting at the last sunlight, ready to bury a red wool blanket while the faces of his parishioners were in shadow with the last warmth of the sun on their backs.

His fingers were stiff, and it took him a long time to twist the lid off the holy water. Drops of water fell on the red blanket and soaked into dark icy spots. He sprinkled the grave and the water disappeared almost before it touched the dim, cold sand; it reminded him of something – he tried to remember what it was, because he thought if he could remember he might understand this. He sprinkled more water; he shook the container until it was empty, and the water fell through the light from sundown like August rain that fell while the sun was still shining, almost evaporating before it touched the wilted squash flowers.

The wind pulled at the priest's brown Franciscan robe and swirled away the corn meal and pollen that had been sprinkled on the blanket. They lowered the bundle into the ground, and they didn't bother to untie the stiff pieces of new rope that were tied around the ends of the blanket. The sun was gone, and over on the highway the eastbound lane was full of headlights. The priest walked away slowly. Leon watched him climb the hill, and when he had disappeared within the tall, thick walls, Leon turned to look up at the high blue mountains in the deep snow that reflected a faint red light from the west. He felt good because it was finished, and he was happy about the sprinkling of the holy water; now the old man could send them big thunderclouds for sure.

9 STUDS TERKEL

FROM "Girl of the Golden West: Ramona Bennett" (1980)

We're on the highway, heading from the Seattle airport to Tacoma.

"Do you know we're on a reservation at this moment? It was reserved forever for the members of my tribe. 'Forever' meant until some white people wanted it. I'm a member

of the Puyallup tribe. It's called that by the whites because they couldn't pronounce our foreign name: Spalallapubhs. (Laughs.). . . .

"We were a fishing people. We had camps all the way from McNeill's Island to Salmon Bay and clear up to Rodando. In 1854, agents of the United States government met with our people and did a treaty. They promised us they only needed land to farm. They assured us that our rights as commercial fishing people would not be disturbed. Because Indian people have always been generous, we agreed to share.

"Our tribes were consolidated onto this reservation, twenty-nine thousand acres. We lost eleven thousand in the survey, so we came down to eighteen thousand. We should have known, but we're a trusting people."

We were long-house people, matriarchal, where the whole extended family lived together. We didn't have real estate problems. There was lots of space for everybody, so we didn't have to stand our long houses on end and call them skyscrapers.

The white people decided we'd make good farmers, so they separated our long-house families into forty-, eighty-, and 160-acre tracts. If we didn't improve our land, we'd lose it. They really knew it wouldn't work, but it was a way of breaking up our society. Phil Lucas, who's a beautiful Indian folk singer, says the marriage between the non-Indians and the Indians was a perfect one. The Indian measures his success by his ability to share. The white man measures his importance by how much he can take. There couldn't have been two more perfect cultures to meet, with the white people taking everything and the Indians giving everything.

They then decided that because we couldn't read or write or speak English, we should all be assigned guardians. So the lawyers and judges and police and businessmen who came out with Milwaukee Railroad and Weyerhaeuser Lumber, all these good citizens were assigned their fair share of Indians to be guardians for. They sold the land to each other, kept the money for probate fees, and had the sheriffs come out and remove any Indians still living on this land. Those Indians unwilling to be removed were put on the railroad tracks and murdered. We became landless on our own reservations.

The kids were denied access to anything traditionally theirs. They had programs called Domestic Science, where little Indian girls were taught how to wash dishes for white people, cook meals for white people, mop floors for white people. If they were very, very smart, they were taught how to be beauticians and cut white people's hair, or to be waitresses and serve white people in restaurants, to be clerk typists, maybe, and type white people's ideas. All the boys went through a program called Agricultural Science, where they were taught how to plow white people's fields and take care of white people's cows and chickens and to care for the produce that was being raised on their own land, stolen by non-Indians. If these boys were very, very smart, they were taught to be

26

unemployed welders or unemployed sheet-metal workers. People that do the hiring are whites, and they tend to be more comfortable with people who resemble them.

We are entering a complex of buildings. One stands out from among the others; it has the appearance of a stone fortress.

This is a jail for young Indian boys. It used to be a little Indian hospital. It was the only hospital for us in the whole region. That's Alaska, Montana, Idaho, Washington, and Oregon. The good white folks saw this new modern hospital going up and right away got mad. They started lobbying to get it away from us. About eighteen years ago, the government snatched it away.

I spend eight years as chairwoman of Puyallup Tribal Council, nonstop, working to reacquire the building. Right now, it's used by Washington State as a jail for children. It's called a juvenile diagnostic center. (She nods toward a young boy on the grounds.) You just saw an Indian child. Who the hell do you think gets locked up in this country? Children, minority and white. It's a system that is so goddamn sick that it abandons and locks up its children. Didn't you see the barbed wire? (Impatient with me) I mean, didn't you see the cyclone fence? See the bars on the windows over there?

We enter one of the smaller buildings across the road. It is noninstitutional in appearance and feeling. Small, delighted children are busy at their tasks or listening quietly to one of the young women teachers. A teacher says: "Most of our students and teachers are Indian. We concentrate on traditional crafts and arts and history. We teach respect for the visions of others. We honor elders for their wisdom. We prize good humor, especially when directed at oneself. All natural things are our brothers and sisters, and will teach us if we are aware and listen. We honor persons for what they've done for their people, not what they've done for themselves."

We demanded a school building to get our kids out of the public school system, where they were being failed. It was a struggle getting this school. I've learned from the whites how to grab and how to push. When the state would not return our hospital to us, we just pushed our way on this property and occupied it.

When you read about Indians or when you see them in movies, you see John Wayne theater. You see an Indian sneaking through the bushes to kill some innocent white. (She indicates people walking by, all of whom know her. On occasion, she chats with one or two.) You'd never think those two guys are fishermen and the guy that just walked by is an accountant. So is that gal. You don't think of Indians as professionals. You think of the stereotype that everyone needs to be afraid of.

In school, I learned the same lies you learned: that Columbus discovered America, that there were no survivors at Little Big Horn, that

the first baby born west of the Mississippi was born to Narcissa Whitman. All the same crap that you learned, I learned. Through those movies, I learned that an Irishman who stands up for his rights is a patriot, and an Indian who stands up for his rights is a savage. I learned that the pioneers made the West a fit place for decent folks to live. I learned that white people had to take land away from the Indian people because we didn't know how to use it. It wasn't plowed, logged, and paved. It wasn't strip-mined. It had to be taken from us because we had no environmental knowledge or concerns. We were just not destructive enough to be considered *really* civilized.

What happened is we had land the whites wanted. The government ordered the Indians to move. They were moved so many times, they might as well have had handles. There were always a few patriots who'd say: "For God's sake, we were born here, we buried our dead here. Leave us alone. My God, it's a federal promise. We got a contract. I'm not makin' my grandmother move, I'm not makin' my children move. Bullshit, I'm sick of this." They pick up arms and that would be an uprising. The cavalry rides in. Since we all look alike, they'd kill the first bunch of Indians they saw. This was just tradition. Every single one of those cavalry officers had one of those damn little flags and damn little Bibles. Oh, they were very, very religious. (Laughs.) They opened fire and did a genocide.

They always teach that the only survivor at Little Big Horn was that cavalry horse. Since then, I've realized there were many survivors of Little Big Horn. (Laughs.) They were Sioux and Cheyennes and therefore didn't count, apparently. You never see a roster with all of *their* names.

When I went to school, we learned history so we won't make the same mistakes. This is what I was told. I know damn good and well that if American children in school had learned that the beautiful Cheyenne women at Sand Creek put their shawls over their babies' faces so they wouldn't see the long knives, if the American schoolchildren learned that Indian mothers held their babies close to their bodies when the Gatling guns shot and killed three hundred, there would never have been a My Lai massacre. If the history teacher had really been truthful with American children, Calley would have given an order to totally noncooperating troops. There would have been no one to fight. There would have been a national conscience. The lie has made for an American nightmare, not dream.

When I was in first grade, really tiny, I played a small child in a school play. This was during World War Two. I was born in 1938. My mother was a little dark lady. Caucasians cannot tell people of color apart. To the average white, Chinese, Filipinos, Japanese, all look the same. When my mom came to the school grounds, a little boy named Charles made

slanty eyes at her and called her ugly names. I didn't understand what he was saying, but I just jumped on him and started hitting him. He was a friend of mine, and he didn't know why I was doing it. Neither did I. When the play started, my clothes were all disheveled. I was confused, hurt, and really feeling bad. When I went on that stage and looked at all those faces, I realized for the first time my mother was a different color from the others and attracted attention. Her skin had always been rich and warm, while mine looked pale and cold. My father was white. It was such a shock that someone could hate my mother for being such a warm, beautiful woman. Much later I found out that Charles's father died in the Pacific and that his whole family was very uptight about the Japanese.

I think of Indian people who, at treaty time, offered to share with a few men from Boston. They never knew there'd be a Boeing Airplane Company or a Weyerhaeuser. They never knew there would be a statue in the harbor inviting wretched masses and that those masses would come like waves of the sea, thousands and thousands of people seeking freedom. Freedoms that those Indian people would never be afforded. With all those waves coming at us, we were just drowning in the American Dream.

The median lifespan for Indians is somewhere in the forties. That's deceptive because our infant mortality rate is four times higher than the national average. We have the magic age of nineteen, the age of drinking, violent deaths, and suicides. Our teenage suicide rate is thirty-four times higher than the national average.

Forty-five is another magic age for the Indian. That's the age of deaths from alcoholism. Our people have gone from the highest protein diet on the face of the earth – buffalo and salmon – to macaroni. If we're not alcoholics, we're popoholics. Ninety percent of us, eighteen and older, are alcoholics. It's a daily suicide: "I can't face my life, lack of future. I can't face the ugly attitudes toward me. I can't face the poverty. So I'll just drink this bottle of Ripple, and I'll kill myself for a few hours. I'll kill some brain cells. Tomorrow, when I get sober, maybe things will be different. When I get sober and things are no different, I'll drink again. I'm not so hopeless that I'll kill myself." It's an optimistic form of suicide.

I once drank very heavily. A little seventeen-year-old girl, who I considered just a child, would just get in my face and give me hell. She would say: "Don't you care about yourself? Don't you realize you're killing an Indian? Why do you want to hurt yourself?" At that point I stopped, and I can't be around people who drink. Oh, I don't mind if you drink. I don't care what non-Indian people do to themselves. But I hate to see an Indian killing himself or herself. That Indian is waiting, marking time and wasting, decade after decade. The family is broken up.

They rush through our communities and gather our children.

29

Thirty-five percent of our children have been removed from their families to boarding schools, foster homes, and institutions. A Shoshone or Sioux or Navajo woman lives in a house like mine. Substandard, no sanitation. No employment on the reservation. Inadequate education. The Mormons have a relocation – child-removal – program. Here's the routine:

A woman from the LDS [Latter Day Saints] knocks on my door. I'm gracious and I invite her in because that's our way. She says: "Oh, look at all your pretty children. Oh, what a nice family. I see that your roof leaks and your house is a little cold and you don't have sanitation. By the looks of your kitchen, you don't have much food, and I notice you have very little furniture. You don't have running water and you have an outdoor toilet. And the nearest school is sixty miles away. Wouldn't you like your children to go and live in this nice house, where they'll have their own bedrooms, wonderful people who care about them, lots of money to buy food, indoor plumbing, posturepedic mattresses and Cannon sheets, and wonderful television sets, and well-landscaped yards? And a neighborhood school, so your children won't have to spend three hours a day on a bus?" And then she says: "If you reeeeeelly, reeeeeeally love your children, you wouldn't want them to live like this. You would want them to have all the good things they need." And that mother thinks: My God, I love my children and what a monster I am! How can I possibly keep them from this paradise?

"My mother grew up poor, like many Indians. She was taken away to boarding school, where they forbade the use of her language, her religion. But she kept her wits about her. She learned to look at things with a raised eyebrow. When she hears something that's funny, she laughs out loud. She provided me with pride, humor, and strength: you don't snivel, you don't quit, you don't back off.

"She talks to graves, talks to plants, talks to rivers. Aside from knowing the traditional things, she was busy growing things, digging clams, smoking fish, sewing. She's an excellent seamstress. At the same time, she's politically and socially sharp.

"When I was a little girl, a couple of FBI agents came to the house. I was maybe four years old. World War Two had just broken out. In a secretive way, they said: 'We'd like to talk to you about security risks. Next-door is this German family, and on the other side these Italians. We want to know if you think they're loyal.' My maiden name was Church, a very British, acceptable name. She said that the Germans were third-generation and are Americans to the core, and the Italian family had already lost a son in the Pacific. Then she said: 'If you're looking for a security risk, I suggest you investigate me, because I don't see any reason for an Indian to be fighting for a government that has stolen lands from the Indian people.' She just shouted at them to get the hell off her porch. Gee, they just back-pedaled off and went." (Laughs.)

I met a bunch of Eskimos from Alaska that the Methodists got hold of. They call it the Methodist ethic. If you work, you're good, if you don't,

you're bad. I don't impose that ethic on other people. These Eskimos are now so task-oriented, they're very, very hyper. They don't know how to relax. The Methodists got hold of their heads, and they lost what they had. They're in a mad dash all the time and don't know how to sit and cogitate.

My little six-year-old will go out, just sit and talk to one of those trees or observe the birds. He can be calm and comfortable doing that. He hasn't been through the same brainwash that the rest of us have.

There's knowledge born in these little ones that ties back to the spirit world, to the Creator. Those little kids in school can tell you that the nations of fish are their brothers and sisters. They'll tell you that their life is no more important than the life of that animal or that tree or that flower. They're born knowing that. It's that our school doesn't beat it out of them.

History's important, what happened in the past is important. But I'm not satisfied with just talking about what happened in 1855 or what happened in 1903, during the murders, or 1961, when they seized our hospital. I want my children to have something good to say in 1990 about what happened in 1979. They're not gonna look in the mirror and see themselves as Indians with no future.

My little son shares the continent with 199,999,999 other folks. (Laughs.) If your government screws up and creates one more damned war, his little brown ass will get blown away, right along with all your people. All those colors (laughs) and all those attitudes. The bombs that

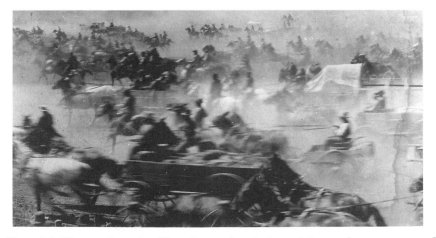

Figure 1.3 The run into the Cherokee outlet. A view of the north-west corner of the Chilocco Indian school grounds. By courtesy of the Oklahoma Historical Society.

31

come don't give a damn if he's got cute little braids, is a little brown boy, talks to cedar trees, and is a sweet little person.

I see the United States government as a little baby brat. If you say no, it throws something at you. If it sees something, it just grabs. Just drools all over and soils itself, and has to have others come in and clean it up. It's a 200-year-old kid. They gave us dual citizenship in 1924. How can a little teeny stupid 150-year-old government grant citizenship to a Yakima Indian who has been here for eight million years? To a Puyallup? What an insult! (Laughs.) How can a lying little trespasser that doesn't know how to act right grant anything to anybody? Why doesn't somebody get that kid in line? Eventually, some stranger will go over and grab that little kid and shake 'im up. I think the United States is just rapidly heading to be shaken around. Unfortunately, I'm living right here and I'm gonna get shaken around right along with the rest of us. (Laughs.) We're all in the same canoe.

2

IMMIGRATION

Introduction 34

10 *Emma Lazarus*
 "The New Colossus" (1883) 35

11 *Henry James*
 FROM "The Inconceivable Alien" (1883) 36

12 *Owen Wister*
 FROM "Shall We Let the Cuckoos Crowd Us Out of Our
 Nest?" (1921) 38

13 *Madison Grant*
 "The Mixture of Two Races" (1917) 40

14 *Arthur M. Schlesinger, Jr.*
 "E Pluribus Unum?" (1992) 41

15 *Abraham Cahan*
 "The Meeting" (1896) 42

16 *Ole E. Rølvaag*
 "The Power of Evil in High Places" (1927) 46

17 *Michael Lee Cohen*
 "David" (1993) 59

18 *Joan Morrison and Charlotte Fox Zabusky*
 FROM "Premier Nguyen Cao Ky: From South Vietnam,
 1975" 62

19 *Al Santoli*
 FROM "Mojados (Wetbacks)" (1988) 66

INTRODUCTION

Immigration is and has always been an important theme in American history. From the 1840s until the early 1920s, when the Quota Acts began to restrict the number of newcomers, immigration was a mass movement. Approximately 30 million people emigrated to the US during those years. Cultivation of the prairie and rapid industrialization were in some ways both the cause and the effect of this large-scale immigration.

The transition from the old to the new world was not an easy one. Immigrants were sometimes met with suspicion, prejudice and fear, particularly those from eastern and southern Europe who arrived around the turn of the century. Referred to as "the new immigrants," they had little or no capital, lacked industrial skills, and were often poorly educated. Since so many came and competed for low-paying jobs in new factories, they were often blamed for the problems of the fast-growing cities in which they sometimes lived in great poverty. But their effect on American society was great. As Oscar Handlin, in his essay "Immigration in American Life: A Reappraisal," (1961) has written:

> The story of immigration is a tale of wonderful success, the compounded biography of thousands of humble people who through their own efforts brought themselves across great distances to plant their roots and to thrive in alien soil. Its only parallel is the story of the United States which began in the huddled settlements at the edge of the wilderness and pulled itself upward to immense material and spiritual power.

Since 1886 the Statue of Liberty has been a symbol of welcome to immigrants. Inscribed on the base of the statue is Emma Lazarus's famous poem about the "golden door," supposedly open to all immigrants in need of a better place (extract 10). In 1883 novelist Henry James reflected on the entry of new immigrants to Ellis Island and concluded that "we must go . . . *more* than half-way to meet them" (see extract 11). Immigrants were, however, not always met with the policy of open welcome. In Owen Wister's popular prose (see extract 12) immigrants are seen as aliens. Such nativism was sometimes backed by quasi-philosophical essays such as our excerpt from Madison Grant's *The Passing of the Great Race*, published in 1917.

Even though these attitudes may only have been representative of a fraction of Americans, their utterances reveal some of the antagonism against immigrants who were not of a western European stock. Measured against the views of Wister and Grant, the melting-pot ideology may be understood as a blessing and an appeal to common sense.

That was, however, not always the case. Leaders of some immigrant groups felt the overt pressure to assimilate as a threat. During the first decade of this century the general idea was that the nation should work actively to mix the new immigrants into "the melting pot." Giving up old cultural ties in the process, the immigrant would hopefully emerge as a genuine American. As a result the melting-pot idea was often fought, sometimes desperately but mostly with little success by immigrants who strongly identified with their mother culture.

From time to time the policy of assimilation has been challenged by movements of ethnic awareness. The conflict between assimilation and preservation is dramatically presented in a chapter from a novel by the Jewish-American writer Abraham Cahan, an immigrant from Russia, who struggled to develop an American culture in Yiddish.

To some contemporary writers the popular ethnic revival and cultural pluralism of the 1960s and 1970s may have gone too far. Thus the historian Arthur M. Schlesinger, Jr. argues for a return to the melting-pot concept in the preface of his controversial book *The Disuniting of America: Reflections on a Multicultural Society* (1992; see extract 14).

Today the largest groups of immigrants come from Asia and Latin America. Their life in the US has given material to a new wave of immigrant literature which unfortunately cannot be represented here. The interview with a second-generation Korean-American, however (extract 17), brings us into an immigrant culture in a large city ghetto in present-day America.

Of all fiction produced by Scandinavian-Americans, O. E. Rølvaag's *The Giants in the Earth* from 1927 (in English translation) remains the classic account of immigrant life in the midwest. The chapter chosen here may be read as a short story about different attitudes to life on the plains in the days of the first immigrant settlers, especially through the main characters Per and his wife Beret. Beret's problems were undoubtedly not uncommon among the early immigrants on the prairies.

The last two extracts – from interviews with the South Vietnamese Nguyen Cao Ky and with a Mexican-American "wetback" family – represent the voices of more recent immigrants to the United States.

10 EMMA LAZARUS

"The New Colossus" (1883)

Not like the brazen giant of Greek fame
With conquering limbs astride from land to land,
Here at our sea-washed, sunset gates shall stand
A mighty woman with a torch, whose flame
Is the imprisoned lightning, and her name

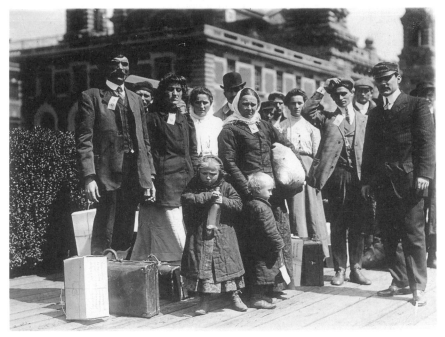

Figure 2.1 Immigrants at Ellis Island
Photograph courtesy of Brown Brothers

Mother of Exiles. From her beacon-hand
Glows world-wide welcome; her mild eyes command
The air-bridged harbor that twin cities frame.
"Keep, ancient lands, your storied pomp!" cries she
With silent lips. "Give me your tired, your poor.
Your huddled masses yearning to breathe free
The wretched refuse of your teeming shore.
Send these, the homeless, tempest-tost to me,
I lift my lamp beside the golden door!"

11 HENRY JAMES

FROM "The Inconceivable Alien" (1883)

I think indeed that the simplest account of the action of Ellis Island on
the spirit of any sensitive citizen who may have happened to "look in" is
that he comes back from his visit not at all the same person that he went.
He has eaten of the tree of knowledge, and the taste will be for ever in his
mouth. He had thought he knew before, thought he had the sense of the
degree in which it is his American fate to share the sanctity of his

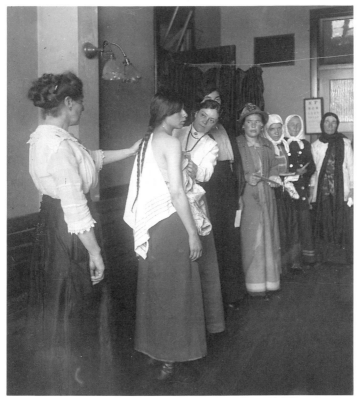

Figure 2.2 The physical examination of immigrants on arrival at Ellis Island,
c. 1912
Photograph courtesy of Brown Brothers

American consciousness, the intimacy of his American patriotism, with
the inconceivable alien; but the truth had never come home to him with
any such force. In the lurid light projected upon it by those courts of
dismay it shakes him – or I like at least to imagine it shakes him – to the
depths of his being; I like to think of him, I positively *have* to think of him,
as going about ever afterwards with a new look, for those who can see it,
in his face, the outward sign of the new chill in his heart. So is stamped,
for detection, the questionably privileged person who has had an appa-
rition, seen a ghost in his supposedly safe old house. Let not the unwary,
therefore, visit Ellis Island.

The after-sense of that acute experience, however, I myself found, was
by no means to be brushed away; I felt it grow and grow, on the contrary,
wherever I turned: other impressions might come and go, but this
affirmed claim of the alien, however immeasurably alien, to share in
one's supreme relation was everywhere the fixed element, the reminder

not to be dodged. One's supreme relation, as one had always put it, was one's relation to one's country – a conception made up so largely of one's countrymen and one's countrywomen. Thus it was as if, all the while, with such a fond tradition of what these products predominantly were, the idea of the country itself underwent something of that profane overhauling through which it appears to suffer the indignity of change. Is not our instinct in this matter, in general, essentially the safe one – that of keeping the idea simple and strong and continuous, so that it shall be perfectly sound? To touch it overmuch, to pull it about, is to put it in peril of weakening; yet on this free assault upon it, this readjustment of it in *their* monstrous, presumptuous interest, the aliens, in New York, seemed perpetually to insist. The combination there of their quantity and their quality – that loud primary stage of alienism which New York most offers to sight – operates, for the native, as their note of settled possession, something they have nobody to thank for; so that *un*settled possession is what we, on our side, seem reduced to – the implication of which, in its turn, is that, to recover confidence and regain lost ground, we, not they, must make the surrender and accept the orientation. We must go, in other words, *more* than half-way to meet them; which is all the difference, for us, between possession and dispossession. This sense of dispossession, to be brief about it, haunted me so, I was to feel, in the New York streets and in the packed trajectiles to which one clingingly appeals from the streets, just as one tumbles back into the streets in appalled reaction from *them*, that the art of beguiling or duping it became an art to be cultivated – though the fond alternative vision was never long to be obscured, the imagination, exasperated to envy, of the ideal, in the order in question; of the luxury of some such close and sweet and *whole* national consciousness as that of the Switzer and the Scot.

12 OWEN WISTER

FROM "Shall We Let the Cuckoos Crowd Us Out of Our Nest?" (1921)

That spirit of our country which we symbolize in the figure of Uncle Sam has always been a hospitable spirit. Uncle Sam has told the whole world that the latchstring of his door hangs outside, and that if any stranger comes and pulls it, he will find a warm welcome within.

Many have pulled that string: Strangers from all sorts of shores have entered Uncle Sam's large house. He has been glad to see them all, until lately. Recently some of these newcomers have made him wonder if his hospitality is not being abused.

When a man asks you into his house, he does not expect you to complain of the food, turn his pictures to the wall, smash the win-

dows, or tear down the staircase. Even less does he expect you to try and blow up the foundations of the house.

The Constitution of the United States was very gradually and very thoughtfully created by a rational race; a common-sense race; a race that through centuries has slowly evolved the idea of self-government, and the capacity for self-government. . . .

A cuckoo is a bird that never builds its own nest, but always lays its egg in the nest of some other bird. The bird who built the nest sits on all the eggs.

When they hatch, the young cuckoo is fed just as impartially by its stepmother as the true children are fed.

After a while, it grows and swells, and pushes the true children out to make room for itself; and the true children perish.

Our country is crowded with cuckoos, all very busy laying eggs. They meet and plot. They harangue each other. They curse the house of Uncle Sam. They ask, "Who was George Washington, anyhow? " I have heard them myself.

They tell each other that private property is highway robbery. That is merely because they haven't any, and want yours and mine without working for it. They worm their way into our schools and colleges, and ingeniously inflame the minds of our native young people, who are too immature yet to understand anything about anything. They are laying their plans to push our native young out of the nest.

These Trotzky Cuckoos, and Marx Cuckoos, and Kaiser Cuckoos, to say nothing of some cuckoos of Oriental feather, need a deal more watching than we give them. They get into the law, too, so that when some cuckoos are about to be sent back to their own countries, other cuckoos interfere and see that they don't go.

The American eagle is much larger than any cuckoo, but he is not larger than a million cuckoos. If he does not bestir himself, his eaglets some day may be pushed out of the nest.

Alien eggs are being laid in our American nests. Our native blood is a diminishing drop in the bucket of inundating aliens. Our native inheritance of Liberty, defined and assured by Law, is being mocked and undermined. Our native spirit is being diluted and polluted by organized minorities every day.

Cuckoos there are who would like to change New York's name to Moscow and call Broadway Lenine Street; other cuckoos would rename Washington, Dublin. And we have opened our doors to these birds, made them welcome!

It might actually come to pass some day that the American Eagle, simply to be able to call his soul his own, would have to deal emphatically with all cuckoos. . . . Eternal vigilance cannot watch Liberty and the movies at the same time.

13 MADISON GRANT

"The Mixture of Two Races" (1917)

There exists to-day a widespread and fatuous belief in the power of environment, as well as of education and opportunity to alter heredity, which arises from the dogma of the brotherhood of man, derived in turn from the loose thinkers of the French Revolution and their American mimics. Such beliefs have done much damage in the past, and if allowed to go uncontradicted, may do much more serious damage in the future. Thus the view that the negro slave was an unfortunate cousin of the white man, deeply tanned by the tropic sun, and denied the blessings of Christianity and civilization, played no small part with the sentimentalists of the Civil War period, and it has taken us fifty years to learn that speaking English, wearing good clothes, and going to school and to church, does not transform a negro into a white man. Nor was a Syrian or Egyptian freedman transformed into a Roman by wearing a toga, and applauding his favorite gladiator in the amphitheatre. We shall have a similar experience with the Polish Jew, whose dwarf stature, peculiar mentality, and ruthless concentration on self-interest are being engrafted upon the stock of the nation.

Recent attempts have been made in the interest of inferior races among our immigrants to show that the shape of the skull does change, not merely in a century, but in a single generation. In 1910, the report of the anthropological expert of the Congressional Immigration Commission, gravely declared that a round skull Jew on his way across the Atlantic might and did have a round skull child, but that a few years later, in response to the subtle elixir of American institutions, as exemplified in an East Side tenement, might and did have a child whose skull was appreciably longer; and that a long skull south Italian, breeding freely, would have precisely the same experience in the reverse direction. In other words, the Melting Pot was acting instantly under the influence of a changed environment.

What the Melting Pot actually does in practice, can be seen in Mexico, where the absorption of the blood of the original Spanish conquerors by the native Indian population has produced the racial mixture which we call Mexican, and which is now engaged in demonstrating its incapacity for self-government. The world has seen many such mixtures of races, and the character of a mongrel race is only just beginning to be understood at its true value.

It must be borne in mind that the specializations which characterize the higher races are of relatively recent development, are highly unstable and when mixed with generalized or primitive characters, tend to disappear. Whether we like to admit it or not, the result of the mixture

40

of two races, in the long run, gives us a race reverting to the more ancient, generalized and lower type. The cross between a white man and an Indian is an Indian; the cross between a white man and a negro is a negro; the cross between a white man and a Hindu is a Hindu; and the cross between any of the three European races and a Jew is a Jew.

In the crossing of the blond and brunet elements of a population, the more deeply rooted and ancient dark traits are prepotent or dominant. This is a matter of everyday observation, and the working of this law of nature is not influenced or affected by democratic institutions or by religious beliefs.

As measured in terms of centuries, unit characters are immutable, and the only benefit to be derived from a changed environment and better food conditions, is the opportunity afforded a race which has lived under adverse conditions, to achieve its maximum development, but the limits of that development are fixed for it by heredity and not by environment.

14 ARTHUR M. SCHLESINGER, JR.

"E Pluribus Unum?" (1992)

America was a multiethnic country from the start. Hector St. John de Crèvecoeur emigrated from France to the American colonies in 1759, married an American woman, settled on a farm in Orange County, New York, and published his *Letters from an American Farmer* during the American Revolution. This eighteenth-century French American marveled at the astonishing diversity of the other settlers – "a mixture of English, Scotch, Irish, French, Dutch, Germans, and Swedes," a "strange mixture of blood" that you could find in no other country.

He recalled one family whose grandfather was English, whose wife was Dutch, whose son married a Frenchwoman, and whose present four sons had married women of different nationalities. "From this promiscuous breed," he wrote, "that race now called Americans have arisen." (The word *race* as used in the eighteenth and nineteenth centuries meant what we mean by nationality today; thus people spoke of "the English race," "the German race," and so on.) What, Crèvecoeur mused, were the characteristics of this suddenly emergent American race? *Letters from an American Farmer* propounded a famous question: "What then is the American, this new man?" (Twentieth-century readers must overlook eighteenth-century male obliviousness to the existence of women.)

Crèvecoeur gave his own question its classic answer: "*He* is an American, who leaving behind him all his ancient prejudices and manners, receives new ones from the new mode of life he has embraced, the new government he obeys, and the new rank he holds. The American is a

41

new man, who acts upon new principles. . . . *Here individuals of all nations are melted into a new race of men.*"

E pluribus unum. The United States had a brilliant solution for the inherent fragility of a multiethnic society: the creation of a brand-new national identity, carried forward by individuals who, in forsaking old loyalties and joining to make new lives, melted away ethnic differences. Those intrepid Europeans who had torn up their roots to brave the wild Atlantic *wanted* to forget a horrid past and to embrace a hopeful future. They *expected* to become Americans. Their goals were escape, deliverance, assimilation. They saw America as a transforming nation, banishing dismal memories and developing a unique national character based on common political ideals and shared experiences. The point of America was not to preserve old cultures, but to forge a new *American* culture.

15 ABRAHAM CAHAN

"The Meeting" (1896)

A few weeks later, on a Saturday morning, Jake, with an unfolded telegram in his hand, stood in front of one of the desks at the Immigration Bureau of Ellis Island, He was freshly shaven and clipped, smartly dressed in his best clothes and ball shoes, and, in spite of the sickly expression of shamefacedness and anxiety which distorted his features, he looked younger than usual.

All the way to the island he had been in a flurry of joyous anticipation. The prospect of meeting his dear wife and child, and, incidentally, of showing off his swell attire to her, had thrown him into a fever of impatience. But on entering the big shed he had caught a distant glimpse of Gitl and Yosselé through the railing separating the detained immigrants from their visitors, and his heart had sunk at the sight of his wife's uncouth and un-American appearance. She was slovenly dressed in a brown jacket and skirt of grotesque cut, and her hair was concealed under a voluminous wig of a pitch-black hue. This she had put on just before leaving the steamer, both "in honor of the sabbath" and by way of sprucing herself up for the great event. Since Yekl had left home she had gained considerably in the measurement of her waist. The wig, however, made her seem stouter and shorter than she would have appeared without it. It also added at least five years to her looks. But she was aware neither of this nor of the fact that in New York even a Jewess of her station and orthodox breeding is accustomed to blink at the wickedness of displaying her natural hair, and that none but an elderly matron may wear a wig without being the occasional target for snowballs or stones. She was naturally dark of complexion, and the nine or ten days

42

spent at sea had covered her face with a deep bronze, which combined with her prominent cheek bones, inky little eyes, and, above all, the smooth black wig, to lend her resemblance to a squaw.

Jake had no sooner caught sight of her than he had averted his face, as if loth to rest his eyes on her, in the presence of the surging crowd around him, before it was inevitable. He dared not even survey that crowd to see whether it contained any acquaintance of his, and he vaguely wished that her release were delayed indefinitely.

Presently the officer behind the desk took the telegram from him, and in another little while Gitl, hugging Yosselé with one arm and a bulging parcel with the other, emerged from a side door.

"Yekl!" she screamed out in a piteous high key, as if crying for mercy.

"Dot'sh alla right!" he returned in English, with a wan smile and unconscious of what he was saying. His wandering eyes and dazed mind were striving to fix themselves upon the stern functionary and the questions he bethought himself of asking before finally releasing his prisoners. The contrast between Gitl and Jake was so striking that the officer wanted to make sure – partly as a matter of official duty and partly for the fun of the thing – that the two were actually man and wife.

"Oi a lamentation upon me! He shaves his beard!" Gitl ejaculated to herself as she scrutinized her husband. "Yosselé, look! Here is taté!"

But Yosselé did not care to look at taté. Instead, he turned his frightened little eyes – precise copies of Jake's – and buried them in his mother's cheek.

When Gitl was finally discharged she made to fling herself on Jake. But he checked her by seizing both loads from her arms. He started for a distant and deserted corner of the room, bidding her follow. For a moment the boy looked stunned, then he burst out crying and fell to kicking his father's chest with might and main, his reddened little face appealingly turned to Gitl. Jake continuing his way tried to kiss his son into toleration, but the little fellow proved too nimble for him. It was in vain that Gitl, scurrying behind, kept expostulating with Yosselé: "Why, it is taté!" Taté was forced to capitulate before the march was brought to its end.

At length, when the secluded corner had been reached, and Jake and Gitl had set down their burdens, husband and wife flew into mutual embrace and fell to kissing each other. The performance had an effect of something done to order, which, it must be owned, was far from being belied by the state of their minds at the moment. Their kisses imparted the taste of mutual estrangement to both. In Jake's case the sensation was quickened by the strong steerage odors which were emitted by Gitl's person, and he involuntarily recoiled.

"You look like a *poritz*,"[1] she said shyly.

"How are you! How is mother?"

43

"How should she be? So, so. She sends you her love," Gitl mumbled out.

"How long was father ill? "

"Maybe a month. He cost us health enough."

He proceeded to make advances to Yosselé, she appealing to the child in his behalf. For a moment the sight of her, as they were both crouching before the boy, precipitated a wave of thrilling memories on Jake and made him feel in his own environment. Presently, however, the illusion took wing and here he was, Jake the Yankee, with this bonnetless, wigged, dowdyish little greenhorn by his side! That she was his wife, nay, that he was a married man at all, seemed incredible to him. The sturdy, thriving urchin had at first inspired him with pride; but as he now cast another side glance at Gitl's wig he lost all interest in him, and began to regard him, together with his mother, as one great obstacle dropped from heaven, as it were, in his way.

Gitl, on her part, was overcome with a feeling akin to awe. She, too, could not get herself to realize that this stylish young man – shaved and dressed as in Povodye is only some young nobleman – was Yekl, her own Yekl, who had all these three years never been absent from her mind. And while she was once more examining Jake's blue diagonal cutaway, glossy stand-up collar, the white four-in-hand necktie, coquettishly tucked away in the bosom of his starched shirt, and, above all, his patent leather shoes, she was at the same time mentally scanning the Yekl of three years before. The latter alone was hers, and she felt like crying to the image to come back to her and let her be *his* wife.

Presently, when they had got up and Jake was plying her with per-functory questions, she chanced to recognize a certain movement of his upper lip – an old trick of his. It was as if she had suddenly discovered her own Yekl in an apparent stranger, and, with another pitiful outcry, she fell on his breast.

"Don't! " he said, with patient gentleness, pushing away her arms. "Here everything is so different."

She colored deeply.

"They don't wear wigs here," he ventured to add.

"What then? " she asked, perplexedly.

"You will see. It is quite another world."

"Shall I take it off, then? I have a nice Saturday kerchief," she faltered. "It is of silk – I bought it at Kalmen's for a bargain. It is still brand new."

"Here one does not wear even a kerchief."

"How then? Do they go about with their own hair? " she queried in ill-disguised bewilderment.

"*Vell, alla right*, put in on, quick! "

As she set about undoing her parcel, she bade him face about and screen her, so that neither he nor any stranger could see her bareheaded while she was replacing the wig by the kerchief. He obeyed. All the while

the operation lasted he stood with his gaze on the floor, gnashing his teeth with disgust and shame, or hissing some Bowery oath.

"Is this better? " she asked bashfully, when her hair and part of her forehead were hidden under a kerchief of flaming blue and yellow, whose end dangled down her back.

The kerchief had a rejuvenating effect. But Jake thought that it made her look like an Italian woman of Mulberry Street on Sunday.

"*Alla right*, leave it be for the present," he said in despair, reflecting that the wig would have been the lesser evil of the two.

When they reached the city Gitl was shocked to see him lead the way to a horse car.

"*Oi* woe is me! Why, it is Sabbath! " she gasped.

He irately essayed to explain that a car, being an uncommon sort of vehicle, riding in it implied no violation of the holy day. But this she sturdily met by reference to railroads.[2] Besides, she had seen horse cars while stopping in Hamburg,[3] and knew that no orthodox Jew would use them on the seventh day. At length Jake, losing all self-control, fiercely commanded her not to make him the laughingstock of the people on the street and to get in without further ado. As to the sin of the matter he was willing to take it all upon himself. Completely dismayed by his stern manner, amid the strange, uproarious, forbidding surroundings, Gitl yielded.

As the horses started she uttered a groan of consternation and remained looking aghast and with a violently throbbing heart. If she had been a culprit on the way to the gallows she could not have been more terrified than she was now at this her first ride on the day of rest.

The conductor came up for their fares. Jake handed him a ten-cent piece, and raising two fingers, he roared out: "Two! He ain' no maur as tree years, de liddle feller! " And so great was the impression which his dashing manner and his English produced on Gitl, that for some time it relieved her mind and she even forgot to be shocked by the sight of her husband handling coin on the Sabbath.

Having thus paraded himself before his wife, Jake all at once grew kindly disposed toward her.

"You must be hungry? " he asked.

"Not at all! Where do you eat your *varimess*? "[4]

"Don't say varimess" he corrected her complaisantly; "here it is called *dinner*."

"*Dinner?*[5] And what if one becomes fatter? " she confusedly ventured an irresistible pun.

This was the way in which Gitl came to receive her first lesson in the five or six score English words and phrases which the omnivorous Jewish jargon has absorbed in the Ghettos of English-speaking countries.

1 Yiddish for nobleman.
2 Orthodox Jews are not permitted to ride in any sort of vehicle on the Sabbath.
3 German port from which immigrants embarked.
4 Yiddish for dinner.
5 Yiddish for thinner.

16 OLE E. RØLVAAG

"The Power of Evil in High Places" (1927)

That summer many land seekers passed through the settlement on their way west. The arrival of a caravan was always an event of the greatest importance. How exciting they were, those little ships of the Great Plain! The prairie schooners, rigged with canvas tops which gleamed whitely in the shimmering light, first became visible as tiny specks against the eastern sky; one might almost imagine them to be sea gulls perched far, far away on an endless green meadow; but as one continued to watch, the white dots grew; they came drifting across the prairie like the day; after long waiting, they gradually floated out of the haze, distinct and clear; then, as they drew near, they proved to be veritable wagons, with horses hitched ahead, with folk and all their possessions inside, and a whole herd of cattle following behind.

The caravan would crawl slowly into the settlement and come to anchor in front of one of the sod houses; the moment it halted, people would swarm down and stretch themselves and begin to look after the teams; cattle would bellow; sheep would bleat as they ran about. Many queer races and costumes were to be seen in these caravans, and a babble of strange tongues shattered the air. Nut-brown youngsters, dressed only in a shirt and a pair of pants, would fly around between the huts, looking for other youngsters; an infant, its mother crooning softly to it, would sit securely perched in the fold of her arm; white-haired old men and women, who should have been living quietly at home, preparing for a different journey, were also to be seen in the group, running about like youngsters; the daily jogging from sky line to sky line had brightened their eyes and quickened their tongues. All were busy; each had a thousand questions to ask; every last one of them was in high spirits, though they knew no other home than the wagon and the blue skies above . . . The Lord only could tell whence all these people had come and whither they were going! . . .

The caravan usually intended to stop only long enough for the women folk to boil coffee and get a fresh supply of water; but the starting was always delayed, for the men had so many questions to ask. Once in a while during these halts a fiddler would bring out his fiddle and play a

tune or two, and then there would be dancing. Such instances were rare, but good cheer and excitement invariably accompanied these visits.

– Why not settle right here? The Spring Creek folk would ask the west-movers . . . There's plenty of good land left – nothing better to be found between here and the Pacific Ocean!

– No, not yet. They weren't quite ready to settle; these parts looked fairly crowded . . . The farther west, the better . . . They guessed they would have to go on a way, though this really looked pretty good! . . .

And so the caravans would roll onward into the green stillness of the west. How strange – they vanished faster than they had appeared! The white sails grew smaller and smaller in the glow of the afternoon, until they had dwindled to nothing; the eye might seek them out there in the waning day, and search till it grew blurred, but all in vain – they were gone, and had left no trace! . . .

Foggy weather had now been hanging over the prairie for three whole days; a warm mist of rain mizzled continuously out of the low sky. Toward evening of the third day, the fog lifted and clear sky again appeared; the setting sun burst through the cloud banks rolling up above the western horizon, and transformed them into marvellous fairy castles . . . While this was going on, over to the northeast of the Solum boys' place a lonely wagon had crept into sight; it had almost reached the creek before anyone had noticed it, for the Solum boys were visiting among the Sognings, where there were many young people. But as Beret sat out in the yard, milking, the wagon crossed her view. When she brought in the milk, she remarked in her quiet manner that they were going to have company, at which tidings the rest of the family had to run out and see who might be coming at this time of day.

There was only one wagon, with two cows following behind; on the left side walked a brown-whiskered, stooping man – he was doing the driving; close behind him came a half-grown boy, dragging his feet heavily. The wagon at last crawled up the hill and came to a stop in Per Hansa's yard, where the whole family stood waiting.

"I don't suppose there are any Norwegians in this settlement? No, that would be too much to expect," said the man in a husky, worn-out voice.

"If you're looking for Norwegians, you have found the right place, all right! We sift the people as they pass through here – keep our own, and let the others go! " . . . Per Hansa wanted to run on, for he felt in high spirits; but he checked himself, observing that the man looked as if he stood on the very brink of the grave.

– Was there any chance of putting up here for the night?

"Certainly! certainly! " cried Per Hansa briskly, "provided they were willing to take things as they were."

The man didn't answer, but walked instead to the wagon and spoke to some one inside:

"Kari, now you must brace up and come down. Here we have found Norwegians at last!" As if fearing a contradiction, he added: "Ya, they are real Norwegians. I've talked with them."

On top of his words there came out of the wagon, first a puny boy with a hungry face, somewhat smaller than the other boy; then a girl of about the same size, but looking much older. She helped to get down another boy, about six years old, who evidently had been sleeping and looked cross and tired. That seemed to be all.

The man stepped closer to the wagon. 'Aren't you coming, Kari?"

A groan sounded within the canvas. The girl grabbed hold of her father's arm. "You must untie the rope! Can't you remember *anything?*" she whispered, angrily.

"Ya, that's right! Wait a minute till I come and help you."

An irresistible curiosity took hold of Per Hansa; in two jumps he stood on the tongue of the wagon. The sight that met his eyes sent chills running down his spine. Inside sat a woman on a pile of clothes, with her back against a large immigrant chest; around her wrists and leading to the handles of the chest a strong rope was tied; her face was drawn and unnatural. Per Hansa trembled so violently that he had to catch hold of the wagon box, but inwardly he was swearing a steady stream. To him it looked as if the woman was crucified.

. . . "For God's sake, man!" . . .

The stranger paid no attention; he was pottering about and pleading: "Come down now, Kari . . . Ya, all right, I'll help you! Everything's going to be all right – I know it will! . . . Can you manage to get up?" He had untied the rope, and the woman had risen to her knees.

"O God!" she sighed, putting her hands to her head.

"Please come. That's right; I'll help you!" pleaded the man, as if he were trying to persuade a child.

She came down unsteadily. "Is this the place, Jakob?" she asked in a bewildered way. But now Beret ran up and put her arm around her; the women looked into each other's eyes and instantly a bond of understanding had been established. "You come with me!" urged Beret . . . "O God! This isn't the place, either!" wailed the woman; but she followed Beret submissively into the house.

"Well, well!" sighed the man as he began to unhitch the horses. "Life isn't easy – no, it certainly isn't." . . .

Per Hansa watched him anxiously, hardly knowing what to do. Both the boys kept close to him. Then an idea flashed through his mind: "You boys run over to Hans Olsa's and tell him not to go to bed until I come . . . No, I don't want him here. And you two stay over there to-night. Now run along!"

Turning to the man, he asked, "Aren't there any more in your party?"

"No, not now. We were five, you see, to begin with – five in all – but

48

the others had to go on . . . Haven't they been by here yet? Well, they must be somewhere over to the westward . . . No, life isn't easy." . . . The man wandered on in his monotonous, blurred tone; he sounded all the time as if he were half sobbing.

"Where do you come from?" Per Hansa demanded, gruffly.

The man didn't give a direct answer, but continued to ramble on in the same mournful way, stretching his story out interminably . . . They had been wandering over the prairie for nearly six weeks . . . Ya, it was a hard life. When they had started from Houston County, Minnesota, there had been five wagons in all. Strange that the others hadn't turned up here. Where could they be? It seemed to him as if he had travelled far enough to reach the ends of the earth! . . . Good God, what a nightmare life was! If he had only – only known . . . !

"Did the others go away and *leave you*?" Per Hansa hadn't intended to ask that question, but it had slipped out before he realized what he was saying. He wondered if there could be anything seriously wrong . . .

"They couldn't possibly wait for us – couldn't have been expected to. Everything went wrong, you see, and I didn't know when I would be able to start again . . . Turn the horses loose, John," he said to the boy. "Take the pail and see if you can squeeze some milk out of the cows. Poor beasts, they don't give much now!" Then he turned to Per Hansa again: "I don't know what would have become of us if we hadn't reached this place to-night! We'd have been in a bad hole, that I assure you! Women folk can't bear up . . ." The man stopped and blew his nose.

Per Hansa dreaded what might be coming next. "You must have got off your course, since you are coming down from the north?"

The man shook his head helplessly. "To tell the truth, I don't know where we've been these last few days. We couldn't see the sun."

"Haven't you got a compass?"

"Compass? No! I tried to steer with a rope but the one I had wasn't long enough."

"Like hell you did!" exclaimed Per Hansa, excitedly, full of a sudden new interest.

"Ya, I tried that rope idea – hitched it to the back of the wagon, and let it drag in the wet grass. But it didn't work – I couldn't steer straight with it. The rope was so short, and kept kinking around so much, that it didn't leave any wake."

"Uh-huh!" nodded Per Hansa wisely. "You must be a seafaring man, to have tried that trick!"

"No, I'm no sailor. But fisher-folk out here have told me that it's possible to steer by a rope . . . I had to try *something*."

"Where did you cross the Sioux?"

"How do I know where I crossed it? We came to a river a long way to the east of here – that must have been the Sioux. We hunted and hunted

49

before we could find a place shallow enough to cross . . . God! this has certainly been a wandering in the desert for me! . . . But if Kari only gets better, I won't complain – though I never dreamed that life could be so hard." . . .

"Is she – is she *sick*, that woman of yours? "

The man did not answer this question immediately; he wiped his face with the sleeve of his shirt. When he spoke again, his voice had grown even more blurred and indistinct: "Physically she seems to be as well as ever – as far as I can see. She certainly hasn't overworked since we've been travelling. I hope there's nothing wrong with her . . . But certain things are hard to bear – I suppose it's worse for the mother, too – though the Lord knows it hasn't been easy for me, either! . . . You see, we had to leave our youngest boy out there on the prairie . . ."

"*Leave* him? " . . . These were the only two words that came to Per Hansa's mind.

"Ya, there he lies, our little boy! . . . I never saw a more promising man – you know what I mean – when he grew up . . . But now – oh, well . . ."

Per Hansa felt faint in the pit of his stomach; his throat grew dry; his voice became as husky as that of the other; he came close up to him. "Tell me – how did this happen? "

The man shook his head again, in a sort of dumb despair. Then he cleared his throat and continued with great effort: "I can't tell how it happened! Fate just willed it so. Such things are not to be explained . . . The boy had been ailing for some time – we knew that, but didn't pay much attention. We had other things to think of . . . Then he began to fail fast. We were only one day's journey this side of Jackson; so we went back. That was the time when the others left us. I don't blame them much – it was uncertain when we could go on . . . The doctor we found wasn't a capable man – I realize it now. He spoke only English and couldn't understand what I was saying. He had no idea what was wrong with the boy – I could see that plainly enough . . . Ya, well – so we started again . . . It isn't any use to fight against Fate; that's an old saying, and a true one, too, I guess . . . Before long we saw that the boy wasn't going to recover. So we hurried on, day and night, trying to catch our neighbours . . . Well, that's about all of it. One night he was gone – just as if you had blown out a candle. Ya, let me see – that was five nights ago."

"Have you got him there in the wagon? " demanded Per Hansa, grabbing the man by the arm.

"No, no," he muttered, huskily. "We buried him out there by a big stone – no coffin or anything. But Kari took the best shirt she had and wrapped it all around him – we had to do *something*, you know . . . But," he continued suddenly straightening up, "Paul cannot lie there! As soon as I find my neighbours, I'll go and get him. Otherwise Kari . . ." The man paused between the sobs that threatened to choke him. "I have had

to tie her up the last few days. She insisted on getting out and going back to Paul. I don't think she has had a wink of sleep for over a week . . . It's just as I was saying – some people can't stand things." . . .

Per Hansa leaned heavily against the wagon. "Has she gone crazy? " he asked, hoarsely.

"She isn't much worse than the rest of us. I don't believe . . . Kari is really a well-balanced woman . . . But you can imagine how it feels, to leave a child *that* way . . ."

The boy, John, had finished milking. He had put the pail down and was standing a little way off, listening to his father's story; suddenly he threw himself on the ground, sobbing as if in convulsions.

"John! John! " admonished the father. "Aren't you ashamed of yourself – a grown-up man like you! Take the milk and carry it into the house! "

"That's right! " echoed Per Hansa, pulling himself together. "We'd better all go in. There's shelter here, and plenty to eat."

Beret was bustling around the room when they entered; she had put the woman to bed, and now was tending her. "Where are the boys? " she asked.

Per Hansa told her that he had sent them to Hans Olsa's for the night.

"That was hardly necessary; we could have made room here some-how," Beret's voice carried a note of keen reproach.

The man had paused at the door; now he came over to the bed, took the limp hand, and muttered: "Poor soul! . . . Why, I believe she's asleep already! "

Beret came up and pushed him gently aside. "Be careful! Don't wake her. She needs the rest."

"Ya, I don't doubt it – not I! She hasn't slept for a week, you see – the poor soul! " With a loud sniff, he turned and left the room.

When supper time came the woman seemed to be engulfed in a stupefying sleep. Beret did not join the others at the supper table, but busied herself, instead, by trying to make the wman more comfortable; she loosened her clothes, took off her shoes, and washed her face in warm water; during all this the stranger never stirred. That done, Beret began to fix up sleeping quarters for the strangers, in the barn. She carried in fresh hay and brought out all the bedding she had; she herself would take care of the woman, in case she awoke and needed attention. Beret did little talking, but she went about these arrangements with a firmness and confidence that surprised her husband.

Per Hansa came in from the barn, after helping the strangers settle themselves for the night. Beret was sitting on the edge of the bed, dressing the baby for the night; she had put And-Ongen to bed beside the distracted woman.

"Did she tell you much? " he asked in a low voice.

Beret glanced toward the other bed before she answered:

"Only that she had had to leave one of her children on the way. She wasn't able to talk connectedly."

"It's a terrible thing! " he said, looking away from his wfie. "I think I'll go over to Hans Olsa's for a minute. I want to talk this matter over with him."

"Talk it over with him? " she repeated, coldly. "I don't suppose Hans Olsa knows everything! "

"No, of course not. But these people have got to be helped, and we can't do it all alone." He hesitated for a minute, as if waiting for her consent. "Well, I won't be long," he said as he went out of the door.

When he returned, an hour later, she was still sitting on the edge of the bed, with the baby asleep on her lap. They sat in silence for a long while; at last he began to undress. She waited until he was in bed, then turned the lamp low and lay down herself, but without undressing. . . . The lamp shed only a faint light. It was so quiet in the room that one could hear the breathing of all the others. Beret lay there listening; though the room was still, it seemed alive to her with strange movements; she forced herself to open her eyes and look around. Noticing that Per Hansa wasn't asleep, either, she asked:

"Did you look after the boys? "

"Nothing the matter with them! They were fast asleep in Sofie's bed."

"You told them everything, at Hans Olsa's? "

"Of course! "

"What did they think of it? "

Per Hansa raised himself on his elbows and glanced at the broken creature lying in the bed back of theirs. The woman, apparently, had not stirred a muscle. "It's a bad business," he said. "We must try to get together a coffin and find the boy. We can't let him lie out there – that way." . . . As Beret made no answer, he briefly narrated the story that the man had told him. "The fellow is a good-for-nothing, stupid fool, I'm sure of that," concluded Per Hansa.

She listened to him in silence. For some time she brooded over her thoughts; then in a bitter tone she suddenly burst out: "Now you can see that this kind of a life is impossible! It's beyond human endurance."

He had not the power to read her thoughts; he did not want to know them; to-night every nerve in his body was taut with apprehension and dismay. But he tried to say, reassuringly: "Hans Olsa and I will both go with the man, as soon as the day breaks. If we only had something to make the coffin of! The few pieces of board that I've got here will hardly be enough . . . Now let's go to sleep. Be sure and call me if you need anything! "

He turned over resolutely, as if determined to sleep; but she noticed that he was a long time doing it . . . I wonder what's going through his

mind? she thought. She was glad to have him awake, just the same; to-night there were strange things abroad in the room . . .

The instant the woman had climbed down from the wagon and looked into Beret's face a curtain seemed to be drawn over all the terrible experiences of the last few weeks. She entered a cozy room where things were as they should be; she felt the warm presence of folk who had dwelt here a long time. She took in the whole room at a glance – table and benches and stools; a fire was burning in a real stove; a kettle was boiling; wet clothes were hanging on a line by the stove, giving out a pleasant, familiar odor; and there actually stood two beds, made up with clean bedding! The sense of home, of people who lived in an orderly fashion, swept over her like a warm bath. A kind hand led her to one of the beds, and there she sank down. She mumbled a few words, but soon gave it up; everything about her seemed so wonderfully pleasant; she must keep quiet, so as not to distrub the dream. The hand that helped her had such a sympathetic touch; it took a rag, dipped it in lukewarm water, and wiped her face; then it loosened her clothes and even took off her shoes. But best of all, she could stretch her back again!

. . . Strange that she couldn't remember what had been going on! Had she told the woman all that she ought to know? About the makeshift coffin, and the big stone beside which they would find him? And that she would have to take a blanket with her, for the nights were chilly and Paul had very little on – only a shirt that was worn and thin? . . . No, she couldn't remember anything except that she had been able to lie down and stretch her back; the warmth of the room, and the knowledge that friendly people were near her, had overcome all her senses with a sweet languor. Her body lay as if fast asleep; but away back in the inner depths of her consciousness a wee eye peeped out, half open, and saw things . . .

She remained in the same position until three o'clock in the morning. But then the wee bit of an eye opened wider and her senses slowly began to revive; she realized that she was lying in a strange room, where a lamp burned with a dim light. Suddenly she remembered that she had arrived here last night – but Paul was not with her. . . Too bad I am so forgetful! she thought. I must hurry now before Jakob sees me, because there's no way of stopping him – he always wants to go on! . . . She was fully awake now; she sat up and buttoned her clothes, then slipped quietly out of bed.

For a moment she stood perfectly still, listening; she could hear the breathing of many people; bending suddenly over the bed, she snatched up And-Ongen. She held the child tenderly in her arms and put her cheek against the warm face . . . We must be careful now! she thought. With quiet movements she wrapped her skirt about the sleeping child; glancing around the room to see if all was well, she glided out like a shadow; she did not dare to close the door behind her, lest it should

make a noise . . . "Here is our wagon!" she murmured. "I mustn't let Jakob see me now; he doesn't understand; he only wants to get on!" . . . Clutching the child to her breast, she started on the run, taking a direction away from the house.

Beret was awakened by a voice calling to her from a great distance; it called loudly several times. What a shame they can't let me alone in peace, to get a little rest! she thought, drowsily. I was up so late last night and I need the sleep badly! . . . But the voice kept calling so persistently that after a while she sat up in bed, her mind coming back to reality; she remembered that strangers had arrived last night, that another besides herself was in deep distress. Well, she had done her best to take care of her . . . She turned her head to see how the other woman was resting.

. . . "Heaven have mercy!" . . .

Beret leaped frantically out of bed; in a second she had reached the side of the other bed, but no one was there. She did not notice that And-Ongen was gone, too. A cold draught rushing through the room told her that the door stood open; she hurried over to it. She seemed to recall dimly that some one had recently gone out. Hadn't she heard it in her sleep? Beret went through the door and stood in front of the house, but did not dare to make an outcry; she listened intently, then called in a low voice; getting no answer, she ran around the house, peering hither and thither, but the grey morning light disclosed nothing.

Running back into the house, she called her husband distractedly: "She's gone! Get up! You must hurry!"

In an instant Per Hansa was up and had tumbled into his clothes. "Run over to Hans Olsa's and tell him to come at once! Be as quick as you can! In the meanwhile I'll search down by the creek."

When they came out, the first light of day was creeping up the eastern sky; a slight fog floated along the creek; the morning air was crisp and cool. Per Hansa leaped up into the seat of the wagon and scanned the prairie in every direction . . . What was *that*, over there? Wasn't it a human being standing on the top of the hill? Could she have taken that direction? . . . He jumped down from the wagon, and rushed around to the other side of the house, called to Beret, and pointed up the hill. Instantly they both started out on the run.

The woman did not seem in the least surprised at their coming. When Per Hansa had almost reached her, he stopped stone dead. What, in God's name, was she carrying in her arms? His face blanched with terror. "Come here!" he shouted. In a moment he had the child in his own arms.

And-Ongen was almost awake now and had begun to whimper; things were going on around her that she could not understand; she felt cold, and father had such a queer look on his face . . . Sleepily she cuddled up in the fold of his left arm, her cheek against his heart, though a hard

hand which seemed to be pounding against a wall was trying to wake her up again; she would just let it go on pounding all it pleased. She had to sleep some more! . . . But now mother was here. Hurriedly she was transferred into her mother's arms and squeezed almost to a pancake. She had to gasp for breath; nevertheless she snuggled into her arms as closely as she could, for she felt, oh, so sleepy! . . . But no peace here, either! Here, too, a hand pounded against a wall. Were they tearing down the house? And-Ongen was certainly at a loss to understand all this racket in the middle of the night . . . But let 'em pound!

As Beret walked homeward, carrying the child, it seemed more precious to her than the very first time when she had held it in her arms; and she experienced a wonderful blessing. Upon this night the Lord had been with them: his mighty arm had shielded them from a fearful calamity.

The other woman was still obsessed by her own troubles; she kept on hunting up there on the hill . . . Wouldn't these people help her to find Paul? She had to find him at once – He would be cold with so little on . . . Now they had taken that blessed child away from her; but she didn't wonder – that man had a bad face. She felt afraid of him . . . But no time to think of such things now; Jakob would soon be coming? She began muttering to herself: "Oh, why can't I find the stone? What has become of it? Wasn't it somewhere here? " . . .

Per Hansa went up and spoke to her, his voice sounding hoarse and unnatural. "Come with me now! To-day Hans Olsa and I are going to find your boy." Taking her gently by the arm, he led her back to the house . . . It's very kind of him, to help find Paul, she thought, and followed willingly.

At breakfast she sat very quiet; she ate when they bade her, but never spoke, While they were making the coffin she sat looking on, wondering why they didn't hurry faster with the work. Couldn't they understand that Paul was cold? A little later a handsome woman entered the house – a woman with such a kind face, who lined the coffin inside with a white cloth . . . Now, that is fine of her; that's just what a woman with such a kind face would do! . . . She would have liked to talk to that woman; she had something very important to confide to her; but perhaps she had better not delay her in her work – the coffin had to be lined! . . .

As soon as the coffin was ready, Per Hansa and Hans Olsa, along with the stranger and his wife, left the settlement to hunt for the body of the dead boy. They took quite a stock of provisions with them. On this search they were gone four days; they crisscrossed the prairie for a long way to the east, and searched high and low; but when they returned the coffin was still empty.

After the return from the search the strangers stayed one more day with them. The morning they were to leave it looked dark and threatening,

and Per Hansa wouldn't hear of their setting out; but along toward noon the sky cleared and the weather appeared more settled. The man, very anxious to be on his way, had everything loaded into the wagon, and as soon as the noon meal was over they were ready to go.

But before the man got on his way Per Hansa asked him where he intended to settle.

– Well, he wasn't positive as to the exact place. It was over somewhere toward the James River – his neighbours had told him that.

– Did he know where the James River was? Per Hansa inquired further.

– Certainly he did! How could he ask such a foolish question? The river lay off there; all he needed to do was to steer straight west. After finding the river, of course he'd have to ask. But that part of it would be quite easy . . .

Per Hansa shuddered, and asked no more questions.

The woman had been quite calm since their return. She kept away from the others, muttering to herself and pottering over insignificant things, much like a child at play; but she was docile and inoffensive, and did what anyone told her. A short while before noon that day she took a notion that she must change her clothes; she got up from what she was doing, washed, and went into the wagon. When she came back she had dressed herself in her best; in a way she looked all right, but made a bizarre appearance because she had put so much on . . . The man seemed fairly cheerful as they started; he talked a good deal, heaping many blessings upon Per Hansa . . . If he could only find his neighbours, and Kari could only forget, things would be all right in a little while. Ya, it was a hard life, but – Well, God's blessings on Per Hansa, and many thanks! And now he must be off! . . . His voice was just as husky and blurred as when he came.

The wagon started creaking; the man, short and stooping, led the way; the family piled into the wagon; the two cows jogged behind . . . They laid their course due west . . . Banks of heavy cloud were rolled up on the western horizon – huge, fantastic forms that seemed to await them in Heaven's derision – though they might have been only the last stragglers of the spell of bad weather just past.

After they had gone, Beret could find no peace in the house; her hand trembled; she felt faint and dizzy; every now and then she had to go out and look at the disappearing wagon; and when the hill finally shut off the view she took the youngest two children and went up there to watch. In a way she felt glad that these people were gone; at the same time she reproached herself for not having urged them to stay longer. Sitting now on the hilltop, a strong presentiment came over her that they should not have started to-day. . . . "That's the way I've become," she thought sadly. "Here are folk in the deepest distress, and I am only glad to send them

56

off into direr calamities! What will they do to-night if a storm comes upon them? He is all broken up – he couldn't have been much of a man at any time. And the poor wife insane from grief! Perhaps she will disappear forever this very night . . . What misery, what an unspeakable tragedy, life is for some! " . . .

Slowly, very slowly, the forlorn caravan crept off into the great, mysterious silence always hovering above the plain. To Beret, as she watched, it seemed as if the prairie were swallowing up the people, the wagon, the cows and all. At last the little caravan was merged in the very infinite itself; Beret thought she could see the wagon yet, but was not certain; it might be only a dead tuft of grass far away which the wind stirred . . .

She took the children and went home, walking with slow, dragging steps; she wanted to cry, and felt the need of it, but no tears came . . . Per Hansa and the boys were breaking prairie; to judge from the language they used in talking to the oxen, they must be hard at it. Her loneliness was so great that she felt a physical need of bringing happiness to some living thing; as soon as she got home she took her little remaining store of rice and cooked porridge for supper; the boys were very fond of that dish.

Toward evening the air grew heavy and sultry; the cloud banks, still rolling up in the western sky, had taken on a most threatening aspect; it looked as if a thunderstorm might be coming on.

After supper Per Hansa was due to meet at Hans Olsa's with the other neighbours, to lay plans for the trip to town which had to be made before harvesting set in. The boys asked leave to go, too – it was so much fun to be with the men.

When she had washed the supper dishes Beret went outdoors and sat down on the woodpile. A nameless apprehension tugged at her heart and would not leave her in peace; taking the two children as before, she again ascended the hill. The spell of the afternoon's sadness was still upon her; her constant self-reproach since then had only deepened it . . . Those poor folk were straying somewhere out there, under the towering clouds. Poor souls! The Lord pity the mother who had left a part of herself back east on the prairie! How could the good God permit creatures made in His image to fall into such tribulations? To people this desert would be as impossible as to empty the sea. For how could folk establish homes in an endless wilderness? Was it not the Evil One that had struck them with blindness? . . . Take her own case, for example: here she sat, thousands of miles from home and kindred, lost in a limitless void . . . Out yonder drifted these folk, like chips on a current . . . Must man perish because of his own foolishness? Where, then, was the guiding hand? . . . Beret was gazing at the western sky as the twilight fast gathered around her; her eyes were riveted on a certain cloud that had taken on the shape of a

face, awful of mien and giantlike in proportions; the face seemed to swell out of the prairie and filled half the heavens.

She gazed a long time; now she could see the monster clearer. The face was unmistakable! There were the outlines of the nose and mouth. The eyes – deep, dark caves in the cloud – were closed. The mouth, if it were to open, would be a yawning abyss. The chin rested on the prairie . . . Black and lean the whole face, but of such gigantic, menacing proportions! Wasn't there something like a leer upon it? . . . And the terrible creature was spreading everywhere; she trembled so desperately that she had to take hold of the grass.

It was a strange emotion that Beret was harbouring at this moment; in reality she felt a certain morbid satisfaction – very much like a child that has been arguing with its parents, has turned out to be right, and, just as the tears are coming, cries, "Now, there, you see!" . . . Here was the simple solution to the whole riddle. She had known in her heart all the time that people were never led into such deep affliction unless an evil power had been turned loose among them. And hadn't she clearly felt that there were unspeakable things out yonder – that the great stillness was nothing but life asleep? . . . She sat still as death, feeling the supernatural emanations all around her. The face came closer in the dusk – didn't she feel its cold breath upon her? When that mouth opened and began to suck, terrible things would happen! . . . Without daring to look again, she snatched up the children and ran blindly home.

After a while the others returned, the boys storming boisterously into the house, the father close behind; he was evidently chasing them; by the tone of his voice, she knew he was in high spirits.

"Why, Beret," he cried gayly, as soon as he got inside, "what have you been doing to the windows – covering them up? " He was looking at her with narrow, sparkling eyes. "Beret, Beret, you're a dear girl! " he whispered. Then he came over and fondled her – he wanted to help undress her and put her to bed . . .

"No, no – not *that*! " she cried, vehemently, an intense anger surging up within her. Had he no sense whatever of decency and propriety, no feeling of shame and sin? . . . That's only one more proof, she thought, that the devil has us in his clutches!

After that time, Beret was conscious of the face whenever she was awake, but particularly along toward evening, as the twilight came on; then it drew closer to her and seemed alive. Even during the day she would often be aware of its presence; high noon might stand over the prairie, with the sun shedding a flood of light that fairly blinded the sight, but through and behind the light she would see it – huge and horrible it was, the eyes always closed, with only those empty, cavernlike sockets beneath the brows.

As she went about doing her work, now, she would frequently be

seized by a faintness so great that she had to sit down . . . How was this going to end? she asked herself. Yes, how would it end? . . . Vague premonitions hovered about her like shadows. Many times she was on the point of asking her husband if he saw what she did, towering above the prairie out west; but always she seemed to be tongue-tied . . . Well, why mention it? Couldn't he and the others see it perfectly well for themselves? How could they help it? . . . She noticed that a silence would often fall upon them when they were out-of-doors, especially in the evening. Certainly they saw it! . . . Every evening, now, whether Per Hansa was away or at home, she hung something over the windows – it helped shut out the fear . . .

At first her husband made all sorts of fun of this practice of hers; he teased her about it, as if it were a good joke, and continued to force his caresses on her, his voice low and vibrant with pent-up emotion. But as time went on he ceased laughing; the fear that possessed her had begun to affect him, too . . .

17 MICHAEL LEE COHEN

"David" (1993)

They came looking "for economic opportunities, just like any other immigrants," says David of his parents, who moved their family from Seoul, South Korea, to Los Angeles. David, twenty-seven, has an older brother and a younger sister. He was ten when his family arrived in L.A.'s Koreatown, a neighborhood where many Korean immigrants live when they first land in the States.

He says, "It was hard at first because I didn't speak the language. I wasn't familiar with the surroundings. But I was so young, it didn't take me too long to get adjusted to the life here."

Although his parents had to work terribly hard – "seven days a week, all day, all night" – within five years they were earning enough money to move from Koreatown to the suburbs. In the early 1980s, however, David's father was laid off from his job. They wanted to go into business, says David; now they had no other choice because his mother's five dollars an hour wasn't enough to feed everybody. Pooling their savings with lots of money borrowed from a bank, David's parents scraped together enough to open a grocery store in a predominantly Hispanic neighborhood near downtown L.A. The business prospered. Five years later they sold the grocery and bought a liquor store in South Central Los Angeles.

From his junior year of high school until he graduated from college, David worked only limited hours at his parents' stores, Friday after school and Sunday afternoons. He had Saturdays off. After graduating

from California State University, Fullerton, David began working for his parents full-time. David's father then devoted his time to the paperwork and the accounting, and under his mother's supervision, David ran the store.

According to David, doing business in South Central L.A. was a "big mistake." When I ask why, he tells me matter-of-factly: "Lotta blacks."

In David's mind, this remark is not an indication of racial bigotry; rather, it reflects his "personal experience." He says that while he worked at his parents' grocery store, he had no trouble getting along with the customers, most of whom were Hispanic, because Koreans and Hispanics "have a lot of things in common." He says, "They had courtesy, common courtesy. I wasn't really intimidated by them. I liked them, as a matter of fact. They were really nice, hardworking people."

But David does not "have good things to say about the blacks" who patronized his parents' liquor store. "I mean, the customers were so – they were scary, to put it bluntly. They were scary. I was intimidated by them," says David, who is short and slight. "At first it was just purely the visual, the physical presence. I mean, they're – I mean, I'm generalizing, but this is what I saw – they were huge, they were rude. I'm not trying to sound like a racist or anything, but this is what I saw. And the way they spoke and everything was just totally different, and the way that their lifestyle is totally different from what I perceive people should be like. Using profanities as an everyday word in front of anybody – my parents, my grandmother, y'know. It doesn't matter who is there, it's 'Hey, you fucking whatever, whatever,' y'know, things like that.

"They have no common sense. At the time there were a lot of frictions between Koreans and blacks, so they generalize us by saying, 'You Koreans are moving into South Central. You guys are gonna take over this and that.' I had to take a lot of that stuff for a few months. After getting to know people, maybe it took about two or three months, and after that it's just like I knew everybody by their names, they knew me, so everything was cool. It was just a handful of people that were giving us a hard time.

"After about two years, I was known in the community because I turned the store into sort of like a community center. It wasn't just sell or purchase of liquor, whatever. It was more like they'd ask me, 'Hey Dave, I'm tryin' to fill out this paper, can you help me out?' I said sure, y'know, fill it out for 'em. They need a ride to somewhere, 'Sure, I get off at five. I'll give you ride,' things like that."

I ask David why he did not try to hire other blacks from the neighborhood. He says, "I lived there at the store practically. The only thing I didn't do there is sleep. I ate my breakfast, lunch, dinner there. So in a sense I lived in the community. I know 'bout ninety percent of the black people that live around this area, and I know none of 'em are qualified.

And if they are, they're gonna turn out just like these guys that I hired." He decided it wasn't worth it to try and hire any more blacks from the area. But, he notes, he "just hired a few Hispanic guys, and, oh man, those guys work really hard, working out really good."

David believes the people in the neighborhood understood his decision – that is, his decision to fire the first three blacks that he had hired. "They know that I tried to hire black people from the neighborhood, but it just didn't work out," he says.

David thinks that, because of his "P.R. work," he and his parents have not faced the hostility that many blacks in South Central Los Angeles have expressed toward Korean shopowners. Indeed, David's customers "were cool" about David and his parents even after the Latasha Harlins incident, in which a Korean store owner was convicted of killing a fifteen-year-old black girl, Harlins, whom the store owner accused of stealing a $1.79 bottle of orange juice. The trial judge sentenced the Korean woman to five years' probation, despite footage from the store's video camera that clearly showed the woman had shot Harlins in the back as Harlins was leaving the store.

Relations between David's family and their store's African-American customers were "pretty calm" – that is, "until the verdict came," the verdict in the Rodney King case, in which a nearly all-white jury found four white members of the Los Angeles Police Department not guilty of using excessive force when they beat a black man, King, as they were arresting him after an eight-mile, high-speed chase. The verdict was announced on the afternoon of 29 April 1992. Says David, "That's the day everything changed."

On 29 April, before the verdict had been handed down, an older black man who had lived through the Watts riot of 1965 warned David: "All hell's gonna break loose." Though David knew something would happen that night, he didn't think it would be that bad. But events proved him wrong: hell, or something very close to it, did indeed break loose in South Central Los Angeles. And during this paroxysm of violence – David labels it a "riot," others call it "rebellion," and the L.A. City Council refers to it euphemistically as the "civil disturbances of April 29–30" – the liquor store was destroyed.

First thing the next morning, David, his older brother, and his parents returned to the site where their store once stood, only fifteen or twenty blocks north of the intersection of Florence and Normandie, the epicenter of the preceding night's chaos. "Everything was gone," says David, without any bitterness or anger. Except for two walls that were still standing, everything else was destroyed. "They did a good job," he says. David was glad that his family was alive, and that they had insurance. His parents, however, were speechless.

As David and his family surveyed the still smoldering wreckage, a

group of twenty or so people – men and women, blacks and Hispanics, from little kids to senior citizens – gathered in front of the charred husk that had been a profitable liquor store. David says the people asked, 'Hey Dave, can I have this?' These were neighborhood people. They were asking us if they could have some of the things that weren't burnt. 'Cause we had lotta beer and whatever in the back. So I said, 'Help yourselves, it's yours.' And then, aw man, they just ran inside and took everything that they could. They were going, 'I'm sorry about this, Dave, but you know – ' I said, 'Hey, you didn't do it.' And then they were just giving me hugs and they were really sorry. I don't know how, y'know, truthful they were when they were apologizing. But I just said, 'Yeah, help yourself, take it,' and they took. It was gone. They cleaned out."

Watching the people fight over what little had not been destroyed, all David could think about was how poor and desperate these people must be. He says, "It was pitiful sight."

Only six weeks have passed since his parents' store was destroyed, but he shows incredible equanimity about what happened. When I ask how he can accept the situation so calmly, he says, "It's just not in my personality to get overly excited or overly depressed about whatever happens. Of course, I'm bitter. It's like they just took everything that we worked for, and making excuses that it was Koreans that ruined their life or whatever. I mean, the looting and all that stuff that happened, they shouldn't blame it on Koreans, but I see lotta people *are* doing that and that makes me mad, you know.

"For example, if you watch TV, they have like different people for a panel. They're talking about the L.A. riots. It's black people, they're talking shit, you know what I mean. It doesn't make sense. They should have a Korean person to back Koreans' voice, but the Koreans are always missing. It's just always blacks, more blacks, blacks. That's all there is. The things they say, it makes Koreans look really bad, and it's like we're the scapegoat for what the white people have been doing since the Watts riot. I mean, nothing changed after the Watts riot, so, you know, it happened again. But if things don't change, I think it's gonna happen again, and lotta people agree with me that it's gonna happen again if things don't change. But the way it's going, I don't think it's gonna change.

18 JOAN MORRISON AND CHARLOTTE FOX ZABUSKY

FROM "Premier Nguyen Cao Ky: From South Vietnam, 1975"

It's a common story after great political upheavals: a head of state becomes a grocery store clerk, a general becomes a dishwasher, a governor becomes a waiter. When he was premier of South Vietnam, Nguyen Cao Ky was a flamboyant figure in a black

flightsuit with lavender scarf and pearl-handled pistols, forever pushing the Americans to expand the war to the North. Now he runs a small liquor store on the outskirts of Los Angeles and lives with his wife and six children in a nondescript home in a middle-class housing development. Still trim and dapper at forty-seven, he wears well-tailored beige slacks and a flower-print silk shirt.

Even before I left, even five minutes before I left, I had no idea in my mind that I'm going to leave, because that day the Communist forces were advancing to the capital, Saigon. But, to the last second, I was still trying to direct, to gather the troops to fight and to hold, to fight back. It never came to mind that I am going to leave, because, as a professional soldier in a war situation, there is no alternative. Win the battle or die at the battle. That's the way that my grandfather and my father teach us. That's the way that we, in Asia, believe in, you know.

But then, all my efforts failed. Of course, I tried many months before the end of the war, not just the last days, to carry on; but both the American government and the Vietnamese government, at that time President Thieu, they didn't help me. I have the impression that both of them want me out, you know, so that they can do whatever they want. I think that, at that time, they already had the plan to evacuate, but they didn't tell us. No, they didn't tell anyone. . . .

After I stay in Washington with my family about a year and a half, I decide to move down here to Southern California because I hate politics, and business opportunities are better here, and, besides, down here you have the biggest concentration of Vietnamese in the United States.

The American press, and even people, are still talking about me as the leader of the Vietnamese in the United States. Maybe it's true, but, personally, I have no intention to be a leader. I don't want people to think that. And what can I do to help them in my position? But they do come to me when they need help. I never ask them, but if someone needs help and they come to me, well, my house is open for them, but that's all. And people come to me with small or big problems: red tape, money, there are all sorts of problems that refugees have.

But I don't have those problems. People know me, so they believe I am really very rich. There are all those stories of gold and smuggling opium and that I'm worth, you know, a million dollars. No one ever asks me for my credit. I don't have a bag of gold, but it's just the same as if I have a bag of gold. They never even ask me my credit. To buy a car, to buy a house, to start the business – "Okay. You're Marshall Ky," and that's it. They know I'm a leader.

I can even cosign for a car for a friend. A car dealer asked another Vietnamese, "Do you now have a job? " And he said, "Yes." And he said, "Who do you work for? " And he said, "I work for Marshall Ky," and the car dealer said, "Okay, if you work for that man, it's okay." [*Chuckles.*] He

said, "The only thing that I want you to do is, when you come in the next day for the car, bring Marshall Ky so we can shake hands with him." So he came back and told me, and I said okay. And the next day I went down with him to the car dealer, and he got the car. You see, you don't have to have the bag of gold; people just have to think you have a bag of gold.

I really came with nothing, nothing. I wasn't like some of those others, who have money in Paris and Switzerland in a bank under another name. I'm living simply, because I should live simply, because I have to live simply; but that's all right with me. Because I was educated in foreign countries and traveled often around the world, from the outside, I look like a very modern man. But, inside, deep inside, basically, I am Vietnamese, Asian. My way of thinking, my way of life, are 100 percent Vietnamese. I'm not Buddhist, I'm not Catholic; I am Confucian. Confucianism is pure Asian. So, living here myself and for my family, we have many problems adjusting – not physically, but morally.

The relationship between teachers and American children, I don't like that way. Children have the right to treat the teachers as equals. For us, in ancient times, we are taught that first, the king, the emperor – in other words, the nation; and second, the teacher; and third, the parents. That is the order of respect. So, you see, teachers have a very high position in our society, because we think parents give you birth, but the teachers . . . teachers give you knowledge: how to become a good man. But here, in this country, I found out the children have no respect for the teachers. That's not right.

And concerning the parents' respect and authority, the same thing happens. Teen-agers can go out and find a part-time job and earn four hundred, five hundred, six hundred dollars a month. Well, they become independent. And the society corrupts them, too, so they have less and less respect for their parents. It happened to my own son. Here, working at four dollars an hour, he has a sports car. Oh, yes, you see, they adjust very quick and it corrupts them. Yes, it does. I am very angry, but what can I do? If I beat them, you know, they will try me at the court. That's crazy. You are parents and you can't give a spanking to your own sons and daughters. I can't accept that. In my country, they will listen to me; and if not, well, we'll send them to the front line, and two years in the army and fighting the war will make them, you know, good boys. But here, what can I do? It's very frustrating. I know that Americans have the same problems, because many of them come to me and complain about their teen-agers.

What would you say are the good things in America?

[Long pause.] I don't know . . . maybe the climate . . . this is a beautiful place. It is beautiful country, but that's all. I don't like the way of life. Too

much hurry, hurry, hurry, and not enough time for relaxation. That's why, you know, you have too many mental problems. You have all kinds of problems, physically and mentally. I think you are lucky, but you are not the happiest people in the world. No, I don't think so. Maybe I'm too lazy.

Frankly, I think Americans pay too much attention to materialistic things. You're working too hard to get more, more money, so you've lost, most of the time, the true goal of life, the ultimate goal of life. Materially, when you look at an American, a millionaire, with his big house, big boat, big car, everything, you think he's a happy man. But when you become friends with him, and watch him closely, the way he works every minute, every day, every month of his life, then you feel pity, because he's not happy. I know one American, very rich, and we became very friendly. He's a multimillionaire, but every day he's worrying about his money, you know, and how to make more. I told him, "If you make ten million dollars more, what's the difference? Just tell me. You can't eat five, six meals a day. Already your house is too big for just the two of you. What can you do with millions more, just tell me? Why don't you stop worrying about business and try to enjoy life? Enjoy yourself and use that money to help people."

The other day, a television interviewer, an NBC man – what's his name? Tom Snyder. He asked me, "You own a liquor store now? You stand behind the counter and sell liquor? How can you do that?" And I said, "I am doing an honest business. I am earning a small amount of money for my family. I'm proud of that."

The basic difference between East and West is this: We believe in destiny. I believe that everything that happens to me is destiny. American people believe that *you* can change all, you can change the shape of your life. I don't think so. Even your intelligence – you are born intelligent, you are born smart. No one can teach you to be smart; nothing you can do to increase or improve your intelligence. You talk about being born equal – oh, no. [*Laughs.*] No, you are not born equal. Why is someone born in a Rockefeller house and the other in a poor house? It's destiny. Some people say they can be successful because they work. Yes, but they are born hard workers, and intelligent, and that's why they make a success. It's all destiny. I've escaped death many times, very close, when the one next to me died, not me. Why? Well, Christians, Catholics, they talk about miracles, right? I think it's destiny.

I think I did the best job among the premiers in the last fifteen years in South Vietnam. That was my destiny. So, today, I'm selling liquor. I'm still happy, because I say, "Well, it's my destiny," and what will happen to me next, it will happen, too. I believe that my destiny is I will some day have to go back to Vietnam. You wait and see. The world is changing

65

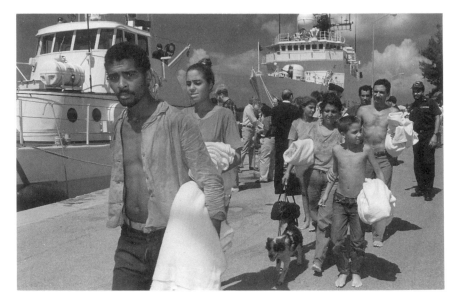

Figure 2.3 Cuban refugees disembarking in Key West, Florida, August 1994
Photograph courtesy of Range/Reuter/Bettman

changing from the beginning for millions of years, a continuous cycle of changing. There will be a change in power, and I will go back.

19 AL SANTOLI

FROM "Mojados (Wetbacks)" (1988)

Rosa María Urbina, age thirty-five, crossed the muddy Rio Grande in 1984 with the hope that she could earn enough money as a housecleaner in El Paso to take her three children out of an orphanage. A widow, she had to place her children in an institution because the $14 a week she earned on a factory assembly line in Juárez was not enough to feed them.

Each morning she joined hundreds of other young to middle-aged women from the hillside colonias, *who walked down to the concrete riverbank and paid men called* burros *to ferry them across the river on their shoulders – and back to the squalor of Juárez in the evening. On one of these excursions, she met a handsome farm worker, José Luis, age twenty-six, with dark mestizo features. It was fate, they believe. Within months, Rosa's children joined them in a two-room apartment on the American side of the river.*

I was introduced to José and Rosa during a tour of overcrowded tenement buildings in South El Paso that house many of the city's fifty thousand illegal residents. In Mexican slang, they are called mojados, *or "wets," the river people.*

My guide, Julie Padilla, a public-health nurse from the Centro de Salud Familiar La Fe clinic, visits the Urbinas to give their two-month-old baby, José Luis, Jr., a post-natal checkup. We walked up a dark stairwell to a dimly lit landing decorated with a colorful gold-framed mural of Our Lady of Guadalupe, the religious patron of all Mexican Catholics. There are sixteen apartments with ripped screen doors along a narrow graffiti-covered corridor. On the back fire-escape is a closet-sized communal toilet. Julie said, "There used to be one bathtub that every family on the corridor shared. But in the past year, that's been taken out. I don't know where they bathe now."

Rosa María, José, and the children have the luxury apartment. Half of the 12-foot-square room is taken up by a bed covered by a magenta Woolworth blanket. On the wall, above a calendar of the Good Shepherd, is a portrait of Pope John Paul II. A Winnie the Pooh blanket serves as a makeshift closet door. On a miniature two-tiered nightstand, alongside baby bottles and a green plant, are metal-framed elementary-school photos of the children. Their seven-year-old daughter's Honor Roll certificate is proudly displayed on a mirror above an all-purpose foldout table.

During winter months, José Luis is out of farm work. The baby is Rosa's full-time chore. They survive on $58 a month in food stamps earmarked for the baby, who is an American citizen by virtue of his birth in El Paso. And WICC, the Women, Infant and Children Care program, provides a bag of groceries each week. Although the children attend public school, José and Rosa seldom leave the apartment. They fear that border patrolmen will send them back across the river to the squalor of Juárez.

ROSA: Before I met José, I crossed back and forth across the river five days each week to my housekeeping jobs in El Paso. On weekends, I took my children out of the orphanage. Then I had to reluctantly return them to the orphanage on Sunday evenings and prepare to go back across the river.

 For a while, I traveled alone, which can be dangerous. But after I met José Luis, we crossed together. There are men who carry people across the river on their shoulders. The water is kind of rough, but that's what these men do to make a living. They charge passengers 1,500 to 2,000 pesos [$1.50 to $2.50]. The water is up to their chests, but they manage to hold us up on their shoulders so we can get to work dry.

JOSÉ: Crossing the river can be very dangerous, especially if you cross alone. There are fast water currents, and sometimes the water is quite high. If you don't know how to swim, the undercurrents can pull you right down. And in places the bottom of the river is like quicksand that can trap you. The water turns into kind of a funnel that can drag you down. Some friends of mine have died. . . .

ROSA: After José and I began living together in El Paso, I decided to bring my children across the river. The water was too high and swift to risk

men carrying them on their shoulders. So I had the children taxied across on a rubber raft.

JOSÉ: Another danger for people who cross the river is crime. Packs of men hang around the riverbank like wolves. They try to steal people's knapsacks or purses. Sometimes they demand that you give your wallet or wristwatch. If you don't obey them, they will knife you. . . .

When the *migra* catch us, they just put us in their truck and take us to their station. They ask our name, address, where we were born. They keep us in a cell maybe three or four hours. Then they put us in a bus and drive us back to Juárez. They drop the women off very near the main bridge. The men are taken a little further away from town. . . .

The men, like myself, who work in the fields come across the river at around 2:30 A.M. to meet the buses that take us to the fields from El Paso. The transportation is owned by the *padrone* of the farms, or by the labor-crew chiefs who hire and pay the workers. In the evenings, we ride the buses back to the river. Sometimes I work twelve hours a day and earn $20. I've learned to check around to see which farms pay the best. Some pay up to $35 a day.

Farm-labor jobs are not very steady. We just grab whatever is open at the moment. I accept anything, any time, as long as it is work. But suppose I take a job that only pays me $12 a day. It would only be enough to cover my transportation and meals in the field. I must find jobs that pay enough to feed my family.

In order to make $25, I must pick seventy-two buckets of chili peppers. That could take me four or five hours; it depends on how fast my hands are. The total amount of buckets we pick depends upon the amount contracted by the big companies in California. For a big contract, we work as long as necessary to complete the order. But the most I can earn in a day is $35.

The landlord who owns this building is very generous. He lets us owe him rent for the months that I am not working. He understands how tough our life is. We pay whatever we can, even if it's only $50. And he knows that, if the day comes where we are raided by immigration officers, we will run.

The rent for this apartment is $125 a month plus electricity. We all live and sleep in this one room. The two boys sleep on the couch. Our daughter, Miriam, sleeps with us on the bed. And the baby sleeps in a crib next to our bed. Fortunately, we have a kitchen, and a closet in this room. Living conditions in Juárez were better, but there was no work at all.

If it is possible, Rosa and I would like to become American citizens. I would have my documents, and the government wouldn't be after us. All we want is to be able to work in peace.

Our dream is to be able to give our children the best of everything. We know that, for them to have a better future and purpose in life, they need a good education. Of the three children in school now, Miriam is the fastest learner. She received an award for being an honor student, the best in her classroom.

We hope the children can finish high school and have the career of their choice. We are going to sacrifice for them, so that they can have the profession that they desire. . . .

The dreams that Rosa María and I had of living in the US and reality are not the same. We hoped to find a job and live comfortably. Now that we are here, our main purpose is to survive.

I worry about our status under the new immigration law. In the previous place where I lived, I paid the rent all the time, but the landlord threw away all of the receipts. So we have no proof that we have been living here enough years to qualify for amnesty.

On the farms where I worked, my employers or crew bosses didn't keep pay records, because I only worked temporarily at each place. And, besides, I was illegal. So what was the use? If the police showed up, we would be in trouble whether or not the employer had a record. And the employers wanted to protect themselves. They didn't pay us with checks; it was always cash.

Fortunately, the last farmer I worked for took taxes and Social Security out of our wages. He is sending me a W-2 form as proof. I am waiting for it now. But things are getting worse, because the immigration police are putting pressure on people who hire undocumented workers. If the police catch illegals on a job site, the boss can be arrested under the new law. So most places have stopped hiring illegals. For example, my last job in El Paso, I was fired because the *migra* would raid the construction site every day. We would have to stop working and run.

When the planting season begins on the farms, I hope the immigration police don't show up. They raid a farm with a truck and four or five police cars. They position themselves outside the entrance to the farm and wait for us to walk by. They ask us for identification. If we cannot show proof that we are legal, we've had it. They'll take us away.

On the farms where I work, some people are legal and others aren't. If you drive your own car, the police usually won't question you. But if you come to work in the employer's bus, they'll take you away.

ROSA: In town, we don't feel comfortable walking on the street. If the immigration officers see us, they will grab us. We are not afraid for ourselves, because we are accustomed to it. But I worry about the children. They have just begun studying in school here in El Paso. They like it very much. My sons are in the sixth and fifth grades, and Miriam is in second grade. They are learning English very quickly. My

oldest boy, Lorenzo, likes social studies and mathematics; he would like to be a doctor. My other son likes the army a lot. He could probably be a good soldier.

JOSÉ: If we become citizens and the United States government asks them to spend time in the army, we would be honored if they are chosen to serve. We would be very proud of our children for doing their duty for their country.

ROSA: My daughter, Miriam, received a certificate from her teacher. You can ask her what she would like to do when she finishes school.

MIRIAM: [Big grin] I like to study English and mathematics. Some day I would like to be a teacher.

ROSA: In the buildings on this block, the majority of the people are families. In each apartment there are three or four children. This is the only area we found where the landlords don't mind renting to families with kids. The kids play outside, in the alley behind our building. Not many cars pass on this street at night, so it is pretty quiet. But other neighborhoods are more active and there is more crime on the streets.

We would like to have an ordinary life, but our problems with the *migra* are nothing new. If they catch me again and send me back to Juárez, I will just come back across the river.

3

AFRICAN AMERICANS

Introduction 72

20 *Moses Grandy*
 "The Auction Block" (pre-1860) 73

21 *Joseph Ingraham*
 "A Peep into a Slave-Mart" (pre-1860) 74

22 *Sojourner Truth*
 "Ain't I a Woman? " (1851) 75

23 *Abraham Lincoln*
 Final Emancipation Proclamation (1863) 76

24 *William DuBois*
 FROM "Of the Faith of the Fathers" (1903) 77

25 *William DuBois*
 "This Double-Consciousness" (1903) 82

26 *Gwendolyn Brooks*
 "We Real Cool" (1960 84

27 *Martin Luther King, Jr.*
 "I Have a Dream" (1963) 84

28 *Malcolm X*
 FROM "The Ballot or the Bullet" (1965) 88

29 *Malcolm X*
 "The Black Man" (1965) 89

30 *US Congress*
 The Civil Rights Act of 1964 91

31 *Septima Clark*
 "Teach How Change Comes About" (pre-1987) 93

INTRODUCTION

It is impossible to conceive of black culture in the US without a reference to the institution of slavery in the south. Human tragedies are spelled out in numerous slave narratives, such as the short account we have selected here (extract 20), given by a husband upon the selling of his wife. At the time marriages between slaves were not legally recognized. What took place in the minds of those who were offered for sale on the "slave-mart" (extract 21) can only be guessed at. As James Baldwin once indicated, all blacks in the US can refer their ancestry back to a bill of sale.

In a speech given at a New York City convention in 1851 Sojourner Truth (1797–1883) combines questions about the status of blacks and that of women. During the 1840s and 1850s abolition and other reform movements attracted many women, particularly in the northeast. Born in slavery, sold three times before she was 12, the mother of five children, Truth furnishes a voice in the struggle for the rights of black women which is unique.

Abraham Lincoln is remembered first of all as the president who freed the slaves. Although he may not have had totally humanitarian motives for issuing the Final Emancipation Proclamation in 1863, it has since become a cornerstone in the history of legal rights for blacks. It was written into the Constitution as the thirteenth amendment and later echoed in American civil rights oratory, in Martin Luther King's speeches.

During the period of Reconstruction blacks were officially granted the right to vote and other civil rights, but their sense of freedom faded away during the last decades of the nineteenth century when they found themselves victims of a strict system of segregation. It is against this historical background that we need to study the texts written by the two black leaders who emerged around 1900, Booker T. Washington and William DuBois.

Washington's "Atlanta Exposition Address" (1901) is often anthologized and therefore not included here. The first of the two excerpts we have included from DuBois's *The Souls of Black Folk* (1903), a classic study of black culture, is an early analysis of the importance of religion and music in black culture. (See well-known blues and gospel texts in chapters 9 and 11 on religion and on mass media.) The second excerpt presents DuBois's notion of "double consciousness," which is now often referred to, not only by other ethnic groups in the US but by a wide range of readers, as a valuable reflection on life in general.

In the 1950s and 1960s the black civil rights movement caught the attention of the entire nation and the whole world for its determined, but non-violent, actions for freedom and equality in American society. The role of Martin Luther King in this struggle cannot be overestimated. Dr

King argued for the necessity of non-violent action as a means of forcing southern authorities to negotiate the issues at stake.

In August of 1963 King organized the massive "March on Washington for Jobs and Freedom," in which some 200,000 people participated. In his speech to the demonstrators and, via television, to the nation he presented his visions of a future society where his children "will not be judged by the color of their skin but by the content of their character." Not only does his speech resonate with images from Jefferson's Declaration of Independence and Lincoln's Gettysburg Address, it draws heavily on traditions from within the black church at the same time.

The "long hot summer" of 1963 resulted in important legislation in Congress, notably the Civil Rights Act of 1964. Its provisions included sections prohibiting discrimination in public accommodations, labor unions and voter registration. (On the desegration of schools, see chapter 10 on education.)

Despite the legal attack upon the nation's racial caste system through the Civil Rights Act and other similar measures, many blacks were dissatisfied with the slowness of real progress, and gave vent to their frustrations by joining more militant organizations such as the Black Muslims and the Black Panthers. James Baldwin discussed these fundamental dilemmas in black culture at the time in his famous essay *The Fire Next Time* (1963). Malcolm X probably remains the symbolic figure for an alternative black vision of separatism and pride. The rhetoric of his speeches from the mid-1960s is markedly different from King's, even though both of them built on American traditions.

To differentiate a specific African American culture may not be so easy today, and issues among blacks are different now from what they were thirty years ago. In her story, Septima Clark, a schoolteacher and administrator in South Carolina, reflects on what the tradition of King and other black leaders means to a new generation.

Black women writers, such as Alice Walker·and Toni Morrison, have gained a prominent place in contemporary American literature. Belonging to an earlier generation of black writers, Gwendolyn Brooks, raised on Chicago's South Side, was the first black poet to receive the Pulitzer prize (1950). Her poem "We Real Cool" was published in 1960.

20 MOSES GRANDY

"The Auction Block" (pre-1860)

I said to him, "For God's sake! Have you bought my wife?" He said he had. When I asked him what she had done, he said she had done nothing, but that her master wanted money. He drew out a pistol and said if I went near the wagon on which she was, he would shoot me. I

asked for leave to shake hands with her which he refused, but said I might stand at a distance and talk with her. My heart was so full that I could say very little. . . . I have never seen or heard from her from that day to this. I loved her as I love my life.

21 JOSEPH INGRAHAM

"A Peep into a Slave-Mart" (pre-1860)

"Will you ride with me into the country? " said a young planter. "I am about purchasing a few negroes and a peep into a slave-mart may not be uninteresting to you." I readily embraced the opportunity and in a few minutes our horses were at the door.

*

A mile from Natchez we came to a cluster of rough wooden buildings, in the angle of two roads, in front of which several saddle-horses, either tied or held by servants, indicated a place of popular resort.

"This is the slave market," said my companion, pointing to a building in the rear; and alighting, we left our horses in charge of a neatly dressed yellow boy belonging to the establishment. Entering through a wide gate into a narrow court-yard, partially enclosed by low buildings, a scene of a novel character was at once presented. A line of negroes, commencing at the entrance with the tallest, who was not more than five feet eight or nine inches in height – for negroes are a low rather than a tall race of men – down to a little fellow about ten years of age, extended in a semicircle around the right side of the yard. There were in all about forty. Each was dressed in the usual uniform of slaves, when in market, consisting of a fashionably shaped, black fur hat, roundabout and trowsers of coarse corduroy velvet, precisely such as are worn by Irish labourers, when they first "come over the water"; good vests, strong shoes, and white cotton shirts, completed their equipment. This dress they lay aside after they are sold, or wear out as soon as may be; for the negro dislikes to retain the indication of his having recently been in the market. With their hats in their hands, which hung down by their sides, they stood perfectly still, and in close order, while some gentlemen were passing from one to another examining for the purpose of buying. With the exception of displaying their teeth when addressed, and rolling their great white eyes about the court – they were so many statues of the most glossy ebony.

As we entered the mart, one of the slave merchants – for a "lot" of slaves is usually accompanied, if not owned, by two or three individuals – approached us, saying "Good morning, gentlemen! Would you like to examine my lot of boys? I have as fine a lot as ever came into market." –

We approached them, one of us as a curious spectator, the other as a purchaser; and as my friend passed along the line, with a scrutinizing eye – giving that singular look, peculiar to the buyer of slaves as he glances from head to foot over each individual – the passive subjects of his observations betrayed no other signs of curiosity than that evinced by an occasional glance. The entrance of a stranger into a mart is by no means an unimportant event to the slave, for every stranger may soon become his master and command his future destinies.

22 SOJOURNER TRUTH

"Ain't I a Woman?" (1851)

Well, children, where there is so much racket there must be something out of kilter. I think that 'twixt the negroes of the South and the women at the North, all talking about rights, the white men will be in a fix pretty soon. But what's all this here talking about?

That man over there says that women need to be helped into carriages, and lifted over ditches, and to have the best place everywhere. Nobody ever helps me into carriages, or over mud-puddles, or gives me any best place! And ain't I a woman? Look at me! Look at my arm! I have ploughed and planted, and gathered into barns, and no man could head me! And ain't I a woman? I could work as much and eat as much as a man – when I could get it – and bear the lash as well! And ain't I a woman? I have borne thirteen children, and seen them most all sold off to slavery, and when I cried out with my mother's grief, none but Jesus heard me! And ain't I a woman?

Then they talk about this thing in the head; what's this they call it? [Intellect, someone whispers.] That's it, honey. What's that got to do with women's rights or negro's rights? If my cup won't hold but a pint, and yours holds a quart, wouldn't you be mean not to let me have my little half-measure full?

Then that little man in black there, he says women can't have as much rights as men, 'cause Christ wasn't a woman! Where did your Christ come from? Where did your Christ come from? From God and a woman! Man had nothing to do with Him.

If the first woman God ever made was strong enough to turn the world upside down all alone, these women together ought to be able to turn it back, and get it right side up again! And now they is asking to do it, the men better let them.

Obliged to you for hearing me, and now old Sojourner ain't got nothing more to say.

23 ABRAHAM LINCOLN

Final Emancipation Proclamation (1863)

BY THE PRESIDENT OF THE UNITED STATES OF AMERICA: A PROCLAMATION

Whereas, on the twentysecond day of September, in the year of our Lord one thousand eight hundred and sixty two, a proclamation was issued by the President of the United States, containing, among other things, the following, towit:

"That on the first day of January, in the year of our Lord one thousand eight hundred and sixty-three, all persons held as slaves within any State or designated part of a State, the people whereof shall then be in rebellion against the United States, shall be then, thenceforward, and forever free; and the Executive Government of the United States, including the military and naval authority thereof, will recognize and maintain the freedom of such persons, and will do no act or acts to repress such persons, or any of them, in any efforts they may make for their actual freedom.

"That the Executive will, on the first day of January aforesaid, by proclamation, designate the States and parts of States, if any, in which the people thereof, respectively, shall then be in rebellion against the United States; and the fact that any State, or the people thereof, shall on that day be, in good faith, represented in the Congress of the United States by members chosen thereto at elections wherein a majority of the qualified voters of such State shall have participated, shall, in the absence of strong countervailing testimony, be deemed conclusive evidence that such State, and the people thereof, are not then in rebellion against the United States."

Now, therefore I, Abraham Lincoln, President of the United States, by virtue of the power in me vested as Commander-in-Chief, of the Army and Navy of the United States in time of actual armed rebellion against authority and government of the United States, and as a fit and necessary war measure for suppressing said rebellion, do, on this first day of January, in the year of our Lord one thousand eight hundred and sixty three, and in accordance with my purpose so to do publicly proclaimed for the full period of one hundred days, from the day first above mentioned, order and designate as the States and parts of States wherein the people thereof respectively, are this day in rebellion against the United States, the following, towit:

Arkansas, Texas, Louisiana, (except the Parishes of St. Bernard, Plaquemines, Jefferson, St. Johns, St. Charles, St. James, Ascension, Assumption, Terrebonne, Lafourche, St. Mary, St. Martin, and Orleans, including the City of New-Orleans) Mississippi, Alabama,

Florida, Georgia, South-Carolina, North-Carolina, and Virginia, (except the fortyeight counties designated as West Virginia, and also the counties of Berkley, Accomac, Northampton, Elizabeth-City, York, Princess Ann, and Norfolk, including the cities of Norfolk & Portsmouth); and which excepted parts are, for the present, left precisely as if this proclamation were not issued.

And by virtue of the power, and for the purpose aforesaid, I do order and declare that all persons held as slaves within said designated States, and parts of States, are, and henceforward shall be free; and that the Executive government of the United States, including the military and naval authorities thereof, will recognize and maintain the freedom of said persons.

And I hereby enjoin upon the people so declared to be free to abstain from all violence, unless in necessary self-defence; and I recommend to them that, in all cases when allowed, they labor faithfully for reasonable wages.

And I further declare and make known, that such persons of suitable condition, will be received into the armed service of the United States to garrison forts, positions, stations, and other places, and to man vessels of all sorts in said service.

And upon this act, sincerely believed to be an act of justice, warranted by the Constitution, upon military necessity, I invoke the considerate judgment of mankind, and the gracious favor of Almighty God.

In witness whereof, I have hereunto set my hand and caused the seal of the United States to be affixed.

Done at the City of Washington, this first day of January, in the year of our Lord one thousand eight hundred and sixty three, and of the Independence of the United States of America the eighty-seventh.

By the President: ABRAHAM LINCOLN

WILLIAM H. SEWARD, Secretary of State.

24 WILLIAM DUBOIS

FROM "Of the Faith of the Fathers" (1903)

The Preacher is the most unique personality developed by the Negro on American soil. A leader, a politician, an orator, a "boss," an intriguer, an idealist, – all these he is, and ever, too, the centre of a group of men, now twenty, now a thousand in number. The combination of a certain adroitness with deep-seated earnestness, of tact with consummate ability, gave him his preëminence, and helps him maintain it. The type, of course, varies according to time and place, from the West Indies in the sixteenth century to New England in the nineteenth, and from the Mississippi bottoms to cities like New Orleans or New York.

The Music of Negro religion is that plaintive rhythmic melody, with its touching minor cadences, which, despite caricature and defilement, still remains the most original and beautiful expression of human life and longing yet born on American soil. Sprung from the African forests, where its counterpart can still be heard, it was adapted, changed, and intensified by the tragic soul-life of the slave, until, under the stress of law and whip, it became the one true expression of a people's sorrow, despair, and hope.

Finally the Frenzy or "Shouting," when the Spirit of the Lord passed by, and, seizing the devotee, made him mad with supernatural joy, was the last essential of Negro religion and the one more devoutly believed in than all the rest. It varied in expression from the silent rapt countenance or the low murmur and moan to the mad abandon of physical fervor, – the stamping, shrieking, and shouting, the rushing to and fro and wild waving of arms, the weeping and laughing, the vision and the trance. All this is nothing new in the world, but old as religion, as Delphi and Endor. And so firm a hold did it have on the Negro, that many generations firmly believed that without this visible manifestation of the God there could be no true communion with the Invisible.

These were the characteristics of Negro religious life as developed up to the time of Emancipation. Since under the peculiar circumstances of the black man's environment they were the one expression of his higher life, they are of deep interest to the student of his development, both socially and psychologically. Numerous are the attractive lines of inquiry that here group themselves. What did slavery mean to the African savage? What was his attitude toward the World and Life? What seemed to him good and evil, – God and Devil? Whither went his longings and strivings, and wherefore were his heart-burnings and disappointments? Answers to such questions can come only from a study of Negro religion as a development, through its gradual changes from the heathenism of the Gold Coast to the institutional Negro church of Chicago.

Moreover, the religious growth of millions of men, even though they be slaves, cannot be without potent influence upon their contemporaries. The Methodists and Baptists of America owe much of their condition to the silent but potent influence of their millions of Negro converts. Especially is this noticeable in the South, where theology and religious philosophy are on this account a long way behind the North, and where the religion of the poor whites is a plain copy of Negro thought and methods. The mass of "gospel" hymns which has swept through American churches and well-nigh ruined our sense of song consists largely of debased imitations of Negro melodies made by ears that caught the jingle but not the music, the body but not the soul, of the Jubilee songs. It is thus clear that the study of Negro religion is not only a vital part of

the history of the Negro in America, but no uninteresting part of American history.

The Negro church of to-day is the social centre of Negro life in the United States, and the most characteristic expression of African character. Take a typical church in a small Virginian town: it is the "First Baptist" – a roomy brick edifice seating five hundred or more persons, tastefully finished in Georgia pine, with a carpet, a small organ, and stained-glass windows. Underneath is a large assembly room with benches. This building is the central club-house of a community of a thousand or more Negroes. Various organizations meet here, – the church proper, the Sunday-school, two or three insurance societies, women's societies, secret societies, and mass meetings of various kinds. Entertainments, suppers, and lectures are held beside the five or six regular weekly religious services. Considerable sums of money are collected and expended here, employment is found for the idle, strangers are introduced, news is disseminated and charity distributed. At the same time this social, intellectual, and economic centre is a religious centre of great power. Depravity, Sin, Redemption, Heaven, Hell, and Damnation are preached twice a Sunday with much fervor, and revivals take place every year after the crops are laid by; and few indeed of the community have the hardihood to withstand conversion. Back of this more formal religion, the Church often stands as a real conserver of morals, a strengthener of family life, and the final authority on what is Good and Right.

Thus one can see in the Negro church to-day, reproduced in microcosm, all that great world from which the Negro is cut off by color-prejudice and social condition. In the great city churches the same tendency is noticeable and in many respects emphasized. A great church like the Bethel of Philadelphia has over eleven hundred members, an edifice seating fifteen hundred persons and valued at one hundred thousand dollars, an annual budget of five thousand dollars, and a government consisting of a pastor with several assisting local preachers, an executive and legislative board, financial boards and tax collectors; general church meetings for making laws; subdivided groups led by class leaders, a company of militia, and twenty-four auxiliary societies. The activity of a church like this is immense and far-reaching, and the bishops who preside over these organizations throughout the land are among the most powerful Negro rulers in the world.

Such churches are really governments of men, and consequently a little investigation reveals the curious fact that, in the South, at least, practically every American Negro is a church member. Some, to be sure, are not regularly enrolled, and a few do not habitually attend services; but, practically, a proscribed people must have a social centre, and that centre for this people is the Negro church. The census of 1890 showed

nearly twenty-four thousand Negro churches in the country, with a total enrolled membership of over two and a half millions, or ten actual church members to every twenty-eight persons, and in some Southern States one in every two persons. Besides these there is the large number who, while not enrolled as members, attend and take part in many of the activities of the church. There is an organized Negro church for every sixty black families in the nation, and in some States for every forty families, owning, on an average, a thousand dollars' worth of property each, or nearly twenty-six million dollars in all.

Such, then, is the large development of the Negro church since Emancipation. The question now is, What have been the successive steps of this social history and what are the present tendencies? First, we must realize that no such institution as the Negro church could rear itself without definite historical foundations. These foundations we can find if we remember that the social history of the Negro did not start in America. He was brought from a definite social environment, – the polygamous clan life under the headship of the chief and the potent influence of the priest. His religion was nature-worship, with profound belief in invisible surrounding influences, good and bad, and his worship was through incantation and sacrifice. The first rude change in this life was the slave ship and the West Indian sugar-fields. The plantation organization replaced the clan and tribe, and the white master replaced the chief with far greater and more despotic powers. Forced and long-continued toil became the rule of life, the old ties of blood relationship and kinship disappeared, and instead of the family appeared a new polygamy and polyandry, which, in some cases, almost reached promiscuity. It was a terrific social revolution, and yet some traces were retained of the former group life, and the chief remaining institution was the Priest or Medicine-man. He early appeared on the plantation and found his function as the healer of the sick, the interpreter of the Unknown, the comforter of the sorrowing, the supernatural avenger of wrong, and the one who rudely but picturesquely expressed the longing, disappointment, and resentment of a stolen and oppressed people. Thus, as bard, physician, judge, and priest, within the narrow limits allowed by the slave system, rose the Negro preacher, and under him the first Afro-American institution, the Negro church. This church was not at first by any means Christian nor definitely organized; rather it was an adaptation and mingling of heathen rites among the members of each plantation, and roughly designated as Voodooism. Association with the masters, missionary effort and motives of expediency gave these rites an early veneer of Christianity, and after the lapse of many generations the Negro church became Christian. . . .

To-day the two groups of Negroes, the one in the North, the other in the South, represent these divergent ethical tendencies, the first tending

toward radicalism, the other toward hypocritical compromise. It is no idle regret with which the white South mourns the loss of the old-time Negro, – the frank, honest, simple old servant who stood for the earlier religious age of submission and humility. With all his laziness and lack of many elements of true manhood, he was at least open-hearted, faithful, and sincere. To-day he is gone, but who is to blame for his going? Is it not those very persons who mourn for him? Is it not the tendency, born of Reconstruction and Reaction, to found a society on lawlessness and deception, to tamper with the moral fibre of a naturally honest and straightforward people until the whites threaten to become ungovernable tyrants and the blacks criminals and hypocrites? Deception is the natural defence of the weak against the strong, and the South used it for many years against its conquerors; to-day it must be prepared to see its black proletariat turn that same two-edged weapon against itself. And how natural this is! The death of Denmark Vesey and Nat Turner proved long since to the Negro the present hopelessness of physical defence. Political defence is becoming less and less available, and economic defence is still only partially effective. But there is a patent defence at hand, – the defence of deception and flattery, of cajoling and lying. It is the same defence which the Jews of the Middle Age used and which left its stamp on their character for centuries. Today the young Negro of the South who would succeed cannot be frank and outspoken, honest and self-assertive, but rather he is daily tempted to be silent and wary, politic and sly; he must flatter and be pleasant, endure petty insults with a smile, shut his eyes to wrong; in too many cases he sees positive personal advantage in deception and lying. His real thoughts, his real aspirations, must be guarded in whispers; he must not criticize, he must not complain. Patience, humility, and adroitness must, in these growing black youth, replace impulse, manliness, and courage. With this sacrifice there is an economic opening, and perhaps peace and some prosperity. Without this there is riot, migration, or crime. Nor is this situation peculiar to the Southern United States, – is it not rather the only method by which undeveloped races have gained the right to share modern culture? The price of culture is a Lie.

On the other hand, in the North the tendency is to emphasize the radicalism of the Negro. Driven from his birthright in the South by a situation at which every fibre of his more outspoken and assertive nature revolts, he finds himself in a land where he can scarcely earn a decent living amid the harsh competition and the color discrimination. At the same time, through schools and periodicals, discussions and lectures, he is intellectually quickened and awakened. The soul, long pent up and dwarfed, suddenly expands in new-found freedom. What wonder that every tendency is to excess, – radical complaint, radical remedies, bitter denunciation or angry silence. Some sink, some rise. The criminal and

the sensualist leave the church for the gambling-hell and the brothel, and fill the slums of Chicago and Baltimore; the better classes segregate themselves from the group-life of both white and black, and form an aristocracy, cultured but pessimistic, whose bitter criticism stings while it points out no way of escape. They despise the submission and subserviency of the Southern Negroes, but offer no other means by which a poor and oppressed minority can exist side by side with its masters. Feeling deeply and keenly the tendencies and opportunities of the age in which they live, their souls are bitter at the fate which drops the Veil between; and the very fact that this bitterness is natural and justifiable only serves to intensify it and make it more maddening.

Between the two extreme types of ethical attitude which I have thus sought to make clear wavers the mass of the millions of Negroes, North and South; and their religious life and activity partake of this social conflict within their ranks. Their churches are differentiating, – now into groups of cold, fashionable devotees, in no way distinguishable from similar white groups save in color of skin; now into large social and business institutions catering to the desire for information and amusement of their members, warily avoiding unpleasant questions both within and without the black world, and preaching in effect if not in word: *Dum vivimus, vivamus.*

But back of this still broods silently the deep religious feeling of the real Negro heart, the stirring, unguided might of powerful human souls who have lost the guiding star of the past and are seeking in the great night a new religious ideal. Some day the Awakening will come, when the pent-up vigor of ten million souls shall sweep irresistibly toward the Goal, out of the Valley of the Shadow of Death, where all that makes life worth living – Liberty, Justice, and Right – is marked "For White People Only."

25 WILLIAM DUBOIS

"This Double-Consciousness" (1903)

Between me and the other world there is ever an unasked question: unasked by some through feelings of delicacy; by others through the difficulty of rightly framing it. All, nevertheless, flutter round it. They approach me in a half-hesitant sort of way, eye me curiously or compassionately, and then, instead of saying directly, How does it feel to be a problem? they say, I know an excellent colored man in my town; or, I fought at Mechanicsville; or, Do not these Southern outrages make your blood boil? At these I smile, or am interested, or reduce the boiling to a simmer, as the occasion may require. To the real question, How does it feel to be a problem? I answer seldom a word.

And yet, being a problem is a strange experience, – peculiar even for one who has never been anything else, save perhaps in babyhood and in Europe. It is in the early days of rollicking boyhood that the revelation first bursts upon one, all in a day, as it were. I remember well when the shadow swept across me. I was a little thing, away up in the hills of New England, where the dark Housatonic winds between Hoosac and Taghkanic to the sea. In a wee wooden schoolhouse, something put it into the boys' and girls' heads to buy gorgeous visiting-cards – ten cents a package – and exchange. The exchange was merry, till one girl, a tall newcomer, refused my card, – refused it peremptorily, with a glance. Then it dawned upon me with a certain suddenness that I was different from the others; or like, mayhap, in heart and life and longing, but shut out from their world by a vast veil. I had thereafter no desire to tear down that veil, to creep through; I held all beyond it in common contempt, and lived above it in a region of blue sky and great wandering shadows. That sky was bluest when I could beat my mates at examination-time, or beat them at a foot-race, or even beat their stringy heads. Alas, with the years all this fine contempt began to fade; for the words I longed for, and all their dazzling opportunities, were theirs, not mine. But they should not keep these prizes, I said; some, all, I would wrest from them. Just how I would do it I could never decide: by reading law, by healing the sick, by telling the wonderful tales that swam in my head – some way. With other black boys the strife was not so fiercely sunny: their youth shrunk into tasteless sycophancy, or into silent hatred of the pale world about them and mocking distrust of everything white; or wasted itself in a bitter cry, Why did God make me an outcast and a stranger in mine own house? The shades of the prison-house closed round about us all: walls strait and stubborn to the whitest, but relentlessly narrow, tall, and unscalable to sons of night who must plod darkly on in resignation, or beat unavailing palms against the stone, or steadily, half hopelessly, watch the streak of blue above.

After the Egyptian and Indian, the Greek and Roman, the Teuton and Mongolian, the Negro is a sort of seventh son, born with a veil, and gifted with second-sight in this American world, – a world which yields him no true self-consciousness, but only lets him see himself through the revelation of the other world. It is a peculiar sensation, this double-consciousness, this sense of always looking at one's self through the eyes of others, of measuring one's soul by the tape of a world that looks on in amused contempt and pity. One ever feels his twoness, – an American, a Negro; two souls, two thoughts, two unreconciled strivings; two warring ideals in one dark body, whose dogged strength alone keeps it from being torn asunder.

The history of the American Negro is the history of this strife, – this longing to attain self-conscious manhood, to merge his double self into a

better and truer self. In this merging he wishes neither of the older selves to be lost. He would not Africanize America, for America has too much to teach the world and Africa. He would not bleach his Negro soul in a flood of white Americanism, for he knows that Negro blood has a message for the world. He simply wishes to make it possible for a man to be both a Negro and an American, without being cursed and spit upon by his fellows, without having the doors of Opportunity closed roughly in his face.

26 GWENDOLYN BROOKS

"We Real Cool" (1960)

THE POOL PLAYERS.
SEVEN AT THE GOLDEN SHOVEL.

> We real cool. We
> Left school. We
>
> Lurk late. We
> Strike straight. We
>
> Sing sin. We
> Thin gin. We
>
> Jazz June. We
> Die soon.

27 MARTIN LUTHER KING, JR.

"I Have a Dream" (1963)

Five score years ago, a great American, in whose symbolic shadow we stand, signed the Emancipation Proclamation. This momentous decree came as a great beacon light of hope to millions of Negro slaves who had been seared in the flames of withering injustice. It came as a joyous daybreak to end the long night of captivity.

But one hundred years later, we must face the tragic fact that the Negro is still not free. One hundred years later, the life of the Negro is still sadly crippled by the manacles of segregation and the chains of discrimination. One hundred years later, the Negro lives on a lonely island of poverty in the midst of a vast ocean of material prosperity. One hundred years later, the Negro is still languished in the corners of American society and finds himself an exile in his own land. So we have come here today to dramatize an appalling condition.

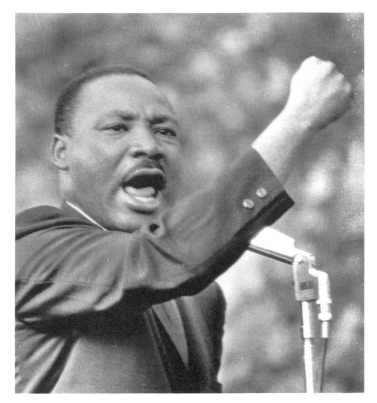

Figure 3.1 Martin Luther King at a mass rally in Philadelphia, 1965
Photograph courtesy of Range/Bettman/UPI

In a sense we have come to our nation's Capital to cash a check. When the architects of our republic wrote the magnificent words of the Constitution and the Declaration of Independence, they were signing a promissory note to which every American was to fall heir. This note was a promise that all men would be guaranteed the unalienable rights of life, liberty, and the pursuit of happiness.

It is obvious today that America has defaulted on this promissory note insofar as her citizens of color are concerned. Instead of honoring this sacred obligation, America has given the Negro people a bad check; a check which has come back marked "insufficient funds." But we refuse to believe that the bank of justice is bankrupt. We refuse to believe that there are insufficient funds in the great vaults of opportunity of this nation. So we have come to cash this check – a check that will give us upon demand the riches of freedom and the security of justice. We have also come to this hallowed spot to remind America of the fierce urgency of *now*. This is no time to engage in the luxury of cooling off or to take the

85

tranquilizing drug of gradualism. *Now* is the time to make real the promises of Democracy. *Now* is the time to rise from the dark and desolate valley of segregation to the sunlit path of racial justice. *Now* is the time to open the doors of opportunity to all of God's children. *Now* is the time to lift our nation from the quicksands of racial injustice to the solid rock of brotherhood.

It would be fatal for the nation to overlook the urgency of the moment and to underestimate the determination of the Negro. This sweltering summer of the Negro's legitimate discontent will not pass until there is an invigorating autumn of freedom and equality. 1963 is not an end, but a beginning. Those who hope that the Negro needed to blow off steam and will now be content will have a rude awakening if the nation returns to business as usual. There will be neither rest nor tranquillity in America until the Negro is granted his citizenship rights. The whirl-winds of revolt will continue to shake the foundations of our nation until the bright day of justice emerges.

But there is something that I must say to my people who stand on the warm threshold which leads into the palace of justice. In the process of gaining our rightful place we must not be guilty of wrongful deeds. Let us not seek to satisfy our thirst for freedom by drinking from the cup of bitterness and hatred. We must forever conduct our struggle on the high plane of dignity and discipline. We must not allow our creative protest to degenerate into physical violence. Again and again we must rise to the majestic heights of meeting physical force with soul force. The marvelous new militancy which has engulfed the Negro community must not lead us to a distrust of all white people, for many of our white brothers, as evidenced by their presence here today, have come to realize that their destiny is tied up with our destiny and their freedom is inextricably bound to our freedom. We cannot walk alone.

And as we walk, we must make the pledge that we shall march ahead. We cannot turn back. There are those who are asking the devotees of civil rights, "When will you be satisfied? " We can never be satisfied as long as the Negro is the victim of the unspeakable horrors of police brutality. We can never be satisfied as long as our bodies, heavy with the fatigue of travel, cannot gain lodging in the motels of the highways and the hotels of the cities. We cannot be satisfied as long as the Negro's basic mobility is from a smaller ghetto to a larger one. We can never be satisfied as long as a Negro in Mississippi cannot vote and a Negro in New York believes he has nothing for which to vote. No, no, we are not satisfied, and we will not be satisfied until justice rolls down like waters and righteousness like a mighty stream.

I am not unmindful that some of you have come here out of great trials and tribulations. Some of you have come fresh from narrow jail cells. Some of you have come from areas where your quest for freedom left

you battered by the storms of persecution and staggered by the winds of police brutality. You have been the veterans of creative suffering. Continue to work with the faith that unearned suffering is redemptive.

Go back to Mississippi, go back to Alabama, go back to South Carolina, go back to Georgia, back to Louisiana, go back to the slums and ghettos of our northern cities, knowing that somehow this situation can and will be changed. Let us not wallow in the valley of despair.

I say to you today, my friends, that in spite of the difficulties and frustrations of the moment I still have a dream. It is a dream deeply rooted in the American dream.

I have a dream that one day this nation will rise up and live out the true meaning of its creed: "We hold these truths to be self-evident; that all men are created equal."

I have a dream that one day on the red hills of Georgia the sons of former slaves and the sons of former slaveowners will be able to sit down together at the table of brotherhood.

I have a dream that one day even the state of Mississippi, a desert state sweltering with the heat of injustice and oppression, will be transformed into an oasis of freedom and justice.

I have a dream that my four little children will one day live in a nation where they will be not judged by the color of their skin but by the content of their character.

I have a dream today.

I have a dream that one day the state of Alabama, whose governor's lips are presently dripping with the words of interposition and nullification, will be transformed into a situation where little black boys and black girls will be able to join hands with little white boys and white girls and walk together as sisters and brothers.

I have a dream today.

I have a dream that one day every valley shall be exalted, every hill and mountain shall be made low, the rough places will be made plain, and the crooked places will be made straight, and the glory of the Lord shall be revealed, and all flesh shall see it together.

This is our hope. This is the faith with which I return to the South. With this faith we will be able to hew out of the mountain of despair a stone of hope. With this faith we will be able to transform the jangling discords of our nation into a beautiful symphony of brotherhood. With this faith we will be able to work together, to pray together, to struggle together, to go to jail together, to stand up for freedom together, knowing that we will be free one day.

This will be the day when all of God's children will be able to sing with new meaning

My country, 'tis of thee,
Sweet land of liberty,
 Of thee I sing;
Land where my fathers died,
Land of the pilgrims' pride,
From every mountain-side
 Let freedom ring.

And if America is to be a great nation this must become true. So let freedom ring from the prodigious hilltops of New Hampshire. Let freedom ring from the mighty mountains of New York. Let freedom ring from the heightening Alleghenies of Pennsylvania!

Let freedom ring from the snowcapped Rockies of Colorado!

Let freedom ring from the curvacious peaks of California!

But not only that; let freedom ring from Stone Mountain of Georgia!

Let freedom ring from Lookout Mountain of Tennessee!

Let freedom ring from every hill and molehill of Mississippi. From every mountainside, let freedom ring.

When we let freedom ring, when we let it ring from every village and every hamlet, from every state and every city, we will be able to speed up that day when all of God's children, black men and white men, Jews and Gentiles, Protestants and Catholics, will be able to join hands and sing in the words of the old Negro spiritual, "Free at last! free at last! thank God almighty, we are free at last!"

28 MALCOLM X

FROM "The Ballot or the Bullet" (1965)

I'm not a politician, not even a student of politics; in fact, I'm not a student of much of anything. I'm not a Democrat, I'm not a Republican, and I don't even consider myself an American. If you and I were Americans, there'd be no problem. Those Hunkies that just got off the boat, they're already Americans; Polacks are already Americans; the Italian refugees are already Americans. Everything that came out of Europe, every blue-eyed thing, is already an American. And as long as you and I have been over here, we aren't Americans yet.

Well, I am one who doesn't believe in deluding myself. I'm not going to sit at your table and watch you eat, with nothing on my plate, and call me a diner. Sitting at the table doesn't make you a diner, unless you eat some of what's on that plate. Being here in America doesn't make you an American. Why, if birth made you American, you wouldn't need any legislation, you wouldn't need any amendments to the Constitution, you wouldn't be faced with civil-rights filibustering in Washington, D.C.,

right now. They don't have to pass civil-rights legislation to make a Polack an American.

No, I'm not an American. I'm one of the 22 million black people who are victims of Americanism. One of the 22 million black people who are the victims of democracy, nothing but disguised hypocrisy. So, I'm not standing here speaking to you as an American, or a patriot, or a flag-saluter, or a flag-waver – no, not I. I'm speaking as a victim of this American system. And I see America through the eye of the victim. I don't see any American dream; I see an American nightmare. . . .

The political philosophy of black nationalism means that the black man should control the politics and the politicians in his own community; no more. The black man in the black community has to be re-educated into the science of politics so he will know what politics is supposed to bring him in return. Don't be throwing out any ballots. A ballot is like a bullet. You don't throw your ballots until you see a target, and if that target is not within your reach, keep your ballot in your pocket. . . .

The economic philosophy of black nationalism is pure and simple. It only means that we should control the economy of our community. Why should white people be running all the stores in our community? Why should white people be running the banks of our community? Why should the economy of our community be in the hands of the white man? Why? If a black man can't move his store into a white community, you tell me why a white man should move his store into a black community. The philosophy of black nationalism involves a re-education program in the black community in regards to economics. Our people have to be made to see that any time you take your dollar out of your community and spend it in a community where you don't live, the community where you live will get poorer and poorer, and the community where you spend your money will get richer and richer. Then you wonder why where you live is always a ghetto or a slum area.

29 MALCOLM X

"The Black Man" (1965)

I felt a challenge to plan, and build, an organization that could help to cure the black man in North America of the sickness which has kept him under the white man's heel.

The black man in North America was mentally sick in his cooperative, sheeplike acceptance of the white man's culture.

The black man in North America was spiritually sick because for centuries he had accepted the white man's Christianity – which asked the black so-called Christian to expect no true Brotherhood of Man, but

to endure the cruelties of the white so-called Christians. Christianity had made black men fuzzy, nebulous, confused in their thinking. It had taught the black man to think if he had no shoes, and was hungry, "we gonna get shoes and milk and honey and fish fries in Heaven."

The black man in North America was economically sick and that was evident in one simple fact: as a consumer, he got less than his share, and as a producer gave *least*. The black American today shows us the perfect parasite image – the black tick under the delusion that he is progressing because he rides on the udder of the fat, three-stomached cow that is white America. For instance, annually, the black man spends over $3 billion for automobiles, but America contains hardly any franchised black automobile dealers. For instance, forty per cent of the expensive imported Scotch whisky consumed in America goes down the throats of the status-sick black man; but the only black-owned distilleries are in bathtubs, or in the woods somewhere. Or for instance – a scandalous shame – in New York City, with over a million Negroes, there aren't twenty black-owned businesses employing over ten people. It's because black men don't own and control their own community's retail establishments that they can't stabilize their own community.

The black man in North America was sickest of all politically. He let the white man divide him into such foolishness as considering himself a black 'Democrat', a black 'Republican', a black 'Conservative', or a black 'Liberal' . . . when a ten-million black vote bloc could be the deciding balance of power in American politics, because the white man's vote is almost always evenly divided. The polls are one place where every black man could fight the black man's cause with dignity, and with the power and the tools that the white man understands, and respects, and fears, and cooperates with. Listen, let me tell you something! If a black bloc committee told Washington's worst "nigger-hater", "We represent ten million votes," why, that "nigger-hater" would leap up: "Well, how *are* you? Come on *in* here! " Why, if the Mississippi black man voted in a bloc, Eastland would pretend to be more liberal than Jacob Javits – or Eastland would not survive in his office. Why else is it that racist politicians fight to keep black men from the polls?

Whenever any group can vote in a bloc, and decide the outcome of elections, and it *fails* to do this, then that group is politically sick. Immigrants once made Tammany Hall the most powerful single force in American politics. In 1880, New York City's first Irish Catholic Mayor was elected and by 1960 America had its first Irish Catholic President. America's black man, voting as a bloc, could wield an even more powerful force.

US politics is ruled by special-interest blocs and lobbies. What group has a more urgent special interest, what group needs a bloc, a lobby, more than the black man? Labor owns one of Washington's largest non-

government buildings – situated where they can literally watch the White House – and no political move is made that doesn't involve how Labor feels about it. A lobby got Big Oil its depletion allowance. The farmer, through his lobby, is the most government-subsidized special-interest group in America today, because a million farmers vote, not as Democrats, or Republicans, liberals, conservatives, but as farmers.

Doctors have the best lobby in Washington. Their special-interest influence successfully fights the Medicare program that's wanted, and needed, by millions of other people. Why, there's a Beet Growers' Lobby! A Wheat Lobby! A Cattle Lobby! A China Lobby! Little countries no one ever heard of have their Washington lobbies, representing their special interests.

The government has departments to deal with the special-interest groups that make themselves heard and felt. A Department of Agriculture cares for the farmers' needs. There is a Department of the Interior – in which the Indians are included. Is the farmer, the doctor, the Indian, the greatest problem in America today? No – it is the black man! There ought to be a Pentagon-sized Washington department dealing with every segment of the black man's problems.

Twenty-two million black men! They have given America four hundred years of toil; they have bled and died in every battle since the Revolution; they were in America before the Pilgrims, and long before the mass immigrations – and they are still today at the bottom of everything!

Why, twenty-two million black people should tomorrow give a dollar apiece to build a skyscraper lobby building in Washington, D.C. Every morning, every legislator should receive a communication about what the black man in America expects and wants and needs. The demanding voice of the black lobby should be in the ears of every legislator who votes on any issue.

The cornerstones of this country's operation are economic and political strength and power. The black man doesn't have the economic strength – and it will take time for him to build it. But right now the American black man has the political strength and power to change his destiny overnight.

30 US CONGRESS

The Civil Rights Act of 1964

Title I – Voting Rights

SEC. 101 (2). No person acting under color of law shall –

(A) in determining whether any individual is qualified under State law or laws to vote in any Federal election, apply any standard, practice, or procedure different from the standards, practices, or procedures applied

under such law or laws to other individuals within the same county, parish, or similar political subdivision who have been found by State officials to be qualified to vote; . . .

(C) employ any literacy test as a qualification for voting in any Federal election unless (i) such test is administered to each individual wholly in writing; (ii) a certified copy of the test and of the answers given by the individual is furnished to him within twenty-five days of the submission of his request made within the period of time during which records and papers are required to be retained and preserved pursuant to title III of the Civil Rights Act of 1960 . . .

Title II – Injunctive Relief against Discrimination in Places of Public Accommodation

SEC. 201. (a) All persons shall be entitled to the full and equal enjoyment of the goods, services, facilities, privileges, advantages, and accommodations of any place of public accommodation, as defined in this section, without discrimination or segregation on the ground of race, color, religion, or national origin.

(b) Each of the following establishments which serves the public is a place of public accommodation within the meaning of this title if its operations affect commerce, or if discrimination or segregation by it is supported by State action:

(1) any inn, motel, or other establishment which provides lodging to transient guests, other than an establishment located within a building which contains not more than five rooms for rent or hire and which is actually occupied by the proprietor of such establishment as his residence;

(2) any restaurant, cafeteria, lunch room, lunch counter, soda fountain, or other facility principally engaged in selling food for consumption on the premises . . .

(3) any motion picture house, theater, concert hall, sports arena, stadium or other place of exhibition or entertainment . . .

(d) Discrimination or segregation by an establishment is supported by State action within the meaning of this title if such discrimination or segregation (1) is carried on under color of any law, statute, ordinance, or regulation; or (2) is carried on under color of any custom or usage required or enforced by officials of the State or political subdivision thereof . . .

SEC. 202. All persons shall be entitled to be free, at any establishment or place, from discrimination or segregation of any kind on the ground of race, color, religion, or national origin, if such discrimination or segregation is or purports to be required by any law, statute, ordinance, regulation, rule, or order of a State or any agency or political subdivision thereof . . .

SEC. 206. (a) Whenever the Attorney General has reasonable cause to believe that any person or groups of persons is engaged in a pattern or practice of resistance to the full enjoyment of any of the rights secured by this title, the Attorney General may bring a civil action in the appropriate district court of the United States by filing with it a complaint . . . requesting such preventive relief, including an application for a permanent or temporary injunction, restraining order or other order against the person or persons responsible for such pattern or practice, as he deems necessary to insure the full enjoyment of the rights herein described.

Title VI – Nondiscrimination in Federally Assisted Programs

SEC. 601. No person in the United States shall, on the ground of race, color, or national origin, be excluded from participation in, be denied the benefits of, or be subjected to discrimination under any program or activity receiving Federal financial assistance.

31 SEPTIMA CLARK

"Teach How Change Comes About" (pre-1987)

In one of the strangest turnabouts to occur after the turbulent sixties, Septima Clark – once fired as a public school teacher in Charleston, South Carolina – ultimately became a member of that city's school board. As the discriminated-against employee turned employer, she acquired the power once denied every black person in the South.

But in this new position, was she able to assure that the school system's classrooms also taught students about people like Dr Martin Luther King, Jr., Rosa Parks, or herself? Or were policy decisions in a public system like Charleston's more difficult to alter than when she worked within the private organizations of Highlander and the Southern Christian Leadership Conference on behalf of the Citizenship Schools?

We still have a long way to go, and I really feel determined that we've got to do a better job. We do some things, though. On 15 January, we celebrate Dr King's birthday, and I went around to school every day last January for one whole week talking about King. Then in February, it was Afro-American Month, and I went to a number of schools talking about the various blacks like Sojourner Truth. In one of the schools, they even sort of talked about me at that time. They know who I am. But we need to do more of that. And I'm not only asking them to do just that. Whenever they speak about a black in America, I think they need to find a white who does somewhat similar. The problem is it's usually all white, even now. Just recently a booklet about American government was passed around in a school board meeting so we could see if we wanted

93

to use it in the schools, and you know there wasn't one black in that book? Not one black. I wanted to know who the black children would have to look up to in that book. I felt it was wrong to place that book in the hands of teachers. There was nothing in there that would help black children to feel that they had a right to the tree of life. And I know how important that is. I didn't feel as if I could ever do anything worthwhile when I was living in North Carolina until Mary McLeod Bethune came down and spoke. And there she was, a real black woman sitting in Roosevelt's ["kitchen"] cabinet, and she said, "I'm just a fly in that bowl of milk, but I'm certainly there." And that gave me a great feeling, that a black woman could be sitting in Roosevelt's cabinet. And I think this is what it would do for our children too. They need to know about such people.

They also need to know how change comes about. You have to develop them to do their own thinking and not accept unjust things but break through those things and change them. I once felt I had to accept things as they were. I rode on the bus and I sat in the section of the bus where black people were supposed to sit and I would get up and give my seat to any white man because I knew it was the law, and I did it without feeling angry. Not until I got to Highlander [*laughter*] did I learn that I should defy laws like that that are unjust.

[But today, teachers say, "If I start talking to my kids about things they ought to change, I'm going to get fired."] And we got that case right now. There is a young woman who has been talking to her children about standing up for their rights, and her name is on the list to be terminated. I don't want to miss that meeting Monday, because I'm going to vote on her to stay in that school. And the only reason they want to fire her is because she will speak out. And she has been an excellent teacher. They're going to try to fire her, but I'm going to fight them.

[I tell teachers and students,] "Stand up for your rights, regardless." You have to stand up and take the consequences. It's not going to be easy. It's not going to be pleasant. After I was fired, I went to Highlander, and for three long months I couldn't sleep. Then at the end of that time, it seemed to me as if my mind cleared up and I decided then that I must have been right. I really didn't find out for sure that I *was* right until Governor Edwards, in 1976, said, "You were unjustly fired," and sent me a check for the pension I was owed. And that made me realize that I was right all the time. But I had to wait until I was eighty years of age to find out. I went all those years knowing that the people thought I was wrong – even my own people. My brother said to me, "Why did you tell them that you were a member of the NAACP?"

I said, "I couldn't live with myself otherwise." So you have to be strong. You have to tell the truth and take the consequences. And it's not going to be easy. It's not going to be pleasant.

[Say you were one of those teachers, for example, and you said to me, "Septima, I can't talk to my white kids in class about the KKK because these kids love their parents and the parents are members of the KKK. Now I know the organization is wrong, but I'm afraid I'll hurt those kids."] I would have to tell you that regardless of what happens, you are going to have to let those kids know the very truth about the KKK, because when you see the kinds of things that they have done, you will know that those things are not right. They might burn your house down. I couldn't tell you that they won't. I have had a lot of things happen to me and I had to live through it. I've had policemen sent to my door looking for the fight. Just harassment. I've had firemen sent to my door looking for the fire. Pure harassment. I've had people call and curse me over the telephone, and I would just say, "Thank you, call again." I'd put the phone down and here would come another call. There were nights when I couldn't sleep for that kind of thing. People were even afraid of me. Thought I was a Communist.

But now that's changed. I have honorary degrees. The housing authority has named a day care center for me. A highway has been named for me. I've been on television. Not long ago I was interviewed five times in one day. I've even had visitors from Spain. So you live through the bad times. You have to have faith.

[Today] you don't have those unjust laws that we had to work on, but when [young people] look long enough, they'll see that it's more subtle things that they have to work on. I say to them, "You have to look at your administrative groups and see if any of you are sitting there helping to make the laws. What about your legislature? What about your city council? What about your county delegation? Do you see any blacks sitting there? What about your school board? Do you see any blacks? I'm the only black on our school board, and when I get off next year I wonder if there will be another one who will come on. What about stores and banks? You can find black clerks and cashiers, but what about the administrative groups? Can you find any there? What about the pollution off our coast? Do you know this is where you get your food to eat, and now this source is going to be denied you if you don't grow up and vote against things like that? And what about the inadequate health screening for our first graders? What about aides for the handicapped children? We need to have special money for handicapped kids and it's coming out in the papers every day. People are voting against those things. We need to have physical education, art, and music in first grade, and Reagan wants to cut these out. Now we've got to stand up in arms against those cuts. Don't sit down and accept them. Instead of accepting them, stand up and vote against them.

And if they get discouraged, I tell them that there were times when I

felt discouraged, too, but I felt I had to go on. I could not do anything by quitting. A quitter receives nothing.

But they are going to do more. Right now I have a feeling that now that we have been able to open doors for them, they should go through those doors and get all the education that they can and then come up and be the administrators. I know I'm not going to live to see a black President, but I do hope in times to come there will be one.

[So political action and education are still the keys to a better future.] I really felt that the great turning point for us was the Voting Rights bill in August of '65. That had a great effect on the American people. That opened the doors for us for both political action and education. They both go together. I'll always remember when one of the fellows we were teaching in Anamanee, Alabama, went up to the bank in Camden to cash a check, and the white man took out his pen and said, "I'll make the X."

He said, "You don't have to make the X for me because I can write my own name."

The white guy says, "My God, them niggers done learned to write."

4

WOMEN IN THE UNITED STATES

Introduction 98

32 Alexis de Tocqueville
"The Young Woman in the Character of a Wife" (1848) 100

33 Thomas R. Dew
FROM "Differences between the Sexes" (1835) 102

34 Seneca Falls Convention
Declaration of Sentiments and Resolutions (1848) 103

35 Kate Chopin
"The Story of an Hour" (1894) 105

36 Charlotte Perkins Gilman
FROM *Women and Economics* (1966) 107

37 Meridel LeSueur
"Women on the Breadlines" (1932) 109

38 Betty Friedan
"That Has No Name" (1963) 115

39 Adrienne Rich
"Think through the Body" (1976) 120

40 Studs Terkel
"Just a Housewife: Therese Carter" (1972) 122

41 Merle Woo
FROM "Letter to Ma" (1980) 126

42 National NOW Times (Editorial)
"Abortion Is Not Immoral" (1989) 129

43 Barbara Newman
FROM "Postmodern Patriarchy Loves Abortion" (1993) 131

INTRODUCTION

Since World War II an increasing number of women in the US have gone to college and have taken jobs outside the home. A new awareness of themselves as workers as well as mothers inspired the upsurge of a women's liberation movement in the 1960s. Since then members of various women's organizations have revealed how women are discriminated against in all walks of life. The present women's movement has looked for ideas and inspiration in the works of earlier women reformers in America, but above all it has used the Civil Rights Act of 1964 to ensure that equal opportunity for jobs is provided for them, and that they are not given lesser pay than males for the same work.

Alexis de Tocqueville's observation of the social status of young women in the US during the 1830s is still a good starting point for a discussion of women's role in the history of American culture. Some would even argue for the lasting validity of his statement that whereas "an unmarried woman is less constrained there than elsewhere," a married woman on the other hand "is subjected to stricter obligations." About the same time Thomas R. Dew, a southern educator, underlined the qualities of "grace, modesty and loveliness" as peculiar to women. His argument that women ideally represented something untainted and "passive" was undoubtedly based on admiration, but it was exactly the kind of language and tone which the early feminist movement reacted so strongly against.

When women were given the right to vote in federal elections by the Nineteenth Amendment in 1919, suffrage had long been an issue. The declarations from the Seneca Falls Convention of 1948, modeled on the Declaration of Independence, mark the beginning of the woman-suffrage movement in the US.

In novels and short stories around the turn of the century Charlotte Perkins Gilman and Kate Chopin among others started to explore new definitions of women's freedom. Gilman also wrote essays on the issue and is perhaps best known for her studies of women's economic dependence. Both of these writers were almost forgotten or ignored in their own lifetime, but are widely studied today. Meridel LeSueur, a midwestern writer born in 1900, has also found a new audience today. Her essay is a strong comment on the conditions in the 1930s in an American city from a woman's point of view.

Betty Friedan's book *The Feminine Mystique* (see extract 38) was one of the major documents which set the new women's movement going. Friedan focused on the life of middle-class suburban housewives. She argued that women should stop playing a passive role or just helping their husbands build careers. Her account of what to her appeared as the rather depressing and tedious routines of a typical surburban housewife

did, however, run counter to the way in which many housewives saw, and may still see, their own situation. In Studs Terkel's interview we meet a housewife in a blue-collar community outside Chicago, who reads *Ms.* magazine, but who nevertheless thinks "Woman's Lib puts down a housewife."

The image of women in music, film and the popular arts has changed over the years. The ever-popular American cowboy movies, for example, usually portrayed women, if they portrayed them at all, as romantic appendages in essentially male adventure or certainly in need of the protection of a strong male hero. In popular stories about urban women they were equally depicted as secretaries or wives at the service of some male. In general, popular American culture saw the woman primarily as the romantic lover or diligent wife who had little life of her own except as it was connected to a more "meaningful" male existence. Since the 1970s, however, American film producers have shown women playing active roles in the workforce and in their relationship with men. There is, nevertheless, a sharp contrast between such women role models and the more common images of young women used in the American advertising business. Duane Hanson, a modern American sculptor, has made a lifelike and unforgettable portrait of a female shopper in a supermarket, a consumer figure far from the ideals of womanhood elsewhere in the media (see figure 4.2).

Women writers of the past have been rediscovered and republished, to provide both an alternative sense of literary history and genuine inspiration for a new generation of readers and writers. Several female authors have gone on to deal not only with the social and economic inequality experienced by women, but with intimate emotional relations. A contemporary poet, Adrienne Rich, is especially concerned with possible new ways of expressing the full scope of female experience. Like other American writers she wants to reexamine common attitudes that women have had toward themselves, toward men, and toward their children. The letter of Merle Woo, a Korean-American writer, to her mother may be studied as an illustration of contemporary cultural values in a mother–daughter relationship.

Since the 1973 Supreme Court ruling in *Roe* v. *Wade*, women's right to abortion has been one of the most controversial issues in contemporary American life and politics. The last two extracts in this chapter – by *NOW* and by Barbara Newman – represent, respectively, a pro-abortion and an anti-abortion position.

32 ALEXIS DE TOCQUEVILLE

"The Young Woman in the Character of a Wife" (1848)

In America the independence of woman is irrecoverably lost in the bonds of matrimony. If an unmarried woman is less constrained there than elsewhere, a wife is subjected to stricter obligations. The former makes her father's house an abode of freedom and of pleasure; the latter lives in the home of her husband as if it were a cloister. Yet these two different conditions of life are perhaps not so contrary as may be supposed, and it is natural that the American women should pass through the one to arrive at the other.

Religious communities and trading nations entertain peculiarly serious notions of marriage: the former consider the regularity of woman's life as the best pledge and most certain sign of the purity of her morals; the latter regard it as the highest security for the order and prosperity of the household. The Americans are at the same time a puritanical people and a commercial nation; their religious opinions as well as their trading habits consequently lead them to require much abnegation on the part of woman and a constant sacrifice of her pleasures to her duties, which is seldom demanded of her in Europe. Thus in the United States the inexorable opinion of the public carefully circumscribes woman within the narrow circle of domestic interests and duties and forbids her to step beyond it.

Upon her entrance into the world a young American woman finds these notions firmly established; she sees the rules that are derived from them; she is not slow to perceive that she cannot depart for an instant from the established usages of her contemporaries without putting in jeopardy her peace of mind, her honor, nay, even her social existence; and she finds the energy required for such an act of submission in the firmness of her understanding and in the virile habits which her education has given her. It may be said that she has learned by the use of her independence to surrender it without a struggle and without a murmur when the time comes for making the sacrifice.

But no American woman falls into the toils of matrimony as into a snare held out to her simplicity and ignorance. She has been taught beforehand what is expected of her and voluntarily and freely enters upon this engagement. She supports her new condition with courage because she chose it. As in America paternal discipline is very relaxed and the conjugal tie very strict, a young woman does not contract the latter without considerable circumspection and apprehension. Precocious marriages are rare. American women do not marry until their understandings are exercised and ripened, whereas in other countries

most women generally begin to exercise and ripen their understandings only after marriage.

I by no means suppose, however, that the great change which takes place in all the habits of women in the United States as soon as they are married ought solely to be attributed to the constraint of public opinion; it is frequently imposed upon themselves by the sole effort of their own will. When the time for choosing a husband arrives, that cold and stern reasoning power which has been educated and invigorated by the free observations of the world teaches an American woman that a spirit of levity and independence in the bonds of marriage is a constant subject of annoyance, not of pleasure; it tells her that the amusements of the girl cannot become the recreations of the wife, and that the sources of a married woman's happiness are in the home of her husband. As she clearly discerns beforehand the only road that can lead to domestic happiness, she enters upon it at once and follows it to the end without seeking to turn back.

The same strength of purpose which the young wives of America display in bending themselves at once and without repining to the austere duties of their new condition is no less manifest in all the great trials of their lives. In no country in the world are private fortunes more precarious than in the United States. It is not uncommon for the same man in the course of his life to rise and sink again through all the grades that lead from opulence to poverty. American women support these vicissitudes with calm and unquenchable energy; it would seem that their desires contract as easily as they expand with their fortunes.

The greater part of the adventurers who migrate every year to people the Western wilds belong, as I observed in the former part of this work, to the old Anglo-American race of the Northern states. Many of these men, who rush so boldly onwards in pursuit of wealth, were already in the enjoyment of a competency in their own part of the country. They take their wives along with them and make them share the countless perils and privations that always attend the commencement of these expeditions. I have often met, even on the verge of the wilderness, with young women who, after having been brought up amid all the comforts of the large towns of New England, had passed, almost without any intermediate stage, from the wealthy abode of their parents to a comfortless hovel in a forest. Fever, solitude, and a tedious life had not broken the springs of their courage. Their features were impaired and faded, but their looks were firm; they appeared to be at once sad and resolute. I do not doubt that these young American women had amassed, in the education of their early years, that inward strength which they displayed under these circumstances. The early culture of the girl may still, therefore, be traced, in the United States, under the aspect of

marriage; her part is changed, her habits are different, but her character is the same.

33 THOMAS R. DEW

FROM "Differences between the Sexes" (1835)

The relative position of the sexes in the social and political world, may certainly be looked upon as the result of organization. The greater physical strength of man, enables him to occupy the foreground in the picture. He leaves the domestic scenes; he plunges into the turmoil and bustle of an active, selfish world; in his journey through life, he has to encounter innumerable difficulties, hardships and labors which constantly beset him. His mind must be nerved against them. Hence courage and boldness are his attributes. It is his province, undismayed, to stand against the rude shocks of the world; to meet with a lion's heart, the dangers which threaten him. He is the shield of woman, destined by nature to guard and protect her. Her inferior strength and sedentary habits confine her within the domestic circle; she is kept aloof from the bustle and storm of active life; she is not familiarized to the out of door dangers and hardships of a cold and scuffling world: timidity and modesty are her attributes. In the great strife which is constantly going forward around her, there are powers engaged which her inferior physical strength prevents her from encountering. She must rely upon the strength of others; man must be engaged in her cause. How is he to be drawn over to her side? Not by menace – not by force; for weakness cannot, by such means, be expected to triumph over might. No! It must be by conformity to that character which circumstances demand for the sphere in which she moves; by the exhibition of those qualities which delight and fascinate – which are calculated to win over to her side the proud lord of creation, and to make him an humble suppliant at her shrine. Grace, modesty and loveliness are the charms which constitute her power. By these, she creates the magic spell that subdues to her will the more mighty physical powers by which she is surrounded. Her attributes are rather of a passive than active character. Her power is more emblematical of that of divinity: it subdues without an effort, and almost creates by mere volition; whilst man must wind his way through the difficult and intricate mazes of philosophy; with pain and toil, tracing effects to their causes, and unraveling the deep mysteries of nature – storing his mind with useful knowledge, and exercising, training and perfecting his intellectual powers, whilst he cultivates his strength and hardens and matures his courage; all with a view of enabling him to assert his rights, and exercise a greater sway over those around him. Woman we behold dependant [sic] and weak; but out of that very

weakness and dependance [sic] springs an irresistible power. She may pursue her studies too – not however with a view of triumphing in the senate chamber – not with a view to forensic display – not with a view of leading armies to combat, or of enabling her to bring into more formidable action the physical power which nature has conferred on her. No! It is but the better to perfect all those feminine graces, all those fascinating attributes, which render her the centre of attraction, and which delight and charm all who breathe the atmosphere in which she moves.

34 SENECA FALLS CONVENTION

Declaration of Sentiments and Resolutions (1848)

When, in the course of human events, it becomes necessary for one portion of the family of man to assume among the people of the earth a position different from that which they have hitherto occupied, but one to which the laws of nature and of nature's God entitle them, a decent respect to the opinions of mankind requires that they should declare the causes that impel them to such a course.

We hold these truths to be self-evident: that all men and women are created equal; that they are endowed by their Creator with certain inalienable rights; that among these are life, liberty, and the pursuit of happiness; that to secure these rights governments are instituted, deriving their just powers from the consent of the governed. Whenever any form of government becomes destructive of these ends, it is the right of those who suffer from it to refuse allegiance to it, and to insist upon the institution of a new government, laying its foundation on such principles, and organizing its powers in such form, as to them shall seem most likely to effect their safety and happiness. Prudence, indeed, will dictate that governments long established should not be changed for light and transient causes; and accordingly all experience hath shown that mankind are more disposed to suffer, while evils are sufferable, than to right themselves by abolishing the forms to which they were accustomed. But when a long train of abuses and usurpations, pursuing invariably the same object, evinces a design to reduce them under absolute despotism, it is their duty to throw off such government, and to provide new guards for their future security. Such has been the patient sufferance of the women under this government, and such is now the necessity which constrains them to demand the equal station to which they are entitled.

The history of mankind is a history of repeated injuries and usurpations on the part of man toward woman, having in direct object the establishment of an absolute tyranny over her. To prove this, let facts be submitted to a candid world.

He has never permitted her to exercise her inalienable right to the elective franchise.

He has compelled her to submit to laws, in the formation of which she had no voice.

He has withheld from her rights which are given to the most ignorant and degraded men – both natives and foreigners.

Having deprived her of this first right of a citizen, the elective franchise, thereby leaving her without representation in the halls of legislation, he has oppressed her on all sides.

He has made her, if married, in the eye of the law, civilly dead.

He has taken from her all right in property, even to the wages she earns.

He has made her, morally, an irresponsible being, as she can commit many crimes with impunity, provided they be done in the presence of her husband. In the covenant of marriage, she is compelled to promise obedience to her husband, he becoming, to all intents and purposes, her master – the law giving him power to deprive her of her liberty, and to administer chastisement.

He has so framed the laws of divorce, as to what shall be the proper causes, and in case of separation, to whom the guardianship of the children shall be given, as to be wholly regardless of the happiness of women – the law, in all cases, going upon the false supposition of the supremacy of man, and giving all power into his hands.

After depriving her of all rights as a married woman, if single, and the owner of property, he has taxed her to support a government which recognizes her only when her property can be made profitable to it.

He has monopolized nearly all the profitable employments, and from those she is permitted to follow, she receives but a scanty remuneration. He closes against her all the avenues to wealth and distinction which he considers most honorable to himself. As a teacher of theology, medicine, or law, she is not known.

He has denied her the facilities for obtaining a thorough education, all colleges being closed against her.

He allows her in Church, as well as State, but a subordinate position, claiming Apostolic authority for her exclusion from the ministry, and, with some exceptions, from any public participation in the affairs of the Church.

He has created a false public sentiment by giving to the world a different code of morals for men and women, by which moral delinquencies which exclude women from society, are not only tolerated, but deemed of little account in man.

He has usurped the prerogative of Jehovah himself, claiming it as his right to assign for her a sphere of action, when that belongs to her conscience and to her God.

He has endeavored, in every way that he could, to destroy her confidence in her own powers, to lessen her self-respect, and to make her willing to lead a dependent and abject life.

Now, in view of this entire disfranchisement of one-half the people of this country, their social and religious degradation – in view of the unjust laws above mentioned, and because women do feel themselves aggrieved, oppressed, and fraudulently deprived of their most sacred rights, we insist that they have immediate admission to all the rights and privileges which belong to them as citizens of the United States.

In entering upon the great work before us, we anticipate no small amount of misconception, misrepresentation, and ridicule; but we shall use every instrumentality within our power to effect our object. We shall employ agents, circulate tracts, petition the State and National legislatures, and endeavor to enlist the pulpit and the press in our behalf. We hope this Convention will be followed by a series of Conventions embracing every part of the country.

35 KATE CHOPIN

"The Story of an Hour" (1894)

Knowing that Mrs. Mallard was afflicted with a heart trouble, great care was taken to break to her as gently as possible the news of her husband's death.

It was her sister Josephine who told her, in broken sentences, veiled hints that revealed in half concealing. Her husband's friend Richards was there, too, near her. It was he who had been in the newspaper office when intelligence of the railroad disaster was received, with Brently Mallard's name leading the list of "killed." He had only taken the time to assure himself of its truth by a second telegram, and had hastened to forestall any less careful, less tender friend in bearing the sad message.

She did not hear the story as many women have heard the same, with a paralyzed inability to accept its significance. She wept at once, with sudden, wild abandonment, in her sister's arms. When the storm of grief had spent itself she went away to her room alone. She would have no one follow her.

There stood, facing the open window, a comfortable, roomy armchair. Into this she sank, pressed down by a physical exhaustion that haunted her body and seemed to reach into her soul.

She could see in the open square before her house the tops of trees that were all aquiver with the new spring life. The delicious breath of rain was in the air. In the street below a peddler was crying his wares.

The notes of a distant song which some one was singing reached her faintly, and countless sparrows were twittering in the eaves.

There were patches of blue sky showing here and there through the clouds that had met and piled above the other in the west facing her window.

She sat with her head thrown back upon the cushion of the chair quite motionless, except when a sob came up into her throat and shook her, as a child who has cried itself to sleep continues to sob in its dreams.

She was young, with a fair, calm face, whose lines bespoke repression and even a certain strength. But now there was a dull stare in her eyes, whose gaze was fixed away off yonder on one of those patches of blue sky. It was not a glance of reflection, but rather indicated a suspension of intelligent thought.

There was something coming to her and she was waiting for it, fearfully. What was it? She did not know; it was too subtle and elusive to name. But she felt it, creeping out of the sky, reaching toward her through the sounds, the scents, the color that filled the air.

Now her bosom rose and fell tumultuously. She was beginning to recognize this thing that was approaching to possess her, and she was striving to beat it back with her will – as powerless as her two white slender hands would have been.

When she abandoned herself a little whispered word escaped her slightly parted lips. She said it over and over under her breath: "Free, free, free!" The vacant stare and the look of terror that had followed it went from her eyes. They stayed keen and bright. Her pulses beat fast, and the coursing blood warmed and relaxed every inch of her body.

She did not stop to ask if it were not a monstrous joy that held her. A clear and exalted perception enabled her to dismiss the suggestion as trivial.

She knew that she would weep again when she saw the kind, tender hands folded in death; the face that had never looked save with love upon her, fixed and gray and dead. But she saw beyond that bitter moment a long procession of years to come that would belong to her absolutely. And she opened and spread her arms out to them in welcome.

There would be no one to live for during those coming years; she would live for herself. There would be no powerful will bending her in that blind persistence with which men and women believe they have a right to impose a private will upon a fellow-creature. A kind intention or a cruel intention made the act seem no less a crime as she looked upon it in that brief moment of illumination.

And yet she had loved him – sometimes. Often she had not. What did it matter! What could love, the unsolved mystery, count for in face of this possession of self-assertion which she suddenly recognized as the strongest impulse of her being!

"Free! Body and soul free!" she kept whispering.

Josephine was kneeling before the closed door with her lips to the keyhole, imploring for admission. "Louise, open the door! I beg; open the door – you will make yourself ill. What are you doing, Louise? For heaven's sake open the door."

"Go away. I am not making myself ill." No; she was drinking in a very elixir of life through that open window.

Her fancy was running riot along those days ahead of her. Spring days, and summer days, and all sorts of days that would be her own. She breathed a quick prayer that life might be long. It was only yesterday she had thought with a shudder that life might be long.

She arose at length and opened the door to her sister's importunities. There was a feverish triumph in her eyes, and she carried herself unwittingly like a goddess of Victory. She clasped her sister's waist, and together they descended the stairs. Richards stood waiting for them at the bottom.

Some one was opening the front door with a latchkey. It was Brently Mallard who entered, a little travel-stained, composedly carrying his grip-sack and umbrella. He had been far from the scene of accident, and did not even know there had been one. He stood amazed at Josephine's piercing cry; at Richards' quick motion to screen him from the view of his wife.

But Richards was too late.

When the doctors came they said she had died of heart disease – of joy that kills.

36 CHARLOTTE PERKINS GILMAN

FROM *Women and Economics* (1966)

As the private home becomes a private home indeed, and no longer the woman's social and industrial horizon; as the workshops of the world – woman's sphere as well as man's – become homelike and beautiful under her influence; and as men and women move freely together in the exercise of common racial functions, – we shall have new channels for the flow of human life.

We shall not move from the isolated home to the sordid shop and back again, in a world torn and dissevered by the selfish production of one sex and the selfish consumption of the other; but we shall live in a world of men and women humanly related, as well as sexually related, working together, as they were meant to do, for the common good of all. The home will be no longer an economic entity, with its cumbrous industrial machinery huddled vulgarly behind it, but a peaceful and permanent expression of personal life as withdrawn from social contact; and that

social contact will be provided for by the many common meeting places necessitated by the organization of domestic industries.

The assembling-room is as deep a need of human life as the retiring room, – not some ball-room or theatre, to which one must be invited of set purpose, but great common libraries and parlors, baths and gymnasia, work-rooms and play-rooms, to which both sexes have the same access for the same needs, and where they may mingle freely in common human expression. The kind of buildings essential to the carrying out of the organization of home industry will provide such places. There will be the separate rooms for individuals and the separate houses for families; but there will be, also, the common rooms for all. These must include a place for the children, planned and built for the happy occupancy of many children for many years, – a home such as no children have ever had. This, as well as rooms everywhere for young people and old people, in which they can be together as naturally as they can be alone, without effort, question, or remark.

Such an environment would allow of free association among us, on lines of common interest; and, in its natural, easy flow, we should develop far higher qualities than are brought out by the uneasy struggles of our present "society" to see each other without wanting to. It would make an enormous difference to woman's power of choosing the right man. Cut off from the purchasing power which is now his easiest way to compass his desires, freely seen and known in his daily work and amusements, a woman could know and judge a man as she is wholly unable to do now. Her personality developed by a free and useful life, but a personality as well as a woman, – the girl trained to economic independence, and associating freely with young men in their common work and play, would learn a new estimate of what constitutes noble manhood. . . .

This change is not a thing to prophesy and plead for. It is a change already instituted, and gaining ground among us these many years with marvellous rapidity. Neither men nor women wish the change. Neither men nor women have sought it. But the same great force of social evolution which brought us into the old relation – to our great sorrow and pain – is bringing us out, with equal difficulty and distress. The time has come when it is better for the world that women be economically independent, and therefore they are becoming so.

It is worth while for us to consider the case fully and fairly, that we may see what it is that is happening to us, and welcome with open arms the happiest change in human condition that ever came into the world. To free an entire half of humanity from an artificial position; to release vast natural forces from a strained and clumsy combination, and set them free to work smoothly and easily as they were intended to work; to introduce conditions that will change humanity from within, making for better motherhood and fatherhood, better babyhood and child-

hood, better food, better homes, better society, – this is to work for human improvement along natural lines. It means enormous racial advance, and that with great swiftness; for this change does not wait to create new forces, but sets free those already potentially strong, so that humanity will fly up like a released spring. And it is already happening. All we need do is to understand and help.

37 MERIDEL LeSUEUR

"Women on the Breadlines" (1932)

I am sitting in the city free employment bureau. It's the women's section. We have been sitting here now for four hours. We sit here every day, waiting for a job. There are no jobs. Most of us have had no breakfast. Some have had scant rations for over a year. Hunger makes a human being lapse into a state of lethargy, especially city hunger. It there any place else in the world where a human being is supposed to go hungry amidst plenty without an outcry, without protest, where only the boldest steal or kill for bread, and the timid crawl the streets, hunger like the beak of a terrible bird at the vitals?

We sit looking at the floor. No one dares think of the coming winter. There are only a few more days of summer. Everyone is anxious to get work to lay up something for that long siege of bitter cold. But there is no work. Sitting in the room we all know it. That is why we don't talk much. We look at the floor dreading to see that knowledge in each other's eyes. There is a kind of humiliation in it. We look away from each other. We look at the floor. It's too terrible to see this animal terror in each other's eyes.

So we sit hour after hour, day after day, waiting for a job to come in. There are many women for a single job. A thin sharp woman sits inside a wire cage looking at a book. For four hours we have watched her looking at that book. She has a hard little eye. In the small bare room there are half a dozen women sitting on the benches waiting. Many come and go. Our faces are all familiar to each other, for we wait here every day.

This is a domestic employment bureau. Most of the women who come here are middle-aged, some have families, some have raised their families and are now alone, some have men who are out of work. Hard times and the man leaves to hunt for work. He doesn't find it. He drifts on. The woman probably doesn't hear from him for a long time. She expects it. She isn't surprised. She struggles alone to feed the many mouths. Sometimes she gets help from the charities. If she's clever she can get herself a good living from the charities, if she's naturally a lick spittle, naturally a little docile and cunning. If she's proud then she

starves silently, leaving her children to find work, coming home after a day's searching to wrestle with her house, her children.

Some such story is written on the faces of all these women. There are young girls too, fresh from the country. Some are made brazen too soon by the city. There is a great exodus of girls from the farms into the city now. Thousands of farms have been vacated completely in Minnesota. The girls are trying to get work. The prettier ones can get jobs in the stores when there are any, or waiting on table, but these jobs are only for the attractive and the adroit. The others, the real peasants, have a more difficult time.

Bernice sits next to me. She is a Polish woman of thirty-five. She has been working in people's kitchens for fifteen years or more. She is large, her great body in mounds, her face brightly scrubbed. She has a peasant mind and finds it hard even yet to understand the maze of the city where trickery is worth more than brawn. Her blue eyes are not clever but slow and trusting. She suffers from loneliness and lack of talk. When you speak to her, her face lifts and brightens as if you had spoken through a great darkness, and she talks magically of little things as if the weather were magic, or tells some crazy tale of her adventures on the city streets, embellishing them in bright colors until they hang heavy and thick like embroidery. She loves the city anyhow. It's exciting to her, like a bazaar. She loves to go shopping and get a bargain, hunting out the places where stale bread and cakes can be had for a few cents. She likes walking the streets looking for men to take her to a picture show. Sometimes she goes to five picture shows in one day, or she sits through one the entire day until she knows all the dialog by heart.

She came to the city a young girl from a Wisconsin farm. The first thing that happened to her, a charlatan dentist took out all her good shining teeth and the fifty dollars she had saved working in a canning factory. After that she met men in the park who told her how to look out for herself, corrupting her peasant mind, teaching her to mistrust everyone. Sometimes now she forgets to mistrust everyone and gets taken in. They taught her to get what she could for nothing, to count her change, to go back if she found herself cheated, to demand her rights.

She lives alone in little rooms. She bought seven dollars' worth of second-hand furniture eight years ago. She rents a room for perhaps three dollars a month in an attic, sometimes in a cold house. Once the house where she stayed was condemned and everyone else moved out and she lived there all winter alone on the top floor. She spent only twenty-five dollars all winter.

She wants to get married but she sees what happens to her married friends, left with children to support, worn out before their time. So she stays single. She is virtuous. She is slightly deaf from hanging out clothes

110

in winter. She had done people's washing and cooking for fifteen years and in that time saved thirty dollars. Now she hasn't worked steady for a year and she has spent the thirty dollars. She had dreamed of having a little house or a houseboat perhaps with a spot of ground for a few chickens. This dream she will never realize.

She has lost all her furniture now along with the dream. A married friend whose husband is gone gives her a bed for which she pays by doing a great deal of work for the woman. She comes here every day now sitting bewildered, her pudgy hands folded in her lap. She is hungry. Her great flesh has begun to hang in folds. She has been living on crackers. Sometimes a box of crackers lasts a week. She has a friend who's a baker and he sometimes steals the stale loaves and brings them to her.

A girl we have seen every day all summer went crazy yesterday at the YW. She went into hysterics, stamping her feet and screaming.

She hadn't had work for eight months. "You've got to give me something," she kept saying. The woman in charge flew into a rage that probably came from days and days of suffering on her part, because she is unable to give jobs, having none. She flew into a rage at the girl and there they were facing each other in a rage both helpless, helpless. This woman told me once that she could hardly bear the suffering she saw, hardly hear it, that she couldn't eat sometimes and had nightmares at night.

So they stood there, the two women, in a rage, the girl weeping and the woman shouting at her. In the eight months of unemployment she had gotten ragged, and the woman was shouting that she would not send her out like that. "Why don't you shine your shoes?" she kept scolding the girl, and the girl kept sobbing and sobbing because she was starving.

"We can't recommend you like that," the harassed YWCA woman said, knowing she was starving, unable to do anything. And the girls and the women sat docilely, their eyes on the ground, ashamed to look at each other, ashamed of something.

Sitting here waiting for a job, the women have been talking in low voices about the girl Ellen. They talk in low voices with not too much pity for her, unable to see through the mist of their own torment. "What happened to Ellen?" one of them asks. She knows the answer already. We all know it.

A young girl who went around with Ellen tells about seeing her last evening back of a cafe downtown, outside the kitchen door, kicking, showing her legs so that the cook came out and gave her some food and some men gathered in the alley and threw small coin on the ground for a look at her legs. And the girl says enviously that Ellen had a swell breakfast and treated her to one too, that cost two dollars.

A scrub woman whose hips are bent forward from stooping with hands gnarled like watersoaked branches clicks her tongue in disgust. No one

saves their money, she says, a little money and these foolish young things buy a hat, a dollar for breakfast, a bright scarf. And they do. If you've ever been without money, or food, something very strange happens when you get a bit of money, a kind of madness. You don't care. You can't remember that you had no money before, that the money will be gone. You can remember nothing but that there is the money for which you have been suffering. Now here it is. A lust takes hold of you. You see food in the windows. In imagination you eat hugely; you taste a thousand meals. You look in windows. Colors are brighter; you buy something to dress up in. An excitement takes hold of you. You know it is suicide but you can't help it. You must have food, dainty, splendid food, and a bright hat so once again you feel blithe, rid of that ratty gnawing shame.

"I guess she'll go on the street now," a thin woman says faintly, and no one takes the trouble to comment further. Like every commodity now the body is difficult to sell and the girls say you're lucky if you get fifty cents.

It's very difficult and humiliating to sell one's body.

Perhaps it would make it clear if one were to imagine having to go out on the street to sell, say, one's overcoat. Suppose you have to sell your coat so you can have breakfast and a place to sleep, say, for fifty cents. You decide to sell your only coat. You take it off and put in on your arm. The street, that has before been just a street, now becomes a mart, something entirely different. You must approach someone now and admit you are destitute and are now selling your clothes, your most intimate possessions. Everyone will watch you talking to the stranger showing him your overcoat, what a good coat it is. People will stop and watch curiously. You will be quite naked on the street. It is even harder to try to sell one's self, more humiliating. It is even humiliating to try to sell one's labor. When there is no buyer.

The thin woman opens the wire cage. There's a job for a nursemaid, she says. The old gnarled women, like old horses, know that no one will have them walk the streets with the young so they don't move. Ellen's friend gets up and goes to the window. She is unbelievably jaunty. I know she hasn't had work since last January. But she has a flare of life in her that glows like a tiny red flame and some tenacious thing, perhaps only youth, keeps it burning bright. Her legs are thin but the runs in her old stockings are neatly mended clear down her flat shank. Two bright spots of rouge conceal her pallor. A narrow belt is drawn tightly around her thin waist, her long shoulders stoop and the blades show. She runs wild as a colt hunting pleasure, hunting sustenance.

It's one of the great mysteries of the city where women go when they are out of work and hungry. There are not many women in the bread line. There are no flop houses for women as there are for men, where a bed can be had for a quarter or less. You don't see women lying on the floor at the mission in the free flops. They obviously don't sleep in the

112

jungle or under newspapers in the park. There is no law I suppose against their being in these places but the fact is they rarely are.

Yet there must be as many women out of jobs in cities and suffering extreme poverty as there are men. What happens to them? Where do they go? Try to get into the YW without any money or looking down at heel. Charities take care of very few and only those that are called "deserving." The lone girl is under suspicion by the virgin women who dispense charity.

I've lived in cities for many months broke, without help, too timid to get in bread lines. I've known many women to live like this until they simply faint on the street from privations, without saying a word to anyone. A woman will shut herself up in a room until it is taken away from her, and eat a cracker a day and be as quiet as a mouse so there are no social statistics concerning her.

I don't know why it is, but a woman will do this unless she has dependents, will go for weeks verging on starvation, crawling in some hole, going through the streets ashamed, sitting in libraries, parks, going for days without speaking to a living soul like some exiled beast, keeping the runs mended in her stockings, shut up in terror in her own misery, until she becomes too super-sensitive and timid to even ask for a job.

Bernice says even strange men she has met in the park have sometimes, that is in better days, given her a loan to pay her room rent. She has always paid them back.

In the afternoon the young girls, to forget the hunger and the deathly torture and fear of being jobless, try to pick up a man to take them to a ten-cent show. They never go to more expensive ones, but they can always find a man willing to spend a dime to have the company of a girl for the afternoon.

Sometimes a girl facing the night without shelter will approach a man for lodging. A woman always asks a man for help. Rarely another woman. I have known girls to sleep in men's rooms for the night on a pallet without molestation and be given breakfast in the morning.

It's no wonder these young girls refuse to marry, refuse to rear children. They are like certain savage tribes, who, when they have been conquered, refuse to breed.

Not one of them but looks forward to starvation for the coming winter. We are in a jungle and know it. We are beaten, entrapped. There is no way out. Even if there were a job, even if that thin acrid woman came and gave everyone in the room a job for a few days, a few hours, at thirty cents an hour, this would all be repeated tomorrow, the next day and the next.

Not one of these women but knows that despite years of labor there is only starvation, humiliation in front of them.

Mrs. Gray, sitting across from me, is a living spokesman for the futility of labor. She is a warning. Her hands are scarred with labor. Her body is a great puckered scar. She has given birth to six children, buried three, supported them all alive and dead, bearing them, burying them, feeding them. Bred in hunger they have been spare, susceptible to disease. For seven years she tried to save her boy's arm from amputation, diseased from tuberculosis of the bone. It is almost too suffocating to think of that long close horror of years of child-bearing, child-feeding, rearing, with the bare suffering of providing a meal and shelter.

Now she is fifty. Her children, economically insecure, are drifters. She never hears of them. She doesn't know if they are alive. She doesn't know if she is alive. Such subtleties of suffering are not for her. For her the brutality of hunger and cold. Not until these are done away with can those subtle feelings that make a human being be indulged.

She is lucky to have five dollars ahead of her. That is her security. She has a tumor that she will die of. She is thin as a worn dime with her tumor sticking out of her side. She is brittle and bitter. Her face is not the face of a human being. She has borne more than it is possible for a human being to bear. She is reduced to the least possible denominator of human feelings.

It is terrible to see her little bloodshot eyes like a beaten hound's, fearful in terror.

We cannot meet her eyes. When she looks at any of us we look away. She is like a woman drowning and we turn away. We must ignore those eyes that are surely the eyes of a person drowning, doomed. She doesn't cry out. She goes down decently. And we all look away.

The young ones know though. I don't want to marry. I don't want any children. So they all say. No children. No marriage. They arm themselves alone, keep up alone. The man is helpless now. He cannot provide. If he propagates he cannot take care of his young. The means are not in his hands. So they live alone. Get what fun they can. The life risk is too horrible now. Defeat is too clearly written on it.

So we sit in this room like cattle, waiting for a nonexistent job, willing to work to the farthest atom of energy, unable to work, unable to get food and lodging, unable to bear children – here we must sit in this shame looking at the floor, worse than beasts at a slaughter.

It is appalling to think that these women sitting so listless in the room may work as hard as it is possible for a human being to work, may labor night and day, like Mrs. Gray wash streetcars from midnight to dawn and offices in the early evening, scrub for fourteen and fifteen hours a day, sleep only five hours or so, do this their whole lives, and never earn one day of security, having always before them the pit of the future. The endless labor, the bending back, the water-soaked hands, earning never

more than a week's wages, never having in their hands more life than that.

It's not the suffering of birth, death, love that the young reject, but the suffering of endless labor without dream, eating the spare bread in bitterness, being a slave without the security of a slave.

38 BETTY FRIEDAN

"That Has No Name" (1963)

The problem lay buried, unspoken, for many years in the minds of American women. It was a strange stirring, a sense of dissatisfaction, a yearning that women suffered in the middle of the twentieth century in the United States. Each suburban wife struggled with it alone. As she made the beds, shopped for groceries, matched slipcover material, ate peanut butter sandwiches with her children, chauffeured Cub Scouts and Brownies, lay beside her husband at night – she was afraid to ask even of herself the silent question – "Is this all?"

For over fifteen years there was no word of this yearning in the millions of words written about women, for women, in all the columns, books and articles by experts telling women their role was to seek fulfillment as wives and mothers. Over and over women heard in voices of tradition and of Freudian sophistication that they could desire no greater destiny than to glory in their own femininity. Experts told them how to catch a man and keep him, how to breastfeed children and handle their toilet training, how to cope with sibling rivalry and adolescent rebellion; how to buy a dishwasher, bake bread, cook gourmet snails, and build a swimming pool with their own hands; how to dress, look, and act more feminine and make marriage more exciting; how to keep their husbands from dying young and their sons from growing into delinquents. They were taught to pity the neurotic, unfeminine, unhappy women who wanted to be poets or physicists or presidents. They learned that truly feminine women do not want careers, higher education, political rights – the independence and the opportunities that the old-fashioned feminists fought for. Some women, in their forties and fifties, still remembered painfully giving up those dreams, but most of the younger women no longer even thought about them. A thousand expert voices applauded their femininity, their adjustment, their new maturity. All they had to do was devote their lives from earliest girlhood to finding a husband and bearing children.

By the end of the 1950s, the average marriage age of women in American dropped to 20, and was still dropping, into the teens. Fourteen million girls were engaged by 17. The proportion of women attending college in comparison with men dropped from 47 per cent

in 1920 to 35 per cent in 1958. A century earlier, women had fought for higher education; now girls went to college to get a husband. By the mid-fifties, 60 per cent dropped out of college to marry, or because they were afraid too much education would be a marriage bar. Colleges built dormitories for "married students", but the students were almost always the husbands. A new degree was instituted for the wives – "Ph.T." (Putting Husband Through).

Then American girls began getting married in high school. And the women's magazines, deploring the unhappy statistics about these young marriages, urged that courses on marriage, and marriage counselors, be installed in the high schools. Girls started going steady at twelve and thirteen, in junior high. Manufacturers put out brassieres with false bosoms of foam rubber for little girls of ten. And an advertisement for a child's dress, sizes 3–6x, in the *New York Times* in the fall of 1960, said: "She Too Can Join the Man-Trap Set."

By the end of the fifties, the United States birthrate was overtaking India's. The birth-control movement, renamed Planned Parenthood, was asked to find a method whereby women who had been advised that a third or fourth baby would be born dead or defective might have it anyhow. Statisticians were especially astounded at the fantastic increase in the number of babies among college women. Where once they had two children, now they had four, five, six. Women who had once wanted careers were now making careers out of having babies. So rejoiced *Life* magazine in a 1956 paean to the movement of American women back to the home.

In a New York hospital, a woman had a nervous breakdown when she found she could not breastfeed her baby. In other hospitals, women dying of cancer refused a drug which research had proved might save their lives: its side effects were said to be unfeminine. "If I have only one life, let me live it as a blonde," a larger-than-life-sized picture of a pretty, vacuous woman proclaimed from newspaper, magazine, and drugstore ads. And across America, three out of every ten women dyed their hair blonde. They ate a chalk called Metrecal, instead of food, to shrink to the size of the thin young models. Department-store buyers reported that American women, since 1939, had become three and four sizes smaller. "Women are out to fit the clothes, instead of vice-versa," one buyer said.

Interior decorators were designing kitchens with mosaic murals and original paintings, for kitchens were once again the center of women's lives. Home sewing became a million-dollar industry. Many women no longer left their homes, except to shop, chauffeur their children, or attend a social engagement with their husbands. Girls were growing up in America without ever having jobs outside the home. In the late fifties, a sociological phenomenon was suddenly remarked: a third of American women now worked, but most were no longer young and very

116

few were pursuing careers. They were married women who held part-time jobs, selling or secretarial, to put their husbands through school, their sons through college, or to help pay the mortgage. Or they were widows supporting families. Fewer and fewer women were entering professional work. The shortages in the nursing, social work, and teaching professions caused crises in almost every American city. Concerned over the Soviet Union's lead in the space race, scientists noted that America's greatest source of unused brain-power was women. But girls would not study physics: it was "unfeminine." A girl refused a science fellowship at Johns Hopkins to take a job in a real-estate office. All she wanted, she said, was what every other American girl wanted – to get married, have four children and live in a nice house in a nice suburb.

The suburban housewife – she was the dream image of the young American women and the envy, it was said, of women all over the world. The American housewife – freed by science and labor-saving appliances from the drudgery, the dangers of childbirth and the illnesses of her grandmother. She was healthy, beautiful, educated, concerned only about her husband, her children, her home. She had found true feminine fulfillment. As a housewife and mother, she was respected as a full and equal partner to man in his world. She was free to choose automobiles, clothes, appliances, supermarkets; she had everything that women ever dreamed of.

In the fifteen years after World War II, this mystique of feminine fulfillment became the cherished and self-perpetuating core of contemporary American culture. Millions of women lived their lives in the image of those pretty pictures of the American suburban housewife, kissing their husbands goodbye in front of the picture window, depositing their station-wagonsful of children at school, and smiling as they ran the new electric waxer over the spotless kitchen floor. They baked their own bread, sewed their own and their children's clothes, kept their new washing machines and dryers running all day. They changed the sheets on the beds twice a week instead of once, took the rug-hooking class in adult education, and pitied their poor frustrated mothers, who had dreamed of having a career. Their only dream was to be perfect wives and mothers; their highest ambition to have five children and a beautiful house, their only fight to get and keep their husbands. They had no thought for the unfeminine problems of the world outside the home; they wanted the men to make the major decisions. They gloried in their role as women, and wrote proudly on the census blank: "Occupation: housewife."

For over fifteen years, the words written for women, and the words women used when they talked to each other, while their husbands sat on the other side of the room and talked shop or politics or septic tanks, were about problems with their children, or how to keep their husbands

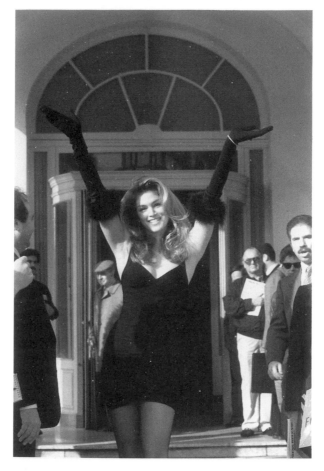

Figure 4.1 Supermodel Cindy Crawford, in 1991
Photograph courtesy of Range/Bettman/UPI

happy, or improve their children's school, or cook chicken or make
slipcovers. Nobody argued whether women were inferior or superior
to men; they were simply different. Words like "emancipation" and
"career" sounded strange and embarrassing; no one had used them
for years. When a Frenchwoman named Simone de Beauvoir wrote a
book called *The Second Sex*, an American critic commented that she
obviously "didn't know what life was all about," and besides, she was
talking about French women. The "woman problem" in American no
longer existed.

If a woman had a problem in the 1950s and 1960s, she knew that
something must be wrong with her marriage, or with herself. Other
women were satisfied with their lives, she thought. What kind of a

118

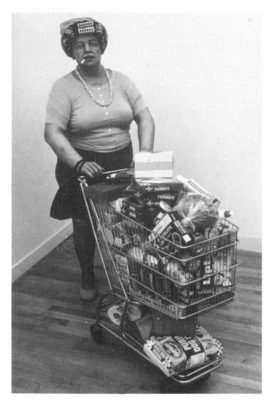

Figure 4.2 "Supermarket Lady": a lifesize fiberglass sculpture
by Duane Hanson, 1970
Photograph courtesy of Harris Gallery, New York

woman was she if she did not feel this mysterious fulfillment waxing
the kitchen floor? She was so ashamed to admit her dissatisfaction that
she never knew how many other women shared it. If she tried to tell her
husband, he didn't understand what she was talking about. She did not
really understand it herself. For over fifteen years women in America
found it harder to talk about this problem than about sex. Even the
psychoanalysts had no name for it. When a woman went to a psychiatrist
for help, as many women did, she would say, "I'm so ashamed," or "I
must be hopelessly neurotic." "I don't know what's wrong with women
today," a suburban psychiatrist said uneasily. "I only know something is
wrong because most of my patients happen to be women. And their
problem isn't sexual." Most women with this problem did not go to see a
psychoanalyst, however. "There's nothing wrong really," they kept telling
themselves. "There isn't any problem."

But on an April morning in 1959, I heard a mother of four, having

coffee with four other mothers in a suburban development fifteen miles from New York, say in a tone of quiet desperation, "the problem." And the others knew, without words, that she was not talking about a problem with her husband, or her children, or her home. Suddenly they realized they all shared the same problem, the problem that has no name. They began, hesitantly, to talk about it. Later, after they had picked up their children at nursery school and taken them home to nap, two of the women cried, in sheer relief, just to know they were not alone.

39 ADRIENNE RICH

"Think through the Body" (1976)

I am really asking whether women cannot begin, at last, to *think through the body*, to connect what has been so cruelly disorganized – our great mental capacities, hardly used; our highly developed tactile sense; our genius for close observation; our complicated, pain-enduring, multi-pleasured physicality.

I know no woman – virgin, mother, lesbian, married, celibate – whether she earns her keep as a housewife, a cocktail waitress, or a scanner of brain waves – for whom her body is not a fundamental problem: its clouded meaning, its fertility, its desire, its so-called frigidity, its bloody speech, its silences, its changes and mutilations, its rapes and ripenings. There is for the first time today a possibility of converting our physicality into both knowledge and power. Physical motherhood is merely one dimension of our being. We know that the sight of a certain face, the sound of a voice, can stir waves of tenderness in the uterus. From brain to clitoris through vagina to uterus, from tongue to nipples to clitoris, from fingertips to clitoris to brain, from nipples to brain and into the uterus, we are strung with invisible messages of an urgency and restlessness which indeed cannot be appeased, and of a cognitive potentiality that we are only beginning to guess at. We are neither "inner" nor "outer" constructed; our skin is alive with signals; our lives and our deaths are inseparable from the release or blockage of our thinking bodies.

But the fear and hatred of our bodies has often crippled our brains. Some of the most brilliant women of our time are still trying to think from somewhere outside their female bodies – hence they are still merely reproducing old forms of intellection. There is an inexorable connection between every aspect of a woman's being and every other; the scholar reading denies at her peril the blood on the tampon; the welfare mother accepts at her peril the derogation of her intelligence. These are issues of survival, because the woman scholar and the welfare mother are both engaged in fighting for the mere right to exist. Both are "marginal"

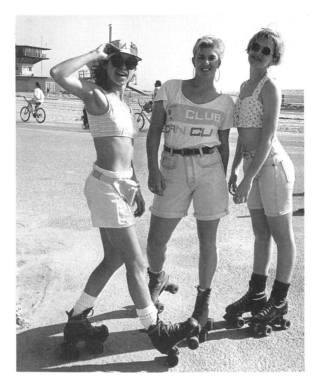

Figure 4.3 Women at Venice Beach, Santa Monica, Los Angeles
Photograph: Jacky Chapman

people in a system founded on the traditional family and its perpetuation.

The physical organization which has meant, for generations of women, unchosen, indentured motherhood, is still a female resource barely touched upon or understood. We have tended either to *become* our bodies – blindly, slavishly, in obedience to male theories about us – or to try to exist in spite of them. "I don't *want* to be the Venus of Willendorf – or the eternal fucking machine." Many women see any appeal to the physical as a denial of mind. We have been perceived for too many centuries as pure Nature, exploited and raped like the earth and the solar system; small wonder if we now long to become Culture: pure spirit, mind. Yet it is precisely this culture and its political institutions which have split us off from itself. In so doing it has also split itself off from life, becoming the death-culture of quantification, abstraction, and the will to power which has reached its most refined destructiveness

in this century. It is this culture and politics of abstraction which women are talking of changing, of bringing to accountability in human terms.

The repossession by women of our bodies will bring far more essential change to human society than the seizing of the means of production by workers. The female body has been both territory and machine, virgin wilderness to be exploited and assembly-line turning out life. We need to imagine a world in which every woman is the presiding genius of her own body. In such a world women will truly create new life, bringing forth not only children (if and as we choose) but the visions, and the thinking, necessary to sustain, console, and alter human existence – a new relationship to the universe. Sexuality, politics, intelligence, power, motherhood, work, community, intimacy will develop new meanings; thinking itself will be transformed.

This is where we have to begin.

40 STUDS TERKEL

"Just a Housewife: Therese Carter" (1972)

Even if it is a woman making an apple dumpling, or a man a stool,
If life goes into the pudding, good is the pudding,
good is the stool.
Content is the woman with fresh life rippling in her,
content is the man.

<div align="right">D. H. Lawrence</div>

We're in the kitchen of the Carter home, as we were eight years ago. It is in Downers Grove Estates, an unincorporated area west of Chicago. There are one-family dwellings in this blue-collar community of skilled craftsmen – "middle class. They've all got good jobs, plumbers, electricians, truckdrivers." Her husband Bob is the foreman of an auto body repair shop. They have three children: two boys, twenty-one and fourteen, and one girl, eighteen.

It is a house Bob has, to a great extent, built himself. During my previous visit he was still working at it. Today it is finished – to his satisfaction. The room is large, remarkably tidy; all is in its place. On the wall is a small blackboard of humorous familiar comment, as well as a bulletin board of newspaper clippings and political cartoons.

On another wall is the kitchen prayer I remembered:

Bless the kitchen in which I cook
Bless each moment within this nook
Let joy and laughter share this room
With spices, skillets and my broom
Bless me and mine with love and health
And I'll not ask for greater wealth.

How would I describe myself? It'll sound terrible – just a housewife. (Laughs.) It's true. What is a housewife? You don't have to have any special talents. I don't have any.

First thing I do in the morning is come in the kitchen and have a cigarette. Then I'll put the coffee on and whatever else we're gonna have for breakfast: bacon and eggs, sausage, waffles, toast, whatever. Then I'll make one lunch for young Bob – when school's on, I'll pack more – and I get them off to work. I'll usually throw a load of clothes in the washer while I'm waiting for the next batch to get up out of bed, and carry on from there. It's nothing really.

Later I'll clean house and sew, do something. I sew a lot of dresses for Cathy and myself. I brought this sewing machine up here years ago. It belongs here. This is my room and I love it, the kitchen.

I start my dinner real early because I like to fuss. I'll bake, cook . . . There's always little interruptions, kids running in and out, take me here, take me there. After supper, I really let down. I'm not a worker after supper. I conk out. I sit and relax and read, take a bath, have my ice cream, and go to bed. (Laughs.) It's not really a full day. You think it *is*? You make me sound important. Keep talking. (Laughs.)

I don't think it's important because for so many years it wasn't considered. I'm doing what I'm doing and I fill my days and I'm very contented. Yet I see women all around that do a lot more than I do. Women that have to work. I feel they're worthy of much more of a title than housewife.

If anybody else would say this, I'd talk back to 'em, but I *myself* feel like it's not much. Anybody can do it. I was gone for four days and Cathy took over and managed perfectly well without me. (Laughs.) I felt great, I really did. I knew she was capable.

I'll never say I'm really a good mother until I see the way they all turn out. So far they've done fine. I had somebody tell me in the hospital I must have done a good job of raising them. I just went along from day to day and they turned out all right.

Oh – I even painted the house last year. How much does a painter get paid for painting a house? (Laughs.) What? I'm a skilled craftsman myself? I never thought about that. Artist? No. (Laughs.) I suppose if you do bake a good cake, you can be called an artist. But I never heard anybody say that. I bake bread too. Oh gosh, I've been a housewife for a long time. (Laughs.)

I never thought about what we'd be worth. I've read these things in the paper: If you were a tailor or a cook, you'd get so much an hour. I think that's a lot of boloney. I think if you're gonna be a mother or a housewife, you should do these things because you want to, not because you have to.

You look around at all these career women and they're really doing

123

things. What am I doing? Cooking and cleaning. (Laughs.) It's necessary, but it's not really great.

It's known they lead a different life than a housewife. I'm not talking about Golda Meir or anybody like that. Just even some women in the neighborhood that have to work and come home and take care of the family. I really think they deserve an awful lot of credit.

A housewife is a housewife, that's all. Low on the totem pole. I can read the paper and find that out. Someone who is a model or a movie star, these are the great ones. I don't necessarily think they are, but they're the ones you hear about. A movie star will raise this wonderful family and yet she has a career. I imagine most women would feel less worthy. Not just me.

Somebody who goes out and works for a living is more important than somebody who doesn't. What they do is very important in the business world. What I do is only important to five people. I don't like putting a housewife down, but everybody has done it for so long. It's sort of the thing you do. Deep down, I feel what I'm doing is important. But you just hate to say it, because what are you? Just a housewife? (Laughs.)

I love being a housewife. Maybe that's why I feel so guilty. I shouldn't be happy doing what I'm doing. (Laughs.) Maybe you're not supposed to be having fun. I never looked on it as a duty.

I think a lot. (Laughs.) Oh sure, I daydream. Everybody does. Some of 'em are big and some of 'em are silly. Sometimes you dream you're still a kid and you're riding your bike. Sometimes you daydream you're really someone special and people are asking you for your advice, that you're in a really big deal. (Laughs.)

I have very simple pleasures. I'm not a deep reader. I can't understand a lot of things. I've never read – oh, how do you pronounce it, Camus? I'm not musically inclined. I don't know anything about art at all. I could never converse with anybody about it. They'd have to be right, because I wouldn't know whether they're right or wrong. I go as far as Boston Pops and the Beatles. (Laughs.) I have no special talents in any direction.

I just read a new Peter De Vries book. I can't think of the name of it, that's terrible. (Suddenly) *Always Panting.* I was the first Peter De Vries fan in the world. I introduced my sister to it and that was the one big thing I've ever done in my life. (Laughs.) Now I'm reading *Grapes of Wrath.* I'm ashamed of myself. Everybody in the family has read that book and I've had it for about fifteen years. Finally I decided to read it because my daughter raved about it.

There is a paperback copy of The Savage God *by A. Alvarez nearby. I indicate it.*

I just started a little bit about Sylvia Plath and I decided I would read this book. *Ms.* magazine has an article about her. Sure I read *Ms.* I don't

think it's unusual just because I live around here. I don't agree with everything in it. But I read it. I read matchbox covers too. (Laughs.)

I think Woman's Lib puts down a housewife. Even though they say if this is what a woman wants, it's perfectly all right. I feel it's said in such a snide way: "If this is all she can do and she's contented, leave her alone." It's patronizing.

I look on reading right now as strictly enjoyment and relaxation. So I won't even let myself pick up a book before ten o'clock at night. If I do, I'm afraid I might forget about everything else. During lunch time I'll look through a magazine because I can put it down and forget about it. But real enjoyable reading I'll do at night.

I'd feel guilty reading during the day. (Laughs.) In your own home. There are so many things you should be doing. If I did it, I wouldn't think the world's coming to an end, but that's the way I'm geared. That's not the time to do it, so I don't do it.

When I went to school a few years ago it was startling around here. Why would an older woman like me be wanting to go back to school? They wouldn't say it directly, but you hear things. I took some courses in college English, psychology, sociology. I enjoyed going but I didn't want to continue on and be a teacher. I still enjoyed being at home much more. Oh, I might go back if there was anything special I'd like.

I enjoy cooking. If it was a job, maybe I wouldn't like doing it. As low on the totem pole as I consider being a housewife, I love every minute of it. You will hear me gripe and groan like everybody else, but I do enjoy it.

I'll also enjoy it when the kids are all gone. I always had the feeling that I can *really* – oh, I don't know what I want to do, but whatever that would be, I can do it. I'll be on my own. I'm looking forward to it. Just a lot of things I've never taken the time to do.

I've never been to the Art Institute. Now that might be one thing I might do. (Laughs.) I've grown up in Chicago and I've never been there and I think that's terrible. Because I've never gotten on the train and gone. I can't spend all that time there yet. But pretty soon I'll be able to.

I haven't been to the Museum of Science and Industry for ten years at least. These things are nothing special to anybody else, but to me they would be. And to sit down and read one whole book in one afternoon if I felt like it. That would be something!

When the kids leave I want it to be a happy kind of time. Just to do the things I would like to do. Not traveling. Just to do what you want to do not at a certain time or a certain day. Sewing a whole dress at one time. Or cooking for just two people.

That's what makes me feel guilty. Usually when kids go off and get married the mother sits and cries. But I'm afraid I'm just gonna smile all the way through it. (Laughs.) They'll think I'm not a typical mother. I love my kids, I love 'em to pieces. But by the same token, I'll be just so

happy for them and for myself and for Bob, too. I think we deserve a time together alone.

I don't look at housework as a drudgery. People will complain: "Why do I have to scrub floors?" To me, that isn't the same thing as a man standing there – it's his livelihood – putting two screws together day after day after day. It would drive anybody nuts. It would drive me wild. That poor man doesn't even get to see the finished product. I'll sit here and I'll cook a pie and I'll get to see everybody eat it. This is my offering. I think it's the greatest satisfaction in the world to know you've pleased some-body. Everybody has to feel needed. I know I'm needed. I'm doing it for them and they're doing it for me. And that's the way it is.

41 MERLE WOO

FROM "Letter to Ma" (1980)

January, 1980

Dear Ma,

I was depressed over Christmas, and when New Year's rolled around, do you know what one of my resolves was? Not to come by and see you as much anymore. I had to ask myself why I get so down when I'm with you, my mother, who has focused so much of her life on me, who has endured so much; one who I am proud of and respect so deeply for simply surviving.

I suppose that one of the main reasons is that when I leave your house, your pretty little round white table in the dinette where we sit while you drink tea (with only three specks of Jasmine) and I smoke and drink coffee, I am down because I believe there are chasms between us. When you say, "I support you, honey, in everything you do except . . . except . . . " I know you mean except my speaking out and writing of my anger at all those things that have caused those chasms. . . .

When I look at you, there are images: images of you as a little ten-year-old Korean girl, being sent alone from Shanghai to the United States, in steerage with only one skimpy little dress, being sick and lonely on Angel Island for three months; then growing up in a "Home" run by white missionary women. Scrubbing floors on your hands and knees, hauling coal in heavy metal buckets up three flights of stairs, tending to the younger children, putting hot bricks on your cheeks to deaden the pain from the terrible toothaches you always had. Working all your life as maid, waitress, salesclerk, office worker, mother. But throughout there is an image of you as strong and courageous, and persevering: climbing out of windows to escape from the Home, then later, from an abusive first husband. There is so much more to these

126

images than I can say, but I think you know what I mean. Escaping out of windows offered only temporary respites; surviving is an everyday chore. You gave me, physically, what you never had, but there was a spiritual, emotional legacy you passed down which was reinforced by society: self-contempt because of our race, our sex, our sexuality. For deeply ingrained in me, Ma, there has been that strong, compulsive force to sink into self-contempt, passivity, and despair. I am sure that my fifteen years of alcohol abuse have not been forgotten by either of us, nor my suicidal depressions.

Now, I know you are going to think that I hate and despise you for your self-hatred, for your isolation. But I don't. Because in spite of your withdrawal, in spite of your loneliness, you have not only survived, but been beside me in the worst of times when your company meant every-thing in the world to me. I just need more than that now, Ma. I have taken and taken from you in terms of needing you to mother me, to be by my side, and I need, now, to take from you two more things: under-standing and support for who I am now and my work.

We are Asian American women and the reaction to our identity is what causes the chasms instead of connections. But do you realize, Ma, that I could never have reacted the way I have if you had not provided for me the opportunity to be free of the binds that have held you down, and to be in the process of self-affirmation? Because of your life, because of the physical security you have given me: my education, my full stomach, my clothed and starched back, my piano and dancing lessons – all those gifts you never received – I saw myself as having worth; now I begin to love myself more, see our potential, and fight for just that kind of social change that will affirm me, my race, my sex, my heritage. And while I affirm myself, Ma, I affirm you.

Today, I am satisfied to call myself either an Asian American Feminist or Yellow Feminist. The two terms are inseparable because race and sex are an integral part of me. This means that I am working with others to realize pride in culture and women and heritage (the heritage that is the exploited yellow immigrant: Daddy and you). Being a Yellow Feminist means being a community activist and a humanist. It does not mean "separatism," either by cutting myself off from non-Asians or men. It does not mean retaining the same power structure and substituting women in positions of control held by men. It does mean fighting the whites and the men who abuse us, straight-jacket us and tape our mouths; it means changing the economic class system and psychological forces (sexism, racism, and homophobia) that really hurt all of us. And I do this, not in isolation, but in the community. . . . Today, as I write to you of all these memories, I feel even more deeply hurt when I realize how many people, how so many people, because of racism and sexism, fail to see what power we sacrifice by not joining hands.

But not all white women are racist, and not all Asian American men

are sexist. And we choose to trust them, love and work with them. And there are visible changes. Real tangible, positive changes. The changes I love to see are those changes within ourselves.

Your grandchildren, my children, Emily and Paul. That makes three generations. Emily loves herself. Always has. There are shades of self-doubt but much less than in you or me. She says exactly what she thinks, most of the time, either in praise or in criticism of herself or others. And at sixteen she goes after whatever she wants, usually center stage. She trusts and loves people, regardless of race or sex (but, of course, she's cautious), loves her community and works in it, speaks up against racism and sexism at school. Did you know that she got Zora Neale Hurston and Alice Walker on her reading list for a Southern Writers class when there were only white authors? That she insisted on changing a script done by an Asian American man when she saw that the depiction of the character she was playing was sexist? That she went to a California State House Conference to speak out for Third World students' needs?

And what about her little brother, Paul? Twelve years old. And remember, Ma? At one of our Saturday Night Family Dinners, how he lectured Ronnie (his uncle, yet!) about how he was a male chauvinist? Paul told me once how he knew he had to fight to be Asian American, and later he added that if it weren't for Emily and me, he wouldn't have to think about feminist stuff too. He says he can hardly enjoy a movie or TV program anymore because of the sexism. Or comic books. And he is very much aware of the different treatment he gets from adults: "You have to do everything right," he said to Emily, "and I can get away with almost anything."

Emily and Paul give us hope, Ma. Because they are proud of who they are, and they care so much about our culture and history. Emily was the first to write your biography because she knows how crucial it is to get our stories in writing.

Ma, I wish I knew the histories of the women in our family before you. I bet that would be quite a story. But that may be just as well, because I can say that *you* started something. Maybe you feel ambivalent or doubtful about it, but you did. Actually, you should be proud of what you've begun. I am. If my reaction to being a Yellow Woman is different than yours was, please know that this is not a judgment on you, a criticism or a denial of you, your worth. I have always supported you, and as the years pass, I think I begin to understand you more and more.

In the last few years, I have realized the value of Homework: I have studied the history of our people in this country. I cannot tell you how proud I am to be a Chinese/Korean American Woman. We have such a proud heritage, such a courageous tradition. I want to tell everyone about that, all the particulars that are left out in the schools. And the full awareness of being a woman makes me want to sing. And I do sing with other Asian Americans and women, Ma, anyone who will sing with me.

I feel now that I can begin to put our lives in a larger framework. Ma, a larger framework! The outlines for us are time and blood, but today there is breadth possible through making connections with others involved in community struggle. In loving ourselves for who we are – American women of color – we can make a vision for the future where we are free to fulfill our human potential. This new framework will not support repression, hatred, exploitation and isolation, but will be a human and beautiful framework, created in a community, bonded not by color, sex or class, but by love and the common goal for the liberation of mind, heart, and spirit.

Ma, today, you are as beautiful and pure to me as the picture I have of you, as a little girl, under my dresser-glass.

42 *NATIONAL NOW TIMES* (EDITORIAL)

"Abortion Is Not Immoral" (1989)

"None of us is for abortion, we're just pro-choice."

Sound familiar? Of course it does. Hardly a rally, a vigil, a speak-out, a march or even a press conference goes by that some speaker doesn't apologize for the fact of abortion and give such a disclaimer to his or her support for abortion rights.

What's wrong with this picture? Plenty. First, intrinsic in the disclaimer is the not-so-subtle suggestion that abortion is somehow morally wrong, but a necessary evil. So who wants to stand up for evil? Second, the word "choice" is meaningless unless it's attached to something else. Sure, the abortion rights movement in America has popularized the term "pro-choice" to the point that almost everyone who hasn't been stranded on a desert island for the last five years knows it means support for legalized abortion. But, by substituting the "C" word for the "A" word, there's still the suggestion that abortion is so bad the speaker will avoid saying the word at nearly any cost – while cautiously looking overhead for signs of lightning. Like most empty terms pro-choice's blessing has now become its curse. A lot of abortion rights opponents, particularly the most strident, are also opponents of a lot of other rights, especially if they have the word civil or women's in front of them. But they've discovered they're not against "choice."

In fact, they're embracing "choice" by leaps and bounds. We now are hearing about "choice" in education. As in the choice of which public schools to send their children – one in the black inner-city or one in the white suburbs. Thought they'd never figure a way around that busing to achieve integration business. Then there's the "right to choose" between public and private schools for their children. They've always had this choice, of course, but in the spirit of broadening choice for those with

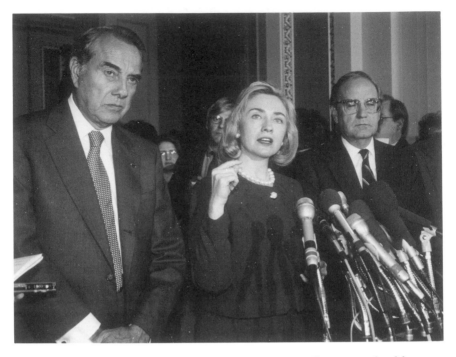

Figure 4.4 First Lady Hillary Clinton at a press conference on health care reform, with Senators Bob Dole and George Mitchell, 1993
Photograph courtesy of Range/Reuter/Bettman

modest incomes, the government should provide money to subsidize middle income families so they can "choose" private or parochial schools for their children. And besides, as a Christian nation, don't we have the obligation to help out the Catholic schools and Christian academies that are so strapped for cash?

Yes, "choice" is cropping up everywhere. And, being "pro-choice" ourselves, what can we say? We can say we're pro-abortion rights, that's what. Because that's what we are.

Abortion is not immoral, It's not evil. It's not even shameful. But it well could be illegal. And if, in our "choice" of language, we inadvertently contribute to the notion that abortion is a "bad choice," we may well be inadvertently helping speed the day it becomes illegal. After all, how long and how hard do we believe people will fight for something they believe is inherently bad?

43 BARBARA NEWMAN

FROM **"Postmodern Patriarchy Loves Abortion"** (1993)

The leaders of organized American feminism have unfortunately defined "reproductive rights" as *the* fundamental issue of equality. But although NOW and NARAL [National Abortion Rights Action League] maintain that abortion is liberating, they have failed to persuade the majority of American women, and for good reason. For abortion is in reality the fruit of a patriarchal system that is still unable to accept either the human dignity or the mature sexuality of women.

The appealing rhetoric of "choice" proves, on closer inspection, to conceal a dangerous double bind. Abortion advocates cite a woman's "right to privacy," claiming that no parent or boyfriend or husband – much less the state – has the right to intervene in her private reproductive decisions. Yet this logic implies that if abortion is a woman's "private choice," then so is child-rearing. The woman who seeks to raise a child despite economic hardship is frequently abandoned by her child's father and finds little help from society. Since she refused the easy choice of abortion, she alone must bear the burden of her difficult and courageous choice. Thus privatizing the sphere of reproduction leaves women, especially poor women, more vulnerable to exploitation than before. Many young mothers seek abortions precisely because they feel they have no "choice" – a feeling of powerlessness, not control, which is too often reinforced by parents, boyfriends, doctors, social workers, and of course, abortion counselors. As the Chicana activist Graciela Olivarez says plaintively, "The poor cry out for justice and equality, and we respond with legalized abortion."

It is not enough to look at the "problem of unwanted pregnancies" unless we ask *why* so many women become pregnant against their will. In many cases, that means asking why so many men do not want pregnant women in their lives. My own belief is that, despite a generation of propaganda about women's "freedom of choice," women and especially teenaged girls in America are still far from being sexually free, but feel pressured into having sexual relationships they don't really want with men they don't really love because having a boyfriend, even an abusive one, is the only form of security they know. And if a woman is not afraid or ashamed to say "no," it is a rare boyfriend who will respect that choice.

In a society where rape and sexual assault are endemic, few unmarried men are willing to take responsibility for either contraception or child care. When their partners become pregnant, they believe they are being moral and responsible if they offer to pay for the "termination." But such morality is self-serving and shallow: It allows men to go right on being manipulative playboys while leaving women to suffer all the pain and

guilt of abortion. Too often, young women expose themselves to the anguish of sacrificing a wanted child in order to "save their relationship" with a man who was not mature enough to use a condom, let alone assume the burdens of fatherhood.

There is yet another reason why so many pregnancies are unwanted: Our patriarchal society does not want, and cannot cope with, mothers in the workplace. The sexual liberation of women is no threat to men as long as we are willing to model our sexuality on theirs, especially that of the least mature. Postmodern patriarchy can accept the women whose sexuality conforms to the consumerist model – sex for fun, pleasure, and profit with no strings attached. Abortion now "liberates" this woman to be just as irresponsible as male playboys have always been. Society can also accept the increasingly rare woman who chooses – and is wealthy enough – to be a full-time wife and mother. But the woman who works in the marketplace *and* bears children, the so-called "working mother" who is in fact the average American woman, still faces discrimination in the workplace and demands on her time and energy so severe that it is no wonder if she greets the news of another pregnancy with horror, even if she is married and affluent. . . .

Given an economic system that inflicts a penalty on motherhood and refuses to recognize fatherhood at all, it is no wonder that so many pregnancies are unwanted. Changing the system to accommodate the reality of working parents would require an enormous investment of thought, creativity, commitment, and of course, money. So it is no wonder that we prefer to take the cheap and time-honored way out. Resolve the dilemma with an act of violence; reduce the woman to a surrogate man, tough and competitive and untroubled by fertility. Then deny that her fertility has any emotional consequences or imposes any responsibilities, least of all on the man who fertilized her. Once this is done, it is easy enough to "terminate" the pregnancy and justify this violence in the usual way, by denying humanity to the "terminated" person. . . .

It is far cheaper to abort the next generation than to nurture it; it is far easier to subject women's bodies to surgical violence than to provide the economic and emotional support that would make our fertility a blessing rather than a curse. As long as patriarchy insists on business-as-usual – in the bedroom, the board room, and the operating room – women's "right" to abortion will be a pitiful surrogate for freedom from the sexual and economic exploitation that compels this oppressive "choice."

5

THE STRUCTURE OF
GOVERNMENT

Introduction 134

44 Founding Fathers
FROM The Constitution of the United States (1787) 136

45 James Madison
FROM "How a Republic Will Reduce the Evil of Faction"
(1788) 144

46 E. L. Doctorow
FROM "A Citizen Reads the Constitution" (1987) 147

47 Thomas Jefferson
FROM "The Roots of Democracy" (1816) 151

48 John Marshall
FROM *Marbury* v. *Madison* (1803) 153

49 Andrew Jackson
FROM Proclamation to the People of South Carolina (1832) 155

50 John Kenneth Galbraith
"The American Presidency: Going the Way of the
Blacksmith?" (1988) 158

INTRODUCTION

With the possible exception of the Declaration of Independence (1776), no American document ranks higher in the eyes of the American people than the Constitution of the United States (drafted 1787). The Constitution is a down-to-earth document which in a practical way outlines the American republican system of government. It is understandable that, after a period of war and upheaval, the Founding Fathers who wrote the Constitution longed for national unity.

This spirit is reflected in the Constitution itself and in the contemporary writings of James Madison, a delegate whose role at the constitutional assembly was so important that he has been called "the father of the Constitution." The main concern of Madison and most others was to prevent any one interest group or "faction" – whether a majority or a minority – from dominating the new government. Their cure was a system of indirect representation rather than direct democracy. The idea of federalism and the system of checks and balances reflect the same basic motive – preventing strong government in any form. Along with two others, Madison wrote a series of articles – now known as the *Federalist Papers* – to persuade the new states to ratify the Constitution.

In 1987, two hundred years after the Founding Fathers agreed on this first written basic law that is still operative, the author E. L. Doctorow gave a talk in Philadelphia, reprinted in part in this chapter as "A Citizen Reads the Constitution." Here he contrasts the Constitution with the eloquent and even revolutionary Declaration of Independence, examining it as an authored text. He also recounts how different generations of Americans have regarded their basic law.

In the fourth text, Thomas Jefferson gives his own view of the Constitution in a private letter in 1816, when he had retired as the third president of the United States and when Madison was the nation's fourth president. Madison had originally distinguished between a democracy which he feared and a republic which he supported. Jefferson, looking back, hails democracy rather than the republican form. His alternative vision is of a "grass-roots" or local democracy with a minimum of officialdom. Indeed, Jefferson's idea of "county republics" or "ward republics" seems very close to that form of direct democracy which Madison had believed to be so dangerous in 1787. Jefferson deplores that Americans, even at this early stage, have a tendency to look upon the Constitution as a sacred text. Nevertheless, the Jeffersonian view of a localistic, county-and-state-centered community rather than a true American nation became dominant for over a century. Despite their differences, Madison helped secure the triumph of the Jeffersonian view.

When Jefferson won in the presidential election of 1800 and again in 1804, Jeffersonian democracy seemed to have permanently removed

from power those who believed in a strong federal government that could serve as the promotor of large industrial enterprises. But at the very moment of Jefferson's victory, the Federalists scored an important victory. In one of his last official actions, the Federalist president John Adams had named his secretary of state, John Marshall, chief justice of the Supreme Court of the United States. And Marshall aspired to make the Supreme Court the ultimate arbiter in the lawmaking process. He did so in the famous *Marbury* v. *Madison* case (1803). William Marbury had also been one of Adams's late appointments – to be a district judge – but Marbury's commission had not actually been delivered to him. Jefferson instructed his new secretary of state, James Madison, to withhold it. Marbury then asked the court for a *mandamus* or court order requiring him to be instated in his job. In the Supreme Court, Marshall wrote a majority opinion that said two things. First, that the president had no moral right to withhold the commission. Second, that the act on which Marbury rested his case was unconstitutional. Therefore the court was powerless to help him. In this way Marshall ingeniously introduced the system of *judicial review* – the doctrine that the US Supreme Court has the right to pass judgment on whether a law is constitutional or not. This was a challenge to the Jeffersonian doctrine that the people, not lawyers or aristocrats, should have the final say.

One of those who sympathized with Jefferson's view was Andrew Jackson, president of the United States from 1829 to 1837. Jackson went even further than Jefferson in claiming that the Supreme Court's opinions could be ignored. Neither Jefferson nor Jackson wished a strong government in Washington, but both actually strengthened the presidency. Jefferson in 1803 had purchased an enormous tract of land west of the Mississippi and east of the Rocky Mountains – known as Louisiana – from France for $15 million. The Senate, surprised, was critical of such presidential initiative but had little choice but to accept the deal. Jackson in 1828 faced a different crisis when South Carolina declared that it had the right under the Constitution to withdraw from the federal union drawn up in 1787. In a sense, South Carolina pulled Jeffersonian localism to its logical conclusion by declaring several acts by the national Congress to be unconstitutional and therefore not binding for South Carolina. In setting an individual state above the union, South Carolina's act of "nullification" was a preview of the conflicts that led to the Civil War. To use Madison's language, here was a "faction" or strong interest trying to dominate the rest. President Jackson, for all his sympathy with localism, refused to accept a break-up of the union. Jackson's proclamation to the South Carolinians in 1832 (extract 49) shows what he thinks about the Constitution and the United States as a nation.

The Constitution has never been periodically revised and updated in the way Jefferson and his supporters believed it should be, but its many

amendments have served part of that purpose. So has, above all, the interpretation of what the Constitution *means* and *permits*. For example, the three branches of government, originally designed by the Founding Fathers to be equal under the Constitution, have undergone an evolution. In the course of time, the executive branch and especially the presidency has come out as the stronger of the three. There have been attempts to change this trend. Soon after the Civil War Congress tried to make a president comply with the will of Congress. The issue was who had the power to appoint or dismiss a member of the president's Cabinet – the president or Congress. Congress believed that it, and no longer the president, should have that right, and tried to impeach (remove) President Johnson to make its point. If Congress had succeeded in its attempt to impeach Andrew Johnson in 1868, the outcome might have been a parliamentary type of government in the United States.

What has emerged in the United States since then, however, is the opposite – presidential government. The rise of what has been called the "imperial presidency" has been particularly noteworthy since the 1930s, the age of the Great Depression and Franklin D. Roosevelt's New Deal. What happened politically as a result of the so-called Watergate affair in the 1970s can be seen at least partly as an attempt by Congress to reduce the power of the modern presidency and regain some of the former prestige of the legislative branch.

Perhaps it is misleading to say that American presidents have become so much more powerful than they used to be. This, at least, is Professor John Kenneth Galbraith's reasoning in his article "The American Presidency: Going the Way of the Blacksmith?" His controversial point is that it is the institution of the presidency, not the individual president, that has been strengthened over time. Paradoxically, because of the rising power of the presidency, the American people has occasionally boosted the power of Congress by filling it with a majority of the opposition party. As a result of the congressional election of 1994, for example, President Clinton found himself faced by a Republican-dominated Congress.

44 FOUNDING FATHERS

FROM The Constitution of the United States (1787)

We, the People of the United States, in order to form a more perfect union, establish justice, insure domestic tranquility, provide for the common defence, promote the general welfare, and secure the blessings of liberty to ourselves and our posterity, do ordain and establish this Constitution for the United States of America.

ARTICLE I

Sec. 1. All legislative powers herein granted shall be vested in a Congress of the United States, which shall consist of a Senate and House of Representatives.

Sec. 2. The House of Representatives shall be composed of members chosen every second year by the people of the several States, and the electors in each State shall have the qualifications requisite for electors of the most numerous branch of the State legislature.

No person shall be a Representative who shall not have attained to the age of twenty-five years, and been seven years a citizen of the United States, and who shall not, when elected, be an inhabitant of that State in which he shall be chosen.

Representatives and direct taxes shall be apportioned among the several States which may be included within this Union, according to their respective numbers.

When vacancies happen in the representation from any State, the executive authority thereof shall issue writs of election to fill such vacancies.

The House of Representatives shall choose their Speaker and other officers; and shall have the sole power of impeachment.

Sec. 3. The Senate of the United States shall be composed of two Senators from each State, chosen by the legislature thereof, for six years; and each Senator shall have one vote.

Immediately after they shall be assembled in consequence of the first election, they shall be divided as equally as may be into three classes. The seats of the Senators of the first class shall be vacated at the expiration of the second year, of the second class at the expiration of the fourth year, and of the third class at the expiration of the sixth year, so that one-third may be chosen every second year; and if vacancies happen by resignation, or otherwise, during the recess of the legislature of any State, the executive thereof may make temporary appointments until the next meeting of the legislature, which shall then fill such vacancies.

Sec. 7. All bills for raising revenue shall originate in the House of Representatives; but the Senate may propose or concur with amendments as on other bills.

Every bill which shall have passed the House of Representatives and the Senate, shall, before it become a law, be presented to the President of the United States; if he approve he shall sign it, but if not he shall return it, with his objections to that house in which it shall have originated, who shall enter the objections at large on their journal, and proceed to reconsider it. If after such reconsideration two-thirds of that house shall

agree to pass the bill, it shall be sent, together with the objections, to the other house, by which it shall likewise be reconsidered, and if approved by two-thirds of that house, it shall become a law. But in all such cases the votes of both houses shall be determined by yeas and nays, and the names of the persons voting for and against the bill shall be entered on the journal of each house respectively. If any bill shall not be returned by the President within ten days (Sundays excepted) after it shall have been presented to him, the same shall be a law, in like manner as if he had signed it, unless the Congress by their adjournment prevent its return, in which case it shall not be a law.

Every order, resolution, or vote to which the concurrence of the Senate and House of Representatives may be necessary (except on a question of adjournment) shall be presented to the President of the United States; and before the same shall take effect, shall be approved by him, or being disapproved by him, shall be repassed by two-thirds of the Senate and House of Representatives, according to the rules and limitations prescribed in the case of a bill.

Sec. 8. The Congress shall have power to lay and collect taxes, duties, imposts, and excises, to pay the debts and provide for the common defence and general welfare of the United States; but all duties, imposts, and excises shall be uniform throughout the United States.

ARTICLE II

Sec. 1. The executive power shall be vested in a President of the United States of America. He shall hold his office during the term of four years, and, together with the Vice President, chosen for the same term, be elected, as follows:

Each State shall appoint, in such manner as the legislature thereof may direct, a number of electors, equal to the whole number of Senators and Representatives to which the State may be entitled in the Congress.

No person except a natural-born citizen, or a citizen of the United States, at the time of the adoption of this Constitution, shall be eligible to the office of President; neither shall any person be eligible to that office who shall not have attained to the age of thirty-five years, and been fourteen years a resident within the United States.

In case of the removal of the President from office, or of his death, resignation, or inability to discharge the powers and duties of the said office, the same shall devolve on the Vice-President, and the Congress may by law provide for the case of removal, death, resignation, or inability, both of the President and Vice-President, declaring what officer shall then act as President, and such officer shall act accordingly, until the disability be removed, or a President shall be elected.

Before he enter on the execution of his office, he shall take the following oath or affirmation: 'I do solemnly swear (or affirm) that I will faithfully execute the office of President of the United States, and will to the best of my ability, preserve, protect, and defend the Constitution of the United States.'

Sec. 2. The President shall be Commander-in-Chief of the Army and Navy of the United States, and of the militia of the several States, when called into the actual service of the United States.

He shall have power, by and with the advice and consent of the Senate, to make treaties, provided two-thirds of the Senators present concur; and he shall nominate, and by and with the advice and consent of the Senate, shall appoint ambassadors, other public ministers and consuls, judges of the Supreme Court, and all other officers of the United States, whose appointments are not herein otherwise provided for, and which shall be established by law; but the Congress may by law vest the appointment of such inferior officers, as they think proper, in the President alone, in the courts of law, or in the heads of departments.

The President shall have power to fill up all vacancies that may happen during the recess of the Senate, by granting commissions which shall expire at the end of their next session.

Sec. 3. He shall from time to time give to the Congress information of the state of the Union, and recommend to their consideration such measures as he shall judge necessary and expedient.

Sec. 4. The President, Vice-President and all civil officers of the United States, shall be removed from office on impeachment for, and conviction of, treason, bribery, or other high crimes and misdemeanors.

ARTICLE III

Sec. 1. The judicial power of the United States, shall be vested in one Supreme Court, and in such inferior courts as the Congress may from time to time ordain and establish. The judges, both of the supreme and inferior courts, shall hold their offices during good behaviour, and shall, at stated times, receive for their services, a compensation, which shall not be diminished during their continuance in office.

Sec. 2. The judicial power shall extend to all cases, in law and equity, arising under this Constitution, the laws of the United States, and treaties made, or which shall be made, under their authority, to all cases affecting ambassadors, other public ministers and consuls; to all cases of admiralty and maritime jurisdiction; to controversies to which the United States shall be a party; to controversies between two or more

States; between a State and citizens of another State; between citizens of different states, between citizens of the same State claiming lands under grants of different States, and between a State, or the citizen thereof, and foreign States, citizens or subjects.

The trial of all crimes, except in cases of impeachment, shall be by jury; and such trial shall be held in the State where the said crimes shall have been committed; but when not committed within any State, the trial shall be at such place or places as the Congress may by law have directed.

ARTICLE IV

Sec. 1. Full faith and credit shall be given in each State to the public acts, records, and judicial proceedings of every other State. And the Congress may by general laws prescribe the manner in which such acts, records, and proceedings shall be provided, and the effect thereof.

Sec. 2. The citizens of each State shall be entitled to all privileges and immunities of citizens in the several States.

A person charged in any State with treason, felony, or other crime, who shall flee from justice, and be found in another State, shall on demand of the executive authority of the State from which he fled, be delivered up, to be removed to the State having jurisdiction of the crime.

Sec. 3. New States may be admitted by the Congress into this Union; but no new States shall be formed or erected within the jurisdiction of any other State; nor any State be formed by the junction of two or more states; or parts of States, without the consent of the legislatures of the States concerned as well as of the Congress.

Amendments to the Constitution (a selection)
Articles I–X, 1791

ARTICLE 1

Congress shall make no law respecting an establishment of religion, or prohibiting the free exercise thereof; or abridging the freedom of speech, or of the press; or the right of the people peaceably to assemble, and to petition the government for a redress of grievances.

ARTICLE II

A well regulated militia, being necessary to the security of a free State, the right of the people to keep and bear arms, shall not be infringed.

ARTICLE IV

The right of the people to be secure in their persons, houses, papers, and effects, against unreasonable searches and seizures, shall not be violated, and no warrants shall issue, but upon probable cause, supported by oath or affirmation, and particularly describing the place to be searched, and the persons or things to be seized.

ARTICLE V

No person shall be held to answer for a capital, or otherwise infamous crime, unless on a presentment or indictment of a grand jury, except in cases arising in the land or naval forces, or in the militia, when in actual service in time of war or public danger; nor shall any person be subject for the same offence to be twice put in jeopardy of life or limb; nor shall be compelled in any criminal case to be a witness against himself, nor be deprived of life, liberty, or property, without due process of law; nor shall private property be taken for public use, without just compensation.

ARTICLE VI

In all criminal prosecutions, the accused shall enjoy the right to a speedy and public trial, by an impartial jury of the State and district wherein the crime shall have been committed, which district shall have been pre-viously ascertained by law, and to be informed of the nature and cause of the accusation; to be confronted with the witnesses against him; to have compulsory process for obtaining witnesses in his favor, and to have the assistance of counsel for his defence.

ARTICLE X

The powers not delegated to the United States by the Constitution, nor prohibited by it to the States, are reserved to the States respectively, or to the people.

ARTICLE XII (1804)

The electors shall meet in their respective states, and vote by ballot for President and Vice-President, one of whom, at least, shall not be an inhabitant of the same state with themselves; they shall name in their ballots the person voted for as President, and in distinct ballots the person voted for as Vice-President, and they shall make distinct lists of all persons voted for as President, and of all persons voted for as Vice-President, and of the number of votes for each, which lists they shall sign

and certify, and transmit sealed to the seat of the Government of the United States, directed to the President of the Senate; The President of the Senate shall, in the presence of the Senate and House of Representatives, open all the certificates and the votes shall then be counted; The person having the greatest number of votes for President, shall be the President, if such number be a majority of the whole number of electors appointed; and if no person have such majority, then from the persons having the highest numbers not exceeding three on the list of those voted for as President, the House of Representatives shall choose immediately, by ballot, the President.

ARTICLE XIII (1865)

Sec. 1. Neither slavery nor involuntary servitude, except as a punishment for crime whereof the party shall have been duly convicted, shall exist within the United States, or any place subject to their jurisdiction.

ARTICLE XIV (1868)

Sec. 1. All persons born or naturalized in the United States, and subject to the jurisdiction thereof, are citizens of the United States and of the State wherein they reside. No State shall make or enforce any law which shall abridge the privileges or immunities of citizens of the United States; nor shall any State deprive any person of life, liberty, or property, without due process of law; nor deny to any person within its jurisdiction the equal protection of the laws.

Sec. 2. Representatives shall be apportioned among the several States according to their respective numbers, counting the whole number of persons in each State, excluding Indians not taxed. But when the right to vote at any election for the choice of electors for President and Vice-President of the United States, Representatives in Congress, the Executive and Judicial officers of a State, or the members of the Legislature thereof, is denied to any of the male inhabitants of such State, being twenty-one years of age, and citizens of the United States, or in any way abridged, except for participation in rebellion, or other crime, the basis of representation therein shall be reduced in the proportion which the number of such male citizens shall bear to the whole number of male citizens twenty-one years of age in such State.

ARTICLE XV (1870)

Sec. 1. The right of citizens of the United States to vote shall not be denied or abridged by the United States or by any State on account of race, color, or previous condition of servitude.

Sec. 2. The Congress shall have power to enforce this article by appropriate legislation.

ARTICLE XVII (1913)

The Senate of the United States shall be composed of two Senators from each State, elected by the people thereof, for six years; and each Senator shall have one vote. The electors in each State shall have the qualifications requisite for electors of the most numerous branch of the State legislature.

When vacancies happen in the representation of any State in the Senate, the executive authority of such State shall issue writs of election to fill such vacancies: *Provided,* That the legislature of any State may empower the executive thereof to make temporary appointments until the people fill the vacancies by election as the legislature may direct.

This amendment shall not be so construed as to affect the election or term of any Senator chosen before it becomes valid as part of the Constitution.

ARTICLE XVIII (1919)

After one year from the ratification of this article, the manufacture, sale, or transportation of intoxicating liquors within, the importation thereof into, or the exportation thereof from the United States and all territory subject to the jurisdiction thereof for beverage purposes is hereby prohibited.

The Congress and the several States shall have concurrent power to enforce this article by appropriate legislation.

ARTICLE XIX (1920)

The right of citizens of the United States to vote shall not be denied or abridged by the United States or by any States on account of sex.

The Congress shall have power to appropriate legislation to enforce the provisions of this article.

ARTICLE XXI (1933)

Sec. 1. The eighteenth article of amendment to the Constitution of the United States is hereby repealed.

Sec. 2. The transportation or importation into any State, territory or possession of the United States for delivery or use therein of intoxicating liquors, in violation of the laws thereof, is hereby prohibited.

ARTICLE XXII (1951)

Sec. 1. No person shall be elected to the office of the President more than twice, and no person who has held the office of President, or acted as President, for more than two years of a term to which some other person was elected President shall be elected to the office of the President more than once. But this Article shall not apply to any person holding the office of President when this Article was proposed by the Congress, and shall not prevent any person who may be holding the office of President or acting as President during the term within which this Article becomes operative, from holding the office of President, or acting as President, during the remainder of such term.

ARTICLE XXIV (1964)

Sec. 1. The right of citizens of the United States to vote in any primary or other election for President or Vice-President, for electors for President or Vice-President, or for Senator or Representative in Congress, shall not be denied or abridged by the United States or any State by reason of failure to pay any poll tax or other tax.

ARTICLE XXV (1967)

Sec. 1. In case of the removal of the President from office or of his death or resignation, the Vice-President shall become President.

Sec. 2. Whenever there is a vacancy in the office of the Vice-President, the President shall nominate a Vice-President who shall take office upon confirmation by a majority vote of both Houses of Congress.

ARTICLE XXVI (1971)

Sec. 1. The right of citizens of the United States, who are eighteen years of age or older, to vote shall not be denied or abridged by the United States or by any State on account of age.

45 JAMES MADISON

FROM "How a Republic Will Reduce the Evil of Faction" (1788)

Among the numerous advantages promised by a well-constructed Union, none deserves to be more accurately developed than its tendency to break and control the violence of faction. . . . Complaints are everywhere heard from our most considerate and virtuous citizens, especially the friends of public and private faith and of public and personal liberty,

that our governments are too unstable, that the public good is disregarded in the conflicts of rival parties, and that the measures are too often decided, not according to the rules of justice and the rights of the minor party, but by the superior force of an interested and overbearing majority. However anxiously we may wish that these complaints had no foundation, the evidence of known facts will not permit us to deny that they are in some degree true.

It will be found, indeed, on a candid review of our situation, that some of the distresses under which we labor have been erroneously charged on the operation of our governments; but it will be found, at the same time, that other causes will not alone account for many of our heaviest misfortunes; and, particularly, for that prevailing and increasing distrust of public engagements and alarm for private rights which are echoed from end of the continent to the other. These must be chiefly, if not wholly, effects of the unsteadiness and injustice with which a factious spirit has tainted our public administration.

By a faction I understand a number of citizens, whether amounting to a majority or minority of the whole, who are united and actuated by some common impulse of passion, or of interest, adverse to the rights of other citizens, or to the permanent and aggregate interests of the community.

There are two methods of curing the mischiefs of faction: the one, by removing its causes; the other, by controlling its effects.

There are again two methods of removing the causes of faction: the one, by destroying the liberty which is essential to its existence; the other, by giving to every citizen the same opinions, the same passions, and the same interests.

It could never be more truly said of the first remedy than that it was worse than the disease. Liberty is to faction what air is to fire, an aliment without which it instantly expires. But it could not be a less folly to abolish liberty, which is essential to political life, because it nourishes faction than it would be to wish the annihilation of air, which is essential to animal life, because it imparts to fire its destructive agency.

The second expedient is as impracticable as the first would be unwise. As long as the reason of man continues fallible, and he is at liberty to exercise it, different opinions will be formed. . . .

So strong is this propensity of mankind to fall into mutual animosities that where no substantial occasion presents itself the most frivolous and fanciful distinctions have been sufficient to kindle their unfriendly passions and excite their most violent conflicts. But the most common and durable source of factions has been the various and unequal distribution of property. Those who hold and those who are without property have ever formed distinct interests in society. Those who are creditors, and those who are debtors, fall under a like discrimination. A landed interest,

a manufacturing interest, a mercantile interest, a moneyed interest, with many lesser interests, grow up of necessity in civilized nations, and divide them into different classes, actuated by different sentiments and views. The regulation of these various and interfering interests forms the principal task of modern legislation and involves the spirit of party and faction in the necessary and ordinary operations of government.

No man is allowed to be a judge in his own cause, because his interest would certainly bias his judgment, and, not improbably, corrupt his integrity. With equal, nay with greater reason, a body of men are unfit to be both judges and parties at the same time; yet what are many of the most important acts of legislation but so many judicial determinations, not indeed concerning the rights of single persons, but concerning the rights of large bodies of citizens? And what are the different classes of legislators but advocates and parties to the causes which they determine? . . .

It is in vain to say that enlightened statesmen will be able to adjust these clashing interests and render them all subservient to the public good. Enlightened statesmen will not always be at the helm. Nor, in many cases, can such an adjustment be made at all without taking into view indirect and remote considerations, which will rarely prevail over the immediate interest which one party may find in disregarding the rights of another or the good of the whole.

The inference to which we are brought is that the *causes* of faction cannot be removed and that relief is only to be sought in the means of controlling its *effects*.

If a faction consists of less than a majority, relief is supplied by the republican principle, which enables the majority to defeat its sinister views by regular vote. It may clog the administration, it may convulse the society; but it will be unable to execute and mask its violence under the forms of the Constitution. When a majority is included in a faction, the form of popular government, on the other hand, enables it to sacrifice to its ruling passion or interest both the public good and the rights of other citizens. To secure the public good and private rights against the danger of such a faction, and at the same time to preserve the spirit and the form of popular government, is then the great object to which our inquiries are directed. . . .

By what means is this object attainable? Evidently by one of two only. Either the existence of the same passion or interest in a majority at the same time must be prevented, or the majority, having such coexistent passion or interest, must be rendered, by their number and local situation, unable to concert and carry into effect schemes of oppression. If the impulse and the opportunity be suffered to coincide, we well know that neither moral nor religious motives can be relied on as an adequate control. They are not found to be such on the injustice and violence of

individuals, and lose their efficacy in proportion to the number combined together, that is, in proportion as their efficacy becomes needful.

From this view of the subject it may be concluded that a pure democracy, by which I mean a society consisting of a small number of citizens, who assemble and administer the government in person, can admit of no cure for the mischiefs of faction. A common passion or interest will, in almost every case, be felt by a majority of the whole; a communication and concert results from the form of government itself; and there is nothing to check the inducements to sacrifice the weaker party or an obnoxious individual. Hence it is that such democracies have ever been spectacles of turbulence and contention; have ever been found incompatible with personal security or the rights of property; and have in general been as short in their lives as they have been violent in their deaths. Theoretic politicians, who have patronized this species of government, have erroneously supposed that by reducing mankind to a perfect equality in their political rights, they would at the same time be perfectly equalized and assimilated in their possessions, their opinions, and their passions.

A republic, by which I mean a government in which the scheme of representation takes place, opens a different prospect and promises the cure for which we are seeking. Let us examine the points in which it varies from pure democracy, and we shall comprehend both the nature of the cure and the efficacy which it must derive from the Union.

The two great points of difference between a democracy and a republic are: first, the delegation of the government, in the latter, to a small number of citizens elected by the rest; secondly, the greater number of citizens and greater sphere of country over which the latter may be extended.

46 E. L. DOCTOROW

FROM "A Citizen Reads the Constitution" (1987)

Not including the amendments, it is approximately five thousand words long – about the length of a short story. It is an enigmatically dry, unemotional piece of work, tolling off in its monotone the structures and functions of government, the conditions and obligations of office, the limitations of powers, the means for redressing crimes and conducting commerce. It makes itself the supreme law of the land. It concludes with instructions on how it can amend itself, and undertakes to pay all the debts incurred by the states under its indigent parent, the Articles of Confederation.

It is no more scintillating as reading than I remember it to have been in Mrs. Brundage's seventh-grade civics class at Joseph H. Wade Junior

High School. It is five thousand words but reads like fifty thousand. It lacks high rhetoric and shows not a trace of wit, as might be expected of the product of a committee of lawyers. It uses none of the tropes of literature to create empathetic states in the mind of the reader. It does not mean to persuade. It abhors metaphor as nature abhors a vacuum.

One's first reaction upon reading it is to rush for relief to an earlier American document:

> We hold these truths to be self-evident, that all men are created equal, that they are endowed by their Creator with certain unalienable Rights, that among these are Life, Liberty and the pursuit of Happiness. That to secure these rights, Governments are instituted among Men, deriving their just powers from the consent of the governed. That whenever any Form of Government becomes destructive of these ends, it is the Right of the People to alter or to abolish it, and to institute new Government.

That is the substantive diction of a single human mind – Thomas Jefferson's, as it happens – even as it speaks for all. It is engaged in the art of literary revolution, rewriting history, overthrowing divine claims to rule and genealogical hierarchies of human privilege as cruel frauds, defining human rights as universal and distributing the source and power of government to the people governed. It is the radical voice of national liberation, combative prose lifting its musketry of self-evident truths and firing away.

Surely I am not the only reader to wish that the Constitution could have been written out of something of the same spirit? Of course, I know instinctively that it could not, that statute writing in the hands of lawyers has its own demands, and those are presumably precision and clarity, which call for sentences bolted at all four corners with *wherein*s and *whereunder*s and *thereof*s and *therein*s and *notwithstanding the foregoing*s.

Still and all, an understanding of the Constitution must come of an assessment of its character as a composition, and it would serve us to explore further why it is the way it is. . . .

It is true but not sufficient to say that the Constitution reads as it does because it was written by a committee of lawyers. Something more is going on here. Every written composition has a voice, a persona, a character of presentation, whether by design of the author or not. The voice of the Constitution is a quiet voice. It does not rally us; it does not call on self-evident truths; it does not arm itself with philosophy or political principle; it does not argue, explain, condemn, excuse or justify. It is postrevolutionary. Not claiming righteousness, it is, however, suffused with rectitude. It is this way because it seeks standing in the world, the elevation of the unlawful acts of men – unlawful first because the British government has been overthrown, and second

because the confederation of the states has been subverted – to the lawful standing of nationhood. All the *hereins* and *whereas*es and *thereof*s are not only legalisms; they also happen to be the diction of the British Empire, the language of the deposed. Nothing has changed that much, the Constitution says, lying; we are nothing that you won't recognize.

But there is something more. The key verb of the text is *shall*, as in "All legislative powers herein granted shall be vested in a Congress of the United States which shall consist of a Senate and a House of Representatives," or "New States may be admitted by the Congress into this Union; but no new State shall be formed or erected within the jurisdiction of any other State." The Constitution does not explicitly concern itself with the grievances that brought it about. It is syntactically futuristic: it prescribes what is to come. It prophesies. Even today, living two hundred years into the prophecy, we read it and find it still ahead of us, still extending itself in time. The Constitution gives law and assumes for itself the power endlessly to give law. It ordains. In its articles and sections, one after another, it offers a ladder to heaven. It is cold, distant, remote as a voice from on high, self-authenticating.

Through most of history kings and their servitor churches did the ordaining, and always in the name of God. But here the people do it: "We the People . . . do ordain and establish this Constitution for the United States." And the word for God appears nowhere in the text. Heaven forbid! In fact, its very last stricture is that "no religious test shall ever be required as a qualification to any office or public trust under the United States."

The voice of the Constitution is the inescapably solemn self-consciousness of the people giving the law unto themselves. But since in the Judeo-Christian world of Western civilization all given law imitates God – God being the ultimate lawgiver – in affecting the transhuman voice of law, that dry monotone that disdains persuasion, the Constitution not only takes on the respectable sound of British statute, it more radically assumes the character of scripture.

The ordaining voice of the Constitution is scriptural, but in resolutely keeping the authority for its dominion in the public consent, it presents itself as the sacred text of secular humanism. . . .

Now, it is characteristic of any sacred text that it has beyond its literal instruction tremendous symbolic meaning for the people who live by it. Think of the Torah, the Koran, the Gospels. The sacred text dispenses not just social order but spiritual identity. And as the states each in its turn ratified the Constitution, usually not without vehement debate and wrangling, the public turned out in the streets of major cities for processions, festivities, with a fresh new sense of themselves and their future. . . .

Yet it is true also of sacred texts that when they create a spiritual

community, they at the same time create a larger community of the excluded. The Philistines are excluded or the pagans or the unwashed.

Even as the Constitution was establishing its sacred self in the general mind, it was still the work, the composition, of writers; and the writers were largely patrician, not working class. They tended to be well educated, wealthy, and not without self-interest. . . .

And so I find here in my reflections a recapitulation of the debate of American constitutional studies of the past two hundred years, in the same manner that ontogeny was once said to recapitulate phylogeny. Thus it was in the nineteenth century that historians such as George Bancroft celebrated the revolutionary nature of the Founding Fathers' work, praising them for having conceived of a republic of equal rights under law, constructed from the materials of the European Enlightenment but according to their own pragmatic Yankee design – a federalism of checks and balances that would withstand the worst buffetings of history, namely the Civil War, in the aftermath of which Bancroft happened to be writing.

Then in the early part of the twentieth century, when the worst excesses of American business were coming to light, one historian, Charles Beard, looked at old Treasury records and other documents and discovered enough to assert that the Fathers stood to gain personally from the way they put the thing together, at least their class did; that they were mostly wealthy men and lawyers; and that the celebrated system of checks and balances, instead of insuring a distribution of power and a democratic form of government, in fact could be seen as having been devised to control populist sentiment and prevent a true majoritarian politics from operating in American life at the expense of property rights. Madison had said as much, Beard claimed, in *Federalist* number 10, which he wrote to urge ratification. Beard's economic interpretation of the Constitution has ever since governed scholarly debate. At the end of the Depression a neo-Beardian, Merrill Jensen, looked again at the postrevolutionary period and came up with a thesis defending the Articles of Confederation as the true legal instrument of the Revolution, which, with modest amendments, could have effected the peace and order of the states with more democracy than a centralist government. In fact, he argued, there was no crisis under the Articles or danger of anarchy, except in the minds of the wealthy men who met in Philadelphia.

But countervailing studies appeared in the 1950s, the era of postwar conservatism, that showed Beard's research to be inadequate, asserting, for instance, that there were as many wealthy men of the framers' class who were against ratification as who were for it, or that men of power and influence tended to react according to the specific needs of their own states and localities, coastal or rural, rather than according to class.

And in the 1960s, the Kennedy years, a new argument appeared describing the Constitutional Convention above all as an exercise of democratic politics, a nationalist reform caucus that was genuinely patriotic, improvisational, and always aware that what it did must win popular approval if it was to become the law of the land.

In my citizen's self-instruction I embrace all of those interpretations. I believe all of them. I agree that something unprecedented and noble was created in Philadelphia; but that economic class self-interest was a large part of it; but that it was democratic and improvisational; but that it was, at the same time, something of a coup. I think all of those theories are true, simultaneously.

47 THOMAS JEFFERSON

FROM "The Roots of Democracy" (1816)

At the birth of our republic . . . we imagined everything republican which was not monarchy. We had not yet penetrated to the mother principle, that "governments are republican only in proportion as they embody the will of their people and execute it." Hence, our first constitutions had really no leading principle in them. But experience and reflection have but more and more confirmed me in the particular importance of the equal representation then proposed. . . .

Where, then, is our republicanism to be found? Not in our Constitution certainly, but merely in the spirit of our people. That would oblige even a despot to govern us republicanly. Owing to this spirit, and to nothing in the form of our Constitution, all things have gone well. But this fact, so triumphantly misquoted by the enemies of reformation, is not the fruit of our Constitution but has prevailed in spite of it. Our functionaries have done well, because generally honest men. If any were not so, they feared to show it. . . .

The true foundation of republican government is the equal right of every citizen in his person and property and in their management. Try by this, as a tally, every provision of our Constitution and see if it hangs directly on the will of the people. Reduce your legislature to a convenient number for full but orderly discussion. Let every man who fights or pays exercise his just and equal right in their election. Submit them to approbation or rejection at short intervals. Let the executive be chosen in the same way, and for the same term, by those whose agent he is to be; and leave no screen of a council behind which to skulk from responsibility.

It has been thought that the people are not competent electors of judges learned in the law. But I do not know that this is true, and, if doubtful, we should follow principle. . . .

The organization of our county administrations may be thought more difficult. But follow principle and the knot unties itself. Divide the counties into wards of such size as that every citizen can attend, when called on, and act in person. Ascribe to them the government of their wards in all things relating to themselves exclusively. A justice chosen by themselves in each, a constable, a military company, a patrol, a school, the care of their own poor, their own portion of the public roads, the choice of one or more jurors to serve in some court, and the delivery, within their own wards, of their own votes for all elective officers of higher sphere will relieve the county administration of nearly all its business, will have it better done, and by making every citizen an acting member of the government, and in the offices nearest and most interesting to him, will attach him by his strongest feelings to the independence of his country and its republican Constitution.

The justices thus chosen by every ward would constitute the county court, would do its judiciary business, direct roads and bridges, levy county and poor rates, and administer all the matters of common interest to the whole county. These wards, called townships in New England, are the vital principle of their governments, and have proved themselves the wisest invention ever devised by the wit of man for the perfect exercise of self-government, and for its preservation.

We should thus marshal our government into: (1) the general federal republic for all concerns foreign and federal; (2) that of the state, for what relates to our own citizens exclusively; (3) the county republics, for the duties and concerns of the county; and (4) the ward republics, for the small and yet numerous and interesting concerns of the neighborhood. And in government, as well as in every other business of life, it is by division and subdivision of duties alone that all matters, great and small, can be managed to perfection. And the whole is cemented by giving to every citizen, personally, a part in the administration of the public affairs.

The sum of these amendments is: (1) general suffrage; (2) equal representation in the legislature; (3) an executive chosen by the people; (4) judges elective or amovable; (5) justices, jurors, and sheriffs elective; (6) ward divisions; and (7) periodical amendments of the Constitution.

I have thrown out these, as loose heads of amendment, for consideration and correction; and their object is to secure self-government by the republicanism of our Constitution, as well as by the spirit of the people, and to nourish and perpetuate that spirit. I am not among those who fear the people. They, and not the rich, are our dependence for continued freedom.

And to preserve their independence, we must not let our rulers load us with perpetual debt. We must make our election between *economy and liberty*, or *profusion and servitude*. . . .

Some men look at constitutions with sanctimonious reverence and

deem them, like the Ark of the Covenant, too sacred to be touched. They ascribe to the men of the preceding age a wisdom more than human and suppose what they did to be beyond amendment. I knew that age well; I belonged to it and labored with it. It deserved well of its country. It was very like the present, but without the experience of the present; and forty years of experience in government is worth a century of book reading. And this they would say themselves were they to rise from the dead. I am certainly not an advocate for frequent and untried changes in laws and constitutions. I think moderate imperfections had better be borne with because, when once known, we accommodate ourselves to them, and find practical means of correcting their ill effects.

But I know also that laws and institutions must go hand in hand with the progress of the human mind. As that becomes more developed, more enlightened, as new discoveries are made, new truths disclosed, and manners and opinions change with the change of circumstances, institutions must advance also, and keep pace with the times. We might as well require a man to wear still the coat which fitted him when a boy, as civilized society to remain ever under the regimen of their barbarous ancestors. . . .

Each generation is as independent of the one preceding as that was of all which had gone before. It has then, like them, a right to choose for itself the form of government it believes most promotive of its own happiness; consequently, to accommodate to the circumstances in which it finds itself, that received from its predecessors; and it is for the peace and good of mankind that a solemn opportunity of doing this every nineteen or twenty years should be provided by the Constitution, so that it may be handed on with periodical repairs from generation to generation, to the end of time, if anything human can so long endure.

48 JOHN MARSHALL

FROM *Marbury v. Madison* (1803)

It is, then, the opinion of the Court:

First, that by signing the commission of Mr. Marbury, the President of the United States appointed him a justice of peace for the County of Washington, in the District of Columbia, and that the seal of the United States, affixed thereto by the secretary of state, is conclusive testimony of the verity of the signature, and of the completion of the appointment; and that the appointment conferred on him a legal right to the office for the space of five years.

Second, that, having this legal title to the office, he has a consequent right to the commission; a refusal to deliver which is a plain violation of that right for which the laws of his country afford him a remedy. . . .

This, then, is a plain case for a mandamus, either to deliver the commission or a copy of it from the record; and it only remains to be inquired whether it can issue from this Court.

The act to establish the judicial courts of the United States authorizes the Supreme Court "to issue writs of mandamus, in cases warranted by the principles and usages of law, to any courts appointed, or persons holding office, under the authority of the United States."

The secretary of state, being a person holding an office under the authority of the United States, is precisely within the letter of the description; and if this Court is not authorized to issue a writ of mandamus to such an officer, it must be because the law is unconstitutional and therefore absolutely incapable of conferring the authority and assigning the duties which its words purport to confer and assign.

The Constitution vests the whole judicial power of the United States in one Supreme Court and such inferior courts as Congress shall, from time to time, ordain and establish. This power is expressly extended to all cases arising under the laws of the United States and, consequently, in some form, may be exercised over the present case because the right claimed is given by a law of the United States.

In the distribution of this power it is declared that "the Supreme Court shall have original jurisdiction in all cases affecting ambassadors, other public ministers, and consuls, and those in which a state shall be a party. In all other cases, the Supreme Court shall have appellate jurisdiction." . . .

To enable this Court, then, to issue a mandamus, it must be shown to be an exercise of appellate jurisdiction or to be necessary to enable them to exercise appellate jurisdiction. . . .

[However,] the authority . . . given to the Supreme Court by the act establishing the judicial courts of the United States to issue writs of mandamus to public officers appears not to be warranted by the Constitution; and it becomes necessary to inquire whether a jurisdiction so conferred can be exercised.

The question whether an act repugnant to the Constitution can become the law of the land is a question deeply interesting to the United States but, happily, not of an intricacy proportioned to its interest. It seems only necessary to recognize certain principles, supposed to have been long and well established, to decide it.

That the people have an original right to establish, for their future government, such principles as, in their opinion, shall most conduce to their own happiness is the basis on which the whole American fabric has been erected. The exercise of this original right is a very great exertion; nor can it, nor ought it, to be frequently repeated. The principles, therefore, so established are deemed fundamental. And as the authority

from which they proceed is supreme and can seldom act, they are designed to be permanent.

This original and supreme will organizes the government and assigns to different departments their respective powers. It may either stop here or establish certain limits not to be transcended by those departments.

The government of the United States is of the latter description. The powers of the legislature are defined and limited; and that those limits may not be mistaken or forgotten, the Constitution is written. To what purpose are powers limited, and to what purpose is that limitation committed to writing, if these limits may, at any time, be law of the nation, and, consequently, the theory of every such government must be that an act of the legislature repugnant to the Constitution is void. . . .

This theory is essentially attached to a written constitution and is, consequently, to be considered by this Court as one of the fundamental principles of our society. It is not, therefore, to be lost sight of in the further consideration of this subject.

If an act of the legislature repugnant to the Constitution is void, does it, notwithstanding its invalidity, bind the courts and oblige them to give it effect? Or, in other words, though it be not law, does it constitute a rule as operative as if it was a law? This would be to overthrow in fact what was established in theory and would seem, at first view, an absurdity too gross to be insisted on. It shall, however, receive a more attentive consideration.

It is, emphatically, the province and duty of the Judicial Department to say what the law is. Those who apply the rule to particular cases must of necessity expound and interpret that rule. If two laws conflict with each other, the courts must decide on the operation of each. So if a law be in opposition to the Constitution, if both the law and the Constitution apply to a particular case, so that the court must either decide that case conformably to the law, disregarding the Constitution, or conformably to the Constitution, disregarding the law, the court must determine which of these conflicting rules governs the case. This is of the very essence of judicial duty. If, then, the courts are to regard the Constitution, and the Constitution is superior to any ordinary act of the legislature, the Constitution, and not such ordinary act, must govern the case to which they both apply.

49 ANDREW JACKSON

FROM Proclamation to the People of South Carolina (1832)

Here is a law of the United States, not even pretended to be unconstitutional, repealed by the authority of a small majority of the voters of a

single state. Here is a provision of the Constitution which is solemnly abrogated by the same authority.

On such expositions and reasonings the ordinance grounds not only an assertion of the right to annul the laws of which it complains but to enforce it by a threat of seceding from the Union if any attempt is made to execute them.

This right to secede is deduced from the nature of the Constitution, which, they say, is a compact between sovereign states who have preserved their whole sovereignty and therefore are subject to no superior; that because they made the compact they can break it when in their opinion it has been departed from by the other states. Fallacious as this course of reasoning is, it enlists state pride and finds advocates in the honest prejudices of those who have not studied the nature of our government sufficiently to see the radical error on which it rests. . . .

The Constitution of the United States, then, forms a *government*, not a league; and whether it be formed by compact between the states or in any other manner, its character is the same. It is a government in which all the people are represented, which operates directly on the people individually, not upon the states; they retained all the power they did not grant. But each state, having expressly parted with so many powers as to constitute, jointly with the other states, a single nation, cannot, from that period, possess any right to secede, because such secession does not break a league but destroys the unity of a nation; and any injury to that unity is not only a breach which would result from the contravention of a compact but it is an offense against the whole Union.

To say that any state may at pleasure secede from the Union is to say that the United States are not a nation, because it would be a solecism to contend that any part of a nation might dissolve its connection with the other parts, to their injury or ruin, without committing any offense. Secession, like any other revolutionary act, may be morally justified by the extremity of oppression; but to call it a constitutional right is confounding the meaning of terms, and can only be done through gross error or to deceive those who are willing to assert a right, but would pause before they made a revolution or incur the penalties consequent on a failure.

Because the Union was formed by a compact, it is said the parties to that compact may, when they feel themselves aggrieved, depart from it; but it is precisely because it is a compact that they cannot. A compact is an agreement or binding obligation. It may by its terms have a sanction or penalty for its breach, or it may not. If it contains no sanction, it may be broken with no other consequence than moral guilt; if it have a sanction, then the breach incurs the designated or implied penalty. A league between independent nations generally has no sanction other than a moral one; or if it should contain a penalty, as there is no

common superior it cannot be enforced. A government, on the contrary, always has a sanction, express or implied; and in our case it is both necessarily implied and expressly given. An attempt by force of arms to destroy a government is an offense, by whatever means the constitutional compact may have been formed; and such government has the right by the law of self-defense to pass acts for punishing the offender, unless that right is modified, restrained, or resumed by the constitutional act. In our system, although it is modified in the case of treason, yet authority is expressly given to pass all laws necessary to carry its powers into effect, and under this grant provision has been made for punishing acts which obstruct the due administration of the laws. . . .

Disunion by armed force is *treason*. Are you really ready to incur its guilt? If you are, on the heads of the instigators of the act be the dreadful consequences; on their heads be the dishonor, but on yours may fall the punishment. On your unhappy state will inevitably fall all the evils of the conflict you force upon the government of your country. It cannot accede to the mad project of disunion, of which you would be the first victims. Its first magistrate cannot, if he would, avoid the performance of his duty. . . .

Fellow citizens of the United States, the threat of unhallowed disunion, the names of those once respected by whom it is uttered, the array of military force to support it, denote the approach of a crisis in our affairs on which the continuance of our unexampled prosperity, our political existence, and perhaps that of all free governments may depend. The conjuncture demanded a free, a full and explicit enunciation, not only of my intentions, but of my principles of action; and as the claim was asserted of a right by a state to annul the laws of the Union, and even to secede from it at pleasure, a frank exposition of my opinions in relation to the origin and form of our government and the construction I give to the instrument by which it was created seemed to be proper.

Having the fullest confidence in the justness of the legal and constitutional opinion of my duties which has been expressed, I rely with equal confidence on your undivided support in my determination to execute the laws, to preserve the Union by all constitutional means, to arrest, if possible, by moderate and firm measures the necessity of a recourse to force; and if it be the will of Heaven that the recurrence of its primeval curse on man for the shedding of a brother's blood should fall upon our land, that it be not called down by any offensive act on the part of the United States.

50 JOHN KENNETH GALBRAITH

"The American Presidency: Going the Way of the Blacksmith?" (1988)

Cambridge, Massachusetts –

Now that the US election and the ensuing discussion and recrimination are pleasantly in the past, there is satisfaction in finding one matter on which all observers are agreed: The 1988 presidential campaign set a new low in banality extending to unimaginative bad taste.

What is not commendable is the almost universal failure to see why the performance was so bad. It is that the presidency has become, by all past standards, a relatively unimportant job. Only from its past significance do its continuity, aura and interest come.

Three factors, all above dispute, have diminished the presidency. They are the exfoliation of great organizations, often referred to as bureaucracy; the fact that powerful controlling circumstances have taken over from presidential decision on foreign policy; and that they have done much the same on domestic policy.

The role of organization is the most obvious change. When Woodrow Wilson sat down at his typewriter to write a speech, as he is held to have done, one cannot doubt that he had a considerable effect on what was said.

Presidential speeches now come from a special speech-writing staff. This staff did not exist until the 1930s, when President Roosevelt, in what was thought a substantial innovation, acquired a small cadre of assistants, who were to have, it was promised, "a passion for anonymity." In the 1940 elections, the president did assemble a small group of speech writers, three or four in number, of whom I was one. When the speech was finally delivered, we listened ardently to the radio to see if any of our words had survived the presidential touch. Not many did.

The case carries on to policy. Wilson, we can safely assume, had a pre-eminent role in the identification and positioning of the Fourteen Points. Now each point would be the product of a task force of around 10 specialists and departmental bystanders, for a total of at least 140 persons. Only then would the president see the plan.

There is an inevitable tendency for power, in the presence of a larger organization, to pass down into the body of that organization. As the power of the president has passed down into organization, so has that of the cabinet officers. In these last years, for example, no one outside the immediate area of concern has known the name of the agriculture secretary.

Finally, there is the Pentagon. This has become a power unto itself, a power sufficiently great that neither candidate in the last election

dreamed of saying anything that might seem to suggest that he was "soft on defense."

In much of his second term, President Reagan has rarely risked a press conference. This has been attributed, not wholly without reason, to an absence of acuity and knowledge. But, in fairness, more must be attributed to the fact that in many of the matters on which he would have been queried, he would have had no role at all.

As to foreign policy, the controlling circumstances to which presidential power is subservient are two. There is the specter of nuclear devastation, which neither capitalism nor communism would survive. But the reality has come to control. That reality carried Ronald Reagan from his undoubted pleasure in denouncing the evil empire to an unprecedented association with Mikhail Gorbachev. And it led to the INF Treaty, in a process that, for mutual survival, must continue.

The controlling force of circumstance has been no less compelling on other foreign policy issues. There is the determination of nations, great and small, to be free of superpower control or influence. There is also the now evident irrelevance of capitalism and communism in their developed form for much of the world.

In one of the more powerful educational exercises of all time, it was discovered that not even the most eloquent ideologue could explain the difference between capitalism and communism to the inhabitants of the Mekong Delta. So it has been, one judges, with the nomads of the mountains and deserts of Afghanistan.

It was open to past presidents to attempt intervention in Indochina, Central America, the Dominican Republic and Cuba. No more. Not even Nicaragua is available for such presidential decision. The most George Bush can hope for is another Grenada.

On domestic policy there is more scope for presidential initiative. But here, too, the great political battles of the past are in the past. The two notable revolutions of this century – that which brought the welfare state and that which gave the government macroeconomic responsibility for employment, price stability and economic growth, that is, the Keynesian revolution – were once within the sphere of presidential action. Both were accepted in the last election. Mr. Bush not only accepted the need for Keynesian deficit financing to sustain employment but, implicitly at least, went far beyond anything that Mr. Keynes would suggest.

The question remains as to why presidential contests generate so much excitement. The answer is, first of all, that thousands of press, television and radio operatives are involved and must justify moderately remunerative travel and employment in the only modern industry exempt from any question as to worker productivity. Not surprisingly, all say, even believe, that they are covering an event of decisive importance.

There is also the strategic aspect of the contest. This has brought into

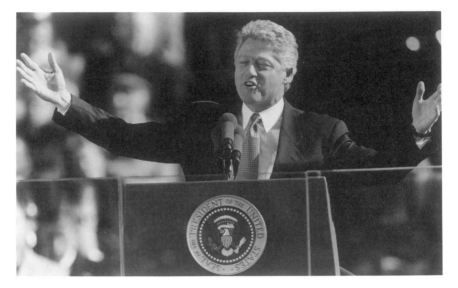

Figure 5.1 President Bill Clinton giving his inauguration speech, 1993
Photograph courtesy of Range/Reuter/Bettman

existence a large number of political experts who are the source of nearly unlimited comment on the design for presenting and shaping the candidate's personality, guiding his commercials and disposing his money. These experts are greatly admired, perhaps compassionately so, for their public life in most cases is very brief. An electoral genius is someone who, having been on the winning side in one election, is about to lose the next.

Finally, there is, as it may be called, the Super Bowl syndrome. Those immediately participant apart, it makes no difference who wins a particular game. But that does not keep millions of people from taking a deep, even breathless interest in the outcome. So with the modern presidential election.

A desire for the job is understandable. The president continues to have a considerable ceremonial role. He enjoys a significant number of nonsalaried benefits. But the penetrating irrelevance of the modern contest is not going unnoticed. Voter turnout in November was the lowest since Calvin Coolidge defeated John W. Davis in 1924. This was at a time when, most historians will agree, the importance of the job was also at a very low ebb.

6

PARTIES AND POLITICS

Introduction 162

51 *George Washington Plunkitt*
FROM "Honest Graft and Dishonest Graft" (1905) 164

52 *Joe McGinnis*
FROM *The Selling of the President* (1969) 165

53 *Studs Terkel*
FROM Interview with Congressman Philip M. Crane (1988) 167

54 *Studs Terkel*
FROM Interview with Ex-Congressman Bob Eckhardt (1988) 170

55 *Hedrick Smith*
FROM *The Power Game: How Washington Works* (1988) 172

56 *The Republican Party*
FROM The Republican Party Platform 1992 175

57 *The Democratic Party*
FROM The Democratic Party Platform 1992 178

INTRODUCTION

George Washington (see chapter 12) and James Madison were among many concerned Americans who warned against the evils of faction and the partisan spirit after the revolution. Nevertheless, political parties began to form around 1800. Then the Federalists, led by the able, pro-British, pro-big government, and industry-promoting Alexander Hamilton, provoked the formation of what became the Democratic-Republican and eventually the Democratic party, at that time led by the pro-French, anti-government, pro-farm and pro-small-business thinker Thomas Jefferson.

Jefferson, too, was actually skeptical of organized parties, and may not have approved of the way the Democrats, led by President Andrew Jackson, later organized a new type of mass party in the 1820s and 1830s. Jackson gave the Democratic party a strong slant of anti-establishment and populism. But because American parties were often in the past simply coalitions of state and local parties, their broader ideological content was not too clear. Very often, it seemed that the major concern of the parties was to bring about a change in who was in power, providing jobs for those who supported the winning party.

One illustration of the local "bread and butter" concerns which American parties have sometimes become famous or infamous for is the political machine. The party machines developed early in the nineteenth century and had lost most of their power by the middle of the twentieth century. While the political machines have been associated with both major parties in the United States, they have been especially connected with the Democratic party. In return for loyal votes, they served as miniature welfare societies for those who were less fortunate in society, such as immigrants and ethnic minorities. There were accordingly many of Irish and Italian descent in leading positions in the machines. Among the most notable Democratic machines was Tammany Hall in New York. Here George Washington Plunkitt was a ward leader. His autobiography gives a vivid picture of the incessant activities of a very local American politician near the end of the nineteenth century and the beginning of the twentieth. His 17–18-hour-long days included attendance at weddings, funerals, courts and jails, and numerous attempts to be of financial assistance to his voters, who were mostly of Italian, Jewish and Irish background. Plunkitt could afford to be generous. In part he could rely on public funds, but as the brief selection from his autobiography shows, he was also privately a wealthy man. How did he become so rich? Plunkitt makes no secret of the fact that it was by means of "honest graft" – graft being the American term for corruption. Readers may find Plunkitt's surprise distinction between "honest" and "dishonest" graft less than convincing. Corruption and city

mismanagement produced a movement for civil service reform in the years around 1900.

The viewpoint that American political parties are without ideological content, and that there is little difference between what for example the Democrats and the Republicans stand for, is exaggerated. Some historians point out that if Thomas Jefferson were alive today, he would still regard the Democratic party as the party of the less established and less fortunate in society.

Still, many Americans lean strongly toward regarding American parties and politicians as so lacking in ideological direction that they have little choice but to "sell" themselves to the people by posing as "somebody" as best they can. This is the message of Joe McGinnis's *The Selling of the President* (1969), from which an excerpt is included here. McGinnis presents the presidential candidate (Nixon) as the creation of marketing experts, often referred to as "Madison Avenue" after the New York City area where important marketing firms are located.

But a similar view has been voiced earlier, for example about Franklin D. Roosevelt – only that he "sold" himself by frequent radio talks, his famous "fireside chats." During the presidential years of Ronald Reagan, a former movie actor, there were many references to the "teflon presidency." One type of complaint about the 1988 (Bush v. Dukakis) and 1992 (Bush v. Clinton) presidential elections was that the candidates avoided the real issues and for the most part remained cosmetically on the surface. In the 1992 election, perhaps the most surprising event was the strong showing of Ross Perot, an independent anti-political Texas businessman. Though a third-party candidate without any clear program, his exceptionally strong backing at the polls reflected a basic reaction among many voters against politicians and politics.

In the third and fourth texts, two politicians – one Republican (Congressman Philip M. Crane) and one Democrat (ex-Congressman Bob Eckhardt) – testify in interviews to the fact that modern politicians are, indeed, asked to perform the feat of running constantly for election while (a) sitting on the fence even as they (b) have their ears close to the ground. The interviews may say something about where the two major parties stand on key issues. At the same time, as Crane is a midwesterner and Eckhardt a Texan, they also reflect regional viewpoints.

Life in the nation's political center is portrayed by a knowledgeable insider – Hedrick Smith – as rough indeed. His book, *The Power Game: How Washington Works* (1988; see extract 55), shows Washington as a battlefield for political war games where everybody fights everybody else in a constantly changing coalition of competing tribes.

But as already pointed out, despite all this and in spite of the American saying that a political platform is something like an old-fashioned railroad platform – simply a place you depart from – there may be

ideological differences beween the political parties in the United States. It is well known that this is frequently the case with so-called third parties, meaning special interest or special cause parties. But perhaps it is even true of the major parties such as the Democrats and the Republicans? Readers are asked to take a look at the extracts from the 1992 political party platforms of the two parties before accepting the idea that the parties are without a profile. The speeches by former presidents of the United States reproduced in other chapters of this book may also be useful in this respect.

51 GEORGE WASHINGTON PLUNKITT

FROM "Honest Graft and Dishonest Graft" (1905)

Everybody is talkin' these days about Tammany men growin' rich on graft, but nobody thinks of drawin' the distinction between honest graft and dishonest graft. There's all the difference in the world between the two. Yes, many of our men have grown rich in politics. I have myself. I've made a big fortune out of the game, and I'm gettin' richer every day, but I've not gone in for dishonest graft – blackmailin' gamblers, saloon-keepers, disorderly people, etc. – and neither has any of the men who have made big fortunes in politics.

There's an honest graft, and I'm an example of how it works. I might sum up the whole thing by sayin': "I seen my opportunities and I took 'em."

Just let me explain by examples. My party's in power in the city, and it's goin' to undertake a lot of public improvements. Well, I'm tipped off, say, that they're going to lay out a new park at a certain place.

I see my opportunity and I take it. I go to that place and I buy up all the land I can in the neighborhood. Then the board of this or that makes its plan public, and there is a rush to get my land, which nobody cared particular for before.

Ain't it perfectly honest to charge a good price and make a profit on my investment and foresight? Of course, it is. Well, that's honest graft.
. . .

Or supposin' it's a new bridge they're goin' to build. I get tipped off and I buy as much property as I can that has to be taken for approaches. I sell at my own price later on and drop some more money in the bank.

Wouldn't you? It's just like lookin' ahead in Wall Street or in the coffee or cotton market. It's honest graft, and I'm lookin' for it every day in the year. I will tell you frankly that I've got a good lot of it, too.

I'll tell you of one case. They were goin' to fix up a big park, no matter where. I got on to it, and went lookin' about for land in that neighborhood.

I could get nothin' at a bargain but a big piece of swamp, but I took it fast enough and held on to it. What turned out was just what I counted on. They couldn't make the park complete without Plunkitt's swamp, and they had to pay a good price for it. Anything dishonest in that?

Tammany was beat in 1901 because the people were deceived into believin' that it worked dishonest graft. They didn't draw a distinction between dishonest and honest graft, but they saw that some Tammany men grew rich, and supposed they had been robbin' the city treasury or levyin' blackmail on disorderly houses, or workin' in with the gamblers and lawbreakers.

As a matter of policy, if nothing else, why should the Tammany leaders go into such dirty business, when there is so much honest graft lyin' around when they are in power? Did you ever consider that?

Now, in conclusion, I want to say that I don't own a dishonest dollar. If my worst enemy was given the job of writin' my epitaph when I'm gone, he couldn't do more than write:

"George W. Plunkitt. He Seen His Opportunities, and He Took 'Em."

52 JOE McGINNIS

FROM *The Selling of the President* (1969)

Chicago was the site of the first ten programmes that Nixon would do in states ranging from Massachusetts to Texas. The idea was to have him in the middle of a group of people, answering questions live. [Frank] Shakespeare and [Harry] Treleaven [directors of advertising in the Nixon presidential campaign] had developed the idea through the primaries and now had it sharpened to a point. Each show would run one hour. It would be live to provide suspense; there would be a studio audience [recruited by the local Republican organization] to cheer Nixon's answers and make it seem to home viewers that enthusiasm for his candidacy was all but uncontrollable; and there would be an effort to achieve a conversational tone that would penetrate Nixon's stuffiness and drive out the displeasure he often seemed to feel when surrounded by other human beings instead of Bureau of the Budget reports. . . .

The set, now that it was finished, was impressive. There was a round blue-carpeted platform, six feet in diameter and eight inches high. Richard Nixon would stand on this and face the panel, which would be seated in a semicircle around him. Bleachers for the audience ranged out behind the panel chairs. Later, Roger Ailes [executive producer of Nixon's one-hour programmes] would think to call the whole effect "the arena concept" and bill Nixon as "the man in the arena." He got this from a Theodore Roosevelt quote which hung, framed, from a wall of his

office in Philadelphia. It said something about how one man in the arena was worth ten, or a hundred, or a thousand carping critics. . . .

Three days later, Roger Ailes composed a memorandum that contained the details of his reaction to the show. He sent it to Shakespeare and Garment [directors of advertising]:

> After completing the first one-hour program, I thought I would put a few general comments down on paper. . . .

I. The Look:

A. He [Nixon] looks good on his feet and shooting "in the round" gives dimension to him.

B. Standing adds to his "feel" of confidence and the viewers' "feel" of his confidence.

C. He still uses his arms a little too "predictably" and a little too often, but at this point it is better not to inhibit him.

D. He seems to be comfortable on his feet and even appears graceful and relaxed, i.e. hands on his hips or arms folded occasionally.

E. His eye contact is good with the panelists, but he should play a little more to the home audience via the head-on camera. I would like to talk to him about this.

F. We are still working on lightening up his eyes a bit, but this is not a major problem. This will be somewhat tougher in smaller studios, but don't worry, he will never look bad:

 1. I may lower the front two key spots a bit.
 2. I may try slightly whiter make-up on upper eyelids.
 3. I may lower the riser he stands on a couple of inches. . . .

I. An effort should be made to keep him in the sun occasionally to maintain a fairly constant level of healthy tan.

J. Generally, he had a very "Presidential" look and style – he smiles easily (and looks good doing it). He should continue to make lighter comments once in a while for pacing.

II. The Questions and Answers:

A. First, his opening remarks are good. He should, perhaps, be prepared with an optional cut in his closing remarks in case we get into time trouble getting off the air. I don't want to take a chance of missing the shots of the audience crowding around him at the end. Bud [Wilkinson] can specifically tell him exactly how much time he has to close.

B. In the panel briefing we should tell the panelists not to ask two-part questions. This slows down the overall pace of the show and makes it difficult for the viewer to remember and thus follow. Instead, the panelists should be instructed that they can continue a

dialogue with Mr Nixon – ask two questions in a row to get the answers. . . .

On one answer from Warner Saunders [the Negro on the panel], he gave an unqualified "yes" and that was good. Whenever possible he should be that definite.

D. He still needs some memorable phrases to use in wrapping up certain points. I feel that I might be able to help in this area, but don't know if you want me to or if he would take suggestions from me on this. Maybe I could have a session with Price and Buchanan.

III. Staging:

A. The microphone cord needs to be dressed and looped to the side.
B. Bud Wilkinson felt there should be more women on the panel since over half the voters are women. Maybe combine a category, i.e. woman reporter or negro woman.
C. The panel was too large at eight. Maximum should be seven, six is still preferable to give more interaction.
D. Bud should be able to interject more often with some prepared lighter or pacing questions.
E. The family should be in the audience at every show. Should I talk with them, Whitaker, or will you?
F. Political VIPs should be in the audience for every show. Nixon handles these introductions extremely well and they are good for reaction shots.
G. I am adding extenders to the zoom lens on all cameras to allow closer shooting for reactions.

IV. General:

A. The show got off to a slow start. Perhaps the opening could be made more exciting by:
 1. adding music or applause earlier. . . .

53 STUDS TERKEL

FROM Interview with Congressman Philip M. Crane (1988)

(Republican, Chicago)

I'm not worried about Democrats moving out here. Your typical city Democrat is a God-fearing person, who believes in family and traditional values, who's not trying to put his hands in your pocket, who wants to work. And when the country goes to war, he's pushing you out of line to get in front. I was brought up with these self-same values. We all pushed those big carts with the high wheels to deliver our *Chicago Daily*

News for ten dollars a month. Some life-long Democrats are among my staunchest supporters.

I was brought up not to pass laws to redistribute income. I was raised as a tither. I've always given ten percent of what I make to charitable causes. I got it from my dad and his mother. I have difficulty with the idea of legislating charity. I'm not opposed to caring for people who can't provide for themselves. We have an obligation. But we've stretched this to intolerable limits, considering the magnitude of our deficit today.

Unless there's a national emergency such as war, we're better letting local communities retain the money and address the problems. Case in point: food stamps. They are unsupervised today and not distributed faithfully.

Once I stopped off at a grocery store in a little Wisconsin town. A well-groomed, attractive woman was in line ahead of me. She had a gallon of ice cream and two candy bars, paid for it with a twenty-dollar food stamp, and got change. You're not supposed to get change from food stamps. How's that money going to be spent? Maybe she gambles with it or goes out to buy booze or cigarettes. If you're gonna enforce the program, you've got to have a cop at every checkout line. It's impossible. Some of these food stamps are used in poker games by the fathers of indigent kids.

In earlier days, you had a township commissioner who knew the families in need. If the father was irresponsible, the kids were taken care of. It was a personal concern. My people are willing to help those less fortunate, but don't need the heavy hand of national government involved in our lives and affairs.

When you see street people on the grates, wrapping themselves in newspapers, it's heart-wrenching. This is uncivilized. To be sure, many of them are mentally troubled, psychologically disturbed. When cops try to get them into warmth and shelter, some of them are positively belligerent.

There is a depersonalization of help today, from the assumption of an all-provident father in Washington shoveling out billions of dollars to address these problems. So it's become Washington's problem and no longer ours. It is a community obligation. Let's get the responsible people together, with all the churches, have a community drive, and raise the money.

There is indeed a great deal of unemployment today. Yet I've got eight kids and seven of them are working. They're not making a whale of a lot of money.

When we had double-digit unemployment, a lot of people said, "This job is demeaning, I won't take it." I was brought up to believe any work is dignified. I don't care if you're digging ditches, if you don't have a job,

take it until you see a better opportunity. One of my youngsters had held down a half-a-dozen different jobs, hired to this one, went on to another.

I say take any job until you find a better one. The government can't create jobs. When the government creates make-work jobs, capital is lost that can be used in the private sector to create a productive job. The government is denying potential for growth, when it takes out tax monies to create make-work.

My constituency is really Middle America, middle-income, Middle West. God's country. We are the hub that holds the extremities from going into orbit. They resent Congress not having the discipline to do something about budget deficits. They're paying an arm and a leg and not getting what they're paying for. They resent government regulation and red tape, all of which hurts their competitive capabilities.

By 1960, I was really turned off politics. It was Tweedledum versus Tweedledee or hold your nose and vote. I got actively involved in helping Goldwater, because he was articulating things. He got back to basics: This God-fearing country is the greatest and we shouldn't be bullied or pushed around or take a back seat to anybody. We should be proud of this country and its work ethic and the free enterprise that built it. Let's go out and do it, instead of whining. Why don't we roll up our sleeves and go to work? What made America great is when the going gets tough, the tough get going.

I really got turned on by THE speech of that '64 campaign delivered by Ronald Reagan. It was that half-hour television speech in support of Goldwater. I was a surrogate speaker for him in Illinois. Whenever our dobbers got low, we'd just replay the Reagan speech and we'd get charged up again.

It was a general speech. It was supportive of the principles. Let's face it, Reagan at his best is doggone good. I was trying to get him the nomination in '68 because I didn't trust Nixon. . . .

He talked about patriotism, pride in ourselves as a country. There's no country that can compare with what we've done. You know, give us your poor and huddled masses and we'll turn them into independent, self-supporting people, who'll enjoy the material blessings that no society has ever seen before, 'cause we're the freest society on the face of the earth. (He pauses.) It wasn't just the speech so much. It charged our batteries.

Ronald Reagan's enduring contribution will be the consequences of his rhetoric. Think about it. We know Jimmy Carter was a very pious man, yet he was afraid to invoke God's name in a public forum. There was some confusion about separation of church and state. Reagan never signs off a State of the Union address without saying God bless you. He invokes God's name comfortably, and Americans relate to that. It's a good value and one we should keep in mind. He has restored patriotism. Americans feel good about themselves again.

169

54 STUDS TERKEL

FROM **Interview with Ex-Congressman Bob Eckhardt** (1988)

(Democrat, Houston)

I did everything wrong from the standpoint of present-day politics. I was opposing the most powerful interest in my district: oil. I had thought at the time that there were more people that bought gasoline than got dividends from Humble Oil. It had really worked for twenty-two years in politics. But as politics became more polarized and people began to take it for granted that you ought to represent the biggest power interest in your district, I got defeated. Frankly, my concept of politics was wrong.

What troubles me a great deal today is the single-interest type of approach to politics. It's a very narrow special concern. Blacks have known where they stand on the broad and important issues. It's not something like gun control, whether you're permitted or not to carry a pistol. Or a tax policy looked at very narrowly. The new wave of congressmen is much more cautious. There is no broad concern. The old members of the House were just as reactionary, but they stood on a kind of principle.

I always thought of liberal and conservative as adjectives, not as nouns. About ten years ago, Congress began to change when politics became more mechanized. It used to be of interest to members to discuss matters of the day on the floor. We spoke more casually. When we debated, it was an exchange of ideas. There was more personality to the matter. They were not merely little Univac machines. At no time was there an immediate demand that you join a particular ideological group. The real test was whether or not your decisions withstood the test of time. Today, everything is an instant reaction to an instant poll. Members don't act like persons, they act like machines.

I had a rather broad program, a lot of it to do with environmental protection, consumer protection, industrial safety. Real issues, I thought, rather than issues brought up by professional advisers, by ideological organizations that stamp you liberal or conservative. What defeated me in last election was not the fact that I voted against the oil companies, who put up the money. I was beaten by the accusation that I was for gun control, and that I had voted against curtailment of the right of the court to insist on the abolition of segregation. They liked to call it busing.

My stand was that busing ought to be required where it was necessary in order to do away with the vestiges of segregation. Most of these were cases where the court ordered that. It would not have defeated me in the old regime. It would not have overwhelmed other things on my record, as it did in a concentrated blitz, within three months before the election. There was something like $850,000 spent against me. To about $350. A

record of twenty-two years in an elective office in essentially the same district can be overwhelmed in three months.

The third issue was prayer in schools. If there were a real debate on the issue, I would have won out. I was in favor of the Supreme Court decision that prevented religious intrusion into the schools. My opponent challenged me to a debate, and when I accepted, he withdrew. It was presented in twenty-second television spots, in overwhelming abundance. I'd have been able, with time or in debate, to show it was a single, more or less meaningless exercise that had absolutely nothing to do with anybody's true beliefs, aside from being against the law of the land. You can't do that in twenty seconds.

Television could be a very great thing for politics. It could create a revival of the stump. Instead, it actually destroys analysis, debate, reason, and substitutes advertising. One-liners. Two-liners take up too much time.

There's a TV picture of a politician. He comes from Texas and he's got a bunch of Brahman cattle behind him and his family is romping through the woods. It has nothing to do with politics. You've got an unlimited amount of time for this kind of programming, if you've got the money. I'd limit the appearance to the person himself, speaking in his own voice, without any background. Most politicians that haven't got much to say would soon exhaust the public's interest in them.

The scandals, open or secret, are happening so regularly, it's as if one is constantly irritated by a blow on the shins to a point where he's no longer sensitive. What the Reagan administration has discovered is that that which becomes commonplace is no longer a scandal. The violations have been unprecedented in their repetitiousness. People have lost their sense of outrage.

Know why? People are really not interested in politics. They've got too many other interests. You find people know so much about football. If they knew the same amount about the stock market, they'd be millionaires. Trivialities have overwhelmed us.

The press and political advisers have learned that if they use generalities and get them fixed in people's minds, they'll win: Get the government off our backs; deregulation is desirable. People are naturally conservative. They don't want to see much changed.

If you can present a matter as a specific issue . . . people are liberal.

Reagan succeeded because of general propositions: He's a nice fella; he's gettin' the government off our backs; he doesn't want any new taxes. People remember Big Government and forget big crooks.

I think Americans have lost a sense of healthy skepticism. I always remember those old conversations with my family. My father was a doctor, who was not particularly political, always talking to his daddy's brother or to his sisters. They questioned the president. They questioned

171

Congress. The issues were specific. It wasn't just an attitude: Oh, they're just a bunch of scoundrels in Washington. It had to do with just not quite believing everything that came their way. I think we've lost that.

55 HEDRICK SMITH

FROM *The Power Game: How Washington Works* (1988)

We Americans are a nation of game players. From Friday night poker and Sunday bingo to corporate rivalry and the nuclear arms race, Americans are preoccupied with winning and losing. Competition is our creed; it is knit into the fabric of our national life. Sports and game shows are national pastimes. Either we play games ourselves or we take part vicariously. We swim, cycle, jog or play tennis – making it a game by matching ourselves against a rival, against par in golf, or against the stopwatch when we hike or run. Five out of six Americans spend several hours a week viewing football, baseball, boxing, bowling, or some other sport on television. One hundred million people tune into television game shows weekly – forty-three million to *Wheel of Fortune*. All over the world, people are playing at commerce on one hundred million sets of Monopoly.

Some people treat life as a game, to be won or lost, instead of seeing it in terms of religious ethic or of some overarching system of values.

In Washington, senators and congressmen talk of politics as a game, and of themselves as "players." To be a player is to have power or influence on some issue. Not to be a player is to be out of the power loop and without influence. The ultimate game metaphors in government are the "war games" – not just the military exercises for fleets of ships or regiments of troops, but those ghostly, computer-run scenarios that our policy-makers and nuclear experts use to test their reflexes and our defenses in a crisis: human survival reduced to a game.

So it seems only natural to look at how we are governed – the way Washington *really* works today – as a power game, not in some belittling sense, but as a way of understanding how government actually works and why it does not work better. For the game is sometimes glorious and uplifting, at other times aggravating or disenchanting. It obviously is a serious game with high stakes, one in which the winners and losers affect many lives – yours, mine, those of the people down the street, and of people all over the world.

When I came to Washington in 1962, to work at the Washington bureau of *The New York Times*, I thought I understood how Washington worked. I knew the usual textbook precepts: that the president and his cabinet were in charge of the government; that Congress declared war and passed budgets; that the secretary of State directed foreign policy;

that seniority determined who wrote legislation in Congress, and that the power of southern committee chairmen – gained by seniority – was beyond the challenge of junior members; that voters elected one party or the other to govern; and the parties set how the members of Congress would vote – except for the southern Democrats, who often teamed up with Republicans.

These old truisms no longer fit reality. My years as a reporter have spanned the administrations of six presidents, and over the course of that time, I have watched a stunning transformation in the way the American system of government operates. The Washington power game has been altered by many factors: new Congressional assertiveness against the presidency, the revolt within Congress against the seniority system, television, the merchandising of candidates, the explosion of special interest politics, the demands of political fundraising, the massive growth of staff power – and by changes in voters as well.

The political transformations of the past fifteen years have rewritten the old rules of the game. Presidents now have much greater difficulty marshaling governing coalitions. Power, instead of residing with the president, often floats away from him, and a skillful leader must learn how to ride the political waves like a surfer or be toppled. The old power oligarchy in Congress has been broken up. The new breed of senators and House members, unlike the old breed, play video politics, a different game from the old inside, backroom politics of Congress. Party labels mean much less now to voters and to many candidates, too.

Altogether, it's a new ball game, with new sets of rules, new ways of getting power leverage, new types of players, new game plans, and new tactics that affect winning and losing. It is a much looser power game now, more wide open, harder to manage and manipulate than it was a quarter of a century ago when I came to town.

My purpose in this book is to take you inside each part of the political process in Washington and to show you how it works. And then, to show you how the whole game of governing fits together – and also to show where it doesn't fit together. My premise is that the power games – that is, how Washington *really* works – have unwritten rules, rituals, customs, and patterns that explain what Max Lerner once called "the ultimate propulsion of events."

In using the metaphor of games, I do not mean to imply that politics is child's play. Governing the United States of America is a serious enterprise. Washington is a world where substance matters. Issues matter. Ideas matter. One political party, for example, can gain the *intellectual* initiative over the other party, and that is vitally important in the power game. The Democrats seized the "idea advantage" at the time of Franklin Roosevelt's New Deal; the Reagan Republicans seized it in the early 1980s with their idea of cutting government and taxes.

173

But Washington is a city engaged simultaneously in substance and in strategems. Principles become intertwined with power plays. For Washington is as much moved by who's up and who's down, who's in and who's out, as it is by setting policy. Politicians are serious when they debate about Star Wars, arms control, a fair tax system, protectionism, and welfare reform. But they are no less serious when they devise gambits to throw the other team on the defensive, when they grandstand to milk a hot issue for public relations points and applause. They pursue the interests of their home team – their constituents. But in the special world of Washington, they also hotly pursue their highly personal interests in the inside power games – turf games, access games, career games, money games, blame games – each of which has an inner logic of its own that often diverts officeholders away from the singleminded pursuit of the best policy.

Politics in Washington is a continuous contest, a constant scramble for points, for power, and influence. Congress is the principal policy arena of battle, round by round, vote by vote. People there compete, take sides, form teams and when one action is finished, the teams dissolve, and members form new sides for the next issues. Of course, team competition is our national way of life, but rarely does the contest take place at such close quarters, among people who rub elbows with each other, professionally and socially, day in and day out.

The lingo of games rings naturally on the playing fields of political combat. For analogies, our politicians often turn to the argot of the sports arena, the track, the boxing ring, the playing field, or the casino. Richard Nixon, as president, would not dream of operating without "a game plan." Jack Kennedy, comparing politics to football, told his press secretary, Pierre Salinger, "if you see daylight, go through the hole." When Gerald Ford was the House Republican leader, he could not resist using football clichés; hardly a major vote could take place without Ford's warning that the ball was on the ten-yard line and the clock was running out. More recently, Ronald Reagan's campaign strategists, like ring handlers coaching a prizefighter, tapped a "sparring partner" to warm up Reagan for the 1980 presidential campaign debates. They chose David Stockman as the person to prep Reagan for debates with John Anderson and Jimmy Carter. Later, Secretary of State Alexander Haig was dropped from the Reagan cabinet because the White House felt that he was not a "team player." Both admirers and critics saw how Henry Kissinger approached our national rivalry with Moscow as a global chess match, with other nations serving as his pawns.

The power game echoes Las Vegas and the daily double. Howard Baker, as Senate majority leader, fashioned the image that Reagan tax-cut economics was a "riverboat gamble." Politicians are forever citing the long odds against them, and talking about frontrunners and dark

horses. Political reporters are kin to sportswriters, indulging in political locker-room talk: We compile "the book" on leading contenders and often devote more attention to the advance handicapping, the pace of the favorite, and the skill of his campaign trainers than to the issues and the national agenda.

But the purpose of this book goes beyond locker-room jargon and game analogies for American politics. The game metaphor helps to explain the patterns and precepts that skilled politicians live by, regardless of party or administration, as well as the consequences in all of this game playing, for all of us. Actually the Washington power game is not one game, but an olympiad of games, going on simultaneously, all over town. My aim is to take that olympiad apart, play by play, game by game, player by player, so that the overall game of governing is revealed.

Seeing the inner workings of Washington as a power game is a way of following the action amidst the babel. It's a metaphor for understanding what makes famous people – and faceless people, unknown but powerful – do what they do. Sometimes it explains why some good people don't play the game better, why they don't win.

Politicians themselves know that there are advantages for those who understand the rules and the moves, the power realities and the winning gambits, and for those who are savvy about the traps and escape routes of modern politics. Some like to say that the power game is an unpredictable casino of chance and improvisation. But most of the time politics is about as casual and offhand as the well-practiced triple flips of an Olympic high diver. The appearance of a casual, impromptu performance may add to its political appeal out in the country, as Reagan's TelePrompTer speeches and rehearsed press conferences do. But the real pros, like chess masters, rarely trust true amateurism in politics. They usually have a pretty good feel for how certain policy lines and maneuvers will play out, before they start.

56 THE REPUBLICAN PARTY

FROM **The Republican Party Platform 1992**

Houston, Texas, 20 August 1992

Family

Our national renewal starts with the family. It is where each new generation gains its moral anchor. It is the school of citizenship, the engine of economic progress, a permanent haven when everything is changing. Change can be good, when it liberates the energy and commitment of family members to build better futures. We welcome

change that corrects the mistakes of the past, particularly those at war against the family. For more than three decades, the liberal philosophy has assaulted the family on every side. Today, its more vocal advocates believe children should be able to sue their parents over decisions about schooling, cosmetic surgery, employment, and other family matters. They deny parental authority and responsibility, fracturing the family into isolated individuals, each of them dependent upon – and helpless before – government.

This is the ultimate agenda of contemporary socialism under all its masks: to liberate youth from traditional family values by replacing family functions with bureaucratic social services. That is why today's liberal Democrats are hostile toward any institution government cannot control, like private childcare or religious schools. . . . Republicans oppose and resist the efforts of the Democrat Party to redefine the traditional American family.

Health care

Republicans believe government control of health care is irresponsible and ineffective. We believe health care choices should remain in the

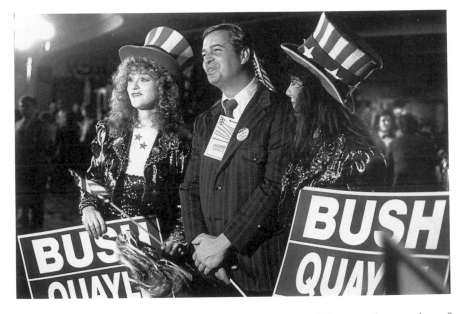

Figure 6.1 Republicans celebrating at the Washington Hilton on the evening of the presidential elections, 8 November 1988
Photograph: Jacky Chapman

hands of the people, not government bureaucrats. This issue truly represents a fundamental difference between the two parties.

Immigration

Our nation of immigrants continues to welcome those seeking a better life. Illegal entry into the United States, on the other hand, threatens the social compact on which immigration is based. That is, the nation accepts immigrants and is enriched by their determination and values. Illegal immigration, on the other hand, undermines the integrity of border communities and already crowded urban neighborhoods. . . .

We will seek stiff penalties for those who smuggle aliens into the country, and for those who produce or sell fraudulent documents. . We will also reduce incentives to enter the United States by promoting initiatives like the North American Free Trade Agreement. In creating new economic opportunity in Mexico, a NAFTA removes the incentive to cross the border illegally in search of work.

Individual rights

The protection of individual rights is the foundation for opportunity and security. The Republican Party is unique in this regard. Since its inception, it has respected every person, even when that proposition was not universally popular. Today, as in the day of Lincoln, we insist that no American's rights are negotiable. That is why we declare that bigotry and prejudice have no place in American life. We denounce all who practice or promote racism, anti-Semitism, or religious intolerance. . . .

Asserting equal rights for all, we support the Bush administration's vigorous enforcement of statutes to prevent illegal discrimination on account of sex, race, creed, or national origin. Promoting opportunity, we reject efforts to replace equal rights with quotas or other preferential treatment. That is why President Bush fought so long against the Democrat Congress to win a civil rights bill worthy of that name.

We renew the historic Republican commitment to the rights of women, from the earliest days of the suffragist movement to the present. Because legal rights mean little without opportunity, we assert economic growth as the key to the continued progress of women in all fields of American life.

We believe the unborn child has a fundamental individual right to life which cannot be infringed. . . . We . . . oppose euthanasia and assisted suicide.

Defense and foreign policy

US defense spending has already been reduced significantly. Five years ago, it was more than a quarter of the federal budget. By 1997 it will be less than a sixth. Spending on defense and intelligence, as a proportion of Gross National Product, will be the lowest since before World War II. Yet any defense budget, however lean, is still too much for the Democrats. They want to start by cutting defense outlays over the next four years by nearly $60,000 million beyond the president's cuts, throwing as many as one million additional Americans out of work. And this may be just the beginning, as the Democrats use the defense budget as a bottomless piggybank to try to beat swords into pork barrels [a negative term implying that members of Congress try to obtain public money for their particular local objectives, often in order to win re-election]. This is folly.

57 THE DEMOCRATIC PARTY

FROM The Democratic Party Platform 1992

New York, NY, 14 July 1992

Opportunity

Our Party's first priority is opportunity – broad-based, non-inflationary economic growth and the opportunity that flows from it. Democrats in 1992 hold nothing more important for America than an economy that offers growth and jobs for all. The only way to lay the foundation for renewed American prosperity is to spur both public and private investment. We must strive to close both the budget deficit and the investment gap. Our major competitors invest far more than we do in roads, bridges, and the information networks and technologies of the future. To make our economy grow, the president and Congress should agree .that savings from defense must be reinvested productively at home, including research, education and training, and other productive instruments. This will sharply increase the meager nine percent of the national budget now devoted to the future.

We will create a "future budget" for investments that make us richer, to be kept separate from those parts of the budget that pay for the past and present. . . . Our economy needs both the people and the funds released from defense at the Cold War's end. We will help the stalwarts of that struggle – the men and women who served in our armed forces and who work in our defense industries – to make the most out of a new era.

The cities

Democrats will create a new partnership to rebuild America's cities after 12 years of Republican neglect. This partnership with the mayors will include consideration of the seven economic growth initiatives set forth by our nation's mayors. We will create jobs by investing significant resources to put people back to work, beginning with a summer jobs initiative and training programs for inner-city youth. We support a stronger community development program and targeted fiscal assistance to cities that need it most. A national public works investment and infrastructure program will provide jobs and strengthen our cities, suburbs, rural communities and country. We will encourage the flow of investment to inner city development and housing through targeted enterprise zones and incentives for private and public pension funds to invest in urban and rural projects.

Education and health care

Over the past 12 years skyrocketing costs and declining middle class incomes have placed higher education out of reach for millions of Americans. It is time to revolutionize the way student loan programs are run. We will make college affordable to all students who are qualified to attend, regardless of family income. A Domestic GI Bill [a measure introduced for all GIs (soldiers) after World War II, to give them a free education instead of going unemployed] will enable all Americans to borrow money for college, so long as they are willing to pay it back as a percentage of their income over time or through national service addressing unmet community needs.

All Americans should have universal access to quality, affordable health care – not as a privilege, but as a right. That requires tough controls on health costs, which are rising at two or three times the rate of inflation, terrorizing American families and businesses and depriving millions of the care they need. We will enact a uniquely American reform of the health care system to control costs and make health care affordable. . . .

Civil and equal rights

We don't have an American to waste. Democrats will continue to lead the fight to ensure that no Americans suffer discrimination or deprivation on the basis of race, gender, language, national origin, religion, age, disability, sexual orientation, or other characteristics irrelevant to ability. We will support the ratification of the Equal Rights Amendment [for women's rights; the necessary number of states never ratified the

amendment proposed twenty years ago]: affirmative action: stronger protection of voting rights for racial and ethnic minorities. . . . We will reverse the Bush administration's assault on civil rights enforcement, and instead work to rebuild and vigorously use machinery for civil rights enforcement; support comparable remedies for women; aggressively prosecute hate crimes; strengthen legal services for the poor; deal with other nations in such a way that Americans of any origin do not become scapegoats or victims of foreign policy disputes; provide civil rights protection for gay men and lesbians and an end to Defense Department discrimination; respect Native American culture and our treaty commitments.

Family, welfare, and individual responsibility

We need a national crackdown on deadbeat parents, an effective system of child support enforcement nationwide, and a systematic effort to establish paternity for every child. We must also make it easier for parents to build strong families through pay equity. Family and medical leave will ensure that workers don't have to choose between family and work. . . .

Welfare should be a second chance, not a way of life. We want to break the cycle of welfare by adhering to two simple principles: no one who is able to work can stay on welfare forever, and no one who works should live in poverty. We will continue to help those who cannot help themselves. We will offer people on welfare a new social contract. . . . This will restore the covenant that welfare was meant to be: a promise of temporary help for people who have fallen on hard times.

Democrats stand behind the right of every woman to choose, consistent with Roe v. Wade [an abortion decision], regardless of ability to pay, and support a national law to protect that right. It is a fundamental constitutional liberty that individual Americans – not government – can best take responsibility for making the most difficult and intensely personal decisions regarding reproduction. The goal of our nation must be to make abortion less necessary, not more difficult or more dangerous.

Restoring community

For ourselves and future generations, we must protect our environment. . . . We believe America's youth can serve its country well through a civilian conservation corps. . . . We will oppose Republican efforts to gut the Clean Air Act in the guise of competitiveness.

Our nation of immigrants has been invigorated repeatedly as new people, ideas and ways of life have become part of the American

tapestry. Democrats support immigration policies that promote fairness, non-discrimination and family reunification. . . .

America's special genius has been to forge a community of shared values from people of remarkable and diverse backgrounds. As the party of inclusion, we take special pride in our country's emergence as the world's largest and most successful multiethnic, multiracial republic. We condemn antisemitism, racism, homophobia, bigotry and negative stereotyping of all kinds. We must help all Americans understand the diversity of our cultural heritage.

But it is also essential that we preserve and pass on to our children the common elements that hold this mosaic together as we work to make our country a land of freedom and opportunity for all. . . . We pledge to bolster the institutions of civil society and place a new emphasis on civic enterprises that seek solutions to the nation's problems.

7

ENTERPRISE

Introduction	184
58 Benjamin Franklin FROM *Autobiography* (1785)	187
59 Francis Grund FROM "To Americans, Business is Everything" (1837)	190
60 Andrew Carnegie FROM *The Gospel of Wealth* (1900)	192
61 Bruce Barton FROM "Christ as a Businessman" (1925)	194
62 Studs Terkel Interview with George Allen, Football Coach (1972)	198
63 Henry Ford FROM *My Life and Work* (1922)	200
64 Andrew Jackson "The Power of the Moneyed Interests" (1837)	203
65 Franklin D. Roosevelt "Organized Money" (1936)	204
66 Dwight D. Eisenhower "The Military-Industrial Complex" (1961)	206

INTRODUCTION

"Capitalism," the historian Carl N. Degler once wrote, "came in the first ships."[1] Many of the colonies were established out of commercial motives. On the other hand, no matter how clever the New England Puritans were as tradesmen, their commercial instinct was usually balanced by a keen sense of religious duty. In the second half of the 1700s, however, after a religious revival at mid-century, the idea that money and religion must join hands to maintain a "moral economy" was slowly disappearing, and commercialization was on its rise. The excerpts from the writings of Benjamin Franklin, the printer and inventor who made a fortune and went on to become a statesman, show how practical business and religious piety coexist. It is sometimes hard to see which of them has the upper hand.

By the 1830s, the "moral economy" was definitely on its way out and a new commercial spirit was sweeping the land even as a movement known as the Second Great Awakening was bringing a revival of American religiousness. This time, commercialization was not rejected by religion. Rather, the age seemed to say that Americans should be free to pursue their interests – whether religious or material – without outside interference. A free commercial life became as important as a free spiritual life, though some reacted strongly against the excessive commercial interest of the new age. The selection from the writings of Francis J. Grund indicates how a recently arrived German observer viewed the commercialism of contemporary Americans compared to the situation in the Europe he knew.

A half-century later, following the Civil War and the rise of big business, Scottish-born Andrew Carnegie – the steel king – was becoming one of the giants of American business. In *The Gospel of Wealth* he presented viewpoints that many would find strange and perhaps appalling today. His view is that wealth is a burden which the rich must carry on behalf of those who are not so clever or wise as to make a fortune. In return, the rich should spend their fortunes for the benefit of mankind. In a way, this is a parallel to the late nineteenth-century view that the white man had been saddled with the burden of civilizing the world's savages by means of colonies (colonialism). Carnegie's views were influenced by contemporary social Darwinism – the idea that those who were most fit succeeded best in business as in life.

Though enterprise in the form of unregulated cut-throat capitalism had culminated around 1900, the American business civilization in a sense climaxed in the 1920s with an almost universal adoration of business values. In *The Man Nobody Knows* (1925) Jesus himself had become the prototype of the modern businessman, as extract 61 shows.

184

The author was Bruce Barton, an advertising executive, and his book was a tremendous success.

By now, advertising and speculation had become part of the everyday life of an ever-increasing number of Americans. Therefore, the Great Depression of the 1930s was a tremendous shock to traditional optimism and generated strong resentment against the speculators who were felt to be responsible for what followed after the 1929 crash on Wall Street. Still, it may not have made Americans basically skeptical of their free enterprise system. Arthur Miller's play *Death of a Salesman* (1949) shows that the single-minded pursuit of monetary success had perverted the American dream, and the response which the play received from American theater audiences suggests that many Americans were uncomfortably aware of the problem. But as Studs Terkel's interview with George Allen, football coach and general manager of the Washington Redskins around 1970, reveals, the business ideal of cut-throat competition is still alive.

Over time, there has been no lack of warning voices against the growing American preoccupation with money. One of them, perhaps strangely, was Henry Ford, whose autobiography appeared in 1922. The

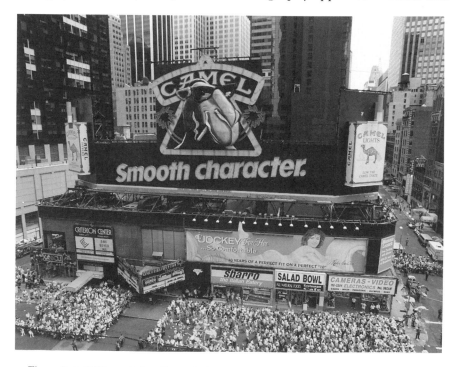

Figure 7.1 Billboard for Camel cigarettes, Times Square, New York, 1993
Photograph courtesy of Range/Reuter/Bettman

automobile producer was one of the most cherished heroes of American enterprise and a great spokesman for business values especially before the Wall Street crash, which he saw as proof of a business world gone wrong. In his praise of the successful man Ford's views sometimes resembled those of Carnegie, but Ford was at the same time a man out of the distant past with a reverence for the "moral economy." His autobiography, from which a small selection is included, reveals Ford's essential Puritanism and his emphasis on free enterprise as opposed to monopoly, on hard work and production as opposed to banking or advertising or speculation. Few men have represented urban society more than Henry Ford, as it invades the tranquil world of the farmer by means of rapid transportation, and yet – what are Ford's views of farm life? Is the automobile his vehicle to reach the land of the past, the agrarian dream?

The real critics of banks and monopolies have been the "common man" on the farms or in the factories or his political spokesmen. As extract 64 shows, the Democratic president Andrew Jackson lashed out against "the moneyed interests" as he was about to leave the White House in 1837. So, in fact, did the Republican reform president Theodore Roosevelt, who chided the "malefactors of great wealth" around the turn of the past century. As extract 65 shows, President Franklin D. Roosevelt, a Democrat, heightened the temperature of the 1936 presidential campaign by striking out vigorously against "organized money." Though FDR had probably done more than the American business world was ever willing to concede to safeguard American democracy and American business, he had long been the target of strong business attacks, especially before the 1936 election. His response was therefore partly predictable, but not the intensity of it.

But when President Dwight D. Eisenhower, a former US military hero, a Republican and also a hero to American business, included in his departing speech in 1961 a strong warning against monopoly in the form of a "military-industrial complex," he more truly surprised many listeners. On the other hand, some commentators believed that the warning ought really to apply to an entire "military-industrial-*labor* complex." They argued that American labor, whose right to unionize had at long last been recognized by the Roosevelt administration in the mid-1930s, had become as dependent on the defense industry as the industrialists themselves. A small excerpt from Eisenhower's farewell warning is included as extract 66.

The last selection of texts in this chapter has to do with consumerism. Expanding the market was clearly in the interest of American producers, and political backers of American business interests – especially the Republicans – became spokesmen for advertising and consumerism in the decades following the Civil War. As chapter 13 (Ideology) shows,

consumerism has been a chief pillar in the generally conservative American business ethos. Thorstein Veblen, a progressive economist, warned Americans at the turn of the century against "conspicuous consumption," but his words fell mostly on deaf ears. Indeed, increased consumption also became the gospel of many on the political left. When the Roosevelt administration in the 1930s saw to it that labor received the right to form unions, one main motive had in fact been to increase workers' wages so that they could become better consumers and thereby help to get the nation's weak economy moving again.

1 Carl N. Degler, *Out of Our Past*, 3rd edition, New York, Harper Colophon Books, 1984, p. 2

58 BENJAMIN FRANKLIN

FROM *Autobiography* (1785)

It was about this time I conceiv'd the bold and arduous project of arriving at moral perfection. I wish'd to live without committing any fault at any time; I would conquer all that either natural inclination, custom, or company might lead me into. As I knew, or thought I knew, what was right and wrong, I did not see why I might not always do the one and avoid the other. But I soon found I had undertaken a task of more difficulty than I had imagined. While my care was employ'd in guarding against one fault, I was often surprised by another; habit took the advantage of inattention; inclination was sometimes too strong for reason. I concluded, at length, that the mere speculative conviction that it was our interest to be completely virtuous, was not sufficient to prevent our slipping; and that the contrary habits must be broken, and good ones acquired and established, before we can have any dependence on a steady, uniform rectitude of conduct. For this purpose I therefore contrived the following method.

In the various enumerations of the moral virtues I had met with in my reading, I found the catalogue more or less numerous, as different writers included more or fewer ideas under the same name. Temperance, for example, was by some confined to eating and drinking, while by others it was extended to mean the moderating every other pleasure, appetite, inclination, or passion, bodily or mental, even to our avarice and ambition. I propos'd to myself, for the sake of clearness, to use rather more names, with fewer ideas annex'd to each, than a few names with more ideas; and I included under thirteen names of virtues all that at that time occurr'd to me as necessary or desirable, and annexed to each a short precept, which fully express'd the extent I gave to its meaning.

These names of virtues, with their precepts, were:

ENTERPRISE

1. TEMPERANCE

Eat not to dullness; drink not to elevation.

2. SILENCE

Speak not but what may benefit others or yourself; avoid trifling conversation.

3. ORDER

Let all your things have their places; let each part of your business have its time.

4. RESOLUTION

Resolve to perform what you ought; perform without fail what you resolve.

5. FRUGALITY

Make no expense but to do good to others or yourself; *i.e.*, waste nothing.

6. INDUSTRY

Lose no time; be always employ'd in something useful; cut off all unnecessary actions.

7. SINCERITY

Use no hurtful deceit; think innocently and justly; and, if you speak, speak accordingly.

8. JUSTICE

Wrong none by doing injuries, or omitting the benefits that are your duty.

9. MODERATION

Avoid extreams; forbear resenting injuries so much as you think they deserve.

10. CLEANLINESS

Tolerate no uncleanliness in body, cloaths, or habitation.

11. TRANQUILLITY

Be not disturbed at trifles, or at accidents common or unavoidable.

12. CHASTITY

Rarely use venery but for health or offspring, never to dullness, weakness, or the injury of your own or another's peace or reputation.

13. HUMILITY

Imitate Jesus and Socrates.

My intention being to acquire the *habitude* of all these virtues, I judg'd it would be well not to distract my attention by attempting the whole at once, but to fix it on one of them at a time; and, when I should be master of that, then proceed to another, and so on till I had gone thro' the thirteen; and, as the previous acquisition of some might facilitate the acquisition of certain others, I arrang'd them with that view, as they stand above. Temperance first, as it tends to procure that coolness and clearness of head, which is so necessary where constant vigilance was to be kept up, and guard maintained against the unremitting attraction of ancient habits, and the force of perpetual temptations. This being acquir'd and establish'd, Silence would be more easy; and my desire being to gain knowledge at the same time that I improv'd in virtue, and considering that in conversation it was obtain'd rather by the use of the ears than of the tongue, and therefore wishing to break a habit I was getting into of prattling, punning, and joking, which only made me acceptable to trifling company, I gave *Silence* the second place. This and the next, *Order*, I expected would allow me more time for attending to my project and my studies. *Resolution*, once become habitual, would keep me firm in my endeavors to obtain all the subsequent virtues; *Frugality* and Industry freeing me from my remaining debt, and producing affluence and independence, would make more easy the practice of Sincerity and Justice, etc., etc.

I determined to give a week's strict attention to each of the virtues successively.

In truth, I found myself incorrigible with respect to Order; and now I am grown old and my memory bad, I feel very sensibly the want of it. But, on the whole, tho' I never arrived at the perfection I had been so ambitious of obtaining, but fell far short of it, yet I was, by the

endeavour, a better and a happier man than I otherwise should have been if I had not attempted it; as those who aim at perfect writing by imitating the engraved copies, tho' they never reach the wish'd-for excellence of those copies, their hand is mended by the endeavour, and is tolerable while it continues fair and legible.

It may be well my posterity should be informed that to this little artifice, with the blessing of God, their ancestor ow'd the constant felicity of his life, down to his 79th year, in which this is written. What reverses may attend the remainder is in the hand of Providence; but, if they arrive, the reflection on past happiness enjoy'd ought to help his bearing them with more resignation. To Temperance he ascribes his long-continued health, and what is still left to him of a good constitution; to Industry and Frugality, the early easiness of his circumstances and acquisition of his fortune, with all that knowledge that enabled him to be a useful citizen, and obtained for him some degree of reputation among the learned; to Sincerity and Justice, the confidence of his country, and the honorable employs it conferred upon him; and to the joint influence of the whole mass of virtues, even in the imperfect state he was able to acquire them, all that evenness of temper, and that cheerfulness in conversation, which makes his company still sought for and agreeable even to his younger acquaintances. I hope, therefore, that some of my descendants may follow the example and reap the benefit.

59 FRANCIS GRUND

FROM "To Americans, Business is Everything" (1837)

There is probably no people on earth with whom business constitutes pleasure, and industry amusement, in an equal degree with the inhabitants of the United States of America. Active occupation is not only the principal source of their happiness, and the foundation of their natural greatness, but they are absolutely wretched without it, and instead of the "*dolce far niente*," know but the horrors of idleness. Business is the very soul of an American; he pursues it, not as a means of procuring for himself and his family the necessary comforts of life, but as the fountain of all human felicity; and shows as much enthusiastic ardour in his application to it as any crusader ever evinced for the conquest of the Holy Land, or the followers of Mohammed for the spreading of the Koran.

From the earliest hour in the morning till late at night the streets, offices, and warehouses of the large cities are thronged by men of all trades and professions, each following his vocation like a *perpetuum mobile*, as if he never dreamt of cessation from labour, or the possibility of becoming fatigued. If a lounger should happen to be parading the street he would be sure to be justled off the side-walk, or to be pushed in every

direction until he keeps time with the rest. Should he meet a friend, he will only talk to him on *business*; on 'change they will only hear him on *business*; and if he retire to some house of entertainment he will again be entertained with *business*. Wherever he goes the hum and bustle of *business* will follow him; and when he finally sits down to his dinner, hoping there, at least, to find an hour of rest, he will discover to his sorrow that the Americans treat that as a *business* too, and despatch it in less time than he is able to stretch his limbs under the mahogany. In a very few minutes the clang of steel and silver will cease, and he will again be left to his solitary reflections, while the rest are about their *business*. In the evenings, if he have no friends or acquaintances, none will intrude on his retirement; for the people are either at home with their families, or preparing for the *business* of the next day.

Whoever goes to the United States for the purpose of settling there must resolve in his mind to find pleasure in business, and business in pleasure; or he will be disappointed, and wish himself back to the sociable idleness of Europe. Nor can any one travel in the United States without making a *business* of it. . . .

Neither is this hurry of business confined to the large cities, or the method of travelling; it communicates itself to every village and hamlet, and extends to and penetrates the western forests. Town and country rival with each other in the eagerness of industrious pursuits. Machines are invented, new lines of communication established, and the depths of the sea explored to afford scope for the spirit of enterprise; and it is as if all America were but one gigantic workshop, over the entrance of which there is the blazing inscription "*No admission here except on business.*"

The position of a man of leisure in the United States is far from being enviable; for unless he take delight in literary and scientific pursuits, he is not only left without companions to enjoy his luxuriant ease, but, what is worse, he forfeits the respect of his fellow citizens, who, by precept and example, are determined to discountenance idleness. . . . Money and property is accumulated for no other visible purpose than being left to the next generation, which is brought up in the same industrious habits, in order to leave *their* children a still greater inheritance. The labouring classes of Europe, the merchants, and even the professional men, are striving to obtain a certain competency, with which they are always willing to retire: the Americans pursue business with unabated vigour till the very hour of death, with no other benefits for themselves than the satisfaction of having enriched their country and their children. Fortunes, which on the continent of Europe, and even in England, would be amply sufficient for an independent existence, are in America increased with an assiduity which is hardly equalled by the industrious zeal of a poor beginner, and the term of "*rentier*" is entirely unknown. . . .

An American carries the spirit of invention even to the counting-room.

He is constantly discovering some new sources of trade, and is always willing to risk his capital and credit on some *terra incognita*, rather than follow the beaten track of others, and content himself with such profits as are realised by his competitors. This is undoubtedly the cause of a great number of unfortunate speculations and subsequent failures; but it constitutes also the technical superiority of the American merchant over the European. He is an inventor, not an imitator; he *creates* new sources of wealth instead of merely *exhausting* the old ones. . . .

An American mechanic does not exercise his trade as he has learned it: he is constantly making improvements, studying out new and ingenious processes either to perfect his work or to reduce its price, and is, in most cases, able to account for the various processes of his art in a manner which would do credit to a philosopher.

60 ANDREW CARNEGIE

FROM *The Gospel of Wealth* (1900)

The problem of our age is the proper administration of wealth, so that the ties of brotherhood may still bind together the rich and poor in harmonious relationship. The conditions of human life have not only been changed, but revolutionized, within the past few hundred years. In former days there was little difference between the dwelling, dress, food, and environment of the chief and those of his retainers. The Indians are to-day where civilized man then was. When visiting the Sioux, I was led to the wigwam of the chief. It was just like the others in external appearance, and even within the difference was trifling between it and those of the poorest of his braves. The contrast between the palace of the millionaire and the cottage of the laborer with us to-day measures the change which has come with civilization.

This change, however, is not to be deplored, but welcomed as highly beneficial. It is well, nay, essential for the progress of the race, that the houses of some should be homes for all that is highest and best in literature and the arts, and for all the refinements of civilization, rather than that none should be so. Much better this great irregularity than universal squalor. Without wealth there can be no Maecenas. The "good old times" were not good old times. Neither master nor servant was as well situated then as today. A relapse to old conditions would be disastrous to both – not the least so to him who serves – and would sweep away civilization with it. But whether the change be for good or ill, it is upon us, beyond our power to alter, and therefore to be accepted and made the best of it. It is a waste of time to criticise the inevitable.

The price which society pays for the law of competition, like the price it pays for cheap comforts and luxuries, is also great; but the advantages

of this law are also greater still, for it is to this law that we owe our wonderful material development, which brings improved conditions in its train. But, whether the law be benign or not, we must say of it, as we say of the change in the conditions of men to which we have referred: It is here; we cannot evade it; no substitutes for it have been found; and while the law may be sometimes hard for the individual, it is best for the race, because it insures the survival of the fittest in every department. We accept and welcome, therefore, as conditions to which we must accommodate ourselves, great inequality of environment, the concentration of business, industrial and commercial, in the hands of a few, and the law of competition between these, as being not only beneficial, but essential for the future progress of the race. . . .

Objections to the foundations upon which society is based are not in order, because the condition of the race is better with these than it has been with any others which have been tried. Of the effect of any new substitutes proposed we cannot be sure. The Socialist or Anarchist who seeks to overturn present conditions is to be regarded as attacking the foundation upon which civilization itself rests, for civilization took its start from the day that the capable, industrious workman said to his incompetent and lazy fellow, "If thou dost not sow, thou shalt not reap," and thus ended primitive Communism by separating the drones from the bees. One who studies this subject will soon be brought face to face with the conclusion that upon the sacredness of property civilization itself depends – the right of the millionaire to his millions. To those who propose to substitute Communism for this intense Individualism the answer, therefore, is: The race has tried that. All progress from that barbarous day to the present time has resulted from its displacement. Not evil, but good, has come to the race from the accumulation of wealth by those who have the ability and energy that produce it. . . .

We start, then, with a condition of affairs under which the best interests of the race are promoted, but which inevitably gives wealth to the few. Thus far, accepting conditions as they exist, the situation can be surveyed and pronounced good. The question then arises, – and, if the foregoing be correct, it is the only question with which we have to deal, – What is the proper mode of administering wealth after the laws upon which civilization is founded have thrown it into the hands of the few? And it is of this great question that I believe I offer the true solution. . . .

There remains, then, only one mode of using great fortunes; but in this we have the true antidote for the temporary unequal distribution of wealth, the reconciliation of the rich and the poor – a reign of harmony – another ideal, differing, indeed, from that of the Communist in requiring only the further evolution of existing conditions, not the total overthrow of our civilization. It is founded upon the present most intense

individualism, and the race is prepared to put it in practice by degrees whenever it pleases. Under its sway we shall have an ideal state, in which the surplus wealth of the few will become, in the best sense, the property of the many, because administered for the common good, and this wealth, passing through the hands of the few, can be made a much more potent force for the elevation of our race than if it had been distributed in small sums to the people themselves. Even the poorest can be made to see this, and to agree that great sums gathered by some of their fellow-citizens and spent for public purposes, from which the masses reap the principal benefit, are more valuable to them than if scattered among them through the course of many years in trifling amounts. . . .

This, then, is held to be the duty of the man of Wealth: First, to set an example of modest, unostentatious living, shunning display or extravagance; to provide moderately for the legitimate wants of those dependent upon him; and after doing so to consider all surplus revenues which come to him simply as trust funds, which he is called upon to administer, and strictly bound as a matter of duty to administer in the manner which, in his judgment, is best calculated to produce the most beneficial results for the community – the man of wealth thus becoming the mere agent and trustee for his poorer brethren, bringing to their service his superior wisdom, experience, and ability to administer, doing for them better than they would or could do for themselves. . . .

Thus is the problem of Rich and Poor to be solved. The laws of accumulation will be left free; the laws of distribution free. Individualism will continue, but the millionaire will be but a trustee for the poor; intrusted for a season with a great part of the increased wealth of the community far better than it could or would have done for itself. . . .

Such, in my opinion, is the true Gospel concerning Wealth, obedience to which is destined some day to solve the problem of the Rich and the Poor, and to bring "Peace on earth, among men Good-Will."

61 BRUCE BARTON

FROM "Christ as a Businessman" (1925)

The little boy's body sat bolt upright in the rough wooden chair, but his mind was very busy.

This was his weekly hour of revolt.

The kindly lady who could never seem to find her glasses would have been terribly shocked if she had known what was going on inside the little boy's mind.

"You must love Jesus," she said every Sunday, "and God."

The little boy did not say anything. He was afraid to say anything; he

was almost afraid that something would happen to him because of the things he thought.

Love God! Who was always picking on people for having a good time, and sending little boys to hell because they couldn't do better in a world which he had made so hard! Why didn't God take some one his own size?

Love Jesus! The little boy looked up at the picture which hung on the Sunday-school wall. It showed a pale young man with flabby forearms and a sad expression. The young man had red whiskers.

Then the little boy looked across to the other wall. There was Daniel, good old Daniel, standing off the lions. The little boy liked Daniel. He liked David, too, with the trusty sling that landed a stone square on the forehead of Goliath. And Moses, with his rod and his big brass snake. They were winners – those three. He wondered if David could whip Jeffries. Samson could! Say, that would have been a fight!

But Jesus! Jesus was the "lamb of God." The little boy did not know what that meant, but it sounded like Mary's little lamb. Something for girls – sissified. Jesus was also "meek and lowly," a "man of sorrow and acquainted with grief." He went around for three years telling people not to do things.

Sunday was Jesus' day; it was wrong to feel comfortable or laugh on Sunday.

The little boy was glad when the superintendent thumped the bell and announced: "We will now sing the closing hymn." One more bad hour was over. For one more week the little boy had got rid of Jesus.

Years went by and the boy grew up and became a business man.

He began to wonder about Jesus.

He said to himself: "Only strong magnetic men inspire great enthusiasm and build great organizations. Yet Jesus built the greatest organization of all. It is extraordinary."

The more sermons the man heard and the more books he read the more mystified he became.

One day he decided to wipe his mind clean of books and sermons.

He said, "I will read what the men who knew Jesus personally said about him. I will read about him as though he were a new historical character, about whom I had never heard anything at all."

The man was amazed.

A physical weakling! Where did they get that idea? Jesus pushed a plane and swung an adze; he was a successful carpenter. He slept outdoors and spent his days walking around his favorite lake. His muscles were so strong that when he drove the money-changers out, nobody dared to oppose him!

A kill-joy! He was the most popular dinner guest in Jerusalem! The

criticism which proper people made was that he spent too much time with publicans and sinners (very good fellows, on the whole, the man thought) and enjoyed society too much. They called him a "wine bibber and a gluttonous man."

A failure! He picked up twelve men from the bottom ranks of business and forged them into an organization that conquered the world.

When the man had finished his reading he exclaimed, "This is a man nobody knows."

"Some day," said he, "some one will write a book about Jesus. Every business man will read it and send it to his partners and his salesmen. For it will tell the story of the founder of modern business."

So the man waited for some one to write the book, but no one did. Instead, more books were published about the "lamb of God" who was weak and unhappy and glad to die.

The man became impatient. One day he said, "I believe I will try to write that book, myself."

And he did. . . .

HIS METHOD

Many leaders have dared to lay out ambitious programs, but this is the most daring of all:

"Go ye into all the world," Jesus said, "and preach the gospel *to the whole creation*."

Consider the sublime audacity of that command. To carry Roman civilization across the then known world had cost millions of lives and billions in treasure. To create any sort of reception for a new idea or product to-day involves a vast machinery of propaganda and expense. Jesus had no funds and no machinery. His organization was a tiny group of uneducated men, one of whom had already abandoned the cause as hopeless, deserting to the enemy. He had come proclaiming a Kingdom and was to end upon a cross; yet he dared to talk of conquering all creation. What was the source of his faith in that handful of followers? By what methods had he trained them? What had they learned from him of the secrets of influencing men?

We speak of the law of "supply and demand," but the words have got turned around. With anything which is not a basic necessity the supply always precedes the demand. Elias Howe invented the sewing machine, but it nearly rusted away before American women could be persuaded to use it. With their sewing finished so quickly what would they ever do with their spare time? Howe had vision, and had made his vision come true; but he could not sell! So his biographer paints a tragic picture – the man who had done more than any other in his generation to lighten the labor

of women is forced to attend the funeral of the woman he loved in a borrowed suit of clothes! . . .

What were his methods of training? How did he meet prospective believers? How did he deal with objections? By what sort of strategy did he interest and persuade? . . .

He was making the journey back from Jerusalem after his spectacular triumph in cleansing the Temple, when he came to Jacob's Well, and being tired, sat down. His disciples had stopped behind at one of the villages to purchase food, so he was alone. The well furnished the water-supply for the neighboring city of the Samaritans, and after a little time a woman came out to it, carrying her pitcher on her shoulder. Between her people, the Samaritans, and his people, the Jews, there was a feud of centuries. To be touched by even the shadow of a Samaritan was defilement according to the strict code of the Pharisees; to speak to one was a crime. The woman made no concealment of her resentment at finding him there. Almost any remark from his lips would have kindled her anger. She would at least have turned away in scorn; she might have summoned her relatives and driven him off.

An impossible situation, you will admit. How could he meet it? How give his message to one who was forbidden by everything holy to listen? The incident is very revealing: there are times when any word is the wrong word; when only silence can prevail. Jesus knew well his precious secret. As the woman drew closer he made no move to indicate that he was conscious of her approach. His gaze was on the ground. When he spoke it was quietly, musingly, as if to himself:

"If you knew who I am," he said, "you would not need to come out here for water. I would give you living water."

The woman stopped short, her interest challenged in spite of herself; she set down the pitcher and looked at the stranger. It was a burning hot day; the well was far from the city; she was heated and tired. What did he mean by such a remark? She started to speak, checked herself and burst out impulsively, her curiosity overleaping her caution:

"What are you talking about? Do you mean to say you are greater than our father Jacob who gave us this well? Have you some magic that will save us this long walk in the sun?"

Dramatic, isn't it – a single sentence achieving triumph, arousing interest and creating desire. With sure instinct he followed up his initial advantage. He began to talk to her in terms of her own life, her ambitions, her hopes, knowing so well that each of us is interested first of all and most of all in himself. When the disciples came up a few minutes later they found an unbelievable sight – a Samaritan listening with rapt attention to the teaching of a Jew. . . .

Surely no one will consider us lacking in reverence if we say that every one of the "principles of modern salesmanship" on which business men

so much pride themselves, is brilliantly exemplified in Jesus' talk and work. The first of these and perhaps the most important is the necessity for "putting yourself in step with your prospect." . . .

THE FOUNDER OF MODERN BUSINESS

When Jesus was twelve years old his father and mother took him to the Feast at Jerusalem.

It was the big national vacation; even peasant families saved their pennies and looked forward to it through the year. Towns like Nazareth were emptied of their inhabitants except for the few old folks who were left behind to look after the very young ones. Crowds of cheerful pilgrims filled the highways, laughing their way across the hills and under the stars at night.

In such a mass of folk it was not surprising that a boy of twelve should be lost. When Mary and Joseph missed him on the homeward trip, they took it calmly and began a search among the relatives.

The inquiry produced no result. Some remembered having seen him in the Temple, but no one had seen him since. . . .

Mary stepped forward and grasped his arm.

"Son, why hast thou thus dealt with us?" she demanded. "Behold thy father and I have sought thee sorrowing."

"How is it that ye sought me?" he asked. "Wist ye not that I must be about my father's *business*?" . . .

What interests us most in this one recorded incident of his boyhood is the fact that for the first time he defined the purpose of his career. He did not say, "Wist ye not that I must practise preaching?" or "Wist ye not that I must get ready to meet the arguments of men like these?" The language was quite different, and well worth remembering. "Wist ye not that I must be about my father's *business*?" he said. He thought of his life as *business*. What did he mean by business? To what extent are the principles by which he conducted his business applicable to ours? And if he were among us again, in our highly competitive world, would his business philosophy work?

62 STUDS TERKEL

Interview with George Allen, Football Coach (1972)

Everything we do is based on winning. I don't care how hard you work or how well organized you are, if you don't win, what good is it? It's down the drain. You can have a tremendous game plan, but if you lose the game, what good was the plan?

One of the greatest things is to be in a locker room after a win. And be

with the players and coaches and realize what's been accomplished, what you've gone through. The rewards are not necessarily tangible. It's the hard work and the agony and the blood and sweat and tears.

When you lose, it's a morgue. That's the way it should be, because you've failed. Once in a while you'll see some tears. I don't think there's anything wrong with crying. I think it's good, it's emotional. I think when you put a lot of yourself into something it should take a lot out. Some people can lose and then go out and be the life of the party. I can't. The only way you can get over a loss is to win the next week.

Grantland Rice, who was one of our great sports writers, said it didn't matter if you won or lost, it was how you played the game. I disagree completely. The main thing is to win. That's what the game is for. Just to go out and play and then say, "Well, I didn't win but I played the game, I participated" – anybody can do that. You have to be number one, whether it's football or selling insurance or anything.

Most coaches aren't too business-minded. I'm the general manager of the Redskins, so I have to be a little more aware of business than just a coach. I'm more interested in how we can get more income in, to use that to help us win. So we can spend more money. Anything you can learn on accounting or business is helpful. We're an organization.

Each player is part of a whole team. A football team is a lot like a machine. It's made up of parts. I like to think of it as a Cadillac. A Cadillac's a pretty good car. All the refined parts working together make the team. If one part doesn't work, one player pulling against you and not doing his job, the whole machine fails.

Nobody is indispensable. If he can't play, we let him know that he's not going to be with us. "Do you want to play somewhere else?" We try to improve and replace some of the parts every year.

The only time you relax is when you win. If you lose, you don't relax until you win. That's the way I am. It's a state of tension almost continuously.

Allen's Ten Commandments

1. Football comes first. "During the off-season, I tell my players that their family and church should come one, two, with football third. But during the six months of the season, the competition in the NFL is so tough that we have to put football ahead of everything else."

2. The greatest feeling in life is to take an ordinary job and accomplish something with it . . .

3. If you can accept defeat and open your pay envelope without feeling guilty, you're stealing. "You're stealing from your employer and from yourself. Winning is the only way to go . . . Losers just look foolish

in a new car or partying it up. As far as I'm concerned, life without victories is like being in prison."

4. Everyone, the head coach especially, must give 110 percent . . . "The average good American pictures himself as a hard worker. But most persons are really operating at less than half-power. They never get above fifty percent . . . Therefore, to get one hundred, you must aim for 110. A man who is concerned with an eight-hour day never works that long, and seldom works half that long. The same man, however, when challenged by a seventeen-hour day, will be just warmed up and driving when he hits the eighth hour . . .

5. Leisure time is that five or six hours when you sleep at night. "Nobody should work all the time. Everybody should have some leisure . . . You can combine two good things at once, sleep and leisure."

6. No detail is too small. No task is too small or too big. "Winning can be defined as the science of being totally prepared. I define preparation in three words: leave nothing undone . . . Nowadays there is . . . no difference between one team and another in the NFL. Usually the winner is going to be the team that's better prepared . . . "

7. You must accomplish things in life, otherwise you are like the paper on the wall. "The achiever is the only individual who is truly alive. There can be no inner satisfaction in simply driving a fine car or eating in a fine restaurant or watching a good movie or television program. Those who think they're enjoying themselves doing any of that are half-dead and don't know it . . . "

8. A person with problems is dead. "Everybody has problems. The successful person solves his. He acknowledges them, works on them, and solves them. He is not disturbed when another day brings another kind of problem . . . The winner . . . solves his own problems. The man swayed by someone else is a two-time loser. First, he hasn't believed in his own convictions and second, he is still lost."

9. We win and lose as a team . . .

10. My prayer is that each man will be allowed to play to the best of his ability.

63 HENRY FORD

FROM *My Life and Work* (1922)

We waste so much time and energy that we have little left over in which to enjoy ourselves. Power and machinery, money and goods, are useful only as they set us free to live. They are but means to an end. For instance, I do not consider the machines which bear my name simply as machines. If that was all there was to it I would do something else. I take them as concrete evidence of the working out of a theory of business

which I hope is something more than a theory of business – a theory that looks toward making this world a better place in which to live. . . .

I am now most interested in fully demonstrating that the ideas we have put into practice are capable of the largest application – that they have nothing peculiarly to do with motor cars or tractors but form something in the nature of a universal code. I am quite certain that it is the natural code and I want to demonstrate it so thoroughly that it will be accepted, not as a new idea, but as a natural code.

The natural thing to do is to work – to recognize that prosperity and happiness can be obtained only through honest effort. Human ills flow largely from attempting to escape from this natural course. I have no suggestion which goes beyond accepting in its fullest this principle of nature. I take it for granted that we must work. All that we have done comes as the result of a certain insistence that since we must work it is better to work intelligently and forehandedly; that the better we do our work the better off we shall be. All of which I conceive to be merely elemental common sense.

The primary functions are agriculture, manufacture, and transportation. Community life is impossible without them. They hold the world together. Raising things, making things, and earning things are as primitive as human need and yet as modern as anything can be. They are of the essence of physical life. When they cease, community life ceases. Things do get out of shape in this present world under the present system, but we may hope for a betterment if the foundations stand sure. The great delusion is that one may change the foundation – usurp the part of destiny in the social process. The foundations of society are the men and means to *grow* things, to *make* things, and to *carry* things. As long as agriculture, manufacture, and transportation survive, the world can survive any economic or social change. As we serve our jobs we serve the world.

There is plenty of work to do. Business is merely work. Speculation in things already produced – that is not business. It is just more or less respectable graft. But it cannot be legislated out of existence. Laws can do very little. Law never does anything constructive. . . .

There can be no greater absurdity and no greater disservice to humanity in general than to insist that all men are equal. Most certainly all men are not equal, and any democratic conception which strives to make men equal is only an effort to block progress. Men cannot be of equal service. The men of larger ability are less numerous than the men of smaller ability; it is possible for a mass of the smaller men to pull the larger ones down – but in so doing they pull themselves down. It is the larger men who give the leadership to the community and enable the smaller men to live with less effort. . . .

I have been speaking in general terms. Let us be more concrete. A

man ought to be able to live on a scale commensurate with the service that he renders. This is rather a good time to talk about this point, for we have recently been through a period when the rendering of service was the last thing that most people thought of. We were getting to a place where no one cared about costs or service. Orders came without effort. Whereas once it was the customer who favoured the merchant by dealing with him, conditions changed until it was the merchant who favoured the customer by selling to him. That is bad for business. Monopoly is bad for business. Profiteering is bad for business. The lack of necessity to hustle is bad for business. Business is never as healthy as when, like a chicken, it must do a certain amount of scratching for what it gets. Things were coming too easily. There was a let-down of the principle that an honest relation ought to obtain between values and prices. The public no longer had to be "catered to." There was even a "public be damned" attitude in many places. It was intensely bad for business. Some men called that abnormal condition "prosperity." It was not prosperity – it was just a needless money chase. Money chasing is not business. . . .

And that is the danger of having bankers in business. They think solely in terms of money. They think of a factory as making money, not goods. They want to watch the money, not the efficiency of production. . . .

The idea persists that there exists an essential conflict between industry and the farm. There is no such conflict. It is nonsense to say that because the cities are overcrowded everybody ought to go back to the farm. If everybody did so farming would soon decline as a satisfactory occupation. It is not more sensible for everyone to flock to the manufacturing towns. If the farms be deserted, of what use are manufacturers? A reciprocity can exist between farming and manufacturing. The manufacturer can give the farmer what he needs to be a good farmer, and the farmer and other producers of raw materials can give the manufacturer what he needs to be a good manufacturer. Then with transportation as a messenger, we shall have a stable and a sound system on built service. If we live in smaller communities where the tension of living is not so high, and where the products of the fields and gardens can be had without the interference of so many profiteers, there will be little poverty or unrest.

Suppose we all moved outdoors every spring and summer and lived the wholesome life of the outdoors for three or four months! We could not have "slack times."

The farm has its dull season. That is the time for the farmer to come into the factory and help produce the things he needs to till the farm. The factory also has its dull season. That is the time for the workmen to go out to the land to help produce food. Thus we might take the slack out of work and restore the balance between the artificial and the natural.

But not the least benefit would be the more balanced view of life we should thus obtain. The mixing of the arts is not only beneficial in a material way, but it makes for breadth of mind and fairness of judgment. A great deal of our unrest to-day is the result of narrow, prejudiced judgment. If our work were more diversified, if we saw more sides of life, if we saw how necessary was one factor to another, we should be more balanced. Every man is better for a period of work under the open sky.

It is not at all impossible. What is desirable and right is never impossible. It would only mean a little teamwork – a little less attention to greedy ambition and a little more attention to life.

64 ANDREW JACKSON

"The Power of the Moneyed Interests" (1837)

It is one of the serious evils of our present system of banking that it enables one class of society, and that by no means a numerous one, by its control over the currency to act injuriously upon the interests of all the others and to exercise more than its just proportion of influence in political affairs. The agricultural, the mechanical, and the laboring classes have little or no share in the direction of the great moneyed corporations; and from their habits and the nature of their pursuits, they are incapable of forming extensive combinations to act together with united force. Such concert of action may sometimes be produced in a single city or in a small district of country by means of personal communications with each other; but they have no regular or active correspondence with those who are engaged in similar pursuits in distant places. They have but little patronage to give to the press and exercise but a small share of influence over it; they have no crowd of dependents above them who hope to grow rich without labor by their countenance and favor and who are, therefore, always ready to exercise their wishes.

The planter, the farmer, the mechanic, and the laborer all know that their success depends upon their own industry and economy and that they must not expect to become suddenly rich by the fruits of their toil. Yet these classes of society form the great body of the people of the United States; they are the bone and sinew of the country; men who love liberty and desire nothing but equal rights and equal laws and who, moreover, hold the great mass of our national wealth, although it is distributed in moderate amounts among the millions of freemen who possess it. But, with overwhelming numbers and wealth on their side, they are in constant danger of losing their fair influence in the government, and with difficulty maintain their just rights against the incessant efforts daily made to encroach upon them.

The mischief springs from the power which the moneyed interest

derives from a paper currency which they are able to control; from the multitude of corporations with exclusive privileges which they have succeeded in obtaining in the different states and which are employed altogether for their benefit; and unless you become more watchful in your states and check this spirit of monopoly and thirst for exclusive privileges, you will, in the end, find that the most important powers of government have been given or bartered away, and the control over your dearest interests has passed into the hands of these corporations.

The paper money system and its natural associates, monopoly and exclusive privileges, have already struck their roots deep in the soil; and it will require all your efforts to check its further growth and to eradicate the evil. The men who profit by the abuses and desire to perpetuate them will continue to besiege the halls of legislation in the general government as well as in the states and will seek, by every artifice, to mislead and deceive the public servants. It is to yourselves that you must look for safety and the means of guarding and perpetuating your free institutions. In your hands is rightfully placed the sovereignty of the country and to you everyone placed in authority is ultimately responsible. It is always in your power to see that the wishes of the people are carried into faithful execution, and their will, when once made known, must sooner or later be obeyed. And while the people remain, as I trust they ever will, uncorrupted and incorruptible and continue watchful and jealous of their rights, the government is safe, and the cause of freedom will continue to triumph over all its enemies.

But it will require steady and persevering exertions on your part to rid yourselves of the iniquities and mischiefs of the paper system and to check the spirit of monopoly and other abuses which have sprung up with it and of which it is the main support. So many interests are united to resist all reform on this subject that you must not hope the conflict will be a short one nor success easy. My humble efforts have not been spared during my administration of the government to restore the constitutional currency of gold and silver; and something, I trust, has been done toward the accomplishment of this most desirable object. But enough yet remains to require all your energy and perseverance. The power, however, is in your hands, and the remedy must and will be applied if you determine upon it.

65 FRANKLIN D. ROOSEVELT

"Organized Money" (1936)

For twelve years this Nation was afflicted with hear-nothing, see-nothing, do-nothing Government. The Nation looked to Government but the Government looked away. Nine mocking years with the golden calf and

three long years of the scourge! Nine crazy years at the ticker and three long years in the breadlines! Nine mad years of mirage and three long years of despair! Powerful influences strive today to restore that kind of government with its doctrine that that Government is best which is most indifferent.

For nearly four years you have had an Administration which instead of twirling its thumbs has rolled up its sleeves. We will keep our sleeves rolled up.

We had to struggle with the old enemies of peace – business and financial monopoly, speculation, reckless banking, class antagonism, sectionalism, war profiteering.

They had begun to consider the Government of the United States as a mere appendage to their own affairs. We know now that Government by organized money is just as dangerous as Government by organized mob.

Never before in all our history have these forces been so united against one candidate as they stand today. They are unanimous in their hate for me – and I welcome their hatred.

I should like to have it said of my first Administration that in it the forces of selfishness and of lust for power met their match. I should like to have it said of my second Administration that in it these forces met their master.

The American people know from a four-year record that today there is only one entrance to the White House – by the front door. Since 4 March 1933, there has been only one pass-key to the White House. I have carried that key in my pocket. It is there tonight. So long as I am President, it will remain in my pocket.

Those who used to have pass-keys are not happy. Some of them are desperate. Only desperate men with their backs to the wall would descend so far below the level of decent citizenship as to foster the current pay-envelope campaign against America's working people. Only reckless men, heedless of consequences, would risk the disruption of the hope for a new peace between worker and employer by returning to the tactics of the labor spy.

Here is an amazing paradox! The very employers and politicians and publishers who talk most loudly of class antagonism and the destruction of the American system now undermine that system by this attempt to coerce the votes of the wage earners of this country. It is the 1936 version of the old threat to close down the factory or the office if a particular candidate does not win. It is an old strategy of tyrants to delude their victims into fighting their battles for them.

Every message in a pay envelope, even if it is the truth, is a command to vote according to the will of the employer. But this propaganda is worse – it is deceit.

They tell the worker his wage will be reduced by a contribution to

some vague form of old-age insurance. They carefully conceal from him the fact that for every dollar of premium he pays for that insurance, the employer pays another dollar. That omission is deceit.

They carefully conceal from him the fact that under the federal law, he receives another insurance policy to help him if he loses his job, and that the premium of that policy is paid 100 percent by the employer and not one cent by the worker. They do not tell him that the insurance policy that is bought for him is far more favorable to him than any policy that any private insurance company could afford to issue. That omission is deceit.

They imply to him that he pays all the cost of both forms of insurance. They carefully conceal from him the fact that for every dollar put up by him his employer puts up three dollars – three for one. And that omission is deceit.

But they are guilty of more than deceit. When they imply that the reserves thus created against both these policies will be stolen by some future Congress, diverted to some wholly foreign purpose, they attack the integrity and honor of American Government itself. Those who suggest that, are already aliens to the spirit of American democracy. Let them emigrate and try their lot under some foreign flag in which they have more confidence.

The fraudulent nature of this attempt is well shown by the record of votes on the passage of the Social Security Act. In addition to an overwhelming majority of Democrats in both Houses, seventy-seven Republican Representatives voted for it and only eighteen against it and fifteen Republican Senators voted for it and only five against it. Where does this last-minute drive of the Republican leadership leave these Republican Representatives and Senators who helped enact this law?

I am sure the vast majority of law-abiding businessmen who are not parties to this propaganda fully appreciate the extent of the threat to honest business contained in this coercion.

I have expressed indignation at this form of campaigning and I am confident that the overwhelming majority of employers, workers and the general public share that indignation and will show it at the polls on Tuesday next.

66 DWIGHT D. EISENHOWER

"The Military-Industrial Complex" (1961)

A vital element in keeping the peace is our military establishment. Our arms must be mighty, ready for instant action, so that no potential aggressor may be tempted to risk his own destruction.

Our military organization today bears little relation to that known by any of my predecessors in peacetime, or indeed by the fighting men of World War II or Korea.

Until the latest of our world conflicts, the United States had no armaments industry. American makers of plowshares could, with time and as required, make swords as well. But now we can no longer risk emergency improvisation of national defense; we have been compelled to create a permanent armaments industry of vast proportions.

Added to this, three and a half million men and women are directly engaged in the defense establishment. We annually spend on military security more than the net income of all United States corporations.

This conjunction of an immense military establishment and a large arms industry is new in the American experience. The total influence – economic, political, even spiritual – is felt in every city, every state house, every office of the federal government. We recognize the imperative need for this development. Yet we must not fail to comprehend its grave implications. Our toil, resources and livelihood are all involved; so is the very structure of our society.

In the councils of government, we must guard against the acquisition of unwarranted influence, whether sought or unsought, by the military-industrial complex. The potential for the disastrous rise of misplaced power exists and will persist.

We must never let the weight of this combination endanger our liberties or democratic processes. We should take nothing for granted. Only an alert and knowledgeable citizenry can compel the proper meshing of the huge industrial and military machinery of defense with our peaceful methods and goals, so that security and liberty may prosper together.

Akin to, and largely responsible for the sweeping changes in our industrial-military posture, has been the technological revolution during the recent decades. In this revolution, research has become central; it also becomes more formalized, complex and costly. A steadily increasing share is conducted for, by or at the direction of, the federal government.

The solitary inventor, tinkering in his shop, has been overshadowed by task forces of scientists in laboratories and testing fields. In the same fashion, the free university, historically the fountainhead of free ideas and scientific discovery, has experienced a revolution in the conduct of research. Partly because of the huge costs involved, a government contract becomes virtually a substitute for intellectual curiosity. For every old blackboard there are now hundreds of new electronic computers.

The prospect of domination of the nation's scholars by federal employment, project allocations and the power of money is ever present – and is

gravely to be regarded. Yet, in holding scientific research and discovery in respect, as we should, we must also be alert to the equal and opposite danger that public policy could itself become the captive of a scientific-technological elite.

It is the task of statesmanship to mold, to balance and to integrate these and other forces, new and old, within the principles of our democratic system – ever aiming toward the supreme goals of our free society.

8

CLASS STRUCTURE

Introduction 210

67 *Thomas Jefferson*
 FROM "Property and Natural Right" (1785) 212

68 *William Graham Sumner*
 FROM "The Forgotten Man" (1883) 213

69 *Upton Sinclair*
 FROM *The Jungle* (1906) 215

70 *Sinclair Lewis*
 FROM *Babbitt* (1922) 216

71 *Emily Moore*
 FROM "Marie Haggerty" (Interview with a
 Nursemaid, 1939) 219

72 *Studs Terkel*
 FROM "Mike Lefevre" (Interview with a Steel
 Mill Worker, 1974) 221

73 *Lyndon B. Johnson*
 FROM "The War on Poverty" (1964) 223

74 *Steven VanderStaay*
 FROM "Hell" and "Joe" (1992) 224

75 *Peter Baida*
 FROM "Confessions of a Reluctant Yuppie" (1985) 227

INTRODUCTION

As long as America remained a predominantly agrarian culture, the dream of the New World as a classless society flourished. Although there were marked schisms between large and small landholders, between wealthy and petty merchants, and between established Americans and new arrivals, the availability of land was regarded as a guarantee of social equality, a safety valve for social dissatisfaction. The independent yeoman farmer would thus serve as the backbone of "a chosen country, with room enough for our descendants to the hundredth and thousandth generation," as President Thomas Jefferson put it in his First Inaugural Address (1801). In the first extract in this chapter, Jefferson, shocked at the great inequality of property and wealth in France, writes to James Madison from Fontainebleau in 1785 that a combination of uncultivated lands and unemployed poor is a violation of man's "natural right."

At the end of the Gilded Age, however – at the heyday of the industrial revolution in America – most land in America had already been settled, and the slums with their masses of poor people served as sharp reminders to Americans that their country had become two nations, a rich one and a poor one. The squalor of the big cities was for instance amply demonstrated in both the prose and the photographs of Jacob Riis's *How the Other Half Lives: Studies Among the Tenements of New York* (1890). The issue was no longer whether America was a class society; it was instead whether this state of affairs was to be accepted as a "natural" result of the freedom of competition (as the Social Darwinists argued), or whether it was society's task to remedy such evils in order to ensure people the right to freedom (as reformers and muckrakers suggested). In extract 68, "The Forgotten Man" (1883), William Graham Sumner argues that destitution and dissipation should be seen not as society's responsibility but as nature's way of removing failures; similarly he sees government regulation of factories and labor conditions as a limitation of people's free choice of workplace. However, as Upton Sinclair implies in the passages from his muckraking novel appropriately entitled *The Jungle* (1906), people suffered the appalling conditions in workplaces like the slaughter houses of Chicago only because they had no choice, except the freedom to starve.

As the twentieth century progressed, however, the white-collar service sector grew, and the share of industrial blue-collar workers in the total labor force declined proportionately. In the modern mass consumption society that emerged with explosive force in the 1920s in particular, the economic and cultural hegemony of the middle classes became more pronounced than ever. In the excerpts from Sinclair Lewis's novel *Babbitt* (1922), we see how its main character, a real-estate broker named

Babbitt, embraces the novelties and technological wonders of the consumer society as signs of his middle-class status and as a means of asserting his increasing success.

As the service sector kept expanding, many American social scientists felt that the European term "working class" was itself irrelevant; they proceeded to group blue-collar industrial workers and white-collar non-professionals together in one class, "the lower middle class," indicative of the general American reluctance to think in terms of the traditional class divisions. Yet, as extracts 71 and 72 demonstrate, the world of a lower middle-class nursemaid ("Marie Haggerty") and the world of a steel-mill worker ("Mike Lefevre") have very little in common. Marie Haggerty's observations from the 1930s reveal her identification with her upper middle-class employers, whereas Mike Lefevre's thoughts from the 1970s express a deep frustration with the Establishment, whether of owners, foremen, or union bosses – a strong resentment at being ignored and looked down upon in a country in which middle-class ideology reigns supreme. These two interviews reveal at the same time that class must be considered not merely in terms of hard facts such as income, occupation, gender, etc., but also in terms of soft criteria such as actual class identification and class consciousness. Divided loyalties are characteristic not only of Marie Haggerty's life; even Mike Lefevre, his deep alienation and anger notwithstanding, harbors middle-class aspirations for his own son. Like most cultural phenomena, class consciousness represents a mesh of conflicting and often contradictory inclinations – which is particularly noticeable in a nation in which an overwhelming majority classify themselves as belonging to the middle class.

Despite their increasing affluence during the late 1940s and the 1950s, Americans discovered at the outset of the 1960s (as they had in the 1890s and the 1930s) that a significant portion – one-fourth or one-fifth – of the population was poor. In his book *The Other America* (1969), a title reminiscent of Riis's work, Michael Harrington argued that the poor were caught in a vicious circle of poverty, that poverty had become "a culture, an institution, a way of life," and that there was "a language of the poor, a psychology of the poor, a world view of the poor."[1] Partly because it challenged traditional American conceptions of social mobility, Harrington's work caused strong political reverberations and helped trigger the "War on Poverty" that was launched by President Lyndon B. Johnson in a special message to Congress in 1964 (extract 73).

Since the late 1960s, however, there has been a growing disillusionment in the United States with the welfare state and the attempts of government programs to eradicate glaring social inequality and despair. References to a Silent Majority or a Moral Majority have called to mind William Graham Sumner's discourse of the Forgotten Man, and arguments that a certain unemployment rate must be tolerated in

post-industrial capitalist society have revitalized Darwinist acceptance of the presence of an impoverished underclass as well as a rich overclass. It is hardly surprising, therefore, that the most visible poor – the homeless – have grown increasingly dejected and bitter in present-day America, as may by seen from the excerpts from Steven VanderStaay's recent interviews with homeless persons, here represented by a Puerto Rican woman ("Hell") and an African American male ("Joe"). (For further reading, see Michael Lee Cohen's "David" in chapter 2.)

At the same time, twentieth-century changes in the class structure of American society have rendered traditional class analysis inadequate. Just as economic studies have been modified by modern changes in ownership and corporate control, social analysis has become complicated by the increasing "post-industrial" class schisms between "bright-collar" executives and professionals, the "white-collar" middle class proper, and "grey-collar" low-paid employees of the service sector. Hence in the last extract in this chapter, Sinclair Lewis's picture of the middle-class Babbitt is complemented by an excerpt from an article by Peter Baida, a self-confessed Yuppie of the mid-1980s.

1 Michael Harrington, *The Other America: Poverty in the United States*, first published 1962, New York, Macmillan, 1969, pp. 16, 17.

67 THOMAS JEFFERSON

FROM "Property and Natural Right" (1785)

To James Madison

I am conscious that an equal division of property is impracticable, but the consequences of this enormous inequality producing so much misery to the bulk of mankind, legislators cannot invent too many devices for subdividing property, only taking care to let their subdivisions go hand in hand with the natural affections of the human mind. The descent of property of every kind therefore to all the children, or to all the brothers and sisters, or other relations in equal degree, is a politic measure and a practicable one. Another means of silently lessening the inequality of property is to exempt all from taxation below a certain point, and to tax the higher portions or property in geometrical progression as they rise. Whenever there are in any country uncultivated lands and unemployed poor, it is clear that the laws of property have been so far extended as to violate natural right. The earth is given as a common stock for man to labor and live on. If for the encouragement of industry we allow it to be appropriated, we must take care that other employment be provided to those excluded from the appropriation. If we do not, the fundamental

right to labor the earth returns to the unemployed. It is too soon yet in our country to say that every man who cannot find employment, but who can find uncultivated land, shall be at liberty to cultivate it, paying a moderate rent. But it is not too soon to provide by every possible means that as few as possible shall be without a little portion of land. The small landholders are the most precious part of a state.

68 WILLIAM GRAHAM SUMNER

FROM "The Forgotten Man" (1883)

When you see a drunkard in the gutter, you are disgusted, but you pity him. When a policeman comes and picks him up you are satisfied. You say that "society" has interfered to save the drunkard from perishing. Society is a fine word, and it saves us the trouble of thinking to say that society acts. The truth is that the policeman is paid by somebody, and when we talk about society we forget who it is that pays. It is the Forgotten Man again. It is the industrious workman going home from a hard day's work, whom you pass without noticing, who is mulcted of a percentage of his day's earnings to hire a policeman to save the drunkard from himself. All the public expenditure to prevent vice has the same effect. Vice is its own curse. If we let nature alone, she cures vice by the most frightful penalties. It may shock you to hear me say it, but when you get over the shock, it will do you good to think of it: a drunkard in the gutter is just where he ought to be. Nature is working away at him to get him out of the way, just as she sets up her processes of dissolution to remove whatever is a failure in its line. Gambling and less mentionable vices all cure themselves by the ruin and dissolution of their victims. Nine-tenths of our measures for preventing vice are really protective towards it, because they ward off the penalty. "Ward off," I say, and that is the usual way of looking at it; but is the penalty really annihilated? By no means. It is turned into police and court expenses and spread over those who have resisted vice. It is the Forgotten Man again who has been subjected to the penalty while our minds were full of the drunkards, spendthrifts, gamblers, and other victims of dissipation. Who is, then, the Forgotten Man? He is the clean, quiet, virtuous, domestic citizen, who pays his debts and his taxes and is never heard of out of his little circle. Yet who is there in the society of a civilized state who deserves to be remembered and considered by the legislator and statesman before this man?

Another class of cases is closely connected with this last. There is an apparently invincible prejudice in people's minds in favor of state regulation. All experience is against state regulation and in favor of liberty. The freer the civil institutions are, the more weak or mischievous

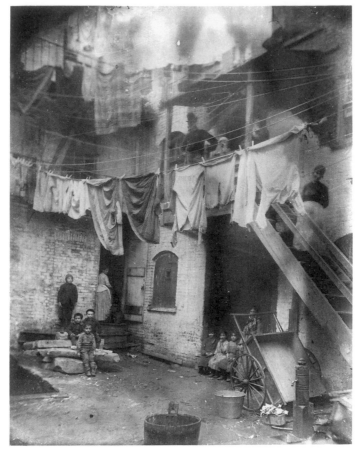

Figure 8.1 Slum dwellers in Baxter Street Court, New York, *c.* 1888
Photograph courtesy of The Jacob A. Riis Collection, Museum of the City of
New York

state regulation is. The Prussian bureaucracy can do a score of things for
the citizen which no governmental organ in the United States can do;
and, conversely, if we want to be taken care of as Prussians and French-
men are, we must give up something of our personal liberty.

Now we have a great many well-intentioned people among us who
believe that they are serving their country when they discuss plans for
regulating the relations of employer and employee, or the sanitary
regulations of dwellings, or the construction of factories, or the way to
behave on Sunday, or what people ought not to eat or drink or smoke.
All this is harmless enough and well enough as a basis of mutual
encouragement and missionary enterprise, but it is almost always
made a basis of legislation. The reformers . . . get factory acts and

other acts passed regulating the relation of employers and employee and set armies of commissioners and inspectors traveling about to see to things, instead of using their efforts, if any are needed, to lead the free men to make their own conditions as to what kind of factory buildings they will work in, how many hours they will work, what they will do on Sunday and so on. The consequence is that men lose the true education in freedom which is needed to support free institutions. They are taught to rely on government officers and inspectors. The whole system of government inspectors is corrupting to free institutions. In England, the liberals used always to regard state regulation with suspicion, but since they have come into power, they plainly believe that state regulation is a good thing – if *they* regulate – because, of course, they want to bring about good things. In this country each party takes turns, according as it is in or out, in supporting or denouncing the non-interference theory.

69 UPTON SINCLAIR

FROM *The Jungle* (1906)

There were the men in the pickle rooms, for instance, where old Antanas had gotten his death; scarce a one of these that had not some spot of horror on his person. Let a man so much as scrape his finger pushing a truck in the pickle rooms, and he might have a sore that would put him out of the world; all the joints in his fingers might be eaten by the acid, one by one. Of the butchers and floorsmen, the beef boners and trimmers, and all those who used knives, you could scarcely find a person who had the use of his thumb; time and time again the base of it had been slashed, till it was a mere lump of flesh against which the man pressed the knife to hold it. The hands of these men would be criss-crossed with cuts, until you could no longer pretend to count them or to trace them. They would have no nails, – they had worn them off pulling hides; their knuckles were swollen so that their fingers spread out like a fan. There were men who worked in the cooking rooms, in the midst of steam and sickening odors, by artificial light; in these rooms the germs of tuberculosis might live for two years, but the supply was renewed every hour. There were the beef luggers, who carried two-hundred-pound quarters into the refrigerator cars, a fearful kind of work, that began at four o'clock in the morning, and that wore out the most powerful men in a few years. There were those who worked in the chilling rooms, and whose special disease was rheumatism; the time limit that a man could work in the chilling rooms was said to be five years. There were the wool pluckers, whose hands went to pieces even sooner than the hands of the pickle men; for the pelts of the sheep had to be painted with acid to loosen the wool, and then the pluckers had to pull out this wool with

their bare hands, till the acid had eaten their fingers off. There were those who made the tins for the canned meat, and their hands, too, were a maze of cuts, and each cut represented a chance for blood poisoning. Some worked at the stamping machines, and it was very seldom that one could work long there at the pace that was set, and not give out and forget himself, and have a part of his hand chopped off. There were the "hoisters," as they were called, whose task it was to press the lever which lifted the dead cattle off the floor. They ran along upon a rafter, peering down through the damp and the steam, and as old Durham's architects had not built the killing room for the convenience of the hoisters, at every few feet they would have to stoop under a beam, say four feet above the one they ran on, which got them into the habit of stooping, so that in a few years they would be walking like chimpanzees. Worst of any, however, were the fertilizer men, and those who served in the cooking rooms. These people could not be shown to the visitor – for the odor of a fertilizer man would scare any ordinary visitor at a hundred yards, and as for the other men, who worked in tank rooms full of steam, and in some of which there were open vats near the level of the floor, their peculiar trouble was that they fell into the vats; and when they were fished out, there was never enough of them left to be worth exhibiting – sometimes they would be overlooked for days, till all but the bones of them had gone out to the world as Durham's Pure Leaf Lard! . . .

It was stupefying, brutalizing work; it left her [Elzbieta] no time to think, no strength for anything. She was part of the machine she tended, and every faculty that was not needed for the machine was doomed to be crushed out of existence. There was only one mercy about the cruel grind – that it gave her the gift of insensibility. Little by little she sank into a torpor – she fell silent. She would meet Jurgis and Ona in the evening, and the three would walk home together, often without saying a word. Ona, too, was falling into a habit of silence – Ona, who had once gone about singing like a bird. She was sick and miserable, and often she would barely have strength enough to drag herself home. And there they would eat what they had to eat, and afterwards, because there was only their misery to talk of, they would crawl into bed and fall into a stupor and never stir until it was time to get up again, and dress by candlelight, and go back to the machines. They were so numbed that they did not even suffer much from hunger, now; only the children continued to fret when the food ran short.

70 SINCLAIR LEWIS

FROM *Babbitt* (1922)

There was nothing of the giant in the aspect of the man who was beginning to awaken on the sleeping-porch of a Dutch Colonial house in that residential district of Zenith known as Floral Heights.

His name was George F. Babbitt. He was forty-six years old now, in April, 1920, and he made nothing in particular, neither butter nor shoes nor poetry, but he was nimble in the calling of selling houses for more than people could afford to pay. . . .

It was the best of nationally advertised and quantitatively produced alarm-clocks, with all modern attachments, including cathedral chime, intermittent alarm, and a phosphorescent dial. Babbitt was proud of being awakened by such a rich device. Socially it was almost as creditable as buying expensive cord tires. . . .

He creaked to his feet, groaning at the waves of pain which passed behind his eyeballs. Though he waited for their scorching recurrence, he looked blurrily out at the yard. It delighted him, as always; it was the neat yard of a successful business man of Zenith, that is, it was perfection, and made him also perfect. He regarded the corrugated iron garage. For the three-hundred-and-sixty-fifth time in a year he reflected, "No class to that tin shack. Have to build me a frame garage. But by golly it's the only thing on the place that isn't up-to-date!" While he stared he thought of a community garage for his acreage development, Glen Oriole. He stopped puffing and jiggling. His arms were akimbo. His petulant, sleep-swollen face was set in harder lines. He suddenly seemed capable, an official, a man to contrive, to direct, to get things done.

On the vigor of his idea he was carried down the hard, clean, unused-looking hall into the bathroom.

Though the house was not large it had, like all houses on Floral Heights, an altogether royal bathroom of porcelain and glazed tile and metal sleek as silver. The towel-rack was a rod of clear glass set in nickel. The tub was long enough for a Prussian Guard, and above the set bowl was a sensational exhibit of tooth-brush holder, shaving-brush holder, soap-dish, sponge-dish, and medicine-cabinet, so glittering and so ingenious that they resembled an electrical instrument-board. But the Babbitt whose god was Modern Appliances was not pleased. The air of the bathroom was thick with the smell of a heathen toothpaste. "Verona been at it again! 'Stead of sticking to Lilidol, like I've re-peat-ed-ly asked her, she's gone and gotten some confounded stinkum stuff that makes you sick!" . . .

Before he followed his wife, Babbitt stood at the westernmost window of their room. This residential settlement, Floral Heights, was on a rise; and though the center of the city was three miles away – Zenith had between three and four hundred thousand inhabitants now – he could see the top of the Second National Tower, an Indiana limestone building of thirty-five stories.

Its shining walls rose against April sky to a simple cornice like a streak of white fire. Integrity was in the tower, and decision. It bore its strength lightly as a tall soldier. As Babbitt stared, the nervousness was soothed

from his face, his slack chin lifted in reverence. All he articulated was "That's one lovely sight!" but he was inspired by the rhythm of the city; his love of it renewed. He beheld the tower as a temple-spire of the religion of business, a faith passionate, exalted, surpassing common men; and as he clumped down to breakfast he whistled the ballad "Oh, by gee, by gosh, by jingo" as though it were a hymn melancholy and noble. . . .

The Lettish-Croat maid, a powerful woman, beat the dinner-gong.

The roast of beef, roasted potatoes, and string beans were excellent this evening and, after an adequate sketch of the day's progressive weather-states, his four-hundred-and-fifty-dollar fee, his lunch with Paul Riesling, and the proven merits of the new cigar-lighter, he was moved to a benign, "Sort o' thinking about buying a new car. Don't believe we'll get one till next year, but still, we might."

Verona, the older daughter, cried, "Oh, Dad, if you do, why don't you get a sedan? That would be perfectly slick! A closed car is so much more comfy than an open one."

"Well now, I don't know about that. I kind of like an open car. You get more fresh air that way."

"Oh, shoot, that's just because you never tried a sedan. Let's get one. It's got a lot more class," said Ted.

"A closed car does keep the clothes nicer," from Mrs. Babbitt; "You don't get your hair blown all to pieces," from Verona; "It's a lot sportier," from Ted; and from Tinka, the youngest, "Oh, let's have a sedan! Mary Ellen's father has got one." Ted wound up, "Oh, everybody's got a closed car now, except us!"

Babbitt faced them: "I guess you got nothing very terrible to complain about! Anyway, I don't keep a car just to enable you children to look like millionaires! And I like an open car, so you can put the top down on summer evenings and go out for a drive and get some good fresh air. Besides – A closed car costs more money."

"Aw, gee whiz, if the Doppelbraus can afford a closed car, I guess we can!" prodded Ted.

"Humph! I make eight thousand a year to his seven! But I don't blow it all in and waste it and throw it around, the way he does! Don't believe in this business of going and spending a whole lot of money to show off and—"

They went, with ardor and some thoroughness, into the matters of streamline bodies, hill-climbing power, wire wheels, chrome steel, ignition systems, and body colors. It was much more than a study of transportation. It was an aspiration for knightly rank. In the city of Zenith, in the barbarous twentieth century, a family's motor indicated its social rank as precisely as the grades of the peerage determined the rank of an English family – indeed, more precisely, considering the opinion of old county families upon newly created brewery barons and woolen-mill viscounts. The details of precedence were never officially

218

determined. There was no court to decide whether the second son of a Pierce Arrow limousine should go in to dinner before the first son of a Buick roadster, but of their respective social importance there was no doubt; and where Babbitt as a boy had aspired to the presidency, his son Ted aspired to a Packard twin-six and an established position in the motored gentry.

71 EMILY MOORE

FROM "Marie Haggerty" (Interview with a Nursemaid, 1939)

It wasn't housework I did. I was a nursemaid or a second girl – never just an ordinary girl out to service. My aunts and uncle were very glad to have me working for such nice people, real high-class people. I had a good home and I was treated good. Now if I had gone into a factory to work, the folks would have been worried. The girls in the shops never made over six or seven dollars, and them that dressed so well on that, and paid their board, too, made people lift their eyebrows. I was lots better off. I got seven or eight dollars a week, my room, and it was always a nice one, and the best of food. I was really next thing to a lady's maid, for when the children went to bed, often the mistress would let me hook her dress, or brush her hair, and all the time she'd be talking to me, just like I was her equal. . . .

. . . They often left food and fancy cakes around, just to test us, but I learned my lesson early on that. Once I just had my hand on a fancy cake in the parlor, and I got such a crack on my hand from the cook. She pulled me back to the kitchen and made me sit down and eat my fill of fancy cakes and told me never to take anything that was outside the kitchen, for it was always a trick to see how honest we was.

My specialty was as a nurse girl. I took care of two lovely children. Do you know when the boy was married, he invited me to his wedding just like I was rich folks. They was an awful nice family, so refined and kind. We went to the beach every summer, and what a place it was. They had two saddle horses, two horses for carriage and garden work, and four cows for their own use. There was three men to work around the grounds, and two coachmen. They had a playground for the children and it was kept up swell, better than most public playgrounds. We had lots of good times, especially when the mistress went away. She'd be gone to Europe for months at a time and the mister would let us ride all over Cape Cod with the coachman and the children.

I was living with those folks when I met Pa. . . .

We went to Boston to be married, for we was only summer people at the Cape. The lady I worked for let us have the coachman and the best carriage to go in, and when we got back to the Cape that night, they had a big party. It wasn't exactly like the rich people, but nearly. She had the

gardeners and coachmen clear the barn for dancing, and the cook made up all the refreshments, and she gave us all the punch we could drink. Then before Mr. and Mrs. went to bed, they came out and drank to our health, and wished us their blessings and happiness. The only difference in my wedding and the rich people was that our party was in the barn; but it was nice there, and we had an accordion and a fiddler for music. All night long, as long as the party lasted, people come from all over with tins and pans and beat a serenade, and yelled for the bride and groom. . . .

I didn't mind that there wasn't much left for me because I knew Pa meant well, but it left me depending on the children and they got their own troubles. The children are good but they're too busy to bother with me much. Pa never denied me a solitary thing when he was living, but now, if I didn't watch out for myself, nobody'd care what I had. Pa would turn over in his grave if he knew I went out washing and cleaning, but I have to. Of course, I don't go out working for just anybody. After all, I wasn't used to working for cheap people and I don't do it now. I have my special customers – all real nice people. I don't mind going out to work – I'm independent and that's something. But I won't be bowing to anybody.

I like things nice, but there's no use pretending; I can't have them that way now. The boys don't like me to fix things up much. I tried just once after Pa died. I was having company at the house, and I kind of put things on a little fancy, like rich people do, but the boys made so much fun of me, I vowed I'd never do it again. If Pa had been living, they'd have known better than to laugh at me. Pa would have socked them.

I never thought I'd have to work after I was married, and wouldn't have to, if Pa'd lived. Pa knowed I was used to better things, and he always tried hard to get them for me. Once he came home with a diamond ring for me. I knew he couldn't afford it, and I was afraid to wear it, thinking as how he might not have come by it honestly. I didn't want to question him, though. He might feel bad. I never wore the ring and not long ago, my daughter Marie had it set over for herself. Two or three years after Pa died, I found where the poor man had paid for it bit by bit. Poor Pa, he was a good man.

I never worked at a place before I was married that they didn't treat me as good as anyone in the family. When I worked for Mrs. French, I was second girl; and even if I did have to wait on table, I was served just like the rich folks when it came time for me to eat. Maybe the difference was that I never said "marm" or never had no brogue. The only thing I didn't like about working for people was that we did have to wear uniforms, usually dark blue, and stiff white collars, depending on what kind of work you had to do. Being next to a nurse, I wore about the same as she did, and if there wasn't any nurse in the family, I wore about the same as a parlor maid. We could frizz our hair, or wear it like we wanted to, just so it was neat. I guess I never minded being a maid, and to tell

the truth, I'd rather my Marie was in some nice family, looking after babies, or the like, than working as a waitress. She'd be better off. Kitty would never have made a maid – she's too fly-by-night and independent, but she's a good girl. I think Marie takes after me, in a way. She's contented with her job. Oh, well, the poor girl – I suppose she could have a worse one.

72 STUDS TERKEL

FROM "Mike Lefevre" (Interview with a Steel Mill Worker, 1974)

I'm a dying breed. A laborer. Strictly muscle work . . . pick it up, put it down, pick it up, put it down. We handle between forty and fifty thousand pounds of steel a day. (Laughs) I know this is hard to believe – from four hundred pounds to three- and four-pound pieces. It's dying.

You can't take pride any more. You remember when a guy could point to a house he built, how many logs he stacked. He built it and he was proud of it. I don't really think I could be proud if a contractor built a home for me. I would be tempted to get in there and kick the carpenter in the ass (laughs), and take the saw away from him. 'Cause I would have to be part of it, you know.

It's hard to take pride in a bridge you're never gonna cross, in a door you're never gonna open. You're mass-producing things and you never see the end result of it. (Muses) I worked for a trucker one time. And I got this tiny satisfaction when I loaded a truck. At least I could see the truck depart loaded. In a steel mill, forget it. You don't see where nothing goes.

I got chewed out by my foreman once. He said, "Mike, you're a good worker but you have a bad attitude." My attitude is that I don't get excited about my job. I do my work but I don't say whoopee-doo. The day I get excited about my job is the day I go to a head shrinker. How are you gonna get excited about pullin' steel? How are you gonna get excited when you're tired and want to sit down?

It's not just the work. Somebody built the pyramids. Somebody's going to build something. Pyramids, Empire State building – these things just don't happen. There's hard work behind it. I would like to see a building, say, the Empire State, I would like to see on one side of it a foot-wide strip from top to bottom with the name of every bricklayer, the name of every electrician, with all the names. So when a guy walked by, he could take his son and say, "See, that's me over there on the forty-fifth floor. I put the steel beam in." Picasso can point to a painting. What can I point to? A writer can point to a book. Everybody should have something to point to.

It's the not-recognition by other people. To say a woman is *just* a housewife is degrading, right? Okay. *Just* a housewife. It's also degrading

221

to say *just* a laborer. The difference is that a man goes out and maybe gets smashed.

When I was single, I could quit, just split. I wandered all over the country. You worked just enough to get a poke, money in your pocket. Now I'm married and I got two kids . . . (trails off). I worked on a truck dock one time and I was single. The foreman came over and he grabbed my shoulder, kind of gave me a shove. I punched him and knocked him off the dock. I said, "Leave me alone. I'm doing my work, just stay away from me, just don't give me the with-the-hands business."

Hell, if you whip a damn mule he might kick you. Stay out of my way, that's all. Working is bad enough, don't bug me. I would rather work my ass off for eight hours a day with nobody watching me than five minutes with a guy watching me . Who you gonna sock? You can't sock General Motors, you can't sock anybody in Washington, you can't sock a system.

A mule, an old mule, that's the way I feel. Oh yeah. See. (Shows black and blue marks on arms and legs, burns). You know what I heard from more than one guy at work? "If my kid wants to work in a factory, I am going to kick the hell out of him." I want my kid to be an effete snob. Yeah, mm-hmm. (Laughs.) I want him to be able to quote Walt Whitman, to be proud of it. . . .

Oh yeah, I daydream. I fantasize about a sexy blonde in Miami who's got my union dues. (Laughs.) I think of the head of the union the way I think of the head of my company. Living it up. I think of February in Miami. Warm weather, a place to lay in. When I hear a college kid say, "I'm oppressed." I don't believe him. You know what I'd like to do for one year? Live like a college kid. Just for one year. I'd love to. Wow! (Whispers) Wow! Sports car! Marijuana! (Laughs.) Wild, sexy broads. I'd love that, hell yes, I would.

Somebody has to do this work. If my kid ever goes to college, I just want him to have a little respect, to realize that his dad is one of those somebodies. This is why even on – (muses) yeah. I guess, sure – on the black thing . . . (Sighs heavily.) I can't really hate the colored fella that's working with me all day. The black intellectual I got no respect for. The white intellectual I got no use for. I got no use for the black militant who's gonna scream three hundred years of slavery to me while I'm busting my ass. You know what I mean? (Laughs.) I have one answer for that guy: go see Rockefeller. See Harriman. Don't bother me. We're in the same cotton field. So just don't bug me. (Laughs). . . .

This is gonna sound square, but my kid is my imprint. He's my freedom. There's a line in one of Hemingway's books. I think it's from *For Whom the Bell Tolls*. They're behind the enemy lines, somewhere in Spain, and she's pregnant. She wants to stay with him. He tells her no. He says, "if you die, I die," knowing he's gonna die. But if you go, I go.

Know what I mean? The mystics call it the brass bowl. Continuum. You know what I mean? This is why I work. Every time I see a young guy walk by with a shirt and tie and dressed up real sharp, I'm lookin' at my kid, you know? That's it.

73 LYNDON B. JOHNSON

FROM "The War on Poverty" (1964)

With the growth of our country has come opportunity for our people – opportunity to educate our children, to use our energies in productive work, to increase our leisure – opportunity for almost every American to hope that through work and talent he could create a better life for himself and his family.

The path forward has not been an easy one. But we have never lost sight of our goal – an America in which every citizen shares all the opportunities of his society, in which every man has a chance to advance his welfare to the limit of his capacities. We have come a long way toward this goal. We still have a long way to go.

The distance which remains is the measure of the great unfinished work of our society. To finish that work I have called for a national war on poverty. Our objective: total victory.

There are millions of Americans – one-fifth of our people – who have not shared in the abundance which has been granted to most of us, and on whom the gates of opportunity have been closed. What does this poverty mean to those who endure it? It means a daily struggle to secure the necessities for even a meager existence. It means that the abundance, the comforts, the opportunities they see all around them are beyond their grasp. Worst of all, it means hopelessness for the young.

The young man or woman who grows up without a decent education, in a broken home, in a hostile and squalid environment, in ill health or in the face of racial injustice – that young man or woman is often trapped in a life of poverty. He does not have the skills demanded by a complex society. He does not know how to acquire those skills. He faces a mounting sense of despair which drains initiative and ambition and energy. . . .

Our history has proved that each time we broaden the base of abundance, giving more people the chance to produce and consume, we create new industry, higher production, increased earnings, and better income for all. Giving new opportunity to those who have little will enrich the lives of all the rest.

Because it is right, because it is wise, and because, for the first time in our history, it is possible to conquer poverty, I submit for the consideration of the Congress and the country, the Economic Opportunity Act of 1964. The act does not merely expand old programs or improve what is already being done. It charts a new course. It strikes at the causes, not

just the consequences of poverty. It can be a milestone in our 180-year search for a better life for our people.

74 STEVEN VANDERSTAAY

FROM "Hell" and "Joe" (1992)

HELL

Philadelphia, Pennsylvania

Tough, pleasant, opinionated, Hell limps as she walks. She wears a sweatshirt and cut-off shorts that reveal a row of livid red scars encircling her thigh. Hell is Puerto Rican and 28 years old.

I was in a couple of shelters and any shelter I was in, it was dirty. We had cockroaches the size of mice. I'm not crazy, I'm serious. I wouldn't lie. And the food . . . and violence. There's a whole lot of violence, a whole lot of it. It's like, if you don't like to fight I'd advise you don't go.

If the shelters were any better a lot of people would go to them. But they're not any good. You know, you don't get any respect. It's like you're here under martial law. And it's hard.

If you choose not to go to a shelter and you're just livin' on the street, then you have to worry about . . . well, a woman if she's by herself has to worry about being raped and beat up, and having any change she might have panhandled or whatever taken from her – you know, along with her mentality and her brain. They're gone too. Because it's just too hard. Sleepin' on the sidewalk hard.

But you still have the problem of showering, trying to keep clean. And sleeping. Because downtown you're not allowed to sleep anywhere, men or women. The cops will chase you all over the city, and you just be trying to take a nap, trying to go to sleep. You be forced to sleep places like underground with the subway system. You get to know the route of the trains by heart 'cause you hear them all the time. And it's hard, it really is. It's real hard. You have to be strong if you're going to be homeless.

Like this girl Diane, she got busted in the head. She gets beat up by her boyfriend, her body gets taken advantage of. They call her Dirty Diane because, well, she really don't take care of her monthly thing, just lets it dribble down her leg. Maybe she do that 'cause then nobody'll bother her. I don't know. She been put in the hospital about three or four times for her mental problems. She just don't care anymore.

JOE

Philadelphia, Pennsylvania

Joe is a large, broad-shouldered man with round, brown eyes and thick, salt-and-pepper hair he keeps closely trimmed. He studies me as we get acquainted, watching and observing. His voice is deep and melodic, very comforting to listen to. I wish to myself that he would decide to trust me. Joe relaxes in a long pause, leans back and begins a narrative that lasts for hours: the story and history of all he has witnessed and endured in his many years on the street.

Joe is African American and middle-aged.

Me, I'm a loner. After being out on the streets so long I enjoy being alone. The less people that you have around out on the street the better. Because you can see someone go from a mild, meek-minded person to a murderer in just a few minutes. And if you a street person that still have some type of moral fiber, you gonna be ticked away. You watch a man that's twenty maybe rob another man that's eighty years old. You really want to do somethin' 'bout it but you can't, 'cause you can't survive that way.

Today a lot of the street people are veterans, like myself. They see the corruption in society. A lot of people accept it but they don't. And they find themselves separate from their families. Or their pride won't allow them to go back when they don't have anything.

But the vast majority of the street people today are not old people, they all young. A lot of 'em are cocaine addicts, white and black.

And now there's other folks, families, mens that had good jobs. They in the street too. They're not street people yet but a lot of them do become street people. This happen because of the way you treated.

You see, you a human being, but you not treated like one. You go in the train station and the cops chase you out. It's rainin', it's cold, you gotta go someplace. You can't stay in the street. That changes the rules. 'Cause the streets are survival, total survival. And only a few actually survive and get out of 'em.

People don't know this. The mayors, the governors, people in power, most of the time they come from middle-class, upper middle-class, and wealthy families. They can't relate to a person who never had no money. Most of 'em can't. They've been taught, "Anything you want to be in America you can be." But that's not necessarily the case, not for everyone.

This especially true of the single male. People have no sympathy for the male, he the one society really hate and reject. 'Cause they've always had a stigma in this country that any man that's not out liftin' 200 pounds per load is a bum. So they treat you that way. And if you treated that way for long enough you start to act like one.

I put it to you this way: once you don't work for a while, you get to the

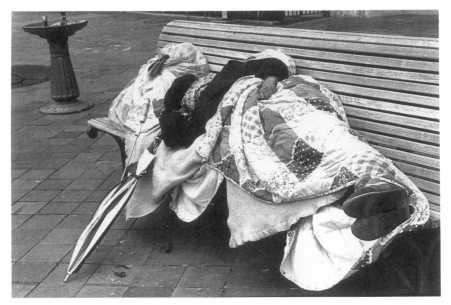

Figure 8.2 Homeless on the streets of Washington D.C.
Photograph: Jacky Chapman

point where you lose touch with what's happenin' beyond you, beyond your environment. Then when you fall far enough to hit the street, you actually start livin' in a different world, a different country. Maybe it's the Bowery, or L.A's skid row . . . people sleepin' on pieces of cardboard in parking lots . . . that's the new world.

In the new world you in society but you not really a part of it no more. And the society you live in, it really don't try to help. They make it as tough as they can on you.

They keep you alive, that's the name of the game, they keep you alive and say, "If you wasn't so lazy everything would be all right." You know what I mean? The society we live in treat you like dogs. "I gave you somethin', even if it was nothin' really to help ya, I gave you somethin'."

Sure, they give you a social worker who despise you, who can do nothing on his own 'cause the system say, "Well, we only allow this person to do this." And see, after they interview maybe two, three hundred people, they resent the street people. Because social workers take a lot of abuse too. And remember, you're talkin' about a person that maybe came from a middle-class family, that have no knowledge of what they doing except the things they have taught them in college. And when they should have gained experience they have a bad attitude due to the

bad experiences they have had with street people. Same thing with the police. It's in their mind that you a bum.

75 PETER BAIDA

FROM "Confessions of a Reluctant Yuppie" (1985)

I'm usually a pleasant fellow, but I began to get grumpy as soon as I agreed to write about Yuppies. "All I'm going to do is show how muddled I am," I complained to my wife. "I've never liked anything anybody else has written about Yuppies, and I'm not going to like what I write."

We were sitting in our purple library. The walls are exactly the color of Matisse's favorite purple – the purple of the stripes in "Odalisque with Striped Dress." The library is our primary claim to fame among the dozen or so of our contemporaries (people in their early thirties) who play a role in what passes for our social life these days. We were the first people in our group to "do" our apartment. Two hundred feet of built-in bookshelves, track lighting, custom-designed cabinetry, and the fabulous purple walls – all at a cost that I would prefer not to make public, but, what the hell – all at a cost of forty-seven thousand, two hundred forty-nine dollars, and it would have been more if we hadn't cut corners.

"What do I know about Yuppies, anyway?" I said to my wife. Through the big window facing south, Manhattan glittered as if it did not realize that its glory days were over. One reason I'm not usually grumpy is that, when the day's work is done, it is very pleasant to sip bourbon in the purple library and watch the city glitter. The lit spire of the Chrysler Building soothes and gently excites me. Is there any place I would rather be? Is this not the good life, or at least one version of it?

"Why do you hate Yuppies?" my wife asked. Her question must have caught me off guard, for the ghost of Quentin Compson rose out of a corner of my mind that I had not visited since long before I got my M.B.A. All that I could reply, in an injured stutter, was, "I don't hate Yuppies! I don't! I don't! I don't!" I knew then that I was about to tackle an assignment that not even bourbon and our view of the Chrysler Building would make palatable. Writing about Yuppies was going to be, as the people of my generation used to say, a real bummer.

In fact, I do not hate the young urban professionals, or Yuppies, whom I know. It's the ones that I don't know, the ones I read about in popular magazines and hear about on television, who bother me. A more pertinent question, then, might be, Why does *Newsweek* hate Yuppies? Here is a representative Yuppie couple, according to the *Newsweek* cover story of December 31, 1984, "The Year of the Yuppie":

When Norman Sandler, 31, a White House correspondent for UPI, and his wife Raeanne, 29, an art director, aren't eating out, which they do at least three times a week, they experiment in the kitchen of their Washington, D.C., apartment. Filed meticulously behind the kitchen door are dozens of recipes, most of which call for special ingredients – all of which the Sandlers seem to have. . . . They've got Hungarian paprika, Masa flour, Cajun Country and homemade garam masala, ground sesame seed for hummus, Pomi strained crushed fresh tomatoes for sauces and wild rice sent to them from Minnesota. Jammed into cupboards alongside the Corning Ware and Revere Ware are garlic cellars, a tortilla press and Tiffany Bloody Mary mugs. In the refrigerator are a hot-pepper sauce brought back from Barbados plus five varieties of mustard including a London grainy and both "country" and "city" types of Grey Poupon; in the freezer, homemade pesto, tortillas brought back from California and a bottle of imported Polish vodka. Meanwhile, below the Burberry raincoats and Tiffany crystal in the front-hall closet is the overflow of their 180-bottle collection of wine and champagne. "I guess this is a substitute for children," says Raeanne as she lovingly fondles a prize Perrier Jouet.

Whom the Gods wish to destroy, they encourage to consent to be interviewed. . . .

One interesting way to put Yuppies into perspective is to compare their attitudes and enthusiasms with those of young urban professionals from other eras. In many ways, for instance, despite the air of genial benevolence that he cultivated as he aged, Benjamin Franklin can be viewed as an early Yuppie. True, Franklin rose from poverty, whereas Yuppies tend to be children of the middle and the upper-middle class. But in his *Autobiography*, in *Poor Richard's Almanack*, and in such works as "The Way to Wealth," "Advice to a Young Tradesman," and "Necessary Hints to Those That Would Be Rich," Franklin gave advice that many Yuppies now follow, whether they know it or not.

Even people who despise Yuppies admit that they work hard. In part, the willingness to work hard derives from the fact that many Yuppies are lawyers or management consultants who bill by the hour. In part, it derives from their desire to prove that they can withstand the punishment that is presumed to be the price of success. And, in part, it derives from the fear of being thought unimportant: if your peers are bragging about their sixty- or seventy-hour work weeks, then you do not want to admit that your job is so undemanding that you can get it done in a mere forty hours.

Franklin's aphorisms – published originally in *Poor Richard's Almanack*

and then polished and republished in a single narrative entitled "The Way to Wealth" – include many that express Yuppie attitudes toward work: "Plough deep, while Sluggards sleep." "Dost thou love life, then do not Squander Time, for that's the Stuff Life is made of." "Since thou art not sure of a Minute, throw not away an Hour." Sometimes Yuppies are accused of working too hard, but here today's responses seem to be based upon a double standard: the willingness to work hard makes a man like Benjamin Franklin or Lee Iacocca a hero; it makes the over-zealous Yuppie a nerd.

9

RELIGION

Introduction 232

76 *Jonathan Edwards*
 FROM "Personal Narrative" (1739?–1742?) 234

77 *Ralph Waldo Emerson*
 FROM "The Manifesto of 1838" 238

78 *James Cardinal Gibbons*
 FROM "The Catholic Church and Labor" (1887) 241

79 *Will Herberg*
 "The Religion of Americans" (1955) 245

80 *Anonymous*
 "Swing Low, Sweet Chariot" and
 "Go Down, Moses" (pre-1860) 250

81 *Billy Graham*
 "The Unfinished Dream" (1970) 251

82 *Pat Robertson*
 FROM "The New World Order" (1992) 255

INTRODUCTION

The Pilgrims and the Puritans who had fled the Old World to seek refuge in the Promised Land considered religion to be the basis of society. They viewed America as a Christian frontier and felt that the Church of England's break with Rome was not radical enough, wanting to cleanse the English church of Popish influence. The Puritans did not restrict religion to ritual practice in the church but emphasized the importance of bringing religion into the worldly rural and urban life.

Undoubtedly Jonathan Edwards (1703–1758) ranks among America's greatest theologians, combining the Puritan doctrine of man's sinfullness and God's omnipotence with a belief in man's rationality and his potential capability to be good. But even though Edwards was well versed in the new sciences and the works of Newton, his reputation as a stern, unyielding Puritan remains unabated. Playing a significant role in the Great Awakening, the religious revivals that swept through the colonies in the eighteenth century, Edwards wanted to stir the parishioners out of their complacency and make them tremble in front of a wrathful god. The excerpts from "Personal Narrative" (his religious autobiography) record his inward journey towards his union with God.

During the age of Romanticism and the coming of Transcendentalism, the new doctrines of faith in man and exaltation of the individual and the worship of nature were incompatible with Edwards's position, and his spiritual influence (which had been strong long after his death) thus declined. Transcendentalism as a moral philosophy reached its peak in the years between 1830 and the Civil War and appealed particularly to those who were weary of the harsh God of traditional Puritanism. Ralph Waldo Emerson, worshipping the absolute goodness of man, and Henry David Thoreau, believing in nature's unspotted innocence, were the two most prominent proponents of transcendentalism. In his "Manifesto" (1838) Emerson, the ex-minister, renounces the Unitarian religion, proclaiming his faith in the soul as the source of religious creativity.

The optimism of Transcendentalism faded somewhat after the horrors of the Civil War and the social crises and labor struggles of the late nineteenth century. The Catholic Church, whose recruitment was primarily from the urban working class, could not ignore the social problems of that class and involved itself in the battle for social equity among the urban poor. In a noteworthy memorial to Cardinal Simeoni (extract 78), Archbishop James Cardinal Gibbons defends the most important labor organization of its day, the Catholic-dominated Knights of Labor, insisting on the right of labor association and the necessity of righting injustices inflicted on labor. The term "Social Gospel" was introduced by some Protestant ministers of the late nineteenth century reinterpreting the Bible to respond to the growing

inequality in the US and stressing the social aspects of Christianity at the expense of its spiritual and moral aspects.

In the twentieth century Western civilization (including the US) has undergone, according to Arnold Toynbee, a process of secularization, a process welcomed even by some theologians, such as for example Harvey Cox in his bestseller *The Secular City* (1965). Even so, regular weekly church attendance among adult Americans is still astonishingly high, particularly compared to that in most European countries. Religion is thus still a very essential part of American life.

It is worth noting what the reputed American sociologist Peter L. Berger said when asked whether he agreed with critics who argued that "Americans are very superficial in their religious perceptions." Berger answered: "Definitely not. I think there's more religious vitality in this country than in any other Western country . . . People are more committed, more interested . . . than Europeans are."[1]

Will Herberg's essay "The Religion of Americans" (extract 79) clarified many religious issues when it was first published in the 1950s, and in many ways it still gives a sound presentation of what Eisenhower once referred to as "our three great faiths."

Religion is also an integral part of the black experience of the US. Scholars discuss whether the traditional negro spirituals ("Go Down, Moses" and "Swing Low, Sweet Chariot" are included in this chapter) marked an escape from the harsh realities of pre-Civil War racial oppression, or whether they indeed voiced a subdued but real protest and hope for better days in the future.

The First Amendment to the Constitution proclaims that there shall be no state religion in the US. This does not mean that religion and politics are entirely separate; in fact they are often linked and even mixed, by both political and religious leaders. Billy Graham's speech (extract 81) exhibits a curious mixture of national pride and religious zeal, sometimes referred to as American Civil Religion. Compared to Pat Robertson's highly controversial interpretations of Christianity and the Bible in terms of political right-wing ideology (extract 82), however, Graham's speech probably appears very moderate and even timid to most observers. Increasingly the religious right's power is an issue in American politics, and candidates of the religious right gained a number of seats during the 1994 congressional elections.

1 *The US News and World Report*, April 11, 1977.

76 JONATHAN EDWARDS

FROM Personal Narrative (1739?–1742?)

I had a variety of concerns and exercises about my soul from my child-hood; but [I] had two more remarkable seasons of awakening, before I met with that change by which I was brought to those new dispositions and that new sense of things that I have since had. The first time was when I was a boy, some years before I went to college, at a time of remarkable awakening in my father's congregation. I was then very much affected for many months, and concerned about the things of religion, and my soul's salvation; and [I] was abundant in duties. I used to pray five times a day in secret, and to spend much time in religious talk with other boys, and used to meet with them to pray together. I experienced I know not what kind of delight in religion. My mind was much engaged in it, and [I] had much self-righteous pleasure; and it was my delight to abound in religious duties. I with some of my schoolmates joined together and built a booth in a swamp, in a very retired spot, for a place of prayer. And besides, I had particular secret places of my own in the woods, where I used to retire by myself and was from time to time much affected. My affections seemed to be lively and easily moved, and I seemed to be in my element when engaged in religious duties. And I am ready to think, many are deceived with such affections, and such a kind of delight as I then had in religion, and mistake it for grace.

But in process of time, my convictions and affections wore off; and I entirely lost all those affections and delights and left off secret prayer, at least as to any constant performance of it, and returned like a dog to his vomit, and went on in the ways of sin. Indeed I was at times very uneasy, especially towards the latter part of my time at college, when it pleased God to seize me with the pleurisy, in which He brought me nigh to the grave and shook me over the pit of hell. And yet, it was not long after my recovery, before I fell again into my old ways of sin. But God would not suffer me to go on with any quietness; I had great and violent inward struggles, till, after many conflicts with wicked inclinations, repeated resolutions, and bonds that I laid myself under by a kind of vows to God, I was brought wholly to break off all former wicked ways and all ways of known outward sin, and to apply myself to seek salvation and practice many religious duties, but without that kind of affection and delight which I had formerly experienced. My concern now wrought more by inward struggles and conflicts, and self-reflections. I made seek-ing my salvation the main business of my life. But yet, it seems to me I sought after a miserable manner, which has made me sometimes since to question whether ever it issued in that which was saving, being ready to doubt whether such miserable seeking ever succeeded. I was indeed

brought to seek salvation in a manner that I never was before; I felt a spirit to part with all things in the world, for an interest in Christ. My concern continued and prevailed, with many exercising thoughts and inward struggles; but yet it never seemed to be proper to express that concern by the name of terror.

From my childhood up, my mind had been full of objections against the doctrine of God's sovereignty, in choosing whom He would to eternal life, and rejecting whom He pleased, leaving them eternally to perish and be everlastingly tormented in hell. It used to appear like a horrible doctrine to me. But I remember the time very well, when I seemed to be convinced and fully satisfied, as to this sovereignty of God and His justice in thus eternally disposing of men, according to His sovereign pleasure. But I never could give an account how, or by what means, I was thus convinced, not in the least imagining at the time, nor a long time after, that there was any extraordinary influence of God's Spirit in it, but only that now I saw further, and my reason apprehended the justice and reasonableness of it. However, my mind rested in it; and it put an end to all those cavils and objections. And there has been a wonderful alteration in my mind, with respect to the doctrine of God's sovereignty, from that day to this, so that I scarce ever have found so much as the rising of an objection against it, in the most absolute sense, in God's showing mercy to whom He will show mercy, and hardening whom He will. God's absolute sovereignty and justice, with respect to salvation and dam-nation, is what my mind seems to rest assured of, as much as of anything that I see with my eyes; at least it is so at times. But I have often, since that first conviction, had quite another kind of sense of God's sovereignty than I had then. I have often since had not only a conviction, but a delightful conviction. The doctrine has very often appeared exceeding pleasant, bright and sweet. Absolute sovereignty is what I love to ascribe to God. But my first conviction was not so.

The first instance that I remember of that sort of inward, sweet delight in God and divine things that I have lived much in since, was on reading those words, I Timothy 1:17, *Now unto the King eternal, immortal, invisible, the only wise God, be honor and glory forever and ever, Amen.* As I read the words, there came into my soul, and was as it were diffused through it, a sense of the glory of the Divine Being, a new sense, quite different from anything I ever experienced before. Never any words of Scripture seemed to me as these words did. I thought within myself, how excellent a Being that was, and how happy I should be, if I might enjoy that God, and be rapt up to him in heaven, and be as it were swallowed up in him forever! I kept saying and, as it were, singing over these words of Scripture to myself; and [I] went to pray to God that I might enjoy Him, and prayed in a manner quite different from what I used to do, with a new sort of

affection. But it never came into my thought that there was anything spiritual, or of a saving nature, in this.

From about that time, I began to have a new kind of apprehensions and ideas of Christ, and the work of redemption, and the glorious way of salvation by Him. An inward, sweet sense of these things, at times, came into my heart; and my soul was led away in pleasant views and contemplations of them. And my mind was greatly engaged to spend my time in reading and meditating on Christ, on the beauty and excellency of His person, and the lovely way of salvation by free grace in Him. I found no books so delightful to me, as those that treated of these subjects. Those words, Canticles 2:1, used to be abundantly with me, *I am the Rose of Sharon, and the lily of the valleys.* The words seemed to me sweetly to represent the loveliness and beauty of Jesus Christ. The whole book of Canticles used to be pleasant to me, and I used to be much in reading it, about that time; and found, from time to time, an inward sweetness, that would carry me away, in my contemplations. This I know not how to express otherwise, than by a calm, sweet abstraction of soul from all the concerns of this world; and sometimes a kind of vision, or fixed ideas and imaginations, of being alone in the mountains, or some solitary wilderness, far from all mankind, sweetly conversing with Christ, and wrapped and swallowed up in God. The sense I had of divine things would often of a sudden kindle up, as it were, a sweet burning in my heart, an ardor of soul that I know not how to express.

Not long ago after I first began to experience these things, I gave an account to my father of some things that had passed in my mind. I was pretty much affected by the discourse we had together; and when the discourse was ended, I walked abroad alone, in a solitary place in my father's pasture, for contemplation. And as I was walking there, and looking up on the sky and clouds, there came into my mind so sweet a sense of the glorious *majesty* and *grace* of God that I know not how to express. I seemed to see them both in a sweet conjunction, majesty and meekness joined together; it was a sweet and gentle and holy majesty, and also a majestic meekness, an awful sweetness, a high and great and holy gentleness.

After this my sense of divine things gradually increased, and became more and more lively, and had more of that inward sweetness. The appearance of every thing was altered; there seemed to be, as it were, a calm, sweet cast, or appearance of divine glory, in almost everything. God's excellency, His wisdom, His purity and love, seemed to appear in every thing: in the sun, and moon, and stars; in the clouds and blue sky; in the grass, flowers, trees; in the water, and all nature; which used greatly to fix my mind. I often used to sit and view the moon for a long time; and in the day [I] spent much time in viewing the clouds and sky, to behold the sweet glory of God in these things, in the meantime

singing forth, with a low voice, my contemplations of the Creator and Redeemer. And scarce anything, among all the works of nature, was so sweet to me as thunder and lightning; formerly, nothing had been so terrible to me. Before, I used to be uncommonly terrified with thunder, and to be struck with terror when I saw a thunder storm rising; but now, on the contrary, it rejoiced me. I felt God, so to speak, at the first appearance of a thunder storm; and [I] used to take the opportunity, at such times, to fix myself in order to view the clouds, and see the lightnings play, and hear the majestic and awful voice of God's thunder, which oftentimes was exceedingly entertaining, leading me to sweet contemplations of my great and glorious God. While thus engaged, it always seemed natural to me to sing, or chant forth my meditations, or to speak my thoughts in soliloquies with a singing voice.

I felt then great satisfaction, as to my good estate, but that did not content me. I had vehement longings of soul after God and Christ, and after more holiness, wherewith my heart seemed to be full and ready to break, which often brought to my mind the words of the Psalmist, Psalms 119:20, *My soul breaketh for the longing that it hath*. I often felt a mourning and lamenting in my heart, that I had not turned to God sooner, that I might have had more time to grow in grace. My mind was greatly fixed on divine things, almost perpetually in the contemplation of them.

My sense of divine things seemed gradually to increase, until I went to preach at New York, which was about a year and a half after they began; and while I was there, I felt them, very sensibly, in a higher degree than I had done before. My longings after God and holiness were much increased. Pure and humble, holy and heavenly Christianity appeared exceedingly amiable to me. I felt a burning desire to be in everything a complete Christian; and conformed to the blessed image of Christ; and that I might live, in all things, according to the pure, sweet and blessed rules of the gospel. I had an eager thirsting after progress in these things, which put me upon pursuing and pressing after them. It was my continual strife day and night, and constant inquiry, how I should *be* more holy, and *live* more holily, and more becoming a child of God and a disciple of Christ. I now sought an increase of grace and holiness, and a holy life, with much more earnestness than ever I sought grace before I had it. I used to be continually examining myself, and studying and contriving for likely ways and means, how I should live holily, with far greater diligence and earnestness, than ever I pursued anything in my life – but yet with too great a dependence on my own strength, which afterwards proved a great damage to me. My experience had not then taught me, as it has done since, my extreme feebleness and impotence, every manner of way, and the bottomless depths of secret corruption and deceit there was in my heart. However, I went on with my eager pursuit after more holiness and conformity to Christ.

The heaven I desired was a heaven of holiness, to be with God and to spend my eternity in divine love and holy communion with Christ.

77 RALPH WALDO EMERSON

FROM "The Manifesto of 1838" or "An Address Delivered before the Senior Class in Divinity College, Cambridge, Sunday evening, July 15, 1838"

Truly speaking, it is not instruction, but provocation, that I can receive from another soul. What he announces, I must find true in me, or reject; and on his word, or as his second, be he who he may, I can accept nothing. On the contrary, the absence of this primary faith is the presence of degradation. As is the flood, so is the ebb. Let this faith depart, and the very words it spake and the things it made become false and hurtful. Then falls the church, the state, art, letters, life. The doctrine of the divine nature being forgotten, a sickness infects and dwarfs the constitution. Once man was all; now he is an appendage, a nuisance. And because the indwelling Supreme Spirit cannot wholly be got rid of, the doctrine of it suffers this perversion, that the divine nature is attributed to one or two persons, and denied to all the rest, and denied with fury. The doctrine of inspiration is lost; the base doctrine of the majority of voices usurps the place of the doctrine of the soul. Miracles, prophecy, poetry, the ideal life, the holy life, exist as ancient history merely; they are not in the belief, nor in the aspiration of society; but, when suggested, seem ridiculous. Life is comic or pitiful as soon as the high ends of being fade out of sight, and man becomes near-sighted, and can only attend to what addresses the senses. . . .

Jesus Christ belonged to the true race of prophets. He saw with open eye the mystery of the soul. Drawn by its severe harmony, ravished with its beauty, he lived in it, and had his being there. Alone in all history he estimated the greatness of man. One man was true to what is in you and me. He saw that God incarnates himself in man, and evermore goes forth anew to take possession of his World. He said, in this jubilee of sublime emotion, "I am divine. Through me, God acts; through me, speaks. Would you see God, see me; or see thee, when thou also thinkest as I now think." But what a distortion did his doctrine and memory suffer in the same, in the next, and the following ages! There is no doctrine of the Reason which will bear to be taught by the Understanding. The understanding caught this high chant from the poet's lips, and said, in the next age, "This was Jehovah come down out of heaven. I will kill you, if you say he was a man." The idioms of his language and the figures of his rhetoric have usurped the place of his truth; and churches are not built on his principles, but on his tropes.

Christianity became a Mythus, as the poetic teaching of Greece and of Egypt, before. He spoke of miracles; for he felt that man's life was a miracle, and all that man doth, and he knew that this daily miracle shines as the character ascends. But the word Miracle, as pronounced by Christian churches, gives a false impression; it is Monster. It is not one with the blowing clover and the falling rain.

He felt respect for Moses and the prophets, but no unfit tenderness at postponing their initial revelations to the hour and the man that now is; to the eternal revelation in the heart. Thus was he a true man. Having seen that the law in us is commanding, he would not suffer it to be commanded. Boldly, with hand, and heart, and life, he declared it was God. Thus is he, as I think, the only soul in history who has appreciated the worth of man.

1. In this point of view we become sensible of the first defect of historical Christianity. Historical Christianity has fallen into the error that corrupts all attempts to communicate religion. As it appears to us, and as it has appeared for ages, it is not the doctrine of the soul, but an exaggeration of the personal, the positive, the ritual. It has dwelt, it dwells, with noxious exaggeration about the *person* of Jesus. The soul knows no persons. It invites every man to expand to the full circle of the universe, and will have no preferences but those of spontaneous love. . . .

That is always best which gives me to myself. The sublime is excited in me by the great stoical doctrine, Obey thyself. That which shows God in me, fortifies me. That which shows God out of me, makes me a wart and a wen. There is no longer a necessary reason for my being. Already the long shadows of untimely oblivion creep over me, and I shall decease forever. . . .

2. The second defect of the traditionary and limited way of using the mind of Christ is a consequence of the first; this, namely; that the Moral Nature, that Law of laws whose revelations introduce greatness – yea, God himself – into the open soul, is not explored as the fountain of the established teaching in society. Men have come to speak of the revelation as somewhat long ago given and done, as if God were dead. The injury to faith throttles the preacher; and the goodliest of institutions becomes an uncertain and inarticulate voice. . . .

The man on whom the soul descends, through whom the soul speaks, alone can teach. Courage, piety, love, wisdom, can teach; and every man can open his door to these angels, and they shall bring him the gift of tongues. But the man who aims to speak as books enable, as synods use, as the fashion guides, and as interest commands, babbles. Let him hush.

To this holy office you propose to devote yourselves. I wish you may feel your call in throbs of desire and hope. The office is the first in the world. It is of that reality that it cannot suffer the deduction of any

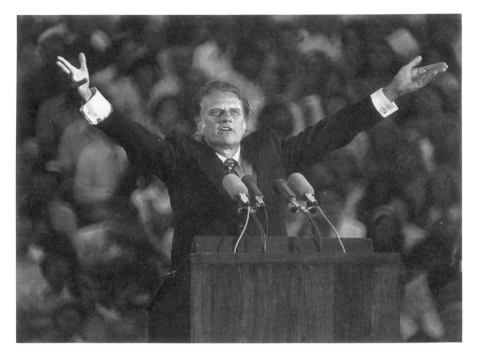

Figure 9.1 Evangelist Billy Graham preaching to an audience of 21,000 at the
Upper Midwest Crusade, 1973
Photograph courtesy of Range/Bettman/UPI

We can listen to no better voices than these men who gave us the
dream that has become America. These men represent thousands who
worked, prayed, suffered, and died to give us this nation.

We are not here today only to honor America; we are come as citizens
to renew our dedication and allegiance to the principles and institutions
that made her great. Lately our institutions have been under attack: the
Supreme Court, the Congress, the presidency, the flag, the home, the
educational system, and even the church – but we are here to say with
loud voices that in spite of their faults and failures we believe in these
institutions!

Let the world know today that the vast majority of us still proudly sing:
"My country, 'tis of thee, sweet land of liberty." America needs to sing
again! America needs to celebrate again! America needs to wave the flag
again! This flag belongs to all Americans – black and white, rich and
poor, liberal and conservative, Republican and Democrat.

I think there is too much discouragement, despair, and negativism in
the nation today. On every hand critics tell us what is wrong with
America, where we have failed, and why we are hated. We have listened

and watched while a relatively small extremist element, both to the left and to the right in our society, has knocked our courts, desecrated our flag, disrupted our educational system, laughed at our religious heritage, and threatened to burn down our cities – and is now threatening to assassinate our leaders.

The overwhelming majority of concerned Americans – white and black, hawks and doves, parents and students, Republicans and Democrats – who hate violence have stood by and viewed all of this with mounting alarm and concern. Today we call upon all Americans to stop this polarization before it is too late – and let's proudly gather around the flag and all that it stands for.

Many people have asked me why I, as a citizen of heaven and a Christian minister, join in honoring any secular state. Jesus said, "Render unto Caesar the things that are Caesar's." The Apostle Paul proudly boasted of being a Roman citizen. The Bible says "Honor the nation." As a Christian, or as a Jew, or as an atheist, each of us has a responsibility to an America that has always stood for liberty, protection, and opportunity.

There are many reasons why we honor America today.

First, we honor America because she has opened her heart and her doors to the distressed and the persecuted of the world. Millions have crossed our threshold into the fresh air of freedom. I believe that the Bible teaches that God blesses a nation which carries out the words of Jesus, "For I was hungered, and ye gave me meat: I was thirsty, and ye gave me drink: I was a stranger, and ye took me in."

Secondly, we honor America because she has been the most generous nation in history. We have shared our wealth and faith with a world in need. When a disaster occurs any place in the world, America is there with help. In famine, in earthquakes, in floods, in stresses of every kind, we pour out millions of dollars every year, even if we have to borrow the money and go in debt.

Thirdly, we honor America because she has never hidden her problems and debts. With our freedom of the press and open communications system, we don't sweep our sins under the rug. If poverty exists, if racial tension exists, if riots occur, the whole world knows about it. Instead of an Iron Curtain we have a picture window. "The whole world watches" – sometimes critically and sometimes with admiration, but nobody can accuse America of trying to hide her problems.

Fourthly, we honor America because she is honestly recognizing and is courageously trying to solve her social problems. In order to fulfill the ultimate problem, much remains to be done – but even our critics abroad are saying, "America is trying." The men who penned the Declaration of Independence were moved by a magnificent dream. This dream amazed the world 194 years ago. And this dream is rooted

in a book we call the Bible. It proclaims freedoms that most people of the world thought were impossible. We are still striving to achieve for all men equally those freedoms bought at such a high price. From the beginning, the dream of freedom and equal opportunity has been a beacon to oppressed peoples all over the world.

Let those who claim they want to improve the nation by destroying it join all of us in a new unity and a new dedication by peaceful means to make these dreams come true.

Fifthly, we honor America because she defends the right of her citizens to dissent. Dissent is impossible in many countries of the world, whereas constructive dissent is the hallmark of our freedom in America. But when dissent takes violent forms and has no moral purpose, it is no longer dissent but anarchy. We will listen respectfully to those who dissent in accordance with constitutional principles, but we strongly reject violence and the erosion of any of our liberties under the guise of a dissent that promises everything but delivers only chaos. As General Eisenhower once wrote: "We must never confuse honest dissent with disloyal subversion."

Sixthly, we honor America because there is woven into the warp and woof of our nation faith in God. The ethical and moral principles of the Judeo-Christian faith and the God of that tradition are found throughout the Declaration of Independence. Most presidents of the United States have declared their faith in God and have encouraged us to read the Bible. I am encouraged to believe that Americans at this hour are striving to retain their spiritual identity despite the inroads of materialism and the rising tide of permissiveness.

On the front page of a Chicago newspaper some time ago there appeared a picture of Betsy Ross sewing the first American flag. Over the picture was the caption, "Time to check our stitches." Let's check the stitches of racism that still persist in our country. Let's check the stitches of poverty that bind some of our countrymen. Let's check the stitches of foreign policy to be sure that our objectives and goals are in keeping with the American dream. Let's check the stitches of pollution brought on by technology. Let's check the stitches of a moral permissiveness that could lead us to decadence. Let's even check the stitches of freedom to see if our freedom in America has become licence. A liberal British writer recently said, "You Americans have become too free until you are no longer free."

The journey will be hard. The day will be long. And the obstacles will be many.

But I remember today a word spoken by Sir Winston Churchill, whose courage and faith and persistence carried his nation through the darkest days of World War II. The headmaster of Harrow, the famous prep school that Churchill had attended as a boy, asked Mr Churchill to

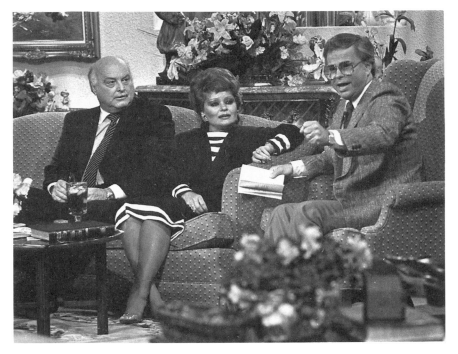

Figure 9.2 Evangelist Jim Bakker (right) with his wife Tammy and guest Edwin
Louis Cole recording their "People That Love" television show, 1986
Photograph courtesy of Range/Bettman/UPI

address the students. The headmaster told the young people to bring
their pencils and their notebooks to record what Britain's greatest man
of the century would say. The moment they waited for came. The old
man stood to his feet and spoke these words: "Never give in! Never give
in! Never! Never!"

I say to you today, "Pursue the vision, reach the goal, fulfill the
American dream – and as you move to do it, never give in! Never
give in! Never! Never! Never! Never!"

82 PAT ROBERTSON

FROM "The New World Order" (1992)

The universal moral law

Through the history of what has been called Christian civilization, the
Ten Commandments, given directly by the God of Jacob thirty-four

hundred years ago to a great leader of the family of Jacob, named Moses, have been considered the heart of the universal moral law.

In one of the great tragedies of history, the Supreme Court of the supposedly Christian United States guaranteed the moral collapse of this nation when it forbade children in the public schools to pray to the God of Jacob, to learn of His moral law, or even to view in their classrooms the heart of the law, the Ten Commandments, which children must obey for their own good or disobey at their peril.

It is one of the supreme ironies of history that the former communist bloc nations are desperately seeking to repair the moral wreckage brought upon their nations by an official policy of atheism, while irreligious liberal groups like the American Civil Liberties Union, People for the American Way, the American Jewish Congress, Americans United for Separation of Church and State, the National Organization for Women, and the liberal media are doing everything in their power to drive the United States into the same moral abyss that the Eastern Bloc countries are clawing their way out of.

The Ten Commandments are for our own good. As Jesus Christ put it, "The Sabbath was made for man." How do these commandments relate to the world?

The utopians have talked of world order. Without saying so explicitly, the Ten Commandments set the only order that will bring world peace – with devotion to and respect of God at the center, strong family bonds and respect next, and the sanctity of people, property, family, reputation, and peace of mind next.

All of the utopian societies that we have examined operate under a cloak of secrecy and a cloud of lies – every single one! They are furtive and conceal from view their real leaders and their real agenda. Each one has a series of concentric circles of order – from the key few to the enlightened initiates, to a larger front organization, to the agencies that they can manipulate.

Not one places God or the Bible at the center of its world schemes. When someone offers us a new social order, you would think we would have a clear right to ask, "If what you are offering is so good for us, why are you trying to sneak it by us the way you did the Federal Reserve Board?" God did not deliver His plan for world order in secret. He announced it from a smoking mountaintop and has subsequently caused hundreds of millions of copies of the law to be printed in virtually every known language on earth.

The first commandment is key to all the others, **"You shall have no other gods before Me."** Money, power, success, and utopian dreams all can become gods who have baser standards than the God of Jacob. Serving the lesser gods permits ethical lapses under the broad heading, "the end justifies the means." If our god is a Marxist paradise, then

killing 60 million human beings is justified, if that is necessary to bring about paradise. If our god is financial success, then wiping out competitors by unethical means is permissible. To have the God of Jacob as the pre-eminent deity means to gain success that all of his ethical standards must be observed along the way. . . .

God's unit of order

The basic unit of social, local, national, and international organization in God's world order is the family. As William Bennett, former secretary of education, said so eloquently, "The first Department of Health, Education, and Welfare is the family."

The basic responsibility for child rearing, social, and moral education belongs to the family. Every attempt at institutional child care has proved a miserable failure. Experiments with primates and human beings have shown beyond any chance of contradiction that the social and intellectual development of young children depends on extended personal nurturing by their mothers.

Furthermore, landmark studies by the World Health Organization, cited by Professor Armand Nicolai of Harvard University, showed that the prolonged absence of either parent had a dramatically negative impact upon young children, who then grow up lacking in drive, susceptible to peer pressure, and mediocre in studies. Although these clear findings are known and available, they are suppressed because women either must work or find personal fulfillment in work. Children are often ignored in the rhetoric of the feminist movement, which for so long denigrated motherhood and exalted the role of women in professions, in manual labor, and more recently in armed combat.

Virtually every recent pressure in society has been antifamily. We have brought in no-fault divorces. We have raised the tax burden on families by an estimated 226 percent. We have subsidized illegitimate births. We have permitted teenage abortions without parental consent. We have opened sex clinics in schools to teach illicit sex and to pass out contraceptives.

The National Education Association actually prints literature to show teachers how to subvert parental rights. More than anything, the number of working mothers has skyrocketed from 32.8 percent in 1948 to 66.6 percent by 1990, much of that caused by government-induced inflation and the resultant drop in the real incomes of male head-of-family wage earners.

The fifth commandment says, **"Honor your father and mother, that your days may be long upon the land."** Under God's order there is to be a family unit of mother, father, and children. The norm is the nuclear family, where both mother and father supply the material

needs and give the appropriate education and discipline to the children. The family is to transmit the culture and traditions of the society to the children.

Children in turn are to respect and obey their parents because parents are God's representatives to them. When parents become elderly and unable to work, the honor due them includes material care. As one person said so poignantly to me, "If a mother and father can afford to care for four children, why can't four children afford to care for their mother and father?"

Instead, in our society we have cut the link given in God's order. We encourage childlessness and abortion that removes younger wage earners to care for the elderly. Then we, through social security, Medicare, Medicaid, and a host of other impersonal government assistance programs, have effectively cut the lifeline between children and their elderly parents. Instead of old age being a time of honor, it is often a time of destitution, as the enlightened humanists of the new world order look for government-funded nursing homes and ways to advertise the Hemlock Society and more efficient euthanasia. . . .

Respect for property

God's order recognizes the sanctity of private property. The eighth commandment, **"You shall not steal"** means that the God of Jacob forbids a citizen to take what belongs to another citizen. He did not permit a Robin Hood to take from the rich and give to the poor, or the greedy rich to steal the possessions of the poor. What a man had accumulated was his. In God's order there are no schemes of wealth redistribution under which government forces productive citizens to give the fruit of their hard-earned labors to those who are nonproductive.

Opportunity was to be equal for all citizens. Those who were rich were instructed in order to receive God's blessings to give generous voluntary gifts to the poor, and sufficient gleaning was to be set aside so that the poor would have an opportunity to earn a living for themselves.

We hear in today's political jargon that there is a difference between human rights and property rights. This is nonsense. Without property of some sort it is impossible to obtain food, clothing, and shelter. It is certainly impossible to obtain recreation, education, books, music, art, travel, and worry-free retirement – the things that are considered the benefits of civilization.

When the framers of the US Declaration of Independence spoke of the pursuit of happiness, they obviously had in mind the ability to work, to accumulate private material possessions, and to pay for the type of lifestyle such possessions made possible. Remember, though, our founders guaranteed the pursuit of happiness, not happiness itself. No

government has the wealth or power to guarantee happiness, but any government can ensure the opportunity of all citizens to pursue their own destiny under God.

Every single utopian vision of world order requires a severe restriction on people's ownership of property and the enjoyment of its fruits. God's world order says that every man should be free to own private property free from the fear of theft by his fellow citizens or confiscation by a greedy government.

False accusers

In the communist countries, a regular part of life for the citizens was the false trials and perjured accusations before kangaroo courts. Judges were corrupt, prosecutors were corrupt, witnesses were corrupt. In the United States, although there are occasional cases of defendants falsely accused, the only true counterpart of the communist legal system is found in America's liberal press.

Private citizens and public officials are slandered and convicted in the press by so-called investigative reporters who act as prosecutor, judge, and jury. The accused has no ability to question evidence brought against him, no appeal to an impartial tribunal, and no ability to review the accuracy of the indictment against him. Under the US Supreme Court decision of *Sullivan v. The New York Times*, the burden of proof in proving press libel is so onerous that few of those victimized by the press have any option other than to suffer in silence the loss of their reputations.

The price that the vicious, sensational press exacts of public officials is so great that good citizens of ability are increasingly reluctant to enter into any type of public service. After thirty years of being the recipient of libel and scorn at the hands of the print media, I have become a bit more hardened to their tactics. But I often wonder who gave these people the right to destroy, humiliate, and damage the reputation of another human being living at peace with them?

The liberal press has tried repeatedly to take away from Christian people in America the right to run for office, to support candidates, to protest government abuses, or to protect themselves in court. Whatever ultimate victory Christian candidates may win is usually nullified by the torrent of unwarranted vituperation they have to experience in the press. With very few exceptions in America, it is absolutely impossible for an evangelical Christian to receive a fair story in the liberal press when he or she is involved in any unfavorable encounter with a government agency at any level.

Regardless of government abuse, the evangelical knows that the government agency will be portrayed in a favorable light and he will

be portrayed unfavorably. In one case in which I was a party, my Jewish attorney could not convince the liberal press that I had been proved completely blameless of the slander that had been brought against me. This was the comment from my lawyer, who has represented worldwide clients and several Israeli government agencies: "I have never encountered such press hostility in my life."

The liberal press represents the Establishment in the United States and Europe. The Nazis used the press to vilify the Jews and make association with them shameful. The communists used the press to undercut their enemies prior to their trial and punishment. In the new world order we can rest assured that those who stand in the way of the Establishment plans will become, like Margaret Thatcher, the victim of unremitting character assassination by the press. . . .

Government as God

With the government as god, the major crimes in society involve breaking government regulations. Morality becomes whatever a majority in Congress or the Supreme Court says it is at any point of time. The litany of government-sponsored crimes includes failure to pay income taxes, lying to the government, operating your affairs against regulations, failure to make full disclosure to a state or federal agency, violating securities laws, speeding laws, parking laws, zoning laws, pollution laws, fishing laws. In a poll taken by *Seventeen* magazine, parking in a parking space reserved for handicapped people was rated as a worse moral offense than sexual relations out of wedlock.

The moral order at the heart of the universe is broken daily by blasphemy, adulterous sex, lying, disrespect for parents, and coveting. Society in fact encourages, where possible, every imaginable conduct to violate the true moral law, while defending petty regulations against the citizens as if *they* had been handed down on tablets from Mount Sinai, instead of from "Gucci Gulch," as the lobbyist-filled corridors of power in the United States capital are derisively called.

Yet the Apostle Paul tells us that love is the fulfilling of the moral law. Against the one who loves his neighbor, "there is no law." Marx fantasized about a classless, stateless society where government had faded away. His was a pipe dream. But in God's order that is precisely what will happen – government and its wasteful laws and regulations will be unnecessary. All that would be necessary would be an association of the citizens to accomplish tasks in common, such as road building and traffic control, which no individual family could do for itself.

Thomas Jefferson described it well when he said, "That government governs best which governs least." The founders of America – at Plymouth Rock and in the Massachusetts Colony – felt that they were

260

organizing a society based on the Ten Commandments and the Sermon on the Mount. They perceived this new land as a successor to the nation of Israel, and they tried their best to model their institutions of governmental order after the Bible. In fact the man who interpreted the meaning of Scripture to them, the pastor, was given a higher place than the governor of the colony. These people built an incredible society because they exalted "the mountain of the Lord's house" above the other mountains.

10

EDUCATION

Introduction		264
83	*Robert Coram* FROM "The Necessity of Compulsory Primary Education" (1791)	266
84	*John Dewey* "My Pedagogic Creed" (1897)	269
85	*US Supreme Court* The 1954 Supreme Court Decision on Segregation	273
86	*US Congressmen* "Protest from the South" (1956)	275
87	*Jonathan Kozol* "The Grim Reality of Ghetto Schools" (1967)	277
88	*Peter Schrag* "Savage Equalities: The Case Against Jonathan Kozol" (1991)	279
89	*Allan Bloom* "The Closing of the American Mind" (1987)	282
90	*Elizabeth Loza Newby* FROM "An Impossible Dream" (1977)	287
91	*Studs Terkel* FROM "Public School Teacher: Rose Hoffman" (1972)	290

INTRODUCTION

In the course of their history Americans have displayed a tremendous faith in education as a means of climbing the social ladder and as an important tool in transmitting American common values to the people. Earlier than in Europe Americans sensed the importance of education as a means of social mobility.

In the first extract of this chapter Robert Coram, a Delaware newspaper editor, argues that the best way of alleviating poverty is through education. Writing after the American Revolution, Coram is concerned with the challenges America is faced with after the newly won independence, and makes a strong case for free elementary compulsory education.

According to Alfred North Whitehead, John Dewey, the famous American philosopher and educational theorist, is to be classed among those who have made philosophic thought relevant to the needs of their own day. Best known for his educational theories, Dewey developed and reformulated his ideas of education over the years, stressing throughout (as in extract 84, "My Pedagogic Creed") the importance of a philosophy of experience and its relation to education.

One of the headaches of American education has been the unequal opportunities offered to white and black children, primarily owing to the policy of placing blacks and whites in separate schools. The decision of the Supreme Court in 1896 *Plessy* v. *Ferguson* approved segregation of the races as being in accordance with the Fourteenth Amendment (see also the introduction to chapter 13). The principle of "separate but equal" helped to justify *de jure* segregation in schools and hit in particular black children in poor school districts. The "separate but equal" doctrine was not challenged by the Supreme Court until 1954 (extract 85), when the Court in its famous decision *Brown* v. *Board of Education of Topeka* declared the policy of "separate but equal" as unconstitutional and banned segregation in public schools. The specific case concerned Oliver Brown's application for his eight-year-old daughter to be allowed to go to a white school in Topeka, Kansas. This was the first major break-through after World War II for the blacks in their fight for equality within the school system.

The Supreme Court decision was opposed primarily by southern states, and in 1956 ninety-six congressmen from the south came out against the decision (extract 86). In the following years school desegregation efforts were often met with strong resistance from southern authorities, and on several occasions the Federal government had to resort to the national guard to enforce the law and sustain order.

By the late 1960s, however, some blacks had lost faith in integration as a means of achieving equal educational opportunities, and many blacks urged a new form of segregation and separation in educational matters.

Although there is *de jure* equality of educational opportunities in the US today, no observer of the American system can fail to notice that the *de facto* situation is far from satisfying. The now classic text by Jonathan Kozol (extract 87) points out some of the inadequacies of the ghetto school as observed by a teacher. In Kozol's recent book, *Savage Inequalities* (1991), he reiterates his old theme, much to the dissatisfaction of Peter Schrag who questions some of Kozol's views (extract 88).

In the extract by Elizabeth Loza Newby the problem of education is not so much with the school as with her own ethnic background. She describes probably a typical dilemma to many immigrant women in the US, forced to choose between the protection of the family and the chances to get higher education.

Public concern about the lack of quality in American education has been pervasive in the 1980s and early 1990s. In 1983 the US Department of Education issued *A Nation at Risk*, a blunt alarum that captured the attention of the public troubled by the deterioration of the schools. A focus on quality and student achievement has since then become a respectable enterprise, even though the reform movement of the 1980s did not achieve its aim of substantially improving education in the US. A recent comparison of 13-year-old American and foreign students by the Educational Testing Service ranked Americans last in mathematics and near the bottom in science.

Professor Allan Bloom's book *The Closing of the American Mind* (1987), from which a chapter is included as extract 89, attributes the social/political crisis of twentieth-century America to an intellectual crisis, a crisis in the educational system. In 1989 the National Governors' Association issued a set of educational objectives that ultimately became the national goals for education and evolved into *America 2000*, an education strategy unveiled in April 1991 by President Bush. One part of *America 2000* has particularly touched a nerve with educators: the development of national standards and voluntary examinations in five core subjects: English, history, mathematics, science and geography. Arguments against a national curriculum come from educational pluralists who fear intellectual homogenization and Orwellian thought control.

Although aspects of the educational system are in disarray, American education is, from another perspective, quite successful. Studs Terkel's interview with Rose Hoffman (the final extract in this chapter) brings us into the classroom. Hoffman shows how the day-to-day educational challenges at the primary level are meaningful and rewarding to a dedicated teacher.

Probably no country can match the excellence and the scholarship of the top American universities, and top students around the world choose US graduate schools to learn science and engineering. Combined with this intellectual quality is the creation of a comprehensive system of

higher education. The percentage of students in high school and college in the United States is unrivalled in the world.

83 ROBERT CORAM

FROM "The Necessity of Compulsory Primary Education" (1791)

[W]e have shown that the most obvious difference between the situation of the savage and the civilized man is the division of property. We have shown also that this difference is the origin of all the miseries and vices of the one and of all the innocence and happiness of the other. We have also demonstrated that the civilized man has been unjustly deprived of his right to the bounties of Providence and that he has been rendered, as much as human laws could do it, an abortive creation.

We will now inquire the best mode of alleviating his miseries, without disturbing the established rules of property. In the savage state, as there is no learning, so there is no need of it. Meum & tuum, which principally receives existence with civil society, is but little known in the rude stages of natural liberty; and where all property is unknown, or rather, where all property is in common, there is no necessity of learning to acquire or defend it. If in adverting from a state of nature to a state of civil society, men gave up their natural liberty and their common right to property, it is but just that they should be protected in their civil liberty and furnished with means of gaining exclusive property, in lieu of that natural liberty and common right of property which they had given up in exchange for the supposed advantages of civil society; otherwise the change is for the worse, and the general happiness is sacrificed for the benefit of a few.

In all contracts, say civilians, there should be a *quid pro quo*. If civil society therefore deprives a man of his natural means of subsistence, it should find him other means; otherwise civil society is not a contract, but a self-robbery, a robbery of the basest kind: "It represents a madman, who tears his body with his arms, and Saturn, who cruelly devours his own children." Society should then furnish the people with means of subsistence, and those means should be an inherent quality in the nature of the government, universal, permanent, and uniform, because their natural means were so. The means I allude to are the means of acquiring knowledge, as it is by the knowledge of some art or science that man is to provide for subsistence in civil society. These means of acquiring knowledge, as I said before, should be an inherent quality in the nature of the government: that is, the education of children should be provided for in the constitution of every state.

By education, I mean instruction in arts as well as sciences. Education,

then, ought to be secured by government to every class of citizens, to every child in the state. The citizens should be instructed in sciences by public schools, and in arts by laws enacted for that purpose, by which parents and others, having authority over children, should be compelled to bind them out to certain trades or professions, that they may be enabled to support themselves with becoming independency when they shall arrive to years of maturity.

Education should not be left to the caprice or negligence of parents, to chance, or confined to the children of wealthy citizens; it is a shame, a scandal to civilized society, that part only of the citizens should be sent to colleges and universities to learn to cheat the rest of their liberties. Are ye aware, legislators, that in making knowledge necessary to the subsistence of your subjects, ye are in duty bound to secure to them the means of acquiring it? Else what is the bond of society but a rope of sand, incapable of supporting its own weight? A heterogeneous jumble of contradiction and absurdity, from which the subject knows not how to extricate himself, but often falls a victim to his natural wants or to cruel and inexorable laws – starves or is hanged. . . .

We despise thieves, not caring to reflect that human nature is always the same; that when it is a man's interest to be a thief he becomes one, but when it is his interest to support a good character he becomes an honest man; that even thieves are honest among each other, because it is their interest to be so. We seldom hear of a man in independent circumstances being indicted for petit felony: the man would be an idiot indeed who would stake a fair character for a few shillings which he did not need, but the greatest part of those indicted for petit felonies are men who have no characters to lose, that is – no substance, which the world always takes for good character.

If a man has no fortune and through poverty or neglect of his parents he has had no education and learned no trade, in such a forlorn situation, which demands our charity and our tears, the equitable and humane laws of England spurn him from their protection, under the harsh term of a vagrant or a vagabond, and he is cruelly ordered to be whipped out of the county. . . .

We have already demonstrated that government should furnish the subject with some substitute in lieu of his natural means of subsistence, which he gave up to government when he submitted to exclusive property in lands. An education is also necessary in order that the subject may know the obligations he is under to government.

The following observations of a celebrated English historian are very applicable: "Every law," says Mrs. Macaulay in her *History of England*, "relating to public or private property and in particular penal statutes ought to be rendered so clear and plain and promulgated in such a manner to the public as to give a full information of its nature and extent

to every citizen. Ignorance of laws, if not wilful, is a just excuse for their transgression, and if the care of government does not extend to the proper education of the subject and to their proper information on the nature of moral turpitude and legal crimes and to the encouragement of virtue, with what face of justice can they punish delinquency? But if, on the contrary, the citizens, by the oppression of heavy taxes, are rendered incapable, by the utmost exertion of honest industry, of bringing up or providing for a numerous family, if every encouragement is given to licentiousness for the purpose of amusing and debasing the minds of the people or for raising a revenue on the vices of the subject, is punishment in this case better than legal murder? Or, to use a strong yet adequate expression, is it better than infernal tyranny?"

"Two regulations are essential to the continuance of republican governments: 1. Such a distribution of lands and such principles of descent and alienation as shall give every citizen a power of acquiring what his industry merits. 2. Such a system of education as gives every citizen an opportunity of acquiring knowledge and fitting himself for places of trust. These are fundamental articles, the *sine qua non* of the existence of the American republics."

"Hence the absurdity of our copying the manners and adopting the institutions of monarchies. In several states we find laws passed establishing provisions for colleges and academies where people of property may educate their sons, but no provision is made for instructing the poorer rank of people even in reading and writing. Yet in these same states every citizen who is worth a few shillings annually is entitled to vote for legislators. This appears to me a most glaring solecism in government. The constitutions are *republican* and the laws of education are *monarchical*. The *former* extend civil rights to every honest industrious man, the *latter* deprive a large proportion of the citizens of a most valuable privilege.

"In our American republics, where government is in the hands of the people, knowledge should be universally diffused by means of public schools. Of such consequence is it to society that the people who make laws should be well informed that I conceive no legislature can be justified in neglecting proper establishments for this purpose.

"Such a general system of education is neither impracticable nor difficult, and excepting the formation of a federal government that shall be efficient and permanent, it demands the first attention of American patriots. Until such a system shall be adopted and pursued, until the statesman and divine shall unite their efforts in *forming* the human mind, rather than in lopping its excrescences after it has been neglected, until legislators discover that the only way to make good citizens and subjects is to nourish them from infancy, and until parents shall be convinced that the *worst* of men are not the proper teachers to make the *best*, mankind cannot know to what degree of perfection society and government may

be carried. America affords the fairest opportunities for making the experiment and opens the most encouraging prospect of success."

Suffer me then, Americans, to arrest, to command your attention to this important subject. To make mankind better is a duty which every man owes to his posterity, to his country, and to his God; and remember, my friends, there is but one way to effect this important purpose – which is – by incorporating education with government. – *This is the rock on which you must build your political salvation!*

84 JOHN DEWEY

"My Pedagogic Creed" (1897)

ARTICLE I. WHAT EDUCATION IS.

I believe that all education proceeds by the participation of the individual in the social consciousness of the race. This process begins unconsciously almost at birth, and is continually shaping the individual's powers, saturating his consciousness, forming his habits, training his ideas, and arousing his feelings and emotions. Through this unconscious education the individual gradually comes to share in the intellectual and moral resources which humanity has succeeded in getting together. He becomes an inheritor of the funded capital of civilization. The most formal and technical education in the world cannot safely depart from this general process. It can only organize it; or differentiate it in some particular direction.

I believe that the only true education comes through the stimulation of the child's powers by the demands of the social situations in which he finds himself. Through these demands he is stimulated to act as a member of a unity, to emerge from his original narrowness of action and feeling and to conceive of himself from the standpoint of the welfare of the group to which he belongs. Through the responses which others make to his own activities he comes to know what these mean in social terms. The value which they have is reflected back into them. For instance, through the response which is made to the child's instinctive babblings the child comes to know what those babblings mean; they are transformed into articulate language and thus the child is introduced into the consolidated wealth of ideas and emotions which are now summed up in language.

I believe that this educational process has two sides – one psychological and one sociological; and that neither can be subordinated to the other or neglected without evil results following. Of these two sides, the psychological is the basis. The child's own instincts and powers furnish the material and give the starting point for all education. Save as the

efforts of the educator connect with some activity which the child is carrying on on his own initiative independent of the educator, education becomes reduced to a pressure from without. It may, indeed, give certain external results but cannot truly be called educative. Without insight into the psychological structure and activities of the individual, the educative process will, therefore, be haphazard and arbitrary. If it chances to coincide with the child's activity it will get a leverage; if it does not, it will result in friction, or disintegration, or arrest of the child's nature.

I believe that knowledge of social conditions, of the present state of civilization, is necessary in order properly to interpret that child's powers. The child has his own instincts and tendencies, but we do not know what these mean until we can translate them into their social equivalents. We must be able to carry them back into a social past and see them as the inheritance of previous race activities. We must also be able to project them into the future to see what their outcome and end will be. In the illustration just used, it is the ability to see in the child's babblings the promise and potency of a future social intercourse and conversation which enables one to deal in the proper way with that instinct.

I believe that the psychological and social sides are organically related and that education cannot be regarded as a compromise between the two, or a superimposition of one upon the other. We are told that the psychological definition of education is barren and formal – that it gives us only the idea of a development of all the mental powers without giving us any idea of the use to which these powers are put. On the other hand, it is urged that the social definition of education, as getting adjusted to civilization, makes of it a forced and external process, and results in subordinating the freedom of the individual to a preconceived social and political status.

I believe each of these objections is true when urged against one side isolated from the other. In order to know what a power really is we must know what its end, use, or function is; and this we cannot know save as we conceive of the individual as active in social relationships. But, on the other hand, the only possible adjustment which we can give to the child under existing conditions, is that which arises through putting him in complete possession of all his powers. With the advent of democracy and modern industrial conditions, it is impossible to foretell definitely just what civilization will be twenty years from now. Hence it is impossible to prepare the child for any precise set of conditions. To prepare him for the future life means to give him command of himself; it means so to train him that he will have the full and ready use of all his capacities; that his eye and ear and hand may be tools ready to command, that his judgment may be capable of grasping the conditions under which it has to work, and the executive forces be trained to act economically and

efficiently. It is impossible to reach this sort of adjustment save as constant regard is had to the individual's own powers, tastes, and interests – say, that is, as education is continually converted into psychological terms.

In sum, I believe that the individual who is to be educated is a social individual and that society is an organic union of individuals. If we eliminate the social factor from the child we are left only with an abstraction; if we eliminate the individual factor from society, we are left only with an inert and lifeless mass. Education, therefore, must begin with a psychological insight into the child's capacities, interests, and habits. It must be controlled at every point by reference to these same considerations. These powers, interests, and habits must be continually interpreted – we must know what they mean. They must be translated into terms of their social equivalents – into terms of what they are capable of in the way of social service.

<div align="center">ARTICLE II. WHAT THE SCHOOL IS.</div>

I believe that the school is primarily a social institution. Education being a social process, the school is simply that form of community life in which all those agencies are concentrated that will be most effective in bringing the child to share in the inherited resources of the race, and to use his own powers for social ends.

I believe that education, therefore, is a process of living and not a preparation for future living.

I believe that the school must represent present life – life as real and vital to the child as that which he carries on in the home, in the neighborhood, or on the play-ground.

I believe that education which does not occur through forms of life, or that are worth living for their own sake, is always a poor substitute for the genuine reality and tends to cramp and to deaden.

I believe that the school, as an institution, should simplify existing social life; should reduce it, as it were, to an embryonic form. Existing life is so complex that the child cannot be brought into contact with it without either confusion or distraction; he is either overwhelmed by the multiplicity of activities which are going on, so that he loses his own power of orderly reaction, or he is so stimulated by these various activities that his powers are prematurely called into play and he becomes either unduly specialized or else disintegrated.

I believe that, as such simplified social life, the school life should grow gradually out of the home life; that it should take up and continue the activities with which the child is already familiar in the home.

I believe that it should exhibit these activities to the child, and reproduce them in such ways that the child will gradually learn the

<div align="center">271</div>

meaning of them, and be capable of playing his own part in relation to them.

I believe that this is a psychological necessity, because it is the only way of securing continuity in the child's growth, the only way of giving a back-ground of past experience to the new ideas given in school.

I believe it is also a social necessity because the home is the form of social life in which the child has been nurtured and in connection with which he has had his moral training. It is the business of the school to deepen and extend his sense of the values bound up in his home life.

I believe that much of present education fails because it neglects this fundamental principle of the school as a form of community life. It conceives the school as a place where certain information is to be given, where certain lessons are to be learned, or where certain habits are to be formed. The value of these is conceived as lying largely in the remote future; the child must do these things for the sake of something else he is to do; they are mere preparation. As a result they do not become a part of the life experience of the child and so are not truly educative.

I believe that the moral education centers about this conception of the school as a mode of social life, that the best and deepest moral training is precisely that which one gets through having to enter into proper relations with others in a unity of work and thought. The present educational systems, so far as they destroy or neglect this unity, render it difficult or impossible to get any genuine, regular moral training.

I believe that the child should be stimulated and controlled in his work through the life of the community.

I believe that under existing conditions far too much of the stimulus and control proceeds from the teacher, because of neglect of the idea of the school as a form of social life.

I believe that the teacher's place and work in the school is to be interpreted from this same basis. The teacher is not in the school to impose certain ideas or to form certain habits in the child, but is there as a member of the community to select the influences which shall affect the child and to assist him in properly responding to these influences.

I believe that the discipline of the school should proceed from the life of the school as a whole and not directly from the teacher.

I believe that the teacher's business is simply to determine on the basis of larger experience and riper wisdom, how the discipline of life shall come to the child.

I believe that all questions of the grading of the child and his promotion should be determined by reference to the same standard. Examinations are of use only so far as they test the child's fitness for social life and reveal the place in which he can be of the most service and where he can receive the most help.

85 US SUPREME COURT

The 1954 Supreme Court Decision on Segregation

In the first cases in this Court construing the Fourteenth Amendment, decided shortly after its adoption, the Court interpreted it as proscribing all state-imposed discriminations against the Negro race. The doctrine of "separate but equal" did not make its appearance in this Court until 1896 in the case of *Plessy* v. *Ferguson, supra*, involving not education but transportation. American courts have since labored with the doctrine for over half a century. In this Court, there have been six cases involving the "separate but equal" doctrine in the field of public education.

In none of these cases was it necessary to re-examine the doctrine to grant relief to the Negro plaintiff. And in *Sweatt* v. *Painter, supra*, the Court expressly reserved decision on the question whether *Plessy* v. *Ferguson* should be held inapplicable to public education.

In the instant cases, that question is directly presented. Here, unlike *Sweatt* v. *Painter*, there are findings below that the Negro and white schools involved have been equalized, or are being equalized, with respect to buildings, curricula, qualifications and salaries of teachers, and other "tangible" factors. Our decision, therefore, cannot turn on merely a comparison of these tangible factors in the Negro and white schools involved in each of the cases. We must look instead to the effect of segregation itself on public education.

In approaching this problem, we cannot turn the clock back to 1868 when the Amendment was adopted, or even to 1896 when *Plessy* v. *Ferguson* was written. We must consider public education in the light of its full development and its present place in American life throughout the Nation. Only in this way can it be determined if segregation in public schools deprives these plaintiffs of the equal protection of the laws.

Today, education is perhaps the most important function of state and local governments. Compulsory school attendance laws and the great expenditures for education both demonstrate our recognition of the importance of education to our democratic society. It is required in the performance of our most basic public responsibilities, even service in the armed forces. It is the very foundation of good citizenship. Today it is a principal instrument in awakening the child to cultural values, in preparing him for later professional training, and in helping him to adjust normally to his environment. In these days, it is doubtful that any child may reasonably be expected to succeed in life if he is denied the opportunity of an education. Such an opportunity, where the state has undertaken to provide it, is a right which must be made available to all on equal terms.

We come then to the question presented: Does segregation of children in public schools solely on the basis of race, even though the physical

facilities and other "tangible" factors may be equal, deprive the children of the minority group of equal educational opportunities? We believe that it does.

In *Sweatt* v. *Painter, supra*, in finding that a segregated law school for Negroes could not provide them equal educational opportunities, this Court relied in large part on "those equalities which are incapable of objective measurement but which make for greatness in a law school". In *McLaurin* v. *Oklahoma State Regents, supra*, the Court, in requiring that a Negro admitted to a white graduate school be treated like all other students, again resorted to intangible considerations: " . . . his ability to study, to engage in discussions and exchange views with other students, and, in general, to learn his profession". Such considerations apply with added force to children in grade and high schools. To separate them from others of similar age and qualifications solely because of their race generates a feeling of inferiority as to their status in the community that may affect their hearts and minds in a way unlikely ever to be undone. The effect of this separation on their educational opportunities was well stated by a finding in the Kansas case by a court which nevertheless felt compelled to rule against the Negro plaintiffs:

> Segregation of white and colored children in public schools has a detrimental effect upon the colored children. The impact is greater when it has the sanction of the law; for the policy of separating the races is usually interpreted as denoting the inferiority of the negro group. A sense of inferiority affects the motivation of a child to learn. Segregation with the sanction of law, therefore has a tendency to [retard] the educational and mental development of negro children and to deprive them of some of the benefits they would receive in a racial[ly] integrated school system.

Whatever may have been the extent of psychological knowledge at the time of *Plessy* v. *Ferguson*, this finding is amply supported by modern authority. Any language in *Plessy* v. *Ferguson* contrary to this finding is rejected. We conclude that in the field of public education the doctrine of "separate but equal" has no place. Separate educational facilities are inherently unequal. Therefore, we hold that the plaintiffs and others similarly situated for whom the actions have been brought are, by reason of the segregation complained of, deprived of the equal protection of the laws guaranteed by the Fourteenth Amendment.

86 US CONGRESSMEN

"Protest from the South" (1956)

We regard the decision of the Supreme Court in the school cases as clear abuse of judicial power. It climaxes a trend in the Federal judiciary undertaking to legislate, in derogation of the authority of Congress, and to encroach upon the reserved rights of the states and the people.

The original Constitution does not mention education. Neither does the Fourteenth Amendment nor any other amendment. The debates preceding the submission of the Fourteenth Amendment clearly show that there was no intent that it should affect the systems of education maintained by the states.

The very Congress which proposed the amendment subsequently provided for segregated schools in the District of Columbia.

When the amendment was adopted in 1868, there were thirty-seven states of the Union. Every one of the twenty-six states that had any substantial racial differences among its people either approved the operation of segregated schools already in existence or subsequently established such schools by action of the same law-making body which considered the Fourteenth Amendment.

As admitted by the Supreme Court in the public school case (*Brown* v. *Board of Education*), the doctrine of separate but equal schools "apparently originated in *Roberts* v. *City of Boston* (1849), upholding school segregation against attack as being violative of a state consitutional guarantee of equality." This constitutional doctrine began in the North – not in the South – and it was followed not only in Massachusetts but in Connecticut, New York, Illinois, Indiana, Michigan, Minnesota, New Jersey, Ohio, Pennsylvania and other northern states until they, exercising their rights as states through the constitutional processes of local self-government, changed their school systems.

In the case of *Plessy* v. *Ferguson* in 1896 the Supreme Court expressly declared that under the Fourteenth Amendment no person was denied any of his rights if the states provided separate but equal public facilities. This decision has been followed in many other cases. It is notable that the Supreme Court, speaking through Chief Justice Taft, a former President of the United States, unanimously declared in 1927 in *Lum* v. *Rice* that the "separate but equal" principle is " . . . within the discretion of the state in regulating its public schools and does not conflict with the Fourteenth Amendment."

This interpretation, restated time and again, became a part of the life of the people of many of the states and confirmed their habits, customs, traditions and way of life. It is founded on elemental humanity and

common sense, for parents should not be deprived by Government of the right to direct the lives and education of their own children.

Though there has been no constitutional amendment or act of Congress changing this established legal principle almost a century old, the Supreme Court of the United States, with no legal basis for such action, undertook to exercise their naked judicial power and substituted their personal political and social ideas for the established law of the land.

This unwarranted exercise of power by the court, contrary to the Constitution, is creating chaos and confusion in the states principally affected. It is destroying the amicable relations between the white and Negro races that have been created through ninety years of patient effort by the good people of both races. It has planted hatred and suspicion where there has been heretofore friendship and understanding.

Without regard to the consent of the governed, outside agitators are threatening immediate and revolutionary changes in our public school systems. If done, this is certain to destroy the system of public education in some of the states.

With the gravest concern for the explosive and dangerous condition created by this decision and inflamed by outside meddlers:

We reaffirm our reliance on the Constitution as the fundamental law of the land.

We decry the Supreme Court's encroachments on rights reserved to the states and to the people, contrary to established law and to the Constitution.

We commend the motives of those states which have declared the intention to resist forced integration by any lawful means.

We appeal to the states and people who are not directly affected by these decisions to consider the constitutional principles involved against the time when they too, on issues vital to them, may be the victims of judicial encroachment.

Even though we constitute a minority in the present Congress, we have full faith that a majority of the American people believe in the dual system of government which has enabled us to achieve our greatness and will in time demand that the reserved rights of the states and of the people be made secure against judicial usurpation.

We pledge ourselves to use all lawful means to bring about a reversal of this decision which is contrary to the Constitution and to prevent the use of force in its implementation.

In this trying period, as we all seek to right this wrong, we appeal to our people not to be provoked by the agitators and troublemakers invading our states and to scrupulously refrain from disorder and lawless acts.

87 JONATHAN KOZOL

"The Grim Reality of Ghetto Schools" (1967)

Jonathan Kozol taught in the Boston public schools until he was fired. Controversy arose over his use of a poem by Langston Hughes in his fourth-grade classroom. The poem, "Ballad of the Landlord," is free of profanity and obscenity: it concerns the conflict between a black tenant and a white landlord.

Perhaps a reader would like to know what it is like to go into a new classroom in the same way that I did and to see before you suddenly, and in terms you cannot avoid recognizing, the dreadful consequences of a year's wastage of real lives.

You walk into a narrow and old wood-smelling classroom and you see before you 35 curious, cautious and untrusting children, aged eight to thirteen, of whom about two-thirds are Negro. Three of the children are designated to you as special students. Thirty per cent of the class is reading at the Second Grade level in a year and in a month in which they should be reading at the height of Fourth Grade performance or at the beginning of the Fifth. Seven children out of the class are up to par. Ten substitutes or teacher changes. Or twelve changes. Or eight. Or eleven. Nobody seems to know how many teachers they have had. Seven of their lifetime records are missing: symptomatic and emblematic at once of the chaos that has been with them all year long. Many more lives than just seven have already been wasted but the seven missing records become an embittering symbol of the lives behind them which, equally, have been lost or mislaid. (You have to spend the first three nights staying up until dawn trying to reconstruct these records out of notes and scraps.) On the first math test you give, the class average comes out to 36. The children tell you with embarrassment that it has been like that since fall.

You check around the classroom. Of forty desks, five have tops with no hinges. You lift a desk-top to fetch a paper and you find that the top has fallen off. There are three windows. One cannot be opened. A sign on it written in the messy scribble of a hurried teacher or some custodial person warns you: DO NOT UNLOCK THIS WINDOW IT IS BROKEN. The general look of the room is as of a bleak-light photograph of a mental hospital. Above the one poor blackboard, gray rather than really black, and hard to write on, hangs from one tack, lopsided, a motto attributed to Benjamin Franklin: *"Well begun is half done."* Everything, or almost everything like that, seems a mockery of itself.

"Not for fourth grade"

Into this grim scenario, drawing on your own pleasures and memories, you do what you can to bring some kind of life. You bring in some cheerful and colorful paintings by Joan Miro and Paul Klee. While the paintings by Miro do not arouse much interest, the ones by Klee become an instantaneous success. One picture in particular, a watercolor titled "Bird Garden," catches the fascination of the entire class. You slip it out of the book and tack it up on the wall beside the doorway and it creates a traffic jam every time the children have to file in or file out. You discuss with your students some of the reasons why Klee may have painted the way he did and you talk about the things that can be accomplished in a painting which could not be accomplished in a photograph. None of this seems to be above the children's heads. Despite this, you are advised flatly by the Art Teacher that your naïveté has gotten the best of you and that the children cannot possibly appreciate this. Klee is too difficult. Children will not enjoy it. You are unable to escape the idea that the Art Teacher means herself instead.

For poetry, in place of the recommended memory gems, going back again into your own college days, you make up your mind to introduce a poem of William Butler Yeats. It is about a lake isle called Innisfree, about birds that have the funny name of "linnets" and about a "bee-loud glade". The children do not all go crazy about it but a number of them seem to like it as much as you do and you tell them how once, three years before, you were living in England and you helped a man in the country to make his home from wattles and clay. The children become intrigued. They pay good attention and many of them grow more curious about the poem than they appeared at first. Here again, however, you are advised by older teachers that you are making a mistake: Yeats is too difficult for children. They can't enjoy it, won't appreciate it, wouldn't like it. You are aiming way above their heads . . . Another idea comes to mind and you decide to try out an easy and rather well-known and not very complicated poem of Robert Frost. The poem is called "Stopping By Woods on a Snowy Evening." This time, your supervisor happens to drop in from the School Department. He looks over the mimeograph, agrees with you that it's a nice poem, then points out to you – tolerantly, but strictly – that you have made another mistake. "Stopping By Woods" is scheduled for Sixth Grade. It is not "a Fourth Grade poem," and it is not to be read or looked at during the Fourth Grade. Bewildered as you are by what appears to be a kind of idiocy, you still feel reproved and criticized and muted and set back and you feel that you have been caught in the commission of a serious mistake . . .

Of all the poems of Langston Hughes that I read to my Fourth Graders, the one that the children liked most was a poem that has the

title "Ballad of the Landlord" . . . This poem may not satisfy the taste of every critic, and I am not making any claims to immortality for a poem just because I happen to like it a great deal. But the reason this poem did have so much value and meaning for me and, I believe, for many of my students, is that it not only seems moving in an obvious and immediate human way but that it *finds* its emotion in something ordinary. It is a poem which really does allow both heroism and pathos to poor people, sees strength in awkwardness and attributes to a poor person standing on the stoop of his slum house every bit as much significance as William Wordsworth saw in daffodils, waterfalls and clouds. At the request of the children later on I mimeographed that poem and, although nobody in the classroom was asked to do this, several of the children took it home and memorized it on their own. I did not assign it for memory, because I do not think that memorizing a poem has any special value. Some of the children just came in and asked if they could recite it. Before long, almost every child in the room had asked to have a turn.

88 PETER SCHRAG

"Savage Equalities: The Case Against Jonathan Kozol" (1991)

It's almost twenty-five years since the publication of Jonathan Kozol's *Death at an Early Age*, which recounted his eight months as a teacher in a rundown Boston ghetto school. Kozol was fired by the then notorious Boston School Committee for reading Langston Hughes's poem "Ballad of a Landlord" to his fourth-grade class – not part of the syllabus, the school committee said – and instantly became a major voice in the movement for school equity and integration of the late 1960s and early 1970s.

Kozol has never strayed far from that theme and has now returned to it with a book called *Savage Inequalities* that's gotten a respectful, even glowing, reception. Just before it came out, *Publishers Weekly* carried an unprecedented open letter on its cover, where it has never run anything but advertising, to tell George Bush to read this "startling and disturbing" new book. *Savage Inequalities* has made Kozol once again the most visible left-wing critic of American education and the star witness in a movement, now spreading to more than a dozen states – among them Alabama, Alaska, Idaho, Illinois, Indiana, Minnesota, Missouri, New Hampshire. North Dakota, South Dakota, Tennessee – to get court orders to equalize per-pupil spending between public schools in rich and poor communities.

It's a moving book – about filthy schools where roofs leak and halls are flooded each time it rains, where three or four classes have to share a gym or cafeteria because there aren't enough rooms, where teachers

have outdated textbooks or none at all. It's also a reminder that a lot of those kids really want to learn, aren't on drugs and understand that this is a society that treats white suburban children a lot better than it treats black inner-city kids. Given the thin gruel that the Bush administration has served up to deal with the nation's horrendous school problems – roughly equal parts school "choice," testing, and that old conservative favorite "more money's not the answer" – it's not surprising that Kozol is getting attention.

The rationale of the equalizers is simple: unequal spending among schools denies children equal protection of the laws. A poor community with a weak tax base simply can't spend as much on each child's education as a wealthy one, even if it raises rates to the breaking point, and that's patently unfair.

But is equalization of all spending – which, in addition to increasing the spending in poor districts, means capping the spending of affluent or motivated districts – really the solution? Consider California, the only major state where equalization has been thoroughly tried. (Texas and New Jersey are now starting down the same path but haven't gotten beyond the political acrimony and administrative chaos to be fair tests.) The results have been a wondrous illustration of the law of unintended consequences.

The most obvious of those consequences is that equalization sharply reduced local incentives to raise school taxes. After the California Supreme Court ruled, in *Serrano* v. *Priest* (1976), that the old funding system was unconstitutional, the legislature agreed to bring per-pupil spending in virtually all of the state's districts to within $100 (later revised to $200) of the state average. It proposed to do that not by requiring the rich districts to spend less, something that would have been academically unseemly and politically impossible, but by directing additional state money to the poor districts. Yet since the funding formula also reduced state funding one dollar for each dollar that districts might have raised in additional local property taxes, it eliminated much of the rationale and motivation for local efforts to improve the schools. (The exceptions to the formula were a few oil-rich districts that get no state aid.)

School equalization might have taken decades to achieve had it not been for the fortuitous passage of Proposition 13 in 1978. By slashing and capping local property tax revenues, Prop 13 shifted the burden of school funding to state income and sales taxes, which made equalization a lot easier to realize. But because of 13, and perhaps because of *Serrano* as well, the state's spending on schools has also slipped precipitately – from sixth or seventh in the nation to twenty-fifth or twenty-sixth. California now spends less per child than any other major industrial state, and less than the national average. As one state education official

said recently, it is much harder to motivate people to pay more taxes for education when they can't see the results right down the street.

Kozol has a lot of numbers dramatizing the inequities in spending between, for example, Camden and Princeton, New Jersey; Chicago and suburban New Trier High School; and New York City and suburban Manhasset (Long Island). But he doesn't point out that the $7,299 New York City spent on each child in 1989–90 was nearly double what most of the fanciest California suburbs got to spend that same year. California now spends roughly $5,100 a year per student. The national average is $5,500. The university town of Davis, where I live, and which sends as many of its graduates to college as New Trier, would kill to get $6,000 per student, let alone $7,000.

With the power to appropriate funds having shifted from local boards to the state government, it is no longer possible to know who is responsible for the financial problems of the local schools – the board that allocates the funds and overspends or mismanages them or the governor and legislature that fail to pony up enough to begin with. The same goes for responsibility for the construction of new schools, now so incomprehensibly divided between state and local agencies that almost no one understands the system.

Moreover, since school boards no longer have anything to do with setting tax rates, the interest of local business groups and taxpayer organizations in the schools – or in running people for the board – has sharply declined, leaving more and more districts in the control of the only well-financed group that's really interested in school affairs: the teachers' union. The Los Angeles school board, which runs the largest system in the state, is now controlled by people who got the lion's share of their election campaign support from UTLA, the United Teachers of Los Angeles. As fiscal control moves to the state, the moderate citizens' groups that once were the backbone of local government and local schools are less and less involved.

It shouldn't be surprising, then, that the union-dominated Los Angeles board awarded huge raises to its teachers three years ago – the average increase was roughly 27 percent over three years – and is now in deep financial trouble. And though it stands out in its generosity to employees, it's hardly alone. Two other large districts, Oakland and Richmond, are in such financial trouble from general mismanagement that they were taken over by state-appointed trustees; two dozen others teeter on the verge of bankruptcy. One-third of all the state's districts, according to state Controller Gray Davis, are spending more money than they take in.

Many of those problems are attributable to the state's generally dismal fiscal situation, but not all of them. District after district has been overly generous in setting pay scales, counting on state appropriations it didn't get. Most of the extra money that was supposed to go toward improving

the inner-city schools also went directly into increasing teacher and administrative salaries even while programs have been cut to the bone. No state in the country has as large a gap between what it pays its school employees and what it spends on everything else. California is fifth in the nation in teachers' salaries and dead last – meaning worst – in class size: many classes are now running well over thirty children, even in elementary schools. We also have leaky roofs and rotting buildings, but we have them in the suburbs as well as in the inner cities.

Kozol says, correctly, that poor children are trapped in awful inner-city schools, while the middle class has choices. But he refuses to give poor children the chance to escape to better public schools, through choice. He's also too simplistic in blaming the comparatively poor performance of our schools on money alone. No country has ever done, or even tried, what this country is now trying: to take such a diverse population of children – 20 percent of them from below the poverty level, many of them speaking little English, many from one-parent or no-parent families (all problems George Bush's education "program" ignores) – and educate each child at least through the twelfth grade for a high-tech culture. Under the circumstances, our schools are doing better than one might expect – as well at least as we did two decades ago. And given also what we've learned about the schools' external problems – poverty, broken families, teenage pregnancies, drugs, lack of health care, lack of child care – the first place to spend (and equalize) new money on children may not be in the K-12 school program, but on broader social problems.

Although Kozol acknowledges that equalization has been problematic in California, his support for the idea remains undiminished. Of course, Proposition 13 and fiscal mismanagement exacerbated the problems here. But the fact remains that equalization – any way you formulate it – tends to destroy local accountability and erode the supports and sense of mission that make strong schools possible.

89 ALLAN BLOOM

"The Closing of the American Mind" (1987)

I have begun to wonder whether the experience of the greatest texts from early childhood is not a prerequisite for a concern throughout life for them and for lesser but important literature. The soul's longing, its intolerable irritation under the constraints of the conditional and limited, may very well require encouragement at the outset. At all events, whatever the cause, our students have lost the practice of and the taste for reading. They have not learned how to read, nor do they have the expectation of delight or improvement from reading. They are

"authentic," as against the immediately preceding university gener-
ations, in having few cultural pretensions and in refusing hypocritical
ritual bows to high culture.

When I first noticed the decline in reading during the late sixties, I
began asking my large introductory classes, and any other group of
younger students to which I spoke, what books really count for them.
Most are silent, puzzled by the question. The notion of books as
companions is foreign to them. Justice Black with his tattered copy of
the Constitution in his pocket at all times is not an example that would
mean much to them. There is no printed word to which they look for
counsel, inspiration or joy. Sometimes one student will say "the Bible."
(He learned it at home, and his Biblical studies are not usually continued
at the university.) There is always a girl who mentions Ayn Rand's _The
Fountainhead_, a book, although hardly literature, which, with its sub-
Nietzschean assertiveness, excites somewhat eccentric youngsters to a
new way of life. A few students mention recent books that struck them
and supported their distinction of human types. It is a complex set of
experiences that enables one to say so simply, "He is a Scrooge." With-
out literature, no such observations are possible and the fine art of
comparison is lost. The psychological obtuseness of our students is
appalling, because they have only pop psychology to tell them what
people are like, and the range of their motives. As the awareness that
we owed almost exclusively to literary genius falters, people become
more alike, for want of knowing they can be otherwise. What poor
substitutes for real diversity are the wild rainbows of dyed hair and
other external differences that tell the observer nothing about what is
inside.

Lack of education simply results in students' seeking for enlightenment
wherever it is readily available, without being able to distinguish
between the sublime and trash, insight and propaganda. For the most
part students turn to the movies, ready prey to interested moralisms such
as the depictions of Gandhi or Thomas More – largely designed to
further passing political movements and to appeal to simplistic needs
for greatness – or to insinuating flattery of their secret aspirations and
vices, giving them a sense of significance. _Kramer vs. Kramer_ may be up-to-
date about divorces and sex roles, but anyone who does not have _Anna
Karenina_ or _The Red and the Black_ as part of his viewing equipment cannot
sense what might be lacking, or the difference between an honest
presentation and an exercise in consciousness-raising, trashy sentimen-
tality and elevated sentiment. As films have emancipated themselves
from the literary tyranny under which they suffered and which gave
them a bad conscience, the ones with serious pretensions have become
intolerably ignorant and manipulative. The distance from the contem-
porary and its high seriousness that students most need in order not to

indulge their petty desires and to discover what is most serious about themselves cannot be found in the cinema, which now only knows the present. Thus, the failure to read good books both enfeebles the vision and strengthens our most fatal tendency – the belief that the here and now is all there is.

The only way to counteract this tendency is to intervene most vigorously in the education of those few who come to the university with a strong urge for *un je ne sais quoi*, who fear that they may fail to discover it, and that the cultivation of their minds is required for the success of their quest. We are long past the age when a whole tradition could be stored up in all students, to be fruitfully used later by some. Only those who are willing to take risks and are ready to believe the implausible are now fit for a bookish adventure. The desire must come from within. People do what they want, and now the most needful things appear so implausible to them that it is hopeless to attempt universal reform. Teachers of writing in state universities, among the noblest and most despised laborers in the academy, have told me that they cannot teach writing to students who do not read, and that it is practically impossible to get them to read, let alone like it. This is where high schools have failed most, filled with teachers who are products of the sixties and reflecting the pallor of university-level humanities. The old teachers who loved Shakespeare or Austen or Donne, and whose only reward for teaching was the perpetuation of their taste, have all but disappeared.

The latest enemy of the vitality of classic texts is feminism. The struggles against elitism and racism in the sixties and seventies had little direct effect on students' relations to books. The democratization of the university helped dismantle its structure and caused it to lose its focus. But the activists had no special quarrel with the classic texts, and they were even a bit infected by their Frankfurt School masters' habit of parading their intimacy with high culture. Radicals had at an earlier stage of egalitarianism already dealt with the monarchic, aristocratic and antidemocratic character of most literary classics by no longer paying attention to their manifest political content. Literary criticism concentrated on the private, the intimate, the feelings, thoughts and relations of individuals, while reducing to the status of a literary convention of the past the fact that the heroes of many classic works were soldiers and statesmen engaged in ruling and faced with political problems. Shakespeare, as he has been read for most of this century, does not constitute a threat to egalitarian right thinking. And as for racism, it just did not play a role in the classic literature, at least in the forms in which we are concerned about it today, and no great work of literature is ordinarily considered racist.

But *all* literature up to today is sexist. The Muses never sang to the poets about liberated women. It's the same old *chanson* from the Bible

and Homer through Joyce and Proust. And this is particularly grave for literature, since the love interest was most of what remained in the classics after politics was purged in the academy, and was also what drew students to reading them. These books appealed to eros while educating it. So activism has been directed against the content of books. The latest translation of Biblical text – sponsored by the National Council of the Churches of Christ – suppresses gender references to God, so that future generations will not have to grapple with the fact that God was once a sexist. But this technique has only limited applicability. Another tactic is to expunge the most offensive authors – for example, Rousseau – from the education of the young or to include feminist responses in college courses, pointing out the distorting prejudices, and using the books only as evidence of the misunderstanding of woman's nature and the history of injustice to it. Moreover, the great female characters can be used as examples of the various ways women have coped with their enslavement to the sexual role. But never, never, must a student be attracted to those old ways and take them as models for him or herself. However, all this effort is wasted. Students cannot imagine that the old literature could teach them anything about the relations they want to have or will be permitted to have. So they are indifferent.

Having heard over a period of years the same kinds of responses to my question about favorite books, I began to ask students who their heroes are. Again, there is usually silence, and most frequently nothing follows. Why should anyone have heroes? One should be oneself and not form oneself in an alien mold. Here positive ideology supports them: their lack of hero-worship is a sign of maturity. They posit their own values. They have turned into a channel first established in the *Republic* by Socrates, who liberated himself from Achilles, and picked up in earnest by Rousseau in *Emile*. Following on Rousseau, Tolstoy depicts Prince Andrei in *War and Peace*, who was educated in Plutarch and is alienated from himself by his admiration for Napoleon. But we tend to forget that Andrei is a very noble man indeed and that his heroic longings give him a splendor of soul that dwarfs the petty, vain, self-regarding concerns of the bourgeoisie that surrounds him. Only a combination of natural sentiment and unity with the spirit of Russia and its history can, for Tolstoy, produce human beings superior to Andrei, and even they are only ambiguously superior. But in America we have only the bourgeoisie, and the love of the heroic is one of the few counterpoises available to us. In us the contempt for the heroic is only an extension of the perversion of the democratic principle that denies greatness and wants everyone to feel comfortable in his skin without having to suffer unpleasant comparisons. Students have not the slightest notion of what an achievement it is to free oneself from public guidance and find resources for guidance within

oneself. From what source within themselves would they draw the goals they think they set for themselves? Liberation from the heroic only means that they have no resource whatsoever against conformity to the current "role models." They are constantly thinking of themselves in terms of fixed standards that they did not make. Instead of being overwhelmed by Cyrus, Theseus, Moses or Romulus, they unconsciously act out the roles of the doctors, lawyers, businessmen or TV personalities around them. One can only pity young people without admirations they can respect or avow, who are artificially restrained from the enthusiasm for great virtue.

In encouraging this deformity, democratic relativism joins a branch of conservatism that is impressed by the dangerous political consequences of idealism. These conservatives want young people to know that this tawdry old world cannot respond to their demands for perfection. In the choice between the somewhat arbitrarily distinguished realism and idealism, a sensible person would want to be both, or neither. But, momentarily accepting a distinction I reject, idealism as it is commonly conceived should have primacy in an education, for man is a being who must take his orientation by his possible perfection. To attempt to suppress this most natural of all inclinations because of possible abuses is, almost literally, to throw out the baby with the bath. Utopianism is, as Plato taught us at the outset, the fire with which we must play because it is the only way we can find out what we are. We need to criticize false understandings of Utopia, but the easy way out provided by realism is deadly. As it now stands, students have powerful images of what a perfect body is and pursue it incessantly. But deprived of literary guidance, they no longer have any image of a perfect soul, and hence do not long to have one. They do not even imagine that there is such a thing.

Following on what I learned from this second question, I began asking a third: Who do you think is evil? To this one there is an immediate response: Hitler. (Stalin is hardly mentioned.) After him, who else? Up until a couple of years ago, a few students said Nixon, but he has been forgotten and at the same time is being rehabilitated. And there it stops. They have no idea of evil; they doubt its existence. Hitler is just another abstraction, an item to fill up an empty category. Although they live in a world in which the most terrible deeds are being performed and they see brutal crime in the streets, they turn aside. Perhaps they believe that evil deeds are performed by persons who, if they got the proper therapy, would not do them again – that there are evil deeds, not evil people. There is no *Inferno* in this comedy. Thus, the most common student view lacks an awareness of the depths as well as the heights, and hence lacks gravity.

90 ELIZABETH LOZA NEWBY

FROM **"An Impossible Dream"** (1977)

As I grew up in both the American and Mexican cultures, I was able to pick up the English language easily. Though Spanish was spoken at home and I was comfortable using Spanish with my family and friends, I knew that if I were to escape from the migrant life, I was going to have to master English. Since I viewed education as the most important thing in my life, I knew that I had to be able to speak and comprehend the language that was used at school. With the help of some very special teachers and an understanding mother, I was able to break the cycle that has imprisoned so many of my people.

At the end of my sophomore year in high school my father decided that my education should be terminated. He thought that school filled me with too many foolish ideas, such as going to college; and besides, school was too worldly. My mother, on the other hand, always encouraged me to continue my education and was happy that I stayed, but she hardly ever opposed Dad's wishes. He was the ruler of the home, and he made sure that we knew that. He did not see the need for me to continue my education: He had arranged a marriage for me when I was a child and schooling was not necessary for me to be a wife and mother. I had known of this arrangement for a long time, for my parents had talked of it incessantly after my fifteenth birthday. Of course, this marriage arrangement custom was and is very old and is hardly ever practiced anymore. But since my father was very "old country," he saw nothing wrong with this ancient custom.

The young man whose wife I was supposed to become was about twenty-eight years old. He came from a very old French and Spanish family of our native home in Mexico. The first time I saw him was on a rainy spring afternoon when I arrived home from school. As I opened the door to our home, I was greeted by five smiling brown faces. . . . The five people in the room were my mother and father, Pablo Rodriguez (the man I was to marry), and his mother and father. The Rodriguezes had traveled all the way from Mexico City to meet me and to take me back with them so that I could marry Pablo.

I was almost sixteen years old. I had had enough education and had developed enough determination to oppose my parents' wishes. . . . I immediately let my negative feelings concerning this arranged marriage be known to all in the room. . . . I was determined not to be forced into a marriage I did not desire just for the sake of tradition. Consequently, I objected and refused to marry the chosen young man.

This action brought shame and disgrace to my father and it was not to be forgotten. . . .

It is easy to see how difficult it was for me to get my father's permission to continue my education after what had occurred.

My dear mother settled him down, and the next day she assured me that I would be allowed to finish school. She said that my father had been reluctant to give his permission; but late that evening, following a convincing argument by my mother he had consented. She also said that she was counting on me not to disappoint her. I hugged her and told her not to worry. We then began to make plans for the completion of my last year in high school, sharing a mood of great happiness.

The last year of high school went by quickly. The work load was tremendous; the pressures were great; and my work at home was heavy. Often I stayed up late studying and got up early to do my chores before I left for school. Such was my routine, day in and day out. Mother did all she could to lighten my load, but I knew she couldn't do more. Besides, I did not want her to overwork. . . .

I took one day at a time; and finally, at the end of the year, I received my high school diploma. Tears were flowing from my eyes as I walked down the center aisle in the school gymnasium and proudly accepted my diploma from the school principal. It was a joyous occasion, and I can still remember the proud expression on my mother's face as she snapped one picture after another with a camera she had borrowed from a neighbor. . . .

It was a grand day of celebration; but even though it was a day to remember and the most exciting event that had ever happened to me up to that time, a more profound life-changing event was about to occur.

Late one afternoon, within a week following my graduation from high school, Mother greeted me at the door . . . holding a letter that was addressed to me from the school principal. She anxiously handed me the letter and asked me to open it immediately. I was nervous and scared as I ripped open the envelope, expecting to read the crushing news that there had been a mixup in their records and that, for some reason, they were rescinding my diploma. As I read the letter I discovered that I could not have been further from the truth. The note said that I was the recipient of a one-thousand-dollar scholarship for college.

The feeling that I experienced at that moment is indescribable. This was an impossible dream come true – an answer to prayer. At last I was being given the opportunity to escape from my dreary migrant existence.

While most of my classmates were destined to go to institutions of higher learning, I considered myself fortunate just to complete high school. My sense of accomplishment, which my mother shared, is beyond expression in words. For Mother it was a wonderful experience to see one of her children graduate from high school, let alone have an opportunity to continue study in college. We were both ecstatic! . . .

Mom and I decided to select an institution near relatives, where I could get help in obtaining employment or perhaps even stay with them while in college. After much consideration we decided on a college in southern Texas, where we had many relatives. We sent for an application and entrance papers and made all the arrangements.

We knew it was going to be difficult to tell Dad; but at this point I felt that I was in so much trouble with Dad from our previous problems that one more defiant act on my part would not make me any less endearing. . . .

He was furious! He was, in fact, so upset that he could hardly speak. The first thing he said was: "I knew I should never have let you go to school this last year. I have been too free with you, and all I have received in return is disgrace!" All this was beyond me, for I failed to see how going to college could be rebellious or disgraceful; and I pointed this out to him. Nevertheless, he continued his tirade and gave me the longest lecture I had ever heard on the evils of college and the terrible nature of career women. It seemed as though he would never finish. Mom and I sat in grave silence until his tirade ended. At this point we tried to tell him about the advantages of higher education and how I would be under the careful eye of relatives while I was in college. This argument did not help, and he stormed out the door while we stood there helpless. . . . He could not understand why I could not accept the traditional life-style of the typical Mexican migrant girl. I know that he loved me, but he just could not understand the changing times and felt threatened by higher education. . . . Dad did not speak to me for the rest of the week. The following Sunday, the day before I was supposed to leave, he finally approached me. . . . He said, "I have given this matter much thought, and I have only one thing to say; so listen carefully for you will have to live with the decision you make. Once we terminate this conversation we shall never speak of it again." By this time my stomach was in knots, and I knew somehow this decision was going to hurt. Then, in the very brief statement he made next, my world came crashing down all around me, leaving me drained and speechless. He continued: "I have decided that you can give up all these foolish ideas about college and have the love and protection of your family, or you can go ahead with your foolish plans to enter college. But the minute you walk out our door, consider it closed to you forever."

I was numb. I couldn't believe what I was hearing. . . .

After Dad had left, Mom came in to comfort me. She placed her hands on my shoulders and said, "Elizabeth I know this is a difficult decision you have to make, but I want you to think about this: Don't let emotion and 'old country' traditions hinder your future. You *are* and *always will be* my daughter. Your father can never take that away from

me. I want you to go and take advantage of this wonderful opportunity. Make us all proud. Your father is slow to change, but give him time and pray for him. Please go with my blessing."

With great reluctance I left home that last Monday of August 1966. It was the most difficult decision I had ever had to make, for I knew full well the consequences of being disowned. That day was a turning point in my life in that my family ties and relationships could never be the same again – I had lost my father forever. I was frightened and lonely as I boarded the bus for college, and my heart was heavy for Mom and the family. I knew that life would never be as it had so long been. Mine was a tearful and sad departue. I cried most of the way to Texas, thinking about the family which I had lost. . . .

91 STUDS TERKEL

FROM "Public School Teacher: Rose Hoffman" (1972)

I'm a teacher. It's a profession I loved and still love. It's been my ambition since I was eight years old. I have been teaching since 1937. Dedication was the thing in my day. I adored teaching. I used to think that teachers had golden toilets. (Laughs.) They didn't do anything we common people did.

She teaches third grade at a school in a changing neighborhood. It is her second school in thirty-three years. She has been at this one for twenty years. "I have a self-contained group. You keep them all day."

Oh, I have seen a great change since January 6, 1937. (Laughs.) It was the Depression, and there was something so wonderful about these dedicated people. The teachers, the children, we were all in the same position. We worked our way out of it, worked hard. I was called a Jewish Polack. (Laughs.) My husband tells me I wash floors on my knees like a Polack. (Laughs.) I was assigned to a fourth grade class. The students were Polish primarily. We had two colored families, but they were sweet. We had a smattering of ethnic groups in those times – people who worked themselves out of the Depression by hard work.

I was the teacher and they were my students. They weren't my equal. I loved them. There isn't one child that had me that can't say they didn't respect me. But I wasn't on an intimate basis. I don't want to know what's happened in the family, if there's a divorce, a broken home. I don't look at the record and find out how many divorces in the family. I'm not a doctor. I don't believe you should study the family's background. I'm not interested in the gory details. I don't care if their father

290

had twenty wives, if their mother is sleeping around. It's none of my business.

A little girl in my class tells me, "My mom's getting married. She's marrying a hippie. I don't like him." I don't want to hear it. It is not my nature to pry.

I have eight-year-olds. Thirty-one in the class and there's about twenty-three Spanish. I have maybe two Appalachians. The twenty-three Puerto Ricans are getting some type of help. The two little Appalachians, they never have the special attention these other children get. Their names aren't Spanish. My heart breaks for them. . . .

I've always been a strong disciplinarian, but I don't give these kids assignments over their head. They know exactly what they do. Habit. This is very boring, very monotonous, but habit is a great thing for these children. I don't tell them the reason for things. I give them the rote method, how to do it. After that, reasoning comes. Each one has to go to the board and show me that they really know. Because I don't trust the papers. They cheat and copy. I don't know how they do it. I walk up and down and watch them. I tell you, it's a way of life. (Laughs.)

At nine o'clock, as soon as the children come in, we have a salute to the flag. I'm watching them. We sing " My Country 'Tis of Thee." And then we sing a parody I found of "My Country 'Tis of Thee."

> To serve my country is to banish selfishness
> And bring world peace
> I love every girl and boy
> New friendships I'll enjoy
> The Golden Rule employ
> Till wars shall cease.

And then we sing "The Star-Spangled Banner." I watch them. It's a dignified exercise. These children love the idea of habit. Something schmaltzy, something wonderful.

I start with arithmetic. I have tables-fun on the board – multiplication. Everything has to be fun, fun, fun, play, play, play. You don't say tables, you say tables-fun. Everything to motivate. See how fast they can do it. It's a catchy thing. When they're doing it, I mark the papers. I'm very fast. God has been good to me. While I'm doing that, I take attendance. That is a must. All this happens before nine fifteen, nine twenty. . . .

Then I have a penmanship lesson on the board. There it is in my beautiful handwriting. I had a Palmer Method diploma. On Mondays I write beautifully, "If we go to an assembly, we do not whistle or talk, because good manners are important. If our manners are good, you'll be

MASS MEDIA AND POPULAR CULTURE

Introduction 296

92 New York Herald
Review of *Uncle Tom's Cabin* (1853) 298

93 Bessie Smith
"Empty Bed Blues" (1920s?) 301

94 Woodie Guthrie
"This Land is Your Land" (1944) 302

95 Mikal Gilmore
FROM "Bruce Springsteen" (1987) 302

96 Studs Terkel
FROM "Jill Robertson: Fantasia" (1982) 309

97 Stanley Kauffmann
"*Little Big Man*" (1970) 313

98 Martin Scorsese, Paul Schrader and Robert de Niro
FROM "*Taxi Driver*" (1992) 315

99 Neil Postman
FROM "The Age of Show Business" (1985) 318

INTRODUCTION

The advent of the penny paper during the first half of the nineteenth century added a new segment of the American population to the newspaper audience, making the newspapers the true mass media of the century. Aided by the rapid development in communication the cheap newspaper became an important source of news and cultural information in the US. The number of American newspapers, including the mercantile dailies and the political papers in addition to the penny papers, was 1,200 in 1833 (three times as many as in England or France), growing to about 3,000 by 1860. In the first text of this chapter a review (1853) of the theatre version of *Uncle Tom's Cabin* from the *New York Herald* shows how art criticism in a newspaper reflects the political mood of the pre-Civil War epoch.

Already in the beginning of the twentieth century advertising was an important part of American popular culture, dividing the population into groups based on class and income levels. For decades the advertisements focused primarily on the middle class, projecting images where men were by definition businessmen and women housewives. During the last decades, however, the focus on class has gradually yielded to a classification of the population into various lifestyles. The target groups are defined in more detail by analyzing various consumption patterns and expectations (see also chapter 7). Besides aiming at increasing the consumption of a particular product (and thus helping to keep the materialistic, consumer society afloat), advertisements often project images of American society which run counter to the basic divisions and contradictions in that society. Advertisements have for example consistently through this century paid little attention to religious, ethnic and racial differences, functioning often in much the same way as the Hollywood movies. An advertisement from the 1920s, "A Golden Girl from Somewhere," which actually is an advertisement for Jordan cars, is included for close analysis and interpretation (Figure 11.3).

Bessie Smith's "Empty Bed Blues" and Woody Guthrie's "This Land is Your Land" (extracts 93 and 94) tell a different story from that of the advertisements. Being the indisputable "Empress of the Blues" from 1923 until 1930 when the Depression destroyed the market for black records, Bessie Smith combined the rural blues with city-oriented lyrics, often developing themes and images that were overtly sexual, such as in "Empty Bed Blues."

Guthrie's "This Land is Your Land" (recorded in 1944) bears the unmistakable mark of leftist protest and was a favorite of the civil rights movement of the 1960s. Guthrie's songs (e.g. "So Long, It's Been Good to Know You" and "This Land . . .") attained a large audience and

influenced later stars such as Bob Dylan. Guthrie is widely regarded as America's most prominent folk singer of this century.

Even before non-British European teenagers pick up the rudiments of the English language, they have become devoted listeners to American rock and folk music. Musicians such as Bob Dylan, Jimi Hendrix, Janis Joplin and Joan Baez captured with their music a whole generation on both sides of the Atlantic in the 1960s, being spearheads in the counter-culture movement at the time. It is worth noting that Bruce Springsteen, the great rocker of the 1970s and 1980s, identifies himself (in the inter-view reprinted as extract 95) with many of the same ideals as the generation of the 1960s, even though the political and ideological climate has changed dramatically.

One very important reason why American culture has had such a tremendous impact on people in various parts of the world in the twentieth century is the popularity of American movies, from the silent movies of the beginning of the century to the movies now being trans-mitted to the consumer via cable networks and satellites. The interview with Jill Robertson, the daughter of a former Hollywood film producer, capitalizes on the make-believe world that the films and the film industry create.

Even though most people probably would position film in the category of popular culture, a number of serious film critics insist on placing film among the "older arts." This question aside, film criticism no doubt functions as an important guide to a potential audience. In his article on "Little Big Man" (1970), Stanley Kauffmann argues that Calder Willingham has succeeded in the daring enterprise of transforming the novel *Little Big Man* into a screenplay which functions according to the principles of the film medium.

In extract 98 Martin Scorsese, the film director, Paul Schrader, the scriptwriter, and Robert de Niro, the actor, give us an illuminating insight into the making of *Taxi Driver* as they discuss initial reactions to the script, the actual shooting of the movie and the intentions and philosophy behind the movie production. They seem happy with the result as summed up by Paul Schrader: "*Taxi Driver* was as much a product of luck and timing as everything else – three sensibilities together at the right time, doing the right thing."

American TV has been accused of breeding violence and producing hollow soap operas, but it is sometimes also praised for excellent documentaries, social reports and quality programs. During the Gulf War in 1991 the American television company Cable News Network (CNN), owned by Ted Turner, established a new kind of global infor-mation system which served not only the general public but also the political leaders involved in the war. Incredibly enough, both the US Defense Secretary and the Chairman of the Joint Chiefs of Staff report-

edly referred to CNN as their best source of information on the effect of the Baghdad bombing. CNN seems to have fulfilled the dreams of media theorist Marshall McLuhan, who envisioned a "global village" where citizens gathered around the electronic hearth. The CNN coverage of the war drew, however, sharp criticism from various quarters, notably for its glorification of the clean, high-tech war and its de-emphasis of the human sufferings involved.

Neil Postman, one of the most renowned media analysts on the American scene, critically examines the role of television in the American society in the final extract of this chapter and concludes that TV is a medium for entertainment only, and not for serious discourse, reflection or education.

92 *NEW YORK HERALD*

Review of *Uncle Tom's Cabin* (1853)

Mrs. Harriet Beecher Stowe's novel of *Uncle Tom's Cabin* has been dramatized at the National Theatre, and, being something of a novelty, it draws crowded houses nightly.

The practice of dramatizing a popular novel, as soon as it takes a run, has become very common. In many instances, and particularly with regard to the highly dramatic and graphic novels of Dickens, these new plays have been very successful, giving pleasure and satisfaction to the public, and putting money into the pockets of the chuckling manager. But in the presentation of *Uncle Tom's Cabin* upon the boards of a popular theatre, we apprehend the manager has committed a serious and mischievous blunder, the tendencies of which he did not comprehend, or did not care to consider, but in relation to which we have a word or two of friendly counsel to submit.

The novel of *Uncle Tom's Cabin* is at present our nine days' literary wonder. It has sold by thousands, and ten, and hundreds of thousands – not, however, on account of any surpassing or wonderful literary merits which it may be supposed to possess, but because of the widely extended sympathy, in all the North, with the pernicious abolition sympathies and "higher law" moral of this ingenious and cunningly devised abolition fable. The *furore* which it has thus created, has brought out quite a number of catchpenny imitators, *pro* and *con*, desirous of filling their sails while yet the breeze is blowing, though it does appear to us to be the meanest kind of stealing of a lady's thunder. This is, indeed, a new epoch and a new field of abolition authorship – a new field of fiction, humbug and deception, for a more extended agitation of the slavery question – than any that has heretofore imperiled the peace and safety of the Union.

The success of *Uncle Tom's Cabin* as a novel, has naturally suggested its success upon the stage; but the fact has been overlooked, that any such representation must be an insult to the South – an exaggerated mockery of Southern institutions – and calculated, more than any other expedient of agitation, to poison the minds of our youth with the pestilent principles of abolitionism. The play, as performed at the National, is a crude and aggravated affair, following the general plot of the story, except in the closing scene, where, instead of allowing Tom to die under the cruel treatment of his new master in Louisiana, he is brought back to a reunion with Wilmot and his wife – returned runaways – all of whom, with Uncle Tom and Aunt Chloe, are set free, with the privilege of remaining upon the old plantation. The incidents of the piecc are thus set forth in the "small bill":-

PROGRAMME

ACT 1 – Exterior of Uncle Tom's Cabin on Shelbey's Plantation; Negro Celebration. Chorus, "Nigga in de Cornfield;" Kentucky Breakdown Dance; Innocence Protected; Slave Dealers on hand. Chorus, " Come then to the Feast;" the Mother's Appeal; Capture of Morna; Interior of Uncle Tom's Cabin; Midnight Escape; Tom driven from his Cabin; Search of the Traders; Miraculous Escape of Morna and her Child. Offering Prayer; the Negro's Hope; Affecting Tableau.

ACT 2 – Family Excitement; Dark Threatenings; Ohio River Frozen over; Snow Storm; Flight of Morna and her Child; Pursuit of the Traders; Desperate Resolve and Escape of Morna on Flowing Ice; Mountain Torrent and Ravine; Cave of Crazy Mag; Chase of Edward; Maniac's Protection; Desperate Encounter of Edward and Traders on the Bridge; Fall of Springer down the Roaring Torrent; Negro Chorus, "We Darkies Hoe the Corn;" Meeting of Edward and Morna; Escape over Mountain Rocks.

ACT 3 – Roadside Inn; Advertisement Extraordinary; the Slave Auctioneer; Rencontre between Edward and Slave Dealers; Interposition of Crazy Mag; Arrival from the West Indies; Singular Discovery. Mountain Dell; Recognition of the Lost Mother; Repentance and Remorse; Return of Tom; the Log Cabin in its Pride; Freedom of Edward and Morna &c.

In the progress of these varied scenes, we have the most extravagant exhibitions of the imaginary horrors of Southern slavery. The negro traders, with their long whips, cut and slash their poor slaves about the stage for mere pastime, and a gang of poor wretches, handcuffed to a chain which holds them all in marching order, two by two, are

thrashed like cattle to quicken their pace. Uncle Tom is scourged by the trader, who has bought him, for "whining" at his bad luck. A reward is posted up, offering four hundred dollars for the runaway, Edward Wilmot, (who, as well as his wife, is nearly white,) the reward to be paid upon "his recovery, or upon proof that he has been killed." But Wilmot shoots down his pursuers in real Christian style, as fast as they come, and after many marvellous escapes, and many fine ranting abolition speeches, (generally preceding his dead shots,) he is liberated as we have described.

This play, and these scenes, are nightly received at one of our most popular theatres with repeated rounds of applause. True, the audience appears to be pleased with the novelty, without being troubled about the moral of the story, which is mischievous in the extreme.

The institution of Southern slavery is recognized and protected by the federal constitution, upon which this Union was established, and which holds it together. But for the compromises on the slavery question, we should have no constitution and no Union – and would, perhaps, have been at this day, in the condition of the South American republics, divided into several military despotisms, constantly warring with each other, and each within itself. The Fugitive Slave law only carries out one of the plain provisions of the constitution. When a Southern slave escapes to us, we are in honor bound to return him to his master. And yet, here in this city – which owes its wealth, population, power, and prosperity, to the Union and the constitution, and this same institution of slavery, to a greater degree than any other city in the Union – here we have nightly represented, at a popular theatre, the most exaggerated enormities of Southern slavery, playing directly into the hands of the abolitionists and abolition kidnappers of slaves, and doing their work for them. What will our Southern friends think of all our professions of respect for their delicate social institution of slavery, when they find that even our amusements are overdrawn caricatures exhibiting our hatred against it and against them? Is this consistent with good faith, or honor, or the every day obligations of hospitality? No, it is not. It is a sad blunder; for when our stage shall become the deliberate agent in the cause of abolitionism, with the sanction of the public, and their approbation, the peace and harmony of this Union will soon be ended.

We would, from all these considerations, advise all concerned to drop the play of *Uncle Tom's Cabin* at once and for ever. The thing is in bad taste – is not according to good faith to the constitution, or consistent with either of the two Baltimore platforms; and is calculated, if persisted in, to become a firebrand of the most dangerous character to the peace of the whole country.

93 BESSIE SMITH

"Empty Bed Blues" (1920s?)

I woke up this morning with an awful aching head,
I woke up this morning with an awful aching head,
My new man had left me just a room and an empty bed.

Bought me a coffee grinder, got the best one I could find,
Bought me a coffee grinder, got the best one I could find,
So he could grind me coffee, cause he had a brand new grind.

He's a deep-sea diver with a stroke that can't go wrong,
He's a deep-sea diver with a stroke that can't go wrong,
He can touch the bottom, and his wind holds out so long.

He knows how to thrill me, and he thrills me night and day,
He knows how to thrill me, and he thrills me night and day,
He's got a new way of loving, almost takes my breath away.

He's got that sweet something, and I told my galfriend Lou,
He's got that sweet something, and I told my galfriend Lou,
'Cause the way she's raving, she must have gone and tried it too.

When my bed gets empty, makes me feel awful mean and blue,
When my bed gets empty, makes me feel awful mean and blue,
'Cause my springs getting rusty, sleepin' single the way I do.

Bought him a blanket, pillow for his head at night,
Bought him a blanket, pillow for his head at night,
Then I bought him a mattress so he could lay just right.

He came home one evening with his fair head way up high,
He came home one evening with his fair head way up high,
What he had to give me made me wring my hands and cry.

He give me a lesson that I never had before,
He give me a lesson that I never had before,
When he got through teaching me, from my elbows down was sore.

He boiled my first cabbage, and he made it awful hot,
He boiled my first cabbage, and he made it awful hot,
Then he put in the bacon and it overflowed the pot.

When you get good lovin' never go and spread the news,
When you get good lovin' never go and spread the news,
They'll double-cross you and leave you with them empty bed blues.

301

94 WOODY GUTHRIE

"This Land is Your Land" (1944)

This land is your land, this land is my land
From California to the New York island,
From the redwood forest to the Gulf Stream waters;
This land was made for you and me.

As I was walking that ribbon of highway
I saw above me that endless skyway;
I saw below me that golden valley;
This land was made for you and me.

I've roamed and rambled and I followed my footsteps
To the sparkling sands of her diamond deserts;
And all around me a voice was sounding;
This land was made for you and me.

One bright Sunday morning in the shadows of the steeple
By the Relief Office I seen my people;
As they stood there hungry, I stood there whistling;
This land was made for you and me.

When the sun came shining, and I was strolling,
And the wheat fields waving and the dust clouds rolling.
As the fog was lifting a voice was chanting:
This land was made for you and me.

Nobody living can ever stop me,
As I go walking that freedom highway;
Nobody living can ever make me turn back,
This land was made for you and me.

As I went walkin, I saw a sign there,
And on the sign it said, "No Trespassing,"
But on the other side it didn't say nothing,
That side was made for you and me.

95 MIKAL GILMORE

FROM "Bruce Springsteen" (1987)

The 1960s are often idealized as times of great innocence and wonder. Although your own work has been recorded in the Seventies and Eighties, some of your best songs seem haunted by the strife of that era. Looking back, do you see the Sixties as a period in which a great deal was at stake in American culture?

I think that in the Sixties there was a rebellion against what people felt was the dehumanization of society, where people were counted as less than people, less than human. It was almost as if there were a temper tantrum against that particular threat. In the Sixties moral lines were drawn relatively easily. "Hey, this is wrong, this is right – I'm standing *here!*" That idea busted up nearly every house in the nation. And people expected revolution. I think some people thought it was going to happen in an explosive burst of some sort of radical, joyous energy, and that all the bullshit and all the Nixons were going to be swept away, and, man, we were going to start all over again and do it right this time. Okay, that was a child-like fantasy. But a lot of those ideas were good ideas.

It's funny, but because of the naiveness of the era, it's easily trivialized and laughed at. But underneath it, I think, people were trying in some sense to redefine their own lives and the country that they lived in, in some more open and free and just fashion. And *that* was real – that desire was real. But I think that as people grew older, they found that the process of changing things actually tends to be *un*romantic and not very dramatic. In fact, it's very slow and very small, and if anything, it's done in inches.

The values from that time are things that I still believe in. I think that all my music – certainly the music I've done in the past five or six years – is a result of that time and those values. I don't know, it seems almost like a lost generation. How do the ideals of that time connect in some pragmatic fashion to the real world today? I don't know if anybody's answered that particular question.

One of the central events that inspired the idealism of that era – the war in Vietnam – was also the most horrific thing to happen to this society in the last twenty years. It tore us apart along political and generational lines, but it also drew a hard line across the nation and forced many of us to take a clear stand.

That's true: that *was* the last time things ever felt that morally clear. Since then – from Watergate on down – who or what the enemy is has grown more obfuscated. It's just too confusing. But you can't wait for events like Vietnam, because if you do, then maybe 55,000 men end up dying and the country is left changed forever. I mean, that experience is *still* not over. And without those particular memories, without the people who were there reminding everybody, it would've happened again already, I'm sure. Certainly, it would have happened in the past eight years if they thought they could have gotten away with it.

So what went wrong? Why is it that so few of the brave ideals of those times carried over to the social and political realities of today?

I think the problem is that people yearn for simple answers. The reason the image of the Reagan presidency is so effective is that it appeared to be very simple. I think that's also the whole reason for the canonization of Oliver North: he said all the right words and pushed

all the right buttons. And people yearn for those sorts of simple answers. But the world will never ever be simple again, if it ever was. The world is nothing but complex, and if you do not learn to interpret its complexities, you're going to be on the river without a paddle.

The classic thing for me is the misinterpretation of "Born in the U.S.A." I opened the paper one day and saw where they had quizzed kids on what different songs meant, and they asked them what "Born in the U.S.A." meant. "Well, it's about my country," they answered. Well, that *is* what it's about – that's certainly one of the things it's about – but if that's as far in as you go, you're going to miss it, you know? I don't think people are being taught to think hard enough about things in general – whether it's about their own lives, politics, the situation in Nicaragua or whatever. Consequently, if you do not learn to do that – if you do not develop the skills to interpret that information – you're going to be easily manipulated, or you're going to walk around simply confused and ineffectual and powerless.

People are being dumped into this incredibly unintelligible society, and they are swimming, barely staying afloat, and then trying to catch on to whatever is going to give them a little safe ground.

I guess when I started in music I thought, "My job is pretty simple. My job is I search for the human things in myself, and I turn them into notes and words, and then in some fashion, I help people hold on to their own humanity – if I'm doing my job right."

You *can* change things – except maybe you can affect only one person, or maybe only a few people. Certainly nothing as dramatic as we expected in the Sixties. When I go onstage, my approach is "I'm going to reach just one person" – even if there's 80,000 people there. Maybe those odds aren't so great, but if that's what they are, that's okay. . . .

You keep talking about your involvement in rock & roll as a job. That's a far cry from the view that many of us had in the Sixties, when we looked upon artists – such as Bob Dylan – not so much as people performing a job but as cultural revolutionaries.

Dylan was a revolutionary. So was Elvis. I'm not that. I don't see myself as having been that. I felt that what I would be able to do, maybe, was redefine what I did in more human terms than it had been defined before, and in more everyday terms. I always saw myself as a nuts-and-bolts kind of person. I felt what I was going to accomplish I would accomplish over a long period of time, not in an enormous burst of energy or genius. To keep an even perspective on it all, I looked at it *like* a job – something that you do every day and over a long period of time.

To me, Dylan and Elvis – what they did was genius. I never really saw myself in that fashion. I'm sure there was a part of me that was afraid of having that kind of ambition or taking on those kinds of responsibilities.

"Born to Run" was certainly an ambitious record. Maybe it wasn't revolutionary, but it was certainly innovative: it redefined what an album could do in the Seventies.

Well, I was shooting for the moon, you know? I always wanted to do that too, on top of it. When I did *Born to Run*, I thought, "I'm going to make the greatest rock & roll record ever made." I guess what I'm saying is, later on my perspective changed a bit so that I felt like I could maybe redefine what doing the particular job was about. So that it does *not* have to drive you crazy or drive you to drugs or drinking, or you do not have to lose yourself in it and lose perspective of your place in the scheme of things, I guess I wanted to try and put a little more human scale on the thing. I felt that was necessary for my *own* sanity, for one thing.

Your next record, "Darkness on the Edge of Town," sounded far less hopeful than "Born to Run." Several critics attributed the sullen mood to the long stall between the records – the ten-month period in which a lawsuit prevented you from recording. What really was happening on "Darkness"?

That was a record where I spent a lot of time focusing. And what I focused on was this one idea: What do you do if your dream comes true? Where does that leave you? What *do* you do if that happens? And I realized part of what you have to face is the problem of isolation. You can get isolated if you've got a lot of dough or if you don't have much dough, whether you're Elvis Presley or whether you're sitting in front of the TV with a six-pack of beer. It's easy to get there. On that record it was like "Well, what I've done, does it have any greater meaning than that I've made a good album and had some luck with it?" I was trying to figure out that question, which is really one I'm still trying to figure out. . . .

On each of your records since "Darkness" – "The River," "Nebraska" and "Born in the USA" – you managed to write about hard working-class realities in ways that sounded surprisingly immediate, coming from a rich, well-known pop star. Was there something about moving into fame and wealth that caused you to identify more closely with the world you were leaving behind?

I think it's probably a normal reaction. I mean, the circumstances of your life are changing, and what they are changing to is unknown to you, and you have never known closely anyone else who has had the same experience. On one hand you cannot hide in the past. You can't say, "Well, I'm the same old guy I used to be." You have to go ahead and meet that person who you're becoming and accept whatever that's about. I always wanted to live solidly in the present, always remember the past and always be planning for the future. So from *Darkness* to *The River*, I was attempting to pull myself into what I felt was going to be the adult world, so that when things became disorienting, I would be strong enough to hold my ground. Those were the records where I was trying to forge that foundation and maintain my connections and try to say, "Well, what is this going to mean? Maybe what this is all going to mean is up to me."

With the later records, that resolve seemed to have more and more political

resonance. In 1979 you took part in the No Nukes benefit concert, and in November 1980 you made some scathing remarks onstage in Arizona on the evening following Ronald Reagan's election. How did events of recent years inspire your new-found political concern and awareness?

I think my response was based on an accumulation of things. I never considered myself a particularly political person. I wasn't when I was younger, and I don't think I really am now. But if you live in a situation where you have seen people's lives wasted . . . I think the thing that frightened me most was seeing all that waste. There wasn't any one specific thing that made me go in that particular direction, but it seemed like if you're a citizen, and if you're living here, then it's your turn to take out the garbage. Your tour of duty should come around.

It just seemed that people's lives are being shaped by forces they do not understand, and if you are going to begin to take a stand and fight against those things, you got to *know* the enemy – and that's getting harder to do. People are so easily affected by buzzwords; they're getting their button pushed with *God, mother, country, apple pie* – even in soda commercials. And so it's like "Where is the real thing? Where is the real America? "

What's also disturbing is the casualness with which people are getting used to being lied to. To me, Watergate felt like this big hustle was going down. And in the end it seemed to legitimize the dope dealer down on the street. "Hey, the president's doing it, so why can't I? " I guess we're pretty much left to find our way on our own these days. The sense of community that there was in the Sixties made you feel like there were a lot of people along for the ride with you. It felt like the whole country was trying to find its way. You do not have a sense that the country is trying to find its way today. And that's a shame. As a result, I think you feel more on your own in the world today. Certainly, *I* feel more isolated in it.

Maybe everybody's just got to grab hold of each other. The idea of America as a family is naive, maybe sentimental or simplistic, but it's a good idea. And if people are sick and hurting and lost, I guess that it falls on everybody to address those problems in some fashion. Because injustice, and the price of that injustice, falls on everyone's heads. The economic injustice falls on everybody's head and steals everyone's freedom. Your wife can't walk down the street at night. People keep guns in their homes. They live with a greater sense of apprehension, anxiety and fear than they would in a more just and open society. It's not an accident, and it's not simply that there are "bad" people out there. It's an inbred part of the way that we are all living: it's a product of what we have accepted, what we have acceded to. And whether we mean it or not, our silence has spoken for us in some fashion. But the challenge is still there: eight years of Reagan is not going to change that.

That seemed part of what "Nebraska" was about: a reaction to the Reagan years. Was that how you intended people to see that record?

In a funny way, I always considered it my most personal record, because it felt to me, in its tone, the most what my childhood felt like. Later on, a bunch of people wrote about it as a response to the Reagan era, and it obviously had that connection.

I think people live from the inside out. Your initial connection is to your friends and your wife and your family. From there your connection may be to your immediate community. And then if you have the energy and the strength, then you say, "Well, how do I connect up to the guy in the next state or, ultimately, to people in the world?" I think that whatever the political implications of my work have been, they've just come out of personal insight. I don't really have a particular political theory or ideology. It came from observations, like, okay, this man is being wasted. *Why* is this man being wasted? This person has lost himself. Why is that? And just trying to take it from there. How does my life interconnect and intertwine with my friends and everybody else? I don't know the answers yet. I'm a guitar player – that's what I do.

But millions of people see you as more than a guitar player. In fact, many see you as nothing less than an inspiring moral leader. But there's a certain irony to being a modern-day hero for the masses. Back in the Sixties nobody ever spoke of the Beatles or the Rolling Stones or Dylan as being overexposed. Yet these days, any pop artist who has a major, sustained impact on a mass audience runs the risk of seeming either overly promoted by the media or too familiar to his audience. In recent years, performers like you, Michael Jackson, Prince and Madonna have all faced this dilemma. Do you ever feel that you're running the danger of overexposure?

Well, what does that mean? What is "overexposed"? It really has no meaning, you know? It's kind of a newspaper thing. I just ignore it, to be honest with you. I make the best records I can make. I try to work on them and put them out when it feels right and they feel like they're ready. That's what it is – not whether I'm overexposed or underexposed or not exposed. It's like "Hey, put the record on. Is it good? Do you like it? Is it rockin' ya? Is it speaking to you? Am I talking to you?" And the rest is what society does to sell newspapers or magazines. You gotta fill 'em up every month. You have an entire counterlife that is attached to your own real life by the slimmest of threads. In the past year, if you believe what was in the newspapers about me, I'd be living in two houses that I've never seen, been riding in cars that I've never had [*laughs*]. This is just what happens. It's, like, uncontrollable: the media monster has to be fed.

So all that sort of stuff, if you believe that it has anything really to do with you, you know, you're gonna go nuts. In the end, people will like my records and feel they were true or feel they weren't. They'll look at the body of work I've done and pull out whatever meaning it has for them. And that's what stands. The rest is transient. It's here today and gone

tomorrow. It's meaningless. Whether Michael Jackson is sleeping in a tank or not, what does it mean to you? It's just a laugh for some people; that's all it really is. And I feel like, hey, if it's a laugh for you, then have one on me. Because when you reach for and achieve fame, one of the byproducts of fame is you will be trivialized, and you will be embarrassed. You *will* be, I guarantee it. I look at that as a part of my job. And I ain't seen nothing compared to, you know, if you look at Elvis's life or even Michael J's. I've had it pretty easy, but I know a little bit of what it's about. These things are gonna happen, and if you don't have a strong enough sense of who you are and what you're doing, they'll kick you in the ass and knock you down and have a good time doing it. That's the nature of our society, and it's one of the roles that people like me play in society. Okay, that's fine, but my feeling is simple: my work is my defense. Simple as that. I've done things I never thought I'd be able to do, I've been places I never thought I'd be. I've written music that is better than I thought I could write. I did stuff that I didn't think I had in me.

You've also come to mean a lot to an awful lot of people.

That's a good thing, but you can take it too far. I do not believe that the essence of the rock & roll idea was to exalt the cult of personality. That is a sidetrack, a dead-end street. That is not the thing to do. And I've been as guilty of it as anybody in my own life. When I jumped over that wall to meet Elvis that night [at Graceland], I didn't know who I was gonna meet. And the guard who stopped me at the door did me the biggest favor of my life. I had misunderstood. It was innocent, and I was having a ball, but it wasn't right. In the end, you cannot live inside that dream. You cannot live within the dream of Elvis Presley or within the dream of the Beatles. It's like John Lennon said: "The dream is over." You can live with that dream in your heart, but you cannot live inside that dream, because it's a perversion, you know? What the best of art says is, it says, "Take this" – this movie or painting or photograph or record – "take what you see in this, and then go find your place in the world. This is a tool: go out and find your place in the world."

I think I made the mistake earlier on of trying to live within that dream, within that rock & roll dream. It's a seductive choice, it's a seductive opportunity. The real world, after all, is frightening. In the end, I realized that rock & roll wasn't just about finding fame and wealth. Instead, for me, it was about finding your place in the world, figuring out where you belong.

It's a tricky balance to do it correctly. You got to be able to hold a lot of contradictory ideas in your mind at one time without letting them drive you nuts. I feel like to do my job right, when I walk out onstage I've got to feel like it's the most important thing in the world. Also I got to feel like, well, it's only rock & roll. Somehow you got to believe both of those things.

96 STUDS TERKEL

FROM "Jill Robertson: Fantasia" (1982)

She is the daughter of a former Hollywood film producer.

Growing up in Hollywood was the only reality I knew. The closest I ever came to feeling glamorous was from my mother's maid, a woman named Dorothy, who used to call me Glamour. She was black. In those days, she was called coloured. When I would see my mother – or my mother's secretary, 'cause there was a hierarchy – interviewing maids or cooks, I'd think of maids and cooks represented in the movies.

I used not to like to go to school. I'd go to work with my father. I'd like to be with him because power didn't seem like work. He had four or five secretaries, and they were always pretty. I thought: How wonderful to have pretty secretaries. I used to think they'd be doing musical numbers. I could imagine them tapping along with his mail. I never saw it real.

To me, a studio head was a man who controlled everyone's lives. It was like being the principal. It was someone you were scared of, someone who knew everything, knew what you were thinking, knew where you were going, knew when you were driving on the studio lot at eighty miles an hour, knew that you had not been on the set in time. The scoldings the stars got. There was a paternalism. It was feudal. It was an archaic system designed to keep us playing: Let's pretend, let's make believe.

First of all, you invented someone, someone's image of someone. Then you'd infantalize them, keep them at a level of consciousness, so they'd be convinced that this is indeed who they are. They had doctors at the studios: "Oh, you're just fine, honey. Take this and you'll be just fine." These stars, who influenced our dreams, had no more to do with their own lives than fairies had, or elves.

I remember playing with my brother and sister. We would play Let's Make a Movie the way other kids would play cowboys and Indians. We'd cry, we'd laugh. We'd do whatever the character did. We had elaborate costumes and sets. We drowned our dolls and all the things one does. The difference was, if we didn't get it right, we'd play it again until we liked it. We even incorporated into our child play the idea of the dailies and the rushes. The repeats of film scenes to get the right angle. If the princess gets killed in a scene, she gets killed again and again and again. It's okay. She gets to live again. No one ever dies. There's no growing up. This was reality to us.

I had a feeling that out there, there were very poor people who didn't have enough to eat. But they wore wonderfully coloured rags and did musical numbers up and down the streets together. My mother did not like us to go into what was called the servants' wing of the house.

My mother was of upper-class Jewish immigrants. They lost everything

in the depression. My father tried to do everything he could to revive my mother's idea of what life had been like for her father in the court of the czar. Whether her father was ever actually in the court is irrelevant. My father tried to make it classy for her. It never was good enough, never could be. She couldn't be a Boston Brahmin.

Russian-Jewish immigrants came from the *shtetls* and ghettos out to Hollywood: this combination jungle-tropical paradise crossed with a nomadic desert. In this magical place that had no relationship to any reality they had ever seen before in their lives, or that anyone else had ever seen, they decided to create their idea of an eastern aristocracy. I'm talking about the kind of homes they would never be invited to. It was, of course, overdone. It was also the baronial mansions of the dukes' homes that their parents could never have gotten into. Goldwyn, Selznick, Zukor, Lasky, Warner. Hollywood – the American Dream – is a Jewish idea.

In a sense, it's a Jewish revenge on America. It combines the Puritan ethic – there's no sex, no ultimate satisfaction – with baroque magnificence. The happy ending was the invention of Russian Jews, designed to drive Americans crazy.

It was a marvellous idea. What could make them crazy but to throw back at them their small towns? Look how happy it is here. Compare the real small towns with the small town on the MGM back lot. There's no resemblance.

The street is Elm Street. It's so green, so bright, of lawns and trees. It's a town somewhere in the centre of America. It's got the white fence and the big porch around the house. And it's got three and four generations. They're turn-of-the-century people before they learned how to yell at each other. It's the boy and girl running into each other's arms. And everybody else is singing. It's everybody sitting down to dinner and looking at each other, and everyone looks just wonderful. No one is sick. No one's mad at anyone else. It's all so simple. It's all exactly what I say it is.

Aunt Mary is a little looney and lives with us because she loves us. It's not that she's crazy and gonna wind up killing one of us one of these days. Or that she's drunk. It's simply that she'd rather live with us and take care of us. The father would be Lewis Stone. He'd have a little bit of a temper now and then. The mother is definitely Spring Byington. She's daffy, but she's never deaf. She hears everything you say and she listens. And she hugs you and her hug is soft and sweet-smelling. The daughter is Judy Garland when she believed in Aunt Em. The boy is Robert Walker before he realized he was gonna drink himself to death. And love and marriage would be innocence and tenderness. And no sex.

The dream to me was to be blond, tall, and able to disappear. I loved movies about boys running away to sea. I wanted to be the laconic, cool,

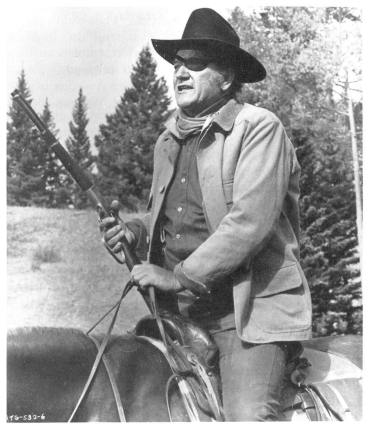

Figure 11.1 John Wayne in Paramount's 1969 western *True Grit*
Photograph courtesy of Range/Bettman/Springer

tall, Aryan male. Precisely the opposite of the angry, anxious, sort of mottle-haired Jewish girl.

I wanted to be this guy who could walk away from any situation that got a little rough. Who could walk away from responsibility. The American Dream, the idea of the happy ending, is an avoidance of responsibility and commitment. If something ends happily, you don't have to worry about it tomorrow.

The idea of the movie star, the perfect-looking woman or man who has breakfast at a glass table on a terrace where there are no mosquitoes. No one ever went to the bathroom in movies. I grew up assuming that movie stars did not. I thought it was terrible to be a regular human being. Movie stars did not look awful, ever. They never threw up. They never got really sick, except in a wonderful way where they'd get a little sweaty,

311

the valley. And at the Little Bighorn, the angles and the editing don't give us a clear idea of the closing of a trap; terrain and disposition are unclear.

But there is life in the film, and the core of it is Dustin Hoffman's performance of Jack Crabb. We hear his 121-year-old voice out of the silence under the titles – there's no music until we're well along, and very little then – when we see him in his (rubber-mask) antiquity. Later, after a boy actor and an early adolescent actor have marked his growing time, Hoffman himself takes up Crabb at about the age of fifteen and carries him through his "periods" of frontier schoolboy, young Cheyenne brave, carnival man, gunfighter, boozer, storekeeper, older Cheyenne brave, hermit, and cavalry mule skinner.

Bernard Shaw said that fine art is either easy or impossible, and as Shaw meant it, Hoffman proves it yet again. He's short, he has a Feiffer profile, his voice is no great shakes, and, although he has charm, he has no great force of personality. What he has is instant credibility. It never seems to cross his mind that he is anything other than what he claims to be at the moment, so it never crosses our minds, either. His secret is not only imagination, not only the requisite vitality, but a lack of objectivity, so great as almost to be simple-minded. It's as if Hoffman were saying, "What do you mean, I'm not a Cheyenne brave? I've been one all my life." This ability to shut out objectivity – to shut out any view of one's self *playing* the part – is an essential particularly for "chameleon" actors, and it's Hoffman's ace.

In Robert Hughes's documentary film about Penn, there is a sequence showing Penn and Hoffman working on a scene from *Little Big Man*. It's a small lesson in the interweaving of two kinds of talent, and the results are in this picture.

The other noteworthy performance is by Chief Dan George as Crabb's Cheyenne "grandfather." I was prejudiced in the chief's favor because he looks a lot like my Uncle Al, dead these many years, and he fed my prejudice with his dignity and humor. Penn's one failure with a performer is Faye Dunaway, a parson's prurient wife who later turns up as a whore. She misses no possible acting cliché. Besides, as a frontier parson's wife, she wears false eyelashes only a trifle smaller than ostrich fans.

Under the energy of the film, the ominous theme is the invincible brutality of the white man, the end of "natural" life in America. At the beginning, when Crabb's young interviewer uses the word "genocide," it irritates the old man, but the film – his story – only substantiates the term. Penn makes contradictorily sure we know his own sympathies. When Indians attack a stagecoach, the murders are supposed to be funny; when cavalrymen attack an Indian village, the murders are tragic.

The color is unobtrusive – certifying without being garish. The Panavision feels comfortable. Penn has made a tangy and, I think,

unique film with American verve, about some of the grisly things that American verve has done.

98 MARTIN SCORSESE, PAUL SCHRADER AND ROBERT DE NIRO

FROM "Taxi Driver" (1992)

PAUL SCHRADER: The script of *Taxi Driver* is the genuine thing. It came from the gut, and while it banged around town everyone who read it realized it was authentic, the real item. After a number of years enough people said somebody should make it so that finally someone *did*.

In 1973 I had been through a particularly rough time, living more or less in my car in Los Angeles, riding around all night, drinking heavily, going to porno movies because they were open all night, and crashing some place during the day. Then, finally, I went to the emergency room in serious pain, and it turned out I had an ulcer. While I was in the hospital, talking to the nurse, I realized I hadn't spoken to anyone in two or three weeks. It really hit me, an image that I was like a taxi driver, floating around in this metal coffin in the city, seemingly in the middle of people, but *absolutely, totally alone.*

The taxicab was a metaphor for loneliness, and once I had that, it was just a matter of creating a plot: the girl he wants but can't have, and the one he can have but doesn't want. He tries to kill the surrogate father of the first and fails, so he kills the surrogate father of the other. I think it took ten days, it may have been twelve – I just wrote continuously. I was staying at an old girlfriend's house, where the heat and gas were all turned off, and I just wrote. When I stopped, I slept on the couch, then I woke up and I went back to typing. As you get older it takes more work. Hovering in the back of my mind is a fondness for those days when it was so painful it just had to come out.

I didn't really write it the way people write scripts today – you know, with a market in mind. I wrote it because it was something that I wanted to write and it was the first thing I wrote. It jumped out of my head.

Right after writing it, I left town for about six months. I came back to Los Angeles after I was feeling a little stronger emotionally and decided to go at it again. I was a freelance critic at the time. I had written a review of *Sisters* and interviewed Brian De Palma at his place at the beach. That afternoon, we were playing chess – we were about evenly matched – and somehow the fact that I had written a script came up. So I gave it to him and he liked it a lot and wanted to do it. De Palma showed the script to the producers, Michael and Julia Phillips, who were three houses down the beach, and he showed it to Marty, who was in town after finishing *Mean Streets*. Michael and Julia told me they wanted

315

to do it but that Marty was a better director for it. So Julia and I went and saw a rough cut of *Mean Streets*, and I agreed. In fact, I thought Marty and Bob De Niro would be the ideal combination, so we aligned ourselves – De Niro, the Phillipses and myself – but we were not powerful enough to get the film made. Then there was a hiatus of a couple of years, and in the intervening time, each of us had successes of our own. I sold my script, *The Yakuza*, for a lot of money. Marty did *Alice*, the Phillipses did *The Sting*, and De Niro did *The Godfather, Part II*.

At that time I remember describing *Taxi Driver*'s Travis as sort of a young man who wandered from the snowy waste of the midwest into an overheated New York cathedral. My own background was anti-Catholic in the style of the Reformation and the Glorious Revolution. The town I was raised in was about one-third Dutch Calvinist and one-third Catholic, and the other third were trying to figure out why they were there, and sort of keeping peace. Well, both cultures, Catholic and Calvinist, are infused with the sense of guilt, redemption by blood, and moral purpose – all acts are moral acts, all acts have consequence. It's impossible to act amorally. There's a kind of divine eye in the sky that ensures your acts are morally judged. So you know once you're raised in that kind of environment, you don't shake that, you shake a lot of things, but the sense of moral responsibility, guilt, and redemption you carry with you forever. So Scorsese and I shared that. I came from essentially a rural, midwestern Protestant and Dutch background, and he is urban and Italian Catholic, so in a way it's a very felicitous joining. The bedrock is the same.

Taxi Driver was as much a product of luck and timing as everything else – three sensibilities together at the right time, doing the right thing. It was still a low-budget, long-shot movie, but that's how it got made. At one point, we could have financed the film with Jeff Bridges, but we elected to hold out and wait until we could finance it with De Niro. It was just a matter of luck and timing. Marty was fully ready to make the film; De Niro was ready to make it. And the nation was ready to see it. You can't plan or scheme for that kind of luck. It just sort of happens – the right film at the right time.

MARTIN SCORSESE: *Taxi Driver* was, I think, the first script I'd worked on that had direct movement from beginning to end. The *Taxi Driver* screenplay seemed very close to me. It was as if I wrote it, that's how strongly I feel about it. Even though the character is from the Midwest, Bob de Niro and I both felt the same way.

Paul wrote *Taxi Driver* out of his own gut and his own heart in two-and-a-half terrible weeks. I felt close to the character by way of Dostoevski. I had always wanted to do a movie of *Notes from the Underground*. I mentioned that to Paul and he said, "Well this is what

I have – *Taxi Driver*," and I said, "Great, this is it." Then Paul said, "What about De Niro? He was great in *Mean Streets*." And it turned out that Bob had a feeling for people like Travis.

Taxi Driver was almost like a commission, in a sense. Bob was the actor, I was the director, and Paul wrote the script. The three of us – Schrader, Bob and I – just came together. It was exactly what we wanted, it was one of the strangest things.

Everything was storyboarded. Even the close-ups because we had to shoot so fast. It would have to be, "Get this shot." Then, "Okay, got it." Then, "Go on, okay, next." That's the way it had to go. But we really felt strongly about the picture. It was the only script that really fell into my lap. I don't like to give scripts to people to write and two months later they come back and it's completely finished. There's very little input that can take place at that point. Thematically, you can change things, you can do things, but visualization is hard then. Schrader's scripts afford me the possibility of going back and then revisualizing.

Schrader usually has shorter scenes and has a better concept of the visual. Maybe not the visual that's going to wind up in my movie version of what he's writing, but at least he has a point of view. Other writers usually take a totally literary point of view, mainly dialogue and long descriptions of scenes. Then you've got to really do the whole thing. And very often, you just wind up shooting dialogue on certain pictures. It's not necessarily *bad*. It's just that they take a *literary* approach, and I prefer a *film* approach, and Schrader had a film approach.

ROBERT DE NIRO: I once told Marty we should put together a movie of outtakes. For example, there were outtakes from *Taxi Driver* I would include. When we were shooting that movie there's this terrible bloody scene and, ironically, funny things happened. That whole slaughter scene in the hallway at the end of the movie took us about four or five takes to shoot. Things went wrong technically. There were a lot of special effects and with those things something always goes wrong. You have this sort of very serious, dramatic kind of carnage going on, and all of a sudden, somebody drops something or machinery breaks down. It just blows the whole thing and it turns out to be funny. Oddly enough, in that sort of scene, I guess because it's so gruesome, everybody's ready to laugh. There was a lot of laughing and joking during the shooting between takes. I remember that. It was a lighter period, even though the material was very heavy.

MARTIN SCORSESE: I had a basic idea that caused me to be precise. Whenever I shot Travis Bickle, when he was alone in the car, or whenever people were talking to him, and that person is in the frame, then the camera was over their shoulder. He was in everybody else's light, but he was alone. Nobody was in his frame. As much as possible, I tried to stick

with that. That is a big problem, because Travis is in everybody else's frame. There would be a certain look in his eyes, a certain close-up of his face, shot with a certain lens. Subtle – not too wide, not to destroy it, not to nudge the audience into, "Hey, this guy's a whacko." Not that sort of thing. But rather to let it sneak up on the audience, like Travis does, and move the camera the way he sees things – all from his point of view. Only one scene is from another point of view: The scene that was improvised was Keitel dancing with Jodie Foster.

I think Bob's range is quite extraordinary. Harry Ufland – who, at the time, was both my agent and Bob's – came by the set one day and Bob had a suit on. He was in between takes, checking out a suit for the wardrobe for *Last Tycoon*. Harry didn't recognize him. For twenty minutes Bob wasn't Travis anymore, he was Monroe Stahr. It's amazing.

99 NEIL POSTMAN

FROM "The Age of Show Business" (1985)

A dedicated graduate student I know returned to his small apartment the night before a major examination only to discover that his solitary lamp was broken beyond repair. After a whiff of panic, he was able to restore both his equanimity and his chances for a satisfactory grade by turning on the television set, turning off the sound, and with his back to the set, using its light to read important passages on which he was to be tested. This is one use of television – as a source of illuminating the printed page.

But the television screen is more than a light source. It is also a smooth, nearly flat surface on which the printed word may be displayed. We have all stayed at hotels in which the TV set has had a special channel for describing the day's events in letters rolled endlessly across the screen. This is another use of television – as an electronic bulletin board.

Many television sets are also large and sturdy enough to bear the weight of a small library. The top of an old-fashioned RCA console can handle as many as thirty books, and I know one woman who has securely placed her entire collection of Dickens, Flaubert, and Turgenev on the top of a 21-inch Westinghouse. Here is still another use of television – as bookcase.

I bring forward these quixotic uses of television to ridicule the hope harbored by some that television can be used to support the literate tradition. Such a hope represents exactly what Marshall McLuhan used to call "rear-view mirror" thinking: the assumption that a new medium is merely an extension or amplification of an older one: that an automobile, for example, is only a fast horse, or an electric light a powerful

candle. To make such a mistake in the matter at hand is to misconstrue entirely how television redefines the meaning of public discourse. Television does not extend or amplify literate culture. It attacks it. If television is a continuation of anything, it is of a tradition begun by the telegraph and photograph in the mid-nineteenth century, not by the printing press in the fifteenth.

What is television? What kinds of conversations does it permit? What are the intellectual tendencies it encourages? What sort of culture does it produce? . . .

Entertainment is the supra-ideology of all discourse on television. No matter what is depicted or from what point of view, the overarching presumption is that it is there for our amusement and pleasure. That is why even on news shows which provide us daily with fragments of tragedy and barbarism, we are urged by the newscasters to "join them tomorrow." What for? One would think that several minutes of murder and mayhem would suffice as material for a month of sleepless nights. We accept the newscasters' invitation because we know that the "news" is not to be taken seriously, that it is all in fun, so to say. Everything about a news show tells us this – the good looks and amiability of the cast, their pleasant banter, the exciting music that opens and closes the show, the vivid film footage, the attractive commercials – all these and more suggest that what we have just seen is no cause for weeping. A news show, to put it plainly, is a format for entertainment, not for education, reflection or catharsis. And we must not judge too harshly those who have framed it in this way. They are not assembling the news to be read, or broadcasting it to be heard. They are televising the news to be seen. They must follow where their medium leads. There is no conspiracy here, no lack of intelligence, only a straight-forward recognition that "good television" has little to do with what is "good" about exposition or other forms of verbal communication but everything to do with what the pictorial images look like. . . .

When a television show is in process, it is very nearly impermissible to say. "Let me think about that" or "I don't know" or "What do you mean when you say . . . ?" or "From what sources does your information come?" This type of discourse not only slows down the tempo of the show but creates the impression of uncertainty or lack of finish. It tends to reveal people in the *act of thinking*, which is as disconcerting and boring on television as it is on a Las Vegas stage. Thinking does not play well on television, a fact that television directors discovered long ago. There is not much to *see* in it. It is, in a phrase, not a performing art. But television demands a performing art. . . .

Film, records and radio (now that it is an adjunct of the music industry) are, of course, equally devoted to entertaining the culture, and their effects in altering the style of American discourse are not

Figure 11.2 A Coca-Cola bottle
Coca-Cola and Coke are registered trademarks which identify the same product of the
Coca-Cola Company.

insignificant. But television is different because it encompasses all forms
of discourse. No one goes to a movie to find out about government policy
or the latest scientific advances. No one buys a record to find out the
baseball scores or the weather or the latest murder. No one turns on
radio any more for soap operas or a presidential address (if a television
set is at hand). But everyone goes to television for all these things and
more, which is why television resonates so powerfully throughout the
culture. Television is our culture's principal mode of knowing about
itself. Therefore – and this is the critical point – how television stages
the world becomes the model for how the world is properly to be staged.
It is not merely that on the television screen entertainment is the
metaphor for all discourse. It is that off the screen the same metaphor
prevails. As typography once dictated the style of conducting politics,
religion, business, education, law and other important social matters,
television now takes command. In courtrooms, classrooms, operating
rooms, board rooms, churches and even airplanes. Americans no longer
talk to each other, they entertain each other. They do not exchange

320

ideas; they exchange images. They do not argue with propositions; they argue with good looks, celebrities and commercials. For the message of television as metaphor is not only that all the world is a stage but that the stage is located in Las Vegas, Nevada.

A Golden Girl from Somewhere

When the Spring is on the mountain and the day is at the door—a golden girl from somewhere stands wondering, expectant, on the world's far edge.

Somewhere beyond that unfathomable sky—beyond the purple hills—lie laughter and joy and smooth delight.

Lithe and splendid, touched with a happy craving that will not be denied, she is going to the place where fairy tales come true.

May she choose the Playboy for her companion to the end of the traveled road—then a wonderful horse on up the slope with Spring to the desolate lone of outer space.

Figure 11.3 Advertisement for Jordan motor cars, *Saturday Evening Post* 196, March 29, 1924

12

THE UNITED STATES AND THE WORLD

Introduction 324

100 George Washington
FROM Farewell Address (1796) 327

101 James Monroe
FROM "The Monroe Doctrine" (1823) 329

102 Charles A. Beard
FROM "The Case for Isolation" (1940) 332

103 Harry Truman
"The Truman Doctrine" (1947) 335

104 George C. Marshall
"The Marshall Plan" (1947) 337

105 Joseph McCarthy
FROM "The Wheeling Speech" (1950) 339

106 John F. Kennedy
First Inaugural Address (1961) 345

107 Lyndon B. Johnson
"American Policy in Viet-nam" (1965) 349

108 George Bush
"The Launch of Attack on Iraq" (1991) 351

109 E. L. Doctorow
Open Letter to the President (1991) 355

INTRODUCTION

The Constitution gives the President a prominent role in conducting relations with foreign nations, although in a sometimes difficult partnership with Congress.

The first text in this chapter, George Washington's "Farewell Address" (1796), is probably best known for its unambiguous advice on US relations to foreign powers, emphasizing the importance of neutrality and warning against "permanent alliances with any portion of the foreign world."

In the years that followed, the US was in conflict with both France (1798–99) and England (1812–14), reminding the Americans of the potential European threat to their newly won independence. In what was later known as the Monroe Doctrine President James Monroe in his annual address to Congress in 1823 emphasized the separateness of the Old and the New World and that America and Europe must lead their separate existence (see extract 101). Worked out essentially by Secretary of State John Quincy Adams, the Doctrine stated the non-interventionist intentions of the US in Europe and in the "existing colonies or dependencies in the Western Hemisphere." Perhaps even more significantly the US proclaimed that it would tolerate no interference on the part of European powers in the newly independent Latin American countries. It is worth noting, however, that the US was no superpower at the time, and the Monroe Doctrine thus did not for the time being cause great concern among the European powers.

As the United States developed into a major nation in the last part of the nineteenth century the fear of foreign invasion or intervention waned and the US started – despite opposition at home – to show imperialist tendencies, notably in the annexation of Cuba, Puerto Rico and the Philippine Islands (in 1898) after a brief, hectic war with Spain. President Theodore Roosevelt (1901–1909) fitted perfectly into the imperialist mood around the turn of the century. In 1904 he formulated his Roosevelt Corollary, which went beyond the Monroe doctrine by justifying US intervention in the Western hemisphere. The next decade witnessed a series of US interventions in line with the Roosevelt Corollary.

Despite the more active role of the US in foreign affairs in the first part of this century, however, the US stayed out of World War I for three years. The Monroe Doctrine's principle of staying out of Europe was entrenched in the hearts and minds of most Americans. Germany's aggressive warfare was, however, gradually viewed as a danger not only to Europe, but to mankind as a whole, and in April 1917 the US declared war on Germany.

The US departure from isolationism helped to end the war, but did

not create a climate of international cooperation as expected. President Wilson's grand design for the future with the establishment of the League of Nations collapsed at home, and very soon Europe was again on the brink of disaster. In the 1920s and 1930s isolationism again became the dominating mood in the US, and even after the rise of Hitler and Mussolini opposition at home against involving the US in Europe's troubles was strong. The renowned historian Charles A. Beard was perhaps the person who most persuasively argued for the US isolationist stance and represented a serious threat to Roosevelt's internationalist position. In extract 102 Beard argues for what he terms Continental Americanism, an isolationist view which had solid support among both Democrats and Republicans. As a matter of fact, the isolationist view was so influential that President Franklin D. Roosevelt was unable to convince Congress to join forces with the allied troops until Japan attacked Pearl Harbor, Hawaii in 1941.

World War II brought an end to American isolationism. It was no longer possible for the biggest superpower on earth to pretend it could exist in "splendid isolation." The challenges of war were over only to be succeeded by the serious tensions of the Cold War, where American foreign policy very soon focused on the goal of containing communism. It was George F. Kennan, in his famous article "The Sources of Soviet Conduct" (July 1947),[1] who introduced the word "containment" in American foreign policy and called for firm resistance to Soviet expansionism. In his address to Congress in March 1947, President Truman officially proclaimed the American post-war policy toward the Soviet Union. The speech, included as extract 103, meant, in Truman's view, "a turning point in American foreign policy, clearly establishing that wherever aggression, direct or indirect, was a threat to peace, the security of America was also in danger."

The Marshall Plan (proclaimed in June 1947) conveyed a more positive expression of American foreign policy through massive aid to Europe (see extract 104). The rationale behind the Marshall Plan was, however, a logical follow-up of Truman's goals for American foreign policy: to assist the free world against communism.

On the domestic scene the Cold War unfortunately spread a sense of unease and anxiety and resulted in a massive witch hunt on radicals and so-called communists in the beginning of the 1950s. Giving his name to the period (McCarthyism), Senator Joseph R. McCarthy was renowned for his blatant demagogic attacks on radicals and moderates alike (well documented in the speech reprinted as extract 105), blaming them (even the President was attacked) for treacherous activities and undermining the American system of government.

In his Inaugural Address in 1961 (extract 106) President John F. Kennedy – the first Catholic in the Oval Office – addressed the

challenges of a changing world by promising to utilize the energy, the faith and the devotion of a new generation. Pledging to attack the problems of the world with a youthful spirit and a flexibility unknown to the proponents of containment, Kennedy appealed both to his fellow Americans and to a global audience. Kennedy's insistent call to Americans: "ask not what your country can do for you – ask what you can do for your country"; and to his fellow citizens of the world: "ask not what Americans will do for you, but what together we can do for the freedom of man," struck a sympathetic chord in people both at home and abroad.

The most dangerous confrontation between the US and the Soviet Union in the post-war period occurred in 1962 during the Cuba crisis. President Kennedy's tough and provocative response to the Soviet missile build-up on Cuba signalled that the world was close to a nuclear catastrophe.

In Vietnam, the US had to pay the costs of containment no policy-maker in Washington had dreamed of. Lyndon B. Johnson's speech in April 1965 (see extract 107) reveals the logic behind the so-called domino theory, which stated that if South Vietnam was taken by the communists, each of the other South-East Asian nations in its turn would become communist under the domination of communist China. The domino theory in particular and US involvement in Vietnam in general gradually came under severe attack both at home and internationally. The anti-war movement, supported by popular songwriters such as Bob Dylan and Joan Baez, was a major factor in Johnson's decision not to run for the White House in 1968 and certainly one of the reasons for America's withdrawal from Vietnam under Nixon.

Primarily because of the withdrawal from Indo-China, the US thought from the mid-1970s that there was relatively little it could accomplish by force of arms. Even though Ronald Reagan's tough cold-war rhetoric in the 1980s differed sharply from Jimmy Carter's foreign policy approach in the late 1970s, the real confrontations with the USSR did not materialize. On the contrary, Reagan's actual policy, despite talk of containment, became gradually more conciliatory towards the USSR. With the disintegration of both the USSR and communist eastern Europe during the late 1980s and the early 1990s, the ideological basis of both the Cold War and the policy of containment in Europe suddenly evaporated. In other parts of the world, notably the Third World, the confrontational posture of US foreign policy has been maintained, first during the Reagan years through low-intensity warfare, and then (under George Bush) through direct confrontation during the Gulf War in 1991. In his statement from the White House on the launch of an attack on Iraq (see extract 108), President Bush explains the rationale for acting now and not waiting any longer, insisting that the sole goal of the attack is the liberation of Kuwait, not the conquest of Iraq. E. L. Doctorow's

passionate plea (included as the final extract in this chapter) for a non-military action against Iraq, published just before Bush's announcement, recalls sentiments from the Vietnam years, even though Doctorow represented a minority opinion at the time. Whether the US warfare in the Gulf represents a more permanent geographical shift in US foreign military involvement following the demise of the communist bloc and the conflicting interests between the rich North and the poor South is not entirely clear.

President Clinton's invasion of Haiti in 1994 does not indicate a dramatic reorientation of American foreign policy; it is difficult to predict, however, whether the president's traditionally uncontested role as the major foreign-policy maker will be affected by the Republican victories in the 1994 congressional elections.

1 George F. Kennan, "The Sources of Soviet Conduct," *Foreign Affairs*, vol. 25, July 1947, pp. 571 ff.

100 GEORGE WASHINGTON

FROM Farewell Address (1796)

Friends and Fellow Citizens:

. . . Observe good faith and justice toward all nations. Cultivate peace and harmony with all. Religion and morality enjoin this conduct. And can it be that good policy does not equally enjoin it? It will be worthy of a free, enlightened, and at no distant period a great nation to give to mankind the magnanimous and too novel example of a people always guided by an exalted justice and benevolence. Who can doubt that in the course of time and things the fruits of such a plan would richly repay any temporary advantages which might be lost by a steady adherence to it? Can it be that Providence has not connected the permanent felicity of a nation with its virtue? The experiment, at least, is recommended by every sentiment which ennobles human nature. Alas! is it rendered impossible by its vices?

In the execution of such a plan nothing is more essential than that permanent, inveterate antipathies against particular nations and passionate attachments for others should be excluded, and that in place of them just and amicable feelings toward all should be cultivated. The nation which indulges toward another an habitual hatred or an habitual fondness is in some degree a slave. It is a slave to its animosity or to its affection, either of which is sufficient to lead it astray from its duty and its interest. Antipathy in one nation against another disposes each more readily to offer insult and injury, to lay hold of slight causes of

umbrage, and to be haughty and intractable when accidental or trifling occasions of dispute occur.

Hence frequent collisions, obstinate, envenomed, and bloody contests. The nation prompted by ill will and resentment sometimes impels to war the government contrary to the best calculations of policy. The government sometimes participates in the national propensity, and adopts through passion what reason would reject. At other times it makes the animosity of the nation subservient to projects of hostility, instigated by pride, ambition, and other sinister and pernicious motives. The peace often, sometimes perhaps the liberty, of nations has been the victim.

So, likewise, a passionate attachment of one nation for another produces a variety of evils. Sympathy for the favorite nation, facilitating the illusion of an imaginary common interest in cases where no real common interest exists, and infusing into one the enmities of the other, betrays the former into a participation in the quarrels and wars of the latter without adequate inducement or justification. It leads also to concessions to the favorite nation of privileges denied to others, which is apt doubly to injure the nation making the concessions by unnecessarily parting with what ought to have been retained, and by exciting jealousy, ill will, and a disposition to retaliate in the parties from whom equal privileges are withheld; and it gives to ambitious, corrupted, or deluded citizens (who devote themselves to the favorite nation) facility to betray or sacrifice the interests of their own country without odium, sometimes even with popularity, gilding with the appearances of a virtuous sense of obligation, a commendable deference for public opinion, or a laudable zeal for public good the base or foolish compliances of ambition, corruption, or infatuation. . . .

The great rule of conduct for us in regard to foreign nations is, in extending our commercial relations to have with them as little *political* connection as possible. So far as we have already formed engagements let them be fulfilled with perfect good faith. Here let us stop.

Europe has a set of primary interests which to us have none or a very remote relation. Hence she must be engaged in frequent controversies, the causes of which are essentially foreign to our concerns. Hence, therefore, it must be unwise in us to implicate ourselves by artificial ties in the ordinary vicissitudes of her politics or the ordinary combinations and collisions of her friendships or enmities.

Our detached and distant situation invites and enables us to pursue a different course. If we remain one people, under an efficient government, the period is not far off when we may defy material injury from external annoyance; when we may take such an attitude as will cause the neutrality we may at any time resolve upon to be scrupulously respected; when belligerent nations, under the impossibility of making acquisitions upon us, will not lightly hazard the giving us provocation;

when we may choose peace or war, as our interest, guided by justice, shall counsel.

Why forego the advantages of so peculiar a situation? Why quit our own to stand upon foreign ground? Why, by interweaving our destiny with that of any part of Europe, entangle our peace and prosperity in the toils of European ambition, rivalship, interest, humor, or caprice?

It is our true policy to steer clear of permanent alliances with any portion of the foreign world, so far, I mean, as we are now at liberty to do it; for let me not be understood as capable of patronizing infidelity to existing engagements. I hold the maxim no less applicable to public than to private affairs that honesty is always the best policy. I repeat, therefore, let those engagements be observed in their genuine sense. But in my opinion it is unnecessary and would be unwise to extend them.

Taking care always to keep ourselves by suitable establishments on a respectable defensive posture, we may safely trust to temporary alliances for extraordinary emergencies.

Harmony, liberal intercourse with all nations are recommended by policy, humanity, and interest. But even our commercial policy should hold an equal and impartial hand, neither seeking nor granting exclusive favors or preferences; consulting the natural course of things; diffusing and diversifying by gentle means the streams of commerce, but forcing nothing; establishing with powers so disposed, in order to give trade a stable course, to define the rights of our merchants, and to enable the Government to support them, conventional rules of intercourse, the best that present circumstances and mutual opinion will permit, but temporary and liable to be from time to time abandoned or varied as experience and circumstances shall dictate; constantly keeping in view that it is folly in one nation to look for disinterested favors from another; that it must pay with a portion of its independence for whatever it may accept under that character; that by such acceptance it may place itself in the condition of having given equivalents for nominal favors, and yet of being reproached with ingratitude for not giving more. There can be no greater error than to expect or calculate upon real favors from nation to nation. It is an illusion which experience must cure, which a just pride ought to discard.

101 JAMES MONROE

FROM "The Monroe Doctrine" (1823)

A precise knowledge of our relations with foreign powers as respects our negotiations and transactions with each is thought to be particularly necessary. . . .

At the proposal of the Russian Imperial government, made through

the minister of the emperor residing here, full power and instructions have been transmitted to the minister of the United States at St. Petersburg to arrange by amicable negotiation the respective rights and interests of the two nations on the northwest coast of this continent. A similar proposal had been made by His Imperial Majesty to the government of Great Britain, which has likewise been acceded to. The government of the United States has been desirous, by this friendly proceeding, of manifesting the great value which they have invariably attached to the friendship of the emperor and their solicitude to cultivate the best understanding with his government.

In the discussions to which this interest has given rise and in the arrangements by which they may terminate the occasion has been judged proper for asserting, as a principle in which the rights and interests of the United States are involved, that the American continents, by the free and independent condition which they have assumed and maintain, are henceforth not to be considered as subjects for future colonization by any European powers. . . .

It was stated at the commencement of the last session that great effort was then making in Spain and Portugal to improve the condition of the people of those countries and that it appeared to be conducted with extraordinary moderation. It need scarcely be remarked that the result has been so far very different from what was then anticipated. Of events in that quarter of the globe with which we have so much intercourse and from which we derive our origin, we have always been anxious and interested spectators. The citizens of the United States cherish sentiments the most friendly in favor of the liberty and happiness of their fellowmen on that side of the Atlantic. In the wars of the European powers in matters relating to themselves we have never taken any part, nor does it comport with our policy so to do. It is only when our rights are invaded or seriously menaced that we resent injuries or make preparation for our defense.

With the movements in this hemisphere we are of necessity more immediately connected, and by causes which must be obvious to all enlightened and impartial observers. The political system of the allied powers is essentially different in this respect from that of America. This difference proceeds from that which exists in their respective governments; and to the defense of our own, which has been achieved by the loss of so much blood and treasure, and matured by the wisdom of their most enlightened citizens, and under which we have enjoyed unexampled felicity, this whole nation is devoted. We owe it, therefore, to candor and to the amicable relations existing between the United States and those powers to declare that we should consider any attempt on their part to extend their system to any portion of this hemisphere as dangerous to our peace and safety.

With the existing colonies or dependencies of any European power we have not interfered and shall not interfere. But with the governments who have declared their independence and maintained it, and whose independence we have, on great consideration and on just principles, acknowledged, we could not view any interposition for the purpose of oppressing them, or controlling in any other manner their destiny, by any European power in any other light than as the manifestation of an unfriendly disposition toward the United States. In the war between those new governments and Spain we declared our neutrality at the time of their recognition, and to this we have adhered, and shall continue to adhere, provided no change shall occur which, in the judgment of the competent authorities of this government, shall make a corresponding change on the part of the United States indispensable to their security.

The late events in Spain and Portugal show that Europe is still unsettled. Of this important fact no stronger proof can be adduced than that the allied powers should have thought it proper, on any principle satisfactory to themselves, to have interposed by force in the internal concerns of Spain. To what extent such interposition may be carried, on the same principle, is a question in which all independent powers whose governments differ from theirs are interested, even those most remote, and surely none more so than the United States.

Our policy in regard to Europe, which was adopted at an early stage of the wars which have so long agitated that quarter of the globe, nevertheless remains the same, which is not to interfere in the internal concerns of any of its powers; to consider the government de facto as the legitimate government for us; to cultivate friendly relations with it, and to preserve those relations by a frank, firm, and manly policy, meeting in all instances the just claims of every power, submitting to injuries from none. But in regard to those continents, circumstances are eminently and conspicuously different. It is impossible that the allied powers should extend their political system to any portion of either continent without endangering our peace and happiness; nor can anyone believe that our southern brethren, if left to themselves, would adopt it of their own accord.

It is equally impossible, therefore, that we should behold such interposition in any form with indifference. If we look to the comparative strength and resources of Spain and those new governments, and their distance from each other, it must be obvious that she can never subdue them. It is still the true policy of the United States to leave the parties to themselves, in the hope that other powers will pursue the same course.

102 CHARLES A. BEARD

FROM "The Case for Isolation" (1940)

The primary foreign policy for the United States may be called for convenience Continental Americanism. The two words imply a concentration of interest on the continental domain and on building here a civilization in many respects peculiar to American life and the potentials of the American heritage. In concrete terms the words mean non-intervention in the controversies and wars of Europe and Asia and resistance to the intrusion of European or Asiatic powers, systems, and imperial ambitions into the western hemisphere. This policy is positive. It is clear-cut. And it was maintained with consistency while the Republic was being founded, democracy extended, and an American civilization developed.

So protected by foreign policy, American civilization stood in marked contrast to the semi-feudal civilizations of Europe, and the country was long regarded as an asylum for the oppressed of all lands. America, it was boasted, offered to toiling masses the example of a nation free from huge conscript armies, staggering debts, and mountainous taxes. For more than a hundred years, while this system lasted, millions of immigrants, fleeing from the wars, oppressions, persecutions, and poverty of Europe, found a haven here; and enlightened Europeans with popular sympathies rejoiced in the fortunes of the United States and in the demonstration of liberty, with all its shortcomings, made on this continent in the presence of the tyrannies of the earth.

No mere adherence to theory or tradition marked the rise and growth of continentalism. The policy was realistically framed with reference to the exigencies of the early Republic and was developed during continuous experience with the vicissitudes of European ambitions, controversies, and wars. When other policies were proposed and departures were made from the established course, continentalism remained a driving force in thought about American foreign policy.

All through the years it was associated with a conception of American civilization. In the beginning the conception was primarily concerned with forms of culture appropriate to the rising Republic; during the middle period of American history it was enlarged and enriched under the influence of democratic vistas; and, despite the spread of industrialism in the later years, its characteristic features were powerful factors in shaping the course of American events. . . .

Until near the close of the nineteenth century, the continental policy of non-interference in the disputes of European nations was followed by the Government of the United States with a consistency which almost amounted to a fixed rule. Washington had formulated it. Monroe had

extended and applied it. Seward had restated and re-emphasized it. Qualified by the Monroe doctrine as to European intervention in this hemisphere, it seemed to be settled for all time as the nation celebrated the hundredth anniversary of its independence.

But the promise of undisturbed permanence was illusory, for another conception of foreign policy for America was already on the horizon. That was the conception of imperialism, world power, and active participation in the great conflicts of interests everywhere. . . .

Owing to the over-seas character of imperialist operations, naval bureaucrats, naval supply interests, and armor-plate makers naturally furnished practical considerations, while an intelligentsia was educating the people into espousing and praising the new course. As roving men, cruising around over the oceans, American naval officers had early come into contact with American merchants abroad, engaged in garnering better profits in trade than they could expect to reap at home. They saw foreign lands in the Orient and other distant places which, they thought, could be easily seized by the United States and turned into sea bases or trading posts. . . .

In summary, under fine phrases, manufactured for the occasion, pleasing to the popular ear, and gratifying to national vanity, politicians in control of the Government of the United States entangled the country in numerous quarrels in Asia and Europe. They made commitments difficult, if not impossible to cancel. They carried on a campaign of agitation designed to educate the people into the belief that the new course was necessary for the very well-being of the country and at the same time made for international peace and good will. They built up in the State Department a bureaucracy and a tradition absolutely opposed to historic continentalism.

Perhaps unwittingly they prepared the way for the next stage in the development of American foreign policy. From their participation in collective world politics, from the imperialist theory of "doing good to backward peoples," it was but a step to President Wilson's scheme for permanent and open participation in European and Asiatic affairs in the alleged interest of universal peace and general welfare. . . .

The third foreign policy proposed for the United States is the inter-nationalism which sets *world* peace as the fundamental objective for the Government in the conduct of relations with other countries. Exponents of the policy often claim a monopoly of the American peace movement and generally insist that only by following their methods can the United States obtain the blessings of peace for itself. Thus internationalism is to be distinguished sharply from the policy of keeping peace for the United States within its continental zone of interests and maintaining pacific relations elsewhere, subject to the primacy of security for American civilization and civil liberties.

Internationalism so defined is marked by specific features. It proposes to connect the United States with the European State system by permanent ties, for the accomplishment of its alleged end. It rejects the doctrine of continental independence which was proclaimed in the effort of 1776 to cut America loose from the entanglements associated with its status as a dominion of the British empire. In taking this position, internationalists also make many assumptions respecting the nature of world history and the possibilities of European politics. They assume that permanent world peace is not only desirable but is indivisible and can be obtained by the pursuit of their methods, especially if the United States will associate itself with certain nations supposed to be committed to permanent peace.

According to the internationalist hypothesis, Americans who advocate peace for the United States in the presence of European and Asiatic wars are not peace advocates in the true sense. In the internationalist view, such advocates are not contributing to peace – they are isolationists pursuing a policy which leads to armaments and wars. In internationalist literature, these peace advocates are frequently represented as selfish, cowardly, and immoral persons, who merely wish "to save their own skins," who refuse to recognize the obligations of the United States to other nations suffering not from their own follies but from the neglect of the American people. Hence there arises an apparently irreconcilable contradiction between advocates of permanent world peace and advocates of peace for the American continent and of pacific measures as constant instruments of American foreign policy. . . .

As an outcome of the historical heritage, American foreign policy became a loose intermingling of conflicting elements – continentalism, imperialism, and internationalism. Each of the three programs was supported, more or less, by specific interests and portions of the intelligentsia. At every crisis in world affairs, as the running fire of debate on foreign events continued in the United States, each school maneuvered for possession of the American mind and the direction of policy, through propaganda and the varied use of communication agencies. In the polls of public opinion, the winds of doctrine veered and twisted.

Yet at repeated tests, taken in formal elections and congressional battles, the principal body of that opinion was found consistently on the side of continentalism. Despite temporary victories, politicians who tried to swing the United States off its continental center of gravity toward imperialism or internationalism were never completely successful. . . .

This continentalism did not seek to make a "hermit" nation out of America. From the very beginning under the auspices of the early Republic, it never had embraced that impossible conception. It did not deny the obvious fact that American civilization had made use of

its European heritages, was a part of western civilization, and had continuous contacts with Occidental and Oriental cultures. It did not deny the obvious fact that wars in Europe and Asia "affect" or "concern" the United States. . . . It did not mean "indifference" to the sufferings of Europe or China (or India or Ethiopia). In truth, in all history, no people ever poured out treasure more generously in aid of human distresses in every quarter of the globe – distresses springing from wars, famines, revolutions, persecutions, and earthquakes.

With reference to such conflicts and sufferings, continentalism merely meant a recognition of the limited nature of American powers to relieve, restore, and maintain life beyond its own sphere of interest and control – a recognition of the hard fact that the United States, either alone or in any coalition, did not possess the power to force peace on Europe and Asia, to assure the establishment of democratic and pacific governments there, or to provide the social and economic underwriting necessary to the perdurance of such governments.

103 HARRY TRUMAN

"The Truman Doctrine" (1947)

The gravity of the situation which confronts the world today necessitates my appearance before a joint session of the Congress. The foreign policy and the national security of this country are involved.

One aspect of the present situation, which I wish to present to you at this time for your consideration and decision, concerns Greece and Turkey.

The United States has received from the Greek Government an urgent appeal for financial and economic assistance. Preliminary reports from the American Economic Mission now in Greece and reports from the American Ambassador in Greece corroborate the statement of the Greek Government that assistance is imperative if Greece is to survive as a free nation.

I do not believe that the American people and the Congress wish to turn a deaf ear to the appeal of the Greek Government.

The very existence of the Greek state is today threatened by the terrorist activities of several thousand armed men, led by Communists, who defy the Government's authority at a number of points, particularly along the northern boundaries.

Greece must have assistance if it is to become a self-supporting and self-respecting democracy. The United States must supply this assistance. We have already extended to Greece certain types of relief and economic aid but these are inadequate. There is no other country to which

democratic Greece can turn. No other nation is willing and able to provide the necessary support for a democratic Greek Government.

The British Government, which has been helping Greece, can give no further financial or economic aid after March 31. Great Britain finds itself under the necessity of reducing or liquidating its commitments in several parts of the world, including Greece.

We have considered how the United Nations might assist in this crisis. But the situation is an urgent one requiring immediate action, and the United Nations and its related organizations are not in a position to extend help of the kind that is required.

I am fully aware of the broad implications involved if the United States extends assistance to Greece and Turkey, and I shall discuss these implications with you at this time.

One of the primary objectives of the foreign policy of the United States is the creation of conditions in which we and other nations will be able to work out a way of life free from coercion. This was a fundamental issue in the war with Germany and Japan, our victory was won over countries which sought to impose their will, and their way of life, upon other nations.

To ensure the peaceful development of nations, free from coercion, the United States has taken a leading part in establishing the United Nations. The United Nations is designed to make possible lasting freedom and independence for all its members. We shall not realize our objectives, however, unless we are willing to help free peoples to maintain their free institutions and their national integrity against aggressive movements that seek to impose on them totalitarian regimes. This is no more than a frank recognition that totalitarian regimes imposed on free peoples, by direct or indirect aggression, undermine the foundations of international peace and hence the security of the United States.

The peoples of a number of countries of the world have recently had totalitarian regimes forced upon them against their will. The Government of the United States has made frequent protests against coercion and intimidation, in violation of the Yalta Agreement, in Poland, Rumania and Bulgaria. I must also state that in a number of other countries there have been similar developments.

At the present moment in world history nearly every nation must choose between alternative ways of life. The choice is too often not a free one.

One way of life is based upon the will of the majority, and is distinguished by free institutions, representative government, free elections, guarantees of individual liberty, freedom of speech and religion, and freedom from political oppression.

The second way of life is based upon the will of the minority forcibly imposed upon the majority. It relies upon terror and oppression, a

controlled press and radio, fixed elections, and the suppression of personal freedoms.

I believe that it must be the policy of the United States to support free peoples who are resisting attempted subjugation by armed minorities or by outside pressures.

I believe that we must assist free peoples to work out their own destinies in their own way.

104 GEORGE C. MARSHALL

"The Marshall Plan" (1947)

I need not tell you gentlemen that the world situation is very serious. That must be apparent to all intelligent people. I think one difficulty is that the problem is one of such enormous complexity that the very mass of facts presented to the public by press and radio make it exceedingly difficult for the man in the street to reach a clear appraisement of the situation. Furthermore, the people of this country are distant from the troubled areas of the earth and it is hard for them to comprehend the plight and consequent reactions of the long-suffering peoples, and the effect of those reactions on their governments in connection with our efforts to promote peace in the world.

In considering the requirements for the rehabilitation of Europe the physical loss of life, the visible destruction of cities, factories, mines, and railroads was correctly estimated, but it has become obvious during recent months that this visible destruction was probably less serious than the dislocation of the entire fabric of European economy. For the past 10 years conditions have been highly abnormal. The feverish preparation for war and the more feverish maintenance of the war effort engulfed all aspects of national economies. Machinery has fallen into disrepair or is entirely obsolete. Under the arbitrary and destructive Nazi rule, virtually every possible enterprise was geared into the German war machine. Long-standing commercial ties, private institutions, banks, insurance companies and shipping companies disappeared through loss of capital, absorption through nationalization or by simple destruction. In many countries, confidence in the local currency has been severely shaken. The breakdown of the business structure of Europe during the war was complete. Recovery has been seriously retarded by the fact that 2 years after the close of hostilities a peace settlement with Germany and Austria has not been agreed upon. But even given a more prompt solution of these difficult problems, the rehabilitation of the economic structure of Europe quite evidently will require a much longer time and greater effort than had been foreseen.

There is a phase of this matter which is both interesting and serious.

The farmer has always produced the foodstuffs to exchange with the city dweller for the other necessities of life. This division of labor is the basis of modern civilization. At the present time it is threatened with breakdown. The town and city industries are not producing adequate goods to exchange with the food-producing farmer. Raw materials and fuel are in short supply. Machinery is lacking or worn out. The farmer or the peasant cannot find the goods for sale which he desires to purchase. So the sale of his farm produce for money which he cannot use seems to him an unprofitable transaction. He, therefore, has withdrawn many fields from crop cultivation and is using them for grazing. He feeds more grain to stock and finds for himself and his family an ample supply of food, however short he may be on clothing and the other ordinary gadgets of civilization. Meanwhile people in the cities are short of food and fuel. So the governments are forced to use their foreign money and credits to procure these necessities abroad. This process exhausts funds which are urgently needed for reconstruction. Thus a very serious situation is rapidly developing which bodes no good for the world. The modern system of the division of labor upon which the exchange of products is based is in danger of breaking down.

The truth of the matter is that Europe's requirements for the next 3 or 4 years of foreign food and other essential products – principally from America – are so much greater than her present ability to pay that she must have substantial additional help, or face economic, social, and political deterioration of a very grave character.

The remedy lies in breaking the vicious circle and restoring the confidence of the European people in the economic future of their own countries and of Europe as a whole. The manufacturer and the farmer throughout wide areas must be able and willing to exchange their products for currencies the continuing value of which is not open to question.

Aside from the demoralizing effect on the world at large and the possibilities of disturbances arising as a result of the desperation of the people concerned, the consequences to the economy of the United States should be apparent to all. It is logical that the United States should do whatever it is able to do to assist in the return of normal economic health in the world, without which there can be no political stability and no assured peace. Our policy is directed not against any country or doctrine but against hunger, poverty, desperation, and chaos. Its purpose should be the revival of a working economy in the world so as to permit the emergence of political and social conditions in which free institutions can exist. Such assistance, I am convinced, must not be on a piecemeal basis as various crises develop. Any assistance that this Government may render in the future should provide a cure rather than a mere palliative. Any government that is willing to assist in the task of recovery will

find full cooperation, I am sure, on the part of the United States Government. Any government which maneuvers to block the recovery of other countries cannot expect help from us. Furthermore, governments, political parties, or groups which seek to perpetuate human misery in order to profit therefrom politically or otherwise will encounter the opposition of the United States.

It is already evident that, before the United States Government can proceed much further in its efforts to alleviate the situation and help start the European world on its way to recovery, there must be some agreement among the countries of Europe as to the requirements of the situation and the part those countries themselves will take in order to give proper effect to whatever action might be undertaken by this Government. It would be neither fitting nor efficacious for this Government to undertake to draw up unilaterally a program designed to place Europe on its feet economically. This is the business of the Europeans. The initiative, I think, must come from Europe. The role of this country should consist of friendly aid in the drafting of a European program and of later support of such a program so far as it may be practical for us to do so. The program should be a joint one, agreed to by a number, if not all European nations.

An essential part of any successful action on the part of the United States is an understanding on the part of the people of America of the character of the problem and the remedies to be applied. Political passion and prejudice should have no part. With foresight, and a willingness on the part of our people to face up to the vast responsibility which history has clearly placed upon our country, the difficulties I have outlined can and will be overcome.

105 JOSEPH McCARTHY

FROM "The Wheeling Speech" (1950)

Ladies and gentlemen, tonight as we celebrate the one hundred and forty-first birthday of one of the greatest men in American history, I would like to be able to talk about what a glorious day today is in the history of the world. As we celebrate the birth of this man who with his whole heart and soul hated war, I would like to be able to speak of peace in our time, of war being outlawed, and of worldwide disarmament. These would be truly appropriate things to be able to mention as we celebrate the birthday of Abraham Lincoln.

Five years after a world war has been won, men's hearts should anticipate a long peace, and men's minds should be free from the heavy weight that comes with war. But this is not such a period – for this is not a period of peace. This is a time of the "cold war." This is a time when

all the world is split into two vast, increasingly hostile armed camps – a time of a great armaments race.

Today we can almost physically hear the mutterings and rumblings of an invigorated god of war. You can see it, feel it, and hear it all the way from the hills of Indochina, from the shores of Formosa, right over into the very heart of Europe itself.

The one encouraging thing is that the "mad moment" has not yet arrived for the firing of the gun or the exploding of the bomb which will set civilization about the final task of destroying itself. There is still a hope for peace if we finally decide that no longer can we safely blind our eyes and close our ears to those facts which are shaping up more and more clearly. And that is that we are now engaged in a show-down fight – not the usual war between nations for land areas or other material gains, but a war between two diametrically opposed ideologies.

The great difference between our western Christian world and the atheistic Communist world is not political, ladies and gentlemen, it is moral. There are other differences, of course, but those could be reconciled. For instance, the Marxian idea of confiscating the land and factories and running the entire economy as a single enterprise is momentous. Likewise, Lenin's invention of the one-party police state as a way to make Marx's idea work is hardly less momentous.

Stalin's resolute putting across of these two ideas, of course, did much to divide the world. With only those differences, however, the East and the West could most certainly still live in peace.

The real, basic difference, however, lies in the religion of immoralism – invented by Marx, preached feverishly by Lenin, and carried to unimaginable extremes by Stalin. This religion of immoralism, if the Red half of the world wins – and well it may – this religion of immoralism will more deeply wound and damage mankind than any conceivable economic or political system.

Karl Marx dismissed God as a hoax, and Lenin and Stalin have added in clear-cut, unmistakable language their resolve that no nation, no people who believe in a God, can exist side by side with their communistic state.

Karl Marx, for example, expelled people from his Communist Party for mentioning such things as justice, humanity, or morality. He called this soulful ravings and sloppy sentimentality.

While Lincoln was a relatively young man in his late thirties, Karl Marx boasted that the Communist specter was haunting Europe. Since that time, hundreds of millions of people and vast areas of the world have fallen under Communist domination. Today, less than 100 years after Lincoln's death, Stalin brags that this Communist specter is not only haunting the world, but is about to completely subjugate it.

Today we are engaged in a final, all-out battle between communistic

340

atheism and Christianity. The modern champions of communism have selected this as the time. And, ladies and gentlemen, the chips are down – they are truly down.

Lest there be any doubt that the time has been chosen, let us go directly to the leader of communism today – Joseph Stalin. Here is what he said – not back in 1928, not before the war, not during the war – but 2 years after the last war was ended: "To think that the Communist revolution can be carried out peacefully, within the framework of a Christian democracy, means one has either gone out of one's mind and lost all normal understanding, or has grossly and openly repudiated the Communist revolution."

And this is what was said by Lenin in 1919, which was also quoted with approval by Stalin in 1947:

"We are living," said Lenin, "not merely in a state, but in a system of states, and the existence of the Soviet Republic side by side with Christian states for a long time is unthinkable. One or the other must triumph in the end. And before that end supervenes, a series of frightful collisions between the Soviet Republic and the Bourgeois states will be inevitable."

Ladies and gentlemen, can there be anyone here tonight who is so blind as to say that the war is not on? Can there be anyone who fails to realize that the Communist world has said, "The time is now" – that this is the time for the show-down between the democratic Christian world and the Communist atheistic world?

Unless we face this fact, we shall pay the price that must be paid by those who wait too long.

Six years ago, at the time of the first conference to map out the peace – Dumbarton Oaks – there were within the Soviet orbit 180,000,000 people. Lined up on the antitotalitarian side there were in the world at that time roughly 1,625,000,000 people. Today, only 6 years later, there are 800,000,000 people under the absolute domination of Soviet Russia – an increase of over 400 percent. On our side, the figure has shrunk to around 500,000,000. In other words, in less than 6 years the odds have changed from 9 to 1 in our favor to 8 to 5 against us. This indicates the swiftness of the tempo of Communist victories and American defeats in the cold war. As one of our outstanding historical figures once said, "When a great democracy is destroyed, it will not be because of enemies from without, but rather because of enemies from within."

The truth of this statement is becoming terrifyingly clear as we see this country each day losing on every front.

At war's end we were physically the strongest nation on earth and, at least potentially, the most powerful intellectually and morally. Ours could have been the honor of being a beacon in the desert of destruction, a shining living proof that civilization was not yet ready to destroy itself.

Unfortunately, we have failed miserably and tragically to arise to the opportunity.

The reason why we find ourselves in a position of impotency is not because our only powerful potential enemy has sent men to invade our shores, but rather because of the traitorous actions of those who have been treated so well by this Nation. It has not been the less fortunate or members of minority groups who have been selling this Nation out, but rather those who have had all the benefits that the wealthiest nation on earth has had to offer – the finest homes, the finest college education, and the finest jobs in Government we can give.

This is glaringly true in the State Department. There the bright young men who are born with silver spoons in their mouths are the ones who have been worst.

Now I know it is very easy for anyone to condemn a particular bureau or department in general terms. Therefore I would like to cite one rather unusual case – the case of a man who has done much to shape our foreign policy.

When Chiang Kai-shek was fighting our war, the State Department had in China a young man named John S. Service. His task, obviously, was not to work for the communization of China. Strangely, however, he sent official reports back to the State Department urging that we torpedo our ally Chiang Kai-shek and stating, in effect, that communism was the best hope of China.

Later, this man – John Service – was picked up by the Federal Bureau of Investigation for turning over to the Communists secret State Department information. Strangely, however, he was never prosecuted. However, Joseph Grew, the Under Secretary of State, who insisted on his prosecution, was forced to resign. Two days after Grew's successor, Dean Acheson, took over as Under Secretary of State, this man – John Service – who had been picked up by the FBI and who had previously urged that communism was the best hope of China, was not only reinstated in the State Department but promoted. And finally, under Acheson, placed in charge of all placements and promotions.

Today, ladies and gentlemen, this man Service is on his way to represent the State Department and Acheson in Calcutta – by far and away the most important listening post in the Far East.

Now, let's see what happens when individuals with Communist connections are forced out of the State Department. Gustave Duran, who was labeled as (I quote) "a notorious international Communist," was made assistant to the Assistant Secretary of State in charge of Latin American affairs. He was taken into the State Department from his job as a lieutenant colonel in the Communist International Brigade. Finally, after intense congressional pressure and criticism, he resigned in 1946 from the State Department – and, ladies and gentlemen, where do you

think he is now? He took over a high-salaried job as Chief of Cultural Activities Section in the office of the Assistant Secretary General of the United Nations.

Then there was a Mrs. Mary Jane Kenny, from the Board of Economic Warfare in the State Department, who was named in an FBI report and in a House committee report as a courier for the Communist Party while working for the Government. And where do you think Mrs. Kenny is – she is now an editor in the United Nations Document Bureau.

Another interesting case was that of Julian H. Wadleigh, economist in the Trade Agreements Section of the State Department for 11 years and [sic] was sent to Turkey and Italy and other countries as United States representative. After the statute of limitations had run so he could not be prosecuted for treason, he openly and brazenly not only admitted but proclaimed that he had been a member of the Communist Party . . . that while working for the State Department he stole a vast number of secret documents . . . and furnished these documents to the Russian spy ring of which he was a part.

You will recall last spring there was held in New York what was known as the World Peace Conference – a conference which was labeled by the State Department and Mr. Truman as the sounding board for Communist propaganda and a front for Russia. Dr. Harlow Shapley was the chairman of that conference. Interestingly enough, according to the new release put out by the Department in July, the Secretary of State appointed Shapley on a commission which acts as liaison between UNESCO and the State Department.

This, ladies and gentlemen, gives you somewhat of a picture of the type of individuals who have been helping to shape our foreign policy. In my opinion the State Department, which is one of the most important government departments, is thoroughly infested with Communists.

I have in my hand 57 cases of individuals who would appear to be either card carrying members or certainly loyal to the Communist Party, but who nevertheless are still helping to shape our foreign policy.

One thing to remember in discussing the Communists in our Government is that we are not dealing with spies who get 30 pieces of silver to steal the blueprints of a new weapon. We are dealing with a far more sinister type of activity because it permits the enemy to guide and shape our policy. . . .

This brings us down to the case of one Alger Hiss who is important not as an individual any more, but rather because he is so representative of a group in the State Department. It is unnecessary to go over the sordid events showing how he sold out the Nation which had given him so much. Those are rather fresh in all of our minds.

However, it should be remembered that the facts in regard to his connection with this international Communist spy ring were made

known to the then Under Secretary of State Berle 3 days after Hitler and Stalin signed the Russo-German alliance pact. At that time one Whittaker Chambers – who was also part of the spy ring – apparently decided that with Russia on Hitler's side, he could no longer betray our Nation to Russia. He gave Under Secretary of State Berle – and this is all a matter of record – practically all, if not more, of the facts upon which Hiss' conviction was based.

Under Secretary Berle promptly contacted Dean Acheson and received word in return that Acheson (and I quote) "could vouch for Hiss absolutely" – at which time the matter was dropped. And this, you understand, was at a time when Russia was an ally of Germany. This condition existed while Russia and Germany were invading and dismembering Poland, and while the Communist groups here were screaming "warmonger" at the United States for their support of the allied nations.

Again in 1943, the FBI had occasion to investigate the facts surrounding Hiss' contacts with the Russian spy ring. But even after that FBI report was submitted, nothing was done.

Then late in 1948 – on August 5 – when the Un-American Activities Committee called Alger Hiss to give an accounting, President Truman at once issued a Presidential directive ordering all Government agencies to refuse to turn over any information whatsoever in regard to the Communist activities of any Government employee to a congressional committee.

Incidentally, even after Hiss was convicted – it is interesting to note that the President still labeled the exposé of Hiss as a "red herring."

If time permitted, it might be well to go into detail about the fact that Hiss was Roosevelt's chief adviser at Yalta when Roosevelt was admittedly in ill health and tired physically and mentally . . . and when, according to the Secretary of State, Hiss and Gromyko drafted the report on the conference.

According to the then Secretary of State Stettinius, here are some of the things that Hiss helped to decide at Yalta. (1) The establishment of a European High Commission; (2) the treatment of Germany – this you will recall was the conference at which it was decided that we would occupy Berlin with Russia occupying an area completely circling the city, which, as you know, resulted in the Berlin airlift which cost 31 American lives; (3) the Polish question; (4) the relationship between UNRRA and the Soviet; (5) the rights of Americans on control commissions of Rumania, Bulgaria, and Hungary; (6) Iran: (7) China – here's where we gave away Manchuria; (8) Turkish Straits question; (9) international trusteeships; (10) Korea.

Of the results of this conference, Arthur Bliss Lane of the State Department had this to say: "As I glanced over the document, I could

not believe my eyes. To me, almost every line spoke of a surrender to Stalin."

As you hear this story of high treason, I know that you are saying to yourself, "Well, why doesn't the Congress do something about it?" Actually, ladies and gentlemen, one of the important reasons for the graft, the corruption, the dishonesty, the disloyalty, the treason in high Government positions – one of the most important reasons why this continues is a lack of moral uprising on the part of the 140,000,000 American people. In the light of history, however, this is not hard to explain.

It is the result of an emotional hang-over and a temporary moral lapse which follows every war. It is the apathy to evil which people who have been subjected to the tremendous evils of war feel. As the people of the world see mass murder, the destruction of defenseless and innocent people, and all of the crime and lack of morals which go with war, they become numb and apathetic. It has always been thus after war.

However, the morals of our people have not been destroyed. They still exist. This cloak of numbness and apathy has only needed a spark to rekindle them. Happily, this spark has finally been supplied.

106 JOHN F. KENNEDY

First Inaugural Address (1961)

We observe today not a victory of party but a celebration of freedom – symbolizing an end as well as a beginning – signifying renewal as well as change. For I have sworn before you and Almighty God the same solemn oath our forebears prescribed nearly a century and three quarters ago.

The world is very different now. For man holds in his mortal hands the power to abolish all forms of human poverty and all forms of human life. And yet the same revolutionary beliefs for which our forebears fought are still at issue around the globe – the belief that the rights of man come not from the generosity of the state but from the hand of God.

We dare not forget today that we are the heirs of that first revolution. Let the word go forth from this time and place, to friend and foe alike, that the torch has been passed to a new generation of Americans – born in this century, tempered by war, disciplined by a hard and bitter peace, proud of our ancient heritage – and unwilling to witness or permit the slow undoing of those human rights to which this nation has always been committed, and to which we are committed today at home and around the world.

Let every nation know, whether it wishes us well or ill, that we shall pay any price, bear any burden, meet any hardship, support any friend, oppose any foe to assure the survival and the success of liberty.

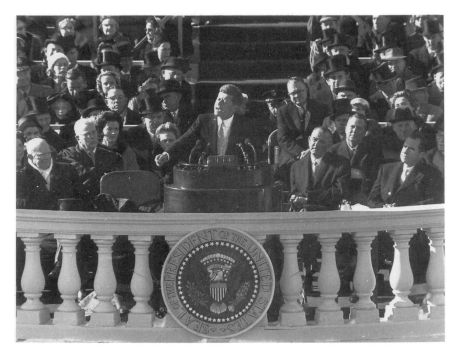

Figure 12.1 President John F. Kennedy giving his inauguration speech, 1961
Photograph courtesy of Range/Bettman/UPI

This much we pledge – and more.

To those old allies whose cultural and spiritual origins we share, we pledge the loyalty of faithful friends. United, there is little we cannot do in a host of cooperative ventures. Divided, there is little we can do – for we dare not meet a powerful challenge at odds and split asunder.

To those new states whom we welcome to the ranks of the free, we pledge our word that one form of colonial control shall not have passed away merely to be replaced by a far more iron tyranny. We shall not always expect to find them supporting our view. But we shall always hope to find them strongly supporting their own freedom – and to remember that, in the past, those who foolishly sought power by riding the back of the tiger ended up inside.

To those peoples in the huts and villages of half the globe struggling to break the bonds of mass misery, we pledge our best efforts to help them help themselves, for whatever period is required – not because the communists may be doing it, not because we seek their votes, but because it is right. If a free society cannot help the many who are poor, it cannot save the few who are rich.

To our sister republics south of our border, we offer a special pledge –

to convert our good words into good deeds – in a new alliance for progress – to assist free men and free governments in casting off the chains of poverty. But this peaceful revolution of hope cannot become the prey of hostile powers. Let all our neighbors know that we shall join with them to oppose aggression or subversion anywhere in the Americas. And let every other power know that this Hemisphere intends to remain the master of its own house.

To that world assembly of sovereign states, the United Nations, our last best hope in an age where the instruments of war have far outpaced the instruments of peace, we renew our pledge of support – to prevent it from becoming merely a forum for invective – to strengthen its shield of the new and the weak – and to enlarge the area in which its writ may run.

Finally, to those nations who would make themselves our adversary, we offer not a pledge but a request: that both sides begin anew the quest for peace, before the dark powers of destruction unleashed by science engulf all humanity in planned or accidental self-destruction.

We dare not tempt them with weakness. For only when our arms are sufficient beyond doubt can we be certain beyond doubt that they will never be employed.

But neither can two great and powerful groups of nations take comfort from our present course – both sides overburdened by the cost of modern weapons, both rightly alarmed by the steady spread of the deadly atom, yet both racing to alter that uncertain balance of terror that stays the hand of mankind's final war.

So let us begin anew – remembering on both sides that civility is not a sign of weakness, and sincerity is always subject to proof. Let us never negotiate out of fear. But let us never fear to negotiate.

Let both sides explore what problems unite us instead of belaboring those problems which divide us.

Let both sides, for the first time, formulate serious and precise pro-posals for the inspection and control of arms – and bring the absolute power to destroy other nations under the absolute control of all nations.

Let both sides seek to invoke the wonders of science instead of its terrors. Together let us explore the stars, conquer the deserts, eradicate disease, tap the ocean depths and encourage the arts and commerce.

Let both sides unite to heed in all corners of the earth the command of Isaiah – to "undo the heavy burdens . . . (and) let the oppressed go free."

And if a beach-head of cooperation may push back the jungle of suspicion, let both sides join in creating a new endeavor, not a new balance of power, but a new world of law, where the strong are just and the weak secure and the peace preserved.

All this will not be finished in the first one hundred days. Nor will it be

finished in the first one thousand days, nor in the life of this Administration, nor even perhaps in our lifetime on this planet. But let us begin.

In your hands, my fellow citizens, more than mine, will rest the final success or failure of our course. Since this country was founded, each generation of Americans has been summoned to give testimony to its national loyalty. The graves of young Americans who answered the call to service surround the globe.

Now the trumpet summons us again – not as a call to bear arms, though arms we need – not as a call to battle, though embattled we are – but a call to bear the burden of a long twilight struggle, year in and year

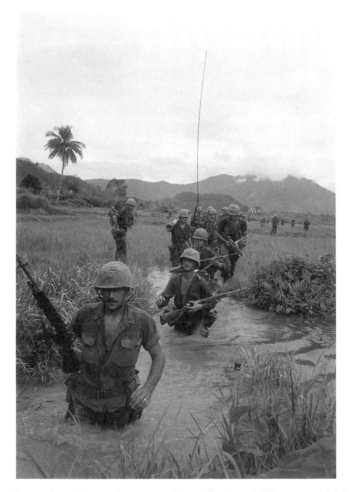

Figure 12.2 US marines near Hoa My, South Vietnam, 1965
Photograph courtesy of Range/Bettman/UPI

out, "rejoicing in hope, patient in tribulation" – a struggle against the common enemies of man: tyranny, poverty, disease and war itself.

Can we forge against these enemies a grand and global alliance, North and South, East and West, that can assure a more fruitful life for all mankind? Will you join in that historic effort?

In the long history of the world, only a few generations have been granted the role of defending freedom in its hour of maximum danger. I do not shrink from this responsibility – I welcome it. I do not believe that any of us would exchange places with any other people or any other generation. The energy, the faith, the devotion which we bring to this endeavor will light our country and all who serve it – and the glow from that fire can truly light the world.

And so, my fellow Americans: ask not what your country can do for you – ask what you can do for your country.

My fellow citizens of the world: ask not what America will do for you, but what together we can do for the freedom of man.

Finally, whether you are citizens of America or citizens of the world, ask of us here the same high standards of strength and sacrifice which we ask of you. With a good conscience our only sure reward, with history the final judge of our deeds, let us go forth to lead the land we love, asking His blessings and His help, but knowing that here on earth God's work must truly be our own.

107 LYNDON B. JOHNSON

"American Policy in Viet-nam" (1965)

Over this war – and all Asia – is another reality: the deepening shadow of Communist China. The rulers in Hanoi are urged on by Peking. This is a regime which has destroyed freedom in Tibet, which has attacked India and has been condemned by the United Nations for aggression in Korea. It is a nation which is helping the forces of violence in almost every continent. The contest in Viet-Nam is part of a wider pattern of aggressive purposes.

Why are these realities our concern? Why are we in South Viet-Nam?

We are there because we have a promise to keep. Since 1954 every American President has offered support to the people of South Viet-Nam. We have helped to build, and we have helped to defend. Thus, over many years, we have made a national pledge to help South Viet-Nam defend its independence.

And I intend to keep that promise.

To dishonor that pledge, to abandon this small and brave nation to its enemies, and to the terror that must follow, would be an unforgivable wrong.

We are also there to strengthen world order. Around the globe from Berlin to Thailand are people whose well-being rests in part on the belief that they can count on us if they are attacked. To leave Viet-Nam to its fate would shake the confidence of all these people in the value of an American commitment and in the value of America's word. The result would be increased unrest and instability, and even wider war.

We are also there because there are great stakes in the balance. Let no one think for a moment that retreat from Viet-Nam would bring an end to conflict. The battle would be renewed in one country and then another. The central lesson of our time is that the appetite of aggression is never satisfied. To withdraw from one battlefield means only to prepare for the next. We must say in Southeast Asia – as we did in Europe – in the words of the Bible: "Hitherto shalt thou come, but no further."

There are those who say that all our efforts there will be futile – that China's power is such that it is bound to dominate all Southeast Asia. But there is no end to that argument until all of the nations of Asia are swallowed up.

There are those who wonder why we have a responsibility there. Well, we have it there for the same reason that we have a responsibility for the defense of Europe. World War II was fought in both Europe and Asia and when it ended we found ourselves with continued responsibility for the defense of freedom.

Our objective is the independence of South Viet-Nam and its freedom from attack. We want nothing for ourselves – only that the people of South Viet-Nam be allowed to guide their own country in their own way.

We will do everything necessary to reach that objective and we will do only what is absolutely necessary.

In recent months attacks on South Viet-Nam were stepped up. Thus, it became necessary for us to increase our response and to make attacks by air. This is not a change of purpose. It is a change in what we believe that purpose requires.

We do this in order to slow down aggression. We do this to increase the confidence of the brave people of South Viet-Nam who have bravely borne this brutal battle for so many years with so many casualties. And we do this to convince the leaders of North Viet-Nam – and all who seek to share their conquest – of a simple fact: We will not be defeated. We will not grow tired. We will not withdraw, either openly or under the cloak of a meaningless agreement.

We know that air attacks alone will not accomplish all of these purposes. But it is our best and prayerful judgment that they are a necessary part of the surest road to peace.

We hope that peace will come switfly. But that is in the hands of others besides ourselves. And we must be prepared for a long continued

conflict. It will require patience as well as bravery – the will to endure as well as the will to resist.

I wish it were possible to convince others with words of what we now find it necessary to say with guns and planes: armed hostility is futile – our resources are equal to any challenge – because we fight for values and we fight for principle, rather than territory or colonies, our patience and our determination are unending.

Once this is clear, then it should also be clear that the only path for reasonable men is the path of peaceful settlement.

Such peace demands an independent South Viet-Nam – securely guaranteed and able to shape its own relationships to all others – free from outside interference – tied to no alliance – a military base for no other country.

These are the essentials of any final settlement.

We will never be second in the search for such a peaceful settlement in Viet-Nam.

There may be many ways to this kind of peace: in discussion or negotiation with the governments concerned; in large groups or in small ones; in the reaffirmation of old agreements or their strengthening with new ones.

We have stated this position over and over again fifty times and more to friend and foe alike. And we remain ready with this purpose for unconditional discussions.

And until that bright and necessary day of peace we will try to keep conflict from spreading. We have no desire to see thousands die in battle – Asians or Americans. We have no desire to devastate that which the people of North Viet-Nam have built with toil and sacrifice. We will use our power with restraint and with all the wisdom that we can command.

But we will use it.

108 GEORGE BUSH

"The Launch of Attack on Iraq" (1991)

Just two hours ago, allied air forces began an attack on military targets in Iraq and Kuwait. These attacks continue as I speak. Ground forces are not engaged. This conflict started August 2nd when the dictator of Iraq invaded a small and helpless neighbor. Kuwait, a member of the Arab League and a member of the United Nations was crushed, its people brutalized.

Five months ago, Saddam Hussein started this cruel war against Kuwait; tonight the battle has been joined. This military action, taken in accord with United Nations resolutions and with the consent of the United States Congress, follows months of constant and virtually endless

diplomatic activity on the part of the United Nations, the United States and many, many other countries. Arab leaders sought what became known as an Arab solution, only to conclude that Saddam Hussein was unwilling to leave Kuwait. Others travelled to Baghdad in a variety of efforts to restore peace and justice. Our Secretary of State James Baker held an historic meeting in Geneva only to be totally rebuffed. This past weekend, in a last ditch effort, the Secretary General of the United Nations went to the Middle East with peace in his heart – his second such mission and he came back from Baghdad with no progress at all in getting Saddam Hussein to withdraw from Kuwait. Now, the 28 countries with forces in the Gulf area have exhausted all reasonable efforts to reach a peaceful resolution, have no choice but to drive Saddam from Kuwait by force. We will not fail.

As I report to you, air attacks are underway against military targets in Iraq. We are determined to knock out Saddam Hussein's nuclear bomb potential. We will also destroy his chemical weapons facilities. Much of Saddam's artillery and tanks will be destroyed. Our operations are designed to best protect the lives of all the coalition forces by targeting Saddam's vast military arsenal. Initial reports from General Schwarzkopf are that our operations are proceeding according to plan.

Our objectives are clear. Saddam Hussein's forces will leave Kuwait. The legitimate government of Kuwait will be restored to its rightful place and Kuwait will once again be free.

Iraq will eventually comply with all relevant United Nations resolutions and then when peace is restored, it is our hope that Iraq will live as a peaceful and cooperative member of the family of nations, thus enhancing the security and stability of the Gulf.

Some may ask, "Why act now? Why not wait?" The answer is clear. The world could wait no longer. Sanctions, though having some effect, showed no signs of accomplishing their objective. Sanctions were tried for well over five months and we and our allies concluded that sanctions alone would not force Saddam from Kuwait.

While the world waited Saddam Hussein systematically raped, pillaged and plundered a tiny nation – no threat to his own. He subjected the people of Kuwait to unspeakable atrocities, and among those maimed and murdered – innocent children. While the world waited Saddam sought to add to the chemical weapons arsenal he now possesses an infinitely more dangerous weapon of mass destruction, a nuclear weapon.

And while the world waited, while the world talked peace and withdrawal Saddam Hussein dug in and moved massive forces into Kuwait. While the world waited, while Saddam stalled, more damage was being done to the fragile economies of the Third World, the emerging democ-

racies of Eastern Europe, to the entire world, including to our own economy.

The United States, together with the United Nations, exhausted every means at our disposal to bring this crisis to a peaceful end. However, Saddam clearly felt that by stalling and threatening and defying the United Nations he could weaken the forces arrayed against him.

While the world waited Saddam Hussein met every overture of peace with open contempt. While the world prayed for peace Saddam prepared for war.

I had hoped that when the United States Congress, in historic debate, took its resolute action Saddam would realize he could not prevail and would move out of Kuwait in accord with the United Nations resolutions. He did not do that.

Instead, he remained intransigent, certain that time was on his side. Saddam was warned over and over again to comply with the will of the United Nations – leave Kuwait or be driven out.

Saddam has arrogantly rejected all warnings. Instead, he tried to make this a dispute between Iraq and the United States of America. Well, he failed. Tonight, 28 nations, countries from five continents – Europe and Asia, Africa and the Arab League have forces in the Gulf area standing shoulder-to-shoulder against Saddam Hussein. These countries had hoped the use of force could be avoided. Regrettably, we now believe that only force will make him leave.

Prior to ordering our forces into battle, I instructed our military commanders to take every necessary step to prevail as quickly as possible and with the greatest degree of protection possible for American and allied servicemen and women. I've told the American people before that this will not be another Vietnam. And I repeat this here tonight. Our troops will have the best possible support in the entire world. And they will not be asked to fight with one hand tied behind their back.

I'm hopeful that this fighting will not go on for long and that casualties will be held to an absolute minimum. This is an historic moment. We have in this past year made great progress in ending the long era of conflict and Cold War. We have before us the opportunity to forge for ourselves and for future generations a new world order, a world where the rule of law, not the law of the jungle, governs the conduct of nations. When we are successful, and we will be, we have a real chance at this new world order, an order in which a credible United Nations can use its peacekeeping role to fulfill the promise and vision of the UN's founders.

We have no argument with the people of Iraq. Indeed, for the innocents caught in this conflict, I pray for their safety. Our goal is not the conquest of Iraq. It is the liberation of Kuwait. It is my hope that somehow the Iraqi people can even now convince their dictator that

he must lay down his arms, leave Kuwait and let Iraq itself rejoin the family of peace-loving nations.

Thomas Paine wrote many years ago: "These are the times that try men's souls." Those well-known words are so very true today. But even as planes of the multinational forces attack Iraq, I prefer to think of peace not war. I am convinced not only that we will prevail, but that out of the horror of combat will come the recognition that no nation can stand against a world united, no nation will be permitted to brutally assault its neighbor.

No president can easily commit our sons and daughters to war. They are the nation's finest. Ours is an all-volunteer force, magnificently trained, highly motivated.

The troops know why they're there. And listen to what they say, for they've said it better than any president or prime minister ever could. Listen to Hollywood Huddleston, Marine Lance Corporal. He says, "Let's free these people so we can go home and be free again." And he's right. The terrible crimes and tortures committed by Saddam's henchmen against the innocent people of Kuwait are an affront to mankind and a challenge to the freedom of all.

Listen to one of our great officers out there, Marine Lieutenant General Walter Boomer. He said, "There are things worth fighting for. A world in which brutality and lawlessness are allowed to go unchecked isn't the kind of world we're going to want to live in."

Listen to Master Sargeant J. K. Kendall of the 82nd Airborne. "We're here for more than just the price of a gallon of gas. What we're doing is going to chart the future of the world for the next 100 years. It's better to deal with this guy now than five years from now."

And finally, we should all sit up and listen to Jackie Jones, an Army lieutenant, when she says, "If we let him get away with this, who knows what's going to be next?"

I've called upon Hollywood and Walter and J. K. and Jackie and all their courageous comrades in arms to do what must be done. Tonight America and the world are deeply grateful to them and to their families.

And let me say to everyone listening or watching tonight: When the troops we've sent in finish their work, I'm determined to bring them home as soon as possible. Tonight, as our forces fight, they and their families are in our prayers.

May God bless each and every one of them and the coalition forces at our side in the Gulf, and may He continue to bless our nation, the United States of America.

109 E. L. DOCTOROW

Open Letter to the President (1991)

Dear Mr. President:

When the United Nations voted sanctions against Iraq something quite unusual took place: A world congress made a virtually unanimous moral judgment against the depredations of a rogue state and then implemented its judgment with action. In international concert, troops were sent to guard Saudi Arabia's borders, and military means of interdiction, on the sea and in the air, were established to punish Iraq by economic strangulation. And it was the United States government, your Administration, that was the creative force behind this achievement.

I wonder why you don't understand what a great thing you accomplished.

This U.N. action, the first major cooperative international action since the end of the cold war, was not a mere repetition of previous instances of voted sactions. Old alliances were breached, old animosities discarded. History has given us a moment to recognize and exploit a characterological change in the nature of the world order. Think of this ad hoc union of nation-states coalescing in the perception of a moral outrage and then taking a powerful noninvasive action to rectify it. There is a moral end – the restitution of what was stolen, the reconstruction of what was destroyed; and there is a moral means to achieve it – the withdrawal of economic fellowship. What makes this action resound is that it comes beneficently in a time of crumbling international real-political structures – when new structures take their being from the course of historical events. Whatever the motives of the allies backing your initiative, and whatever the inducements given them, almost accidentally there is a new united consciousness of nations that can begin to compose the civilized future.

War is an expedient of Saddam Hussein, Mr. President, because he is of the barbarous past. You have the chance to create a future in which, on a smaller and smaller globe, technology races to rectify the damage of earlier technology, and the needs of any one state are becoming the needs of all – air to breathe, water to drink, soil and climate to grow crops, and an unalienated, literate citizenry to advance the civilizations of a democratic planet.

In this light, it becomes tragically regressive to raise troop levels and think only with a military mind. A new period in history brings with it a new sensibility, and what is acceptable in an earlier age is understood as monstrous in our own. As we approach the twenty-first century, it is radiantly apparent that there is now no person on earth who has an inherent moral authority to send other people to their deaths. It is no

longer philosophically possible. A chief executive is not a chieftain. Nor can he be a zealot.

There is a rumor going about that even as you've instructed your Secretary of State to visit Baghdad, the Quartermaster Corps of the Army has ordered 80,000 body bags. It was George Washington, in his prescience, who decided that holders of your office would be addressed as *Mr. President*. It was George Washington who decided we would not have kings. You do not rule by divine right. You are not ordained. You are a Mister. Unless you claim celestial lineage, you simply cannot elevate yourself to an ethical justification of a course of military action that may result in 80,000 dead American young men and women. Or 8,000. Or 800. I have not heard you say that our basic survival and identity as a nation are at issue here. It is no longer a chief executive's license to articulate a national interest, other than our basic survival, that requires the death of 80,000 young men and women.

The last time – another age, a distant past – something like that happened is celebrated now in austere solemnity, one might even think in the spirit of penitence, by that dark granite monument that sits with the names of the Vietnam War dead not far from your office. Tell me now to what end those soldiers died. What acute national interest did their deaths serve? We have hospitals full of those permanently maimed and paralyzed from that war. What real-political analysis of former Secretary of State Kissinger, now again urging blitzkrieg as one of the wise men of television, was borne out in the subsequent history of our security and comfort as a nation? Does he now say of the domino theory that he once so shrilly in his wisdom insisted upon that 50,000 of a generation died so that he can make the rounds at black-tie dinners? It is my understanding we have been talking lately to the Vietnamese about getting the remains of our MIAs home. There is something like normal diplomatic intercourse with these terrors of the Asian continent. And north of Vietnam there is still a Communist monolith government in China doing what Communist governments have always done, but as far as I can tell, you look on China now with a passion no more intense than a salesman's affection for a customer.

I wonder if you give yourself in any day the quiet hours of solitude that this situation requires. Do they let you alone? Do they give you time to think? Even to men with ordinary responsibilities, thinking is hard. Are you able to think? Do you make the mistake of assuming that having committed more than 400,000 troops to the desert you must, if your ultimatum is ignored, set them to fighting or *lose face*? I want to know whose face you would be losing. Do you delude yourself that it would not be a kind of criminal behavior to go to war to *save face*? I want to know whose face you would be saving. Nations are not people. Nations do not have faces – they have histories, they have constitutions, but they do not

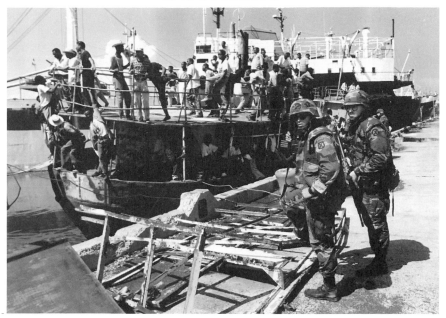

Figure 12.3 US soldiers guarding their encampment in Port-au-Prince, Haiti,
September 1994
Photograph courtesy of Range/Reuter/Bettman

have faces. Perhaps you confuse the nation with yourself and have in mind your own face. But if I were a national leader I would welcome any degree of personal humiliation if it would preserve the life of one 18-year-old solider. I would live content in everlasting disgrace if one paraplegic could get up and walk.

A modern nation's honor is not the honor of a warrior; it is the honor of a father providing for his children, it is the honor of a mother providing for *her* children. Surely that is the true meaning of the otherwise strange internal collapse of the Soviet superstate as well as the overthrow of its satellite governments of Eastern Europe – the universal perception of what, after all, twenty-first-century enlightenment demands.

But if you would still don the helmet, let me suggest that U.N. sanctions and embargo themselves constitute a military action. It is called a siege. As all military leaders from biblical times have understood, the siege is the most cost-effective of all military strategies. Without endangering one's own forces, it brings slow but inevitable doom to the enemy. He lives for a while on his own fat, and then he either surrenders or starves to death. And nothing need be negotiated with him because he is no longer in a position to negotiate.

I look forward with you to the day when Saddam Hussein and everything he represents is buried in the sands of the desert. All we have to do is stand here silently, in our armor, and watch it happen. And go on and see what kind of twenty-first-century world God has given us the opportunity to make.

Yours sincerely,
E. L. Doctorow

13

IDEOLOGY: DOMINANT BELIEFS AND VALUES

Introduction 361

110 Thomas Jefferson, with Amendments by the Continental Congress
FROM The Declaration of Independence (1776) 364

111 Abraham Lincoln
The Gettysburg Address (1863) 367

112 John Marshall Harlan
FROM Dissenting Opinion in *Plessy* v. *Ferguson* (1896) 368

113 Learned Hand
FROM "The Spirit of Liberty" (1944) 369

114 William James
FROM *Pragmatism* (1907) 370

115 Jane Addams
FROM *Twenty Years at Hull House* (1910) 371

116 Woodrow Wilson
FROM First Inaugural Address (1913) 373

117 William J. Clinton
FROM Address on the State of the Union, 1994 375

118 Frederick Jackson Turner
FROM "The Significance of the Frontier in American History"
(1893) 376

119 Theodore Roosevelt
FROM "The Strenuous Life" (1899) 377

120 Studs Terkel
FROM "Jay Slabaugh, 48" (Interview with a Corporate
Executive, 1980) 378

121 Ronald Reagan
FROM Address on the State of the Union, 1986 379

122 Rush H. Limbaugh, III
FROM *See, I Told You So* (1993) 380

123 Earnest Elmo Calkins
FROM "Business Has Wings" (1927) 382

124 Dale Carnegie
FROM *How to Win Friends and Influence People* (1936) 385

125 Malvina Reynolds
"Little Boxes" (1962) 386

126 David Watson
"Civilization is Like a Jetliner" (1983) 387

INTRODUCTION

In his well-known study *An American Dilemma: The Negro Problem and Modern Democracy* (1944) the Swedish sociologist Gunnar Myrdal speaks of "a social *ethos*, a political creed" that is shared by Americans of all national origins, classes, and faiths and that functions as "the cement in the structure of this great and disparate nation." In Myrdal's words,

> These ideals of the essential dignity of the individual human being, of the fundamental equality of all men, and of certain inalienable rights to freedom, justice, and a fair opportunity represent to the American people the essential meaning of the nation's early struggle for independence. In the clarity and intellectual boldness of the Enlightenment period these tenets were written into the Declaration of Independence, the Preamble of the Constitution, the Bill of Rights and into the constitutions of the several states. The ideals of the American Creed have thus become the highest law of the land.[1]

The first four extracts in this chapter are texts by Thomas Jefferson, Abraham Lincoln, John Marshall Harlan and Learned Hand – four "declarations" of this creed which are among the most profoundly humanist documents of American culture. The Declaration of Independence, drafted by Thomas Jefferson, is perhaps the best known of American political documents. The only part of the Declaration that has been somewhat abridged here is its long enumeration of "abuses and usurpations" committed by the British King. (For further reading, see the Bill of Rights of the Constitution, reprinted in chapter 5.) President Lincoln's address delivered at the dedication of the cemetery at Gettysburg, a battlefield of the Civil War, is included for its eloquent, condensed formulation of democratic principles. (See also the Final Emancipation Proclamation in chapter 3 and the Fourteenth Amendment to the Constitution in chapter 5). Lincoln's address is followed by Justice John Marshall Harlan's dissent in the Supreme Court case of *Plessy* v. *Ferguson* from 1896, in which he insists on the constitutional equality of all classes and races in America and deplores the Court's acceptance of racial segregation as constitutional as long as the facilities in question – in this specific case, those of railroad coaches – were said to be "separate but equal." (Harlan's lone dissent foreshadowed the ideas half a century later of the Supreme Court decision of *Brown* v. *Board of Education*, excerpted in chapter 10.) Justice Learned Hand's speech at a mass meeting in Central Park in 1944, a critical year in World War II, rounds off these documents of a general American ethos of liberty and equality.

When defining their visions of life, Americans have at the same time tended to be less concerned with ideas as such than with their

application. In extract 114 (from *Pragmatism*, 1907), William James typically insists that even the field of philosophy ought to judge metaphysical theories in terms of their practical effects.

On closer examination the collectively shared "American Creed" referred to by Myrdal above tends to splinter into differing patterns of beliefs and values that compete for prominence and reflect the heterogeneity of American culture. Some periods and groups have for instance tended to see the "inalienable rights" of American men and women in a reformist and liberal light, whereas other periods and people have given them a predominantly conservative and liberalist definition. In both cases, the dispute often centers on the issue, in Jane Addams's words, of "the overaccumulation at one end of society and the destitution at the other" (extract 115, pp. 371–3).

As examples of the former reformist tradition, texts by Jane Addams, President Woodrow Wilson and President William J. Clinton are included in this chapter. Not least American women have played an important role in campaigns for reform such as the abolitionist movement, the Progressive struggle, the prohibition crusade, and the civil rights movement. During the Progressive era, for instance, women social workers established so-called settlement houses in several American cities to help relieve the problems of poverty and squalor among the urban lower classes, particularly in immigrant tenement districts. In extract 115, Jane Addams writes of the philanthropic and humanitarian ideas that had led her to establish Hull House in Chicago in 1889. In his presidential campaign and election victory of 1912, Woodrow Wilson had moved left to accommodate Progressive ideas of reform, which is seen in the concern in his First Inaugural Address (1913) with the "physical and spiritual cost" of unchecked capitalism (extract 116). The belief in liberal politics, social solidarity, and government action for purposes of economic redress may of course be traced further through Roosevelt's New Deal, Truman's Fair Deal, Kennedy's New Frontier, and Johnson's Great Society, all the way to Clinton's announcement of a new American National Health Plan, reprinted in extract 117 from his 1994 State of the Union Address. (For further examples, see F.D.R.'s "Organized Money" in chapter 7 and Lyndon B. Johnson's "The War on Poverty" in chapter 8.)

As examples of the individualist, anti-governmental, and often conservative ideological tradition in America the following extracts are included in this chapter: an essay by Frederick Jackson Turner on the frontier mentality; a speech by President Theodore Roosevelt at the eve of the nineteenth century; an interview from the late 1970s with a business executive; an Address on the State of the Union by President Ronald Reagan; and some passages from a book by Rush H. Limbaugh, a prominent spokesman of the ultraconservative right in the 1990s.

According to the historian Frederick Jackson Turner's famous thesis (1891), the environment of the frontier served to create an essentially American spirit that was individualist, anti-social, and anti-institutional. (Compare present-day myths of the American West, the cowboy, and the self-made entrepreneur.) In "The Strenuous Life," a speech given to the members of a Chicago men's club in 1899, Theodore Roosevelt likewise celebrated – in the heyday of American industrialism – the hardy qualities of a life of strife and the idea of leading "clean, vigorous, healthy" lives. (For further reading, see for instance Andrew Carnegie's *The Gospel of Wealth* and the excerpts from Henry Ford's *My Life and Work*, both in chapter 7). In Studs Terkel's interview with an American corporate executive in the late 1970s, life in general and business in particular are viewed in Darwinist terms of competition rather than cooperation, evoking a world in which no-growth is inconceivable and you move either forward or backward, up or down. The excerpt from the 1986 State of the Union Address by Ronald Reagan sums up in four brief paragraphs several of the most fundamental ideas and values of American life, such as manifest destiny, freedom, the importance of faith and dream, anti-communism, future-orientation, and progress – but consistently from an individualistic rather than social viewpoint. In the last of these extracts Rush H. Limbaugh, famous for his own radio and TV shows in the 1990s, attacks contemporary political liberalism of the Bill Clinton variety for poisoning American life with its moral relativism and secular humanism.

Arguably, however, the most radical erosion of individualism in American life has been caused not by politics or government but by the development of modern capitalism itself in the late nineteenth and early twentieth century, particularly its socio-economic forces of industrialization, mass immigration, urbanization, incorporation and standardization. At the same time, the transformation of America from a predominantly production-oriented to a mass consumption-oriented culture engendered the most radical shift in values in American history. The traditional Protestant ethos that dominated the first three centuries of American history, characterized by belief patterns connected with work and thrift, saving, self-restraint, character, self-reliance, and self-assertion, was increasingly challenged by a mass culture of consumption which produced an ideology emphasizing leisure and amusement, spending, self-indulgence, personality, conformity, and popularity. This clash of values, which became acute in the 1920s and still serves to characterize American culture, may be seen in the 1924 Buick advertisement (Figure 13.3), which juxtaposes the car's "character" and reliability with its appearance and style. In extract 123, "Business Has Wings" (1927), the advertising executive Earnest Elmo Calkins argues that rapidly changing fashions and popular tastes

interact with advertising to produce a world of business and a style of life which are fluid and capricious; prosperity then becomes a matter of belief – in consumption more than in work as such. (For further reading, compare the passages from Sinclair Lewis's *Babbitt* in chapter 8.) In the excerpt from Dale Carnegie's *How to Win Friends and Influence People* (1936), a book which went through close to a hundred printings in its first three decades of publication, success is connected *not* with exertion, aggressiveness, or inner-directed self-assertion, but with personality, winning ways and other-directed approbation – qualities that have to do with handling people and getting along with superiors in large corporate structures of business and/or government. (See also Bruce Barton's "Christ as a Businessman" in chapter 7.) A song text by Malvina Reynolds entitled "Little Boxes" serves as a conclusion to the idea of the erosion of individual autonomy in present-day, middle-class America, and David Watson's apocalyptic likening of modern civilization to a jetliner evokes the passivization and regimentation of people in a culture of high technology and environmental devastation.

1 Gunnar Myrdal, *An American Dilemma: The Negro Problem and Modern Democracy* (1944), New York, Harper and Row, 1962, pp. 3, 4

110 THOMAS JEFFERSON, WITH AMENDMENTS BY THE CONTINENTAL CONGRESS

FROM The Declaration of Independence (1776)

In Congress, July 4, 1776
The unanimous Declaration of the thirteen united States of America

When in the course of human events, it becomes necessary for one people to dissolve the political bands which have connected them with another, and to assume among the powers of the earth, the separate and equal station to which the Laws of Nature and of Nature's God entitle them, a decent respect to the opinions of mankind requires that they should declare the causes which impel them to the separation.

We hold these truths to be self-evident, that all men are created equal, that they are endowed by their Creator with certain unalienable rights, that among these are life, liberty and the pursuit of happiness. That to secure these rights, governments are instituted among men, deriving their just powers from the consent of the governed. That whenever any form of government becomes destructive of these ends, it is the right of the people to alter or to abolish it, and to institute new government, laying its foundation on such principles and organizing its powers in such form, as to them shall seem most likely to effect their safety and happiness. Prudence, indeed, will dictate that governments long estab-

Figure 13.1 The Declaration of Independence
Photograph courtesy of Range/Bettman

lished should not be changed for light and transient causes; and accordingly all experience hath shown, that mankind are more disposed to suffer, while evils are sufferable, than to right themselves by abolishing the forms to which they are accustomed. But when a long train of abuses and usurpations, pursuing invariably the same object evinces a design to reduce them under absolute despotism, it is their right, it is their duty, to

throw off such government, and to provide new guards for their future security. Such has been the patient sufferance of these Colonies; and such is now the necessity which constrains them to alter their former systems of government. The history of the present King of Great Britain is a history of repeated injuries and usurpations, all having in direct object the establishment of an absolute tyranny over these States. To prove this, let facts be submitted to a candid world.

He has refused his assent to laws, the most wholesome and necessary for the public good.

He has forbidden his Governors to pass laws of immediate and pressing importance, unless suspended in their operation till his assent should be obtained; and when so suspended, he has utterly neglected to attend to them.

He has refused to pass other laws for the accommodation of large districts of people, unless those people would relinquish the right of representation in the Legislature, a right inestimable to them and formidable to tyrants only.

He has called together legislative bodies at places unusual, uncomfortable, and distant from the depository of their public records, for the whole purpose of fatiguing them into compliance with his measures.

He has dissolved representative houses repeatedly, for opposing with manly firmness his invasions on the rights of the people. . . .

He has plundered our seas, ravaged our coasts, burnt our towns, and destroyed the lives of our people.

He is at this time transporting large armies of foreign mercenaries to complete the works of death, desolation and tyranny, already begun with circumstances of cruelty and perfidy scarcely paralleled in the most barbarous ages, and totally unworthy the head of a civilized nation.

He has constrained our fellow citizens taken captive on the high seas to bear arms against their country, to become the executioners of their friends and brethren, or to fall themselves by their hands.

He has excited domestic insurrections amongst us, and has endeavoured to bring on the inhabitants of our frontiers, the merciless Indian savages, whose known rule of warfare, is an undistinguished destruction of all ages, sexes, and conditions.

In every stage of these oppressions we have petitioned for redress in the most humble terms: our repeated petitions have been answered only by repeated injury. A prince whose character is thus marked by every act which may define a tyrant is unfit to be the ruler of a free people.

Nor have we been wanting in attention to our British brethren. We have warned them from time to time of attempts by their legislature to extend an unwarrantable jurisdiction over us. We have reminded them of the circumstances of our emigration and settlement here. We have appealed to their native justice and magnanimity, and we have conjured

them by the ties of our common kindred to disavow these usurpations, which would inevitably interrupt our connections and correspondence. They too have been deaf to the voice of justice and of consanguinity. We must, therefore, aquiesce in the necessity, which denounces our separation, and hold them, as we hold the rest of mankind, enemies in war, in peace friends.

We, therefore, the Representatives of the United States of America, in General Congress assembled, appealing to the Supreme Judge of the world for the rectitude of our intentions, do, in the name, and by authority of the good people of these Colonies, solemnly publish and declare, That these United Colonies are, and of right ought to be Free and Independent States; that they are absolved from all allegiance to the British Crown, and that all political connection between them and the State of Great Britain, is and ought to be totally dissolved; and that as Free and Independent States, they have full power to levy war, conclude peace, contract alliances, establish commerce, and to do all other acts and things which Independent States may of right do. And for the support of this declaration, with a firm reliance on the protection of Divine Providence, we mutually pledge to each other our lives, our fortunes, and our sacred honor.

111 ABRAHAM LINCOLN

The Gettysburg Address (1863)

Fourscore and seven years ago our fathers brought forth, on this continent, a new nation, conceived in Liberty, and dedicated to the proposition that all men are created equal.

Now we are engaged in a great civil war, testing whether that nation, or any nation so conceived, and so dedicated, can long endure. We are met on a great battlefield of that war. We have come to dedicate a portion of that field, as a final resting-place for those who here gave their lives, that that nation might live. It is altogether fitting and proper that we should do this.

But, in a larger sense, we can not dedicate – we can not consecrate – we can not hallow – this ground. The brave men, living and dead, who struggled here, have consecrated it far above our poor power to add or detract. The world will little note, nor long remember what we say here, but it can never forget what they did here. It is for us the living, rather, to be dedicated here to the unfinished work which they who fought here have thus far so nobly advanced. It is rather for us to be here dedicated to the great task remaining before us – that from these honored dead we take increased devotion to that cause for which they here gave the last full measure of devotion – that we here highly resolve that these dead

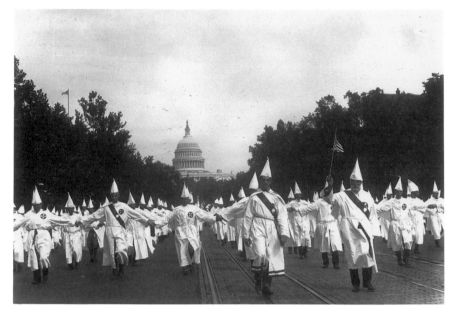

Figure 13.2 Ku Klux Klan parade, Washington D.C., 1925
Photograph courtesy of Range/Bettman/UPI

shall not have died in vain – that this nation, under God, shall have a new birth of freedom – and that government of the people, by the people, for the people, shall not perish from the earth.

112 JOHN MARSHALL HARLAN

FROM Dissenting Opinion in *Plessy* v. *Ferguson* (1896)

The white race deems itself to be the dominant race in this country. And so it is, in prestige, in achievements, in education, in wealth and in power. So, I doubt not, it will continue to be for all time, if it remains true to its great heritage and holds fast to the principles of constitutional liberty. But in view of the Constitution, in the eye of the law, there is in this country no superior, dominant, ruling class of citizens. There is no caste here. Our Constitution is color-blind, and neither knows nor tolerates classes among citizens. In respect of civil rights, all citizens are equal before the law. The humblest is the peer of the most power-ful. The law regards man as man, and takes no account of his surround-ings or of his color when his civil rights as guaranteed by the supreme law of the land are involved. It is, therefore, to be regretted that this high tribunal, the final expositor of the fundamental law of the land, has

reached the conclusion that it is competent for a State to regulate the enjoyment by citizens of their civil rights solely upon the basis of race. . . .

The arbitrary separation of citizens, on the basis of race, while they are on a public highway, is a badge of servitude wholly inconsistent with the civil freedom and the equality before the law established by the Constitution. It cannot be justified upon any legal grounds.

If evils will result from the commingling of the two races upon public highways established for the benefit of all, they will be infinitely less than those that will surely come from state legislation regulating the enjoyment of civil rights upon the basis of race. We boast of the freedom enjoyed by our people above all other peoples. But it is difficult to reconcile that boast with a state of the law which, practically, puts the brand of servitude and degradation upon a large class of our fellow-citizens, our equals before the law. The thin disguise of "equal" accommodations for passengers in railroad coaches will not mislead any one, nor atone for the wrong this day done.

113 LEARNED HAND

FROM "The Spirit of Liberty" (1944)

Liberty lies in the hearts of men and women; when it dies there, no constitution, no law, no court can save it; no constitution, no law, no court can even do much to help it. While it lies there it needs no constitution, no law, no court to save it. And what is this liberty which must lie in the hearts of men and women? It is not the ruthless, the unbridled will; it is not freedom to do as one likes. That is the denial of liberty, and leads straight to its overthrow. A society in which men recognize no check upon their freedom soon becomes a society where freedom is the possession of only a savage few; as we have learned to our sorrow.

What then is the spirit of liberty? I cannot define it; I can only tell you my own faith. The spirit of liberty is the spirit which is not too sure that it is right; the spirit of liberty is the spirit which seeks to understand the minds of other men and women; the spirit of liberty is the spirit which weighs their interests alongside its own without bias; the spirit of liberty remembers that not even a sparrow falls to earth unheeded; the spirit of liberty is the spirit of Him who, near two thousand years ago, taught mankind that lesson it has never learned, but has never quite forgotten; that there may be a kingdom where the least shall be heard and considered side by side with the greatest. And now in that spirit, that spirit of an America which has never been, and which may never be; nay, which never will be except as the conscience and courage of Americans

create it; yet in the spirit of that America which lies hidden in some form in the aspirations of us all; in the spirit of that America for which our young men are at this moment fighting and dying; in that spirit of liberty and of America I ask you to rise and with me pledge our faith in the glorious destiny of our beloved country.

114 WILLIAM JAMES

FROM *Pragmatism* (1907)

The pragmatic method is primarily a method of settling metaphysical disputes that otherwise might be interminable. Is the world one or many? – fated or free? – material or spiritual? – here are notions either of which may or may not hold good of the world; and disputes over such notions are unending. The pragmatic method in such cases is to try to interpret each notion by tracing its respective practical consequences. What difference would it practically make to any one if this notion rather than that notion were true? If no practical difference whatever can be traced, then the alternatives mean practically the same thing, and all dispute is idle. Whenever a dispute is serious, we ought to be able to show some practical difference that must follow from one side or the other's being right.

A glance at the history of the idea will show you still better what pragmatism means. The term is derived from the same Greek word πραγμα, meaning action, from which our words "practice" and "practical" come. It was first introduced into philosophy by Mr. Charles Peirce in 1878. In an article entitled "How to Make Our Ideas Clear," in the "Popular Science Monthly" for January of that year, Mr. Peirce, after pointing out that our beliefs are really rules for action, said that, to develop a thought's meaning, we need only determine what conduct it is fitted to produce: that conduct is for us its sole significance. And the tangible fact at the root of all our thought-distinctions, however subtle, is that there is no one of them so fine as to consist in anything but a possible difference of practice. To attain perfect clearness in our thoughts of an object, then, we need only consider what conceivable effects of a practical kind the object may involve – what sensations we are to expect from it, and what reactions we must prepare. . . .

It is astonishing to see how many philosophical disputes collapse into insignificance the moment you subject them to this simple test of tracing a concrete consequence. There can *be* no difference anywhere that doesn't *make* a difference elsewhere – no difference in abstract truth that doesn't express itself in a difference in concrete fact and in conduct consequent upon that fact, imposed on somebody, somehow, somewhere, and somewhen. The whole function of philosophy ought to be

to find out what definite difference it will make to you and me, at definite instants of our life, if this world-formula or that world-formula be the true one. . . .

Pragmatism represents a perfectly familiar attitude in philosophy, the empiricist attitude, but it represents it, as it seems to me, both in a more radical and in a less objectionable form than it has ever yet assumed. A pragmatist turns his back resolutely and once for all upon a lot of inveterate habits dear to professional philosophers. He turns away from abstraction and insufficiency, from verbal solutions, from bad *a priori* reasons, from fixed principles, closed systems, and pretended absolutes and origins. He turns towards concreteness and adequacy, towards facts, towards action and towards power. That means the empiricist temper regnant and the rationalist temper sincerely given up. It means the open air and possibilities of nature, as against dogma, artificiality, and the pretence of finality in truth.

At the same time it does not stand for any special results. It is a method only. But the general triumph of that method would mean an enormous change in what I called in my last lecture the "temperament" of philosophy. Teachers of the ultra-rationalistic type would be frozen out, much as the courtier type is frozen out in republics, as the ultra-montane type of priest is frozen out in protestant lands. Science and metaphysics would come much nearer together, would in fact work absolutely hand in hand. . . .

Theories thus become instruments, not answers to enigmas, in which we can rest. We don't lie back upon them, we move forward, and, on occasion, make nature over again by their aid. Pragmatism unstiffens all our theories, limbers them up and sets each one at work. Being nothing essentially new, it harmonizes with many ancient philosophic tendencies. It agrees with nominalism for instance, in always appealing to particulars; with utilitarianism in emphasizing practical aspects; with positivism in its disdain for verbal solutions, useless questions and metaphysical abstractions.

115 JANE ADDAMS

FROM *Twenty Years at Hull House* (1910)

The Ethical Culture Societies held a summer school at Plymouth, Massachusetts, in 1892, to which they invited several people representing the then new Settlement movement, that they might discuss with others the general theme of Philanthropy and Social Progress.

I venture to produce here parts of a lecture I delivered in Plymouth, both because I have found it impossible to formulate with the same freshness those early motives and strivings, and because, when published

with other papers given that summer, it was received by the Settlement
people themselves as a satisfactory statement. . . :

In a thousand voices singing the Hallelujah Chorus in Handel's
"Messiah," it is possible to distinguish the leading voices, but the
differences of training and cultivation between them and the voices
of the chorus, are lost in the unity of purpose and in the fact that they
are all human voices lifted by a high motive. This is a weak illus-
tration of what a Settlement attempts to do. It aims, in a measure, to
develop whatever of social life its neighborhood may afford, to focus
and give form to that life, to bring to bear upon it the results of
cultivation and training; but it receives in exchange for the music of
isolated voices the volume and strength of the chorus. It is quite
impossible for me to say in what proportion or degree the subjective
necessity which led to the opening of Hull-House combined the
three trends: first, the desire to interpret democracy in social
terms; secondly, the impulse beating at the very source of our lives,
urging us to aid in the race progress; and, thirdly, the Christian
movement toward humanitarianism. It is difficult to analyze a living
thing; the analysis is at best imperfect. Many more motives may
blend with the three trends; possibly the desire for a new form of
social success due to the nicety of imagination, which refuses worldly
pleasures unmixed with the joys of self-sacrifice; possibly a love of
approbation, so vast that it is not content with the treble clapping of
delicate hands, but wishes also to hear the bass notes from toughened
palms, may mingle with these.

The Settlement, then, is an experimental effort to aid in the
solution of the social and industrial problems which are engendered
by the modern conditions of life in a great city. It insists that these
problems are not confined to any one portion of a city. It is an
attempt to relieve, at the same time, the overaccumulation at one
end of society and the destitution at the other; but it assumes that this
overaccumulation and destitution is most sorely felt in the things that
pertain to social and educational advantages. From its very nature it
can stand for no political or social propaganda. It must, in a sense,
give the warm welcome of an inn to all such propaganda, if per-
chance one of them be found an angel. The one thing to be dreaded
in the Settlement is that it lose its flexibility, its power of quick
adaptation, its readiness to change its methods as its environment
may demand. It must be open to conviction and must have a deep
and abiding sense of tolerance. It must be hospitable and ready for
experiment. It should demand from its residents a scientific patience
in the accumulation of facts and the steady holding of their sym-
pathies as one of the best instruments for that accumulation. It must

372

be grounded in a philosophy whose foundation is on the solidarity of the human race, a philosophy which will not waver when the race happens to be represented by a drunken woman or an idiot boy. Its residents must be emptied of all conceit of opinion and all self-assertion, and ready to arouse and interpret the public opinion of their neighborhood. They must be content to live quietly side by side with their neighbors, until they grow into a sense of relationship and mutual interests. Their neighbors are held apart by differences of race and language which the residents can more easily overcome. They are bound to see the needs of their neighborhood as a whole, to furnish data for legislation, and to use their influence to secure it. In short, residents are pledged to devote themselves to the duties of good citizenship and to the arousing of the social energies which too largely lie dormant in every neighborhood given over to industrialism. They are bound to regard the entire life of their city as organic, to make an effort to unify it, and to protest against its over-differentiation.

It is always easy to make all philosophy point one particular moral and all history adorn one particular tale; but I may be forgiven the reminder that the best speculative philosophy sets forth the solidarity of the human race; that the highest moralists have taught that without the advance and improvement of the whole, no man can hope for any lasting improvement in his own moral or material individual condition; and that the subjective necessity for Social Settlements is therefore identical with that necessity, which urges us on toward social and individual salvation.

116 WOODROW WILSON

FROM First Inaugural Address (1913)

There has been a change of government. It began two years ago, when the House of Representatives became Democratic by a decisive majority. It has now been completed. The Senate about to assemble will also be Democratic. The offices of President and Vice-President have been put into the hands of Democrats. What does the change mean? That is the question that is uppermost in our minds today. That is the question I am going to try to answer in order, if I may, to interpret the occasion.

It means much more than the mere success of a party. The success of a party means little except when the nation is using that party for a large and definite purpose. No one can mistake the purpose for which the nation now seeks to use the Democratic Party. It seeks to use it to interpret a change in its own plans and point of view. . . .

We see that in many things that life is very great. It is incomparably great in its material aspects, in its body of wealth, in the diversity and sweep of its energy, in the industries which have been conceived and built up by the genius of individual men and the limitless enterprise of groups of men. It is great, also, very great, in its moral force. Nowhere else in the world have noble men and women exhibited in more striking forms the beauty and the energy of sympathy and helpfulness and counsel in their efforts to rectify wrong, alleviate suffering, and set the weak in the way of strength and hope. We have built up, moreover, a great system of government, which has stood through a long age as in many respects a model for those who seek to set liberty upon foundations that will endure against fortuitous change, against storm and accident. Our life contains every great thing, and contains it in rich abundance.

But the evil has come with the good, and much fine gold has been corroded. With riches has come inexcusable waste. We have squandered a great part of what we might have used and have not stopped to conserve the exceeding bounty of nature, without which our genius for enterprise would have been worthless and impotent, scorning to be careful, shamefully prodigal as well as admirably efficient. We have been proud of our industrial achievements, but we have not hitherto stopped thoughtfully enough to count the human cost, the cost of lives snuffed out, of energies overtaxed and broken, the fearful physical and spiritual cost to the men and women and children upon whom the dead weight and burden of it all has fallen pitilessly the years through. The groans and agony of it all had not yet reached our ears, the solemn, moving undertone of our life, coming up out of the mines and factories and out of every home where the struggle had its intimate and familiar seat. With the great government went many deep secret things which we too long delayed to look into and scrutinize with candid, fearless eyes. The great government we loved has too often been made use of for private and selfish purposes, and those who used it had forgotten the people.

At last a vision has been vouchsafed us of our life as a whole. We see the bad with the good, the debased and decadent with the sound and vital. With this vision we approach new affairs. Our duty is to cleanse, to reconsider, to restore, to correct the evil without impairing the good, to purify and humanize every process of our common life without weakening or sentimentalizing it.

There has been something crude and heartless and unfeeling in our haste to succeed and be great. Our thought has been "Let every man look out for himself, let every generation look out for itself," while we reared giant machinery which made it impossible that any but those who stood at the levers of control should have a chance to look out for themselves. We had not forgotten our morals. We remembered well

enough that we had set up a policy which was meant to serve the humblest as well as the most powerful, with an eye single to the standards of justice and fair play, and remembered it with pride. But we were very heedless and in a hurry to be great.

We have now come to the sober second thought. The scales of heedlessness have fallen from our eyes. We have made up our minds to square every process of our national life again with the standards we so proudly set up at the beginning and have always carried at our hearts. Our work is a work of restoration.

117 WILLIAM J. CLINTON

FROM Address on the State of the Union, 1994

You know, the First Lady has received now almost a million letters from people all across America and from all walks of life. I'd like to share just one of them with you. Richard Anderson of Reno, Nevada, lost his job and with it, his health insurance. Two weeks later his wife, Judy, suffered a cerebral aneurysm. He rushed her to the hospital, where she stayed in intensive care for 21 days. The Andersons' bills were over $120,000. Although Judy recovered and Richard went back to work at $8 an hour, the bills were too much for them, and they were literally forced into bankruptcy. "Mrs. Clinton," he wrote to Hillary, "no one in the United States of America should have to lose everything they've worked for all their lives because they were unfortunate enough to become ill." It was to help the Richard and Judy Andersons of America that the First Lady and so many others have worked so hard and so long on this health care reform issue. We owe them our thanks and our action.

I know there are people here who say there's no health care crisis. Tell it to Richard and Judy Anderson. Tell it to the 58 million Americans who have no coverage at all for some time each year. Tell it to the 81 million Americans with those preexisting conditions. Those folks are paying more, or they can't get insurance at all. Or they can't ever change their jobs because they or someone in their family has one of those preexisting conditons. Tell it to the small businesses burdened by the skyrocketing cost of insurance. Most small businesses cover their employees, and they pay on average 35 percent more in premiums than big businesses or Government. Or tell it to the 76 percent of insured Americans, three out of four whose policies have lifetime limits. And that means they can find themselves without any coverage at all just when they need it the most. So if any of you believe there's no crisis, you tell it to those people, because I can't. . . .

What does it mean? It means every night millions of well-insured Americans go to bed just an illness, an accident, or a pink slip away

from having no coverage or financial ruin. It means every morning millions of Americans go to work without any health insurance at all, something the workers in no other advanced country in the world do. It means that every year, more and more hard-working people are told to pick a new doctor because their boss has had to pick a new plan. And countless others turn down better jobs because they know if they take the better job, they will lose their health insurance. If we just let the health care system continue to drift, our country will have people with less care, fewer choices, and higher bills. . . .

I want to make this very clear. I am open, as I have said repeatedly, to the best ideas of concerned Members of both parties. I have no special brief for any specific approach, even in our own bill, except this: If you send me legislation that does not guarantee every American private health insurance that can never be taken away, you will force me to take this pen, veto the legislation, and we'll come right back here and start all over again.

118 FREDERICK JACKSON TURNER

FROM "The Significance of the Frontier in American History" (1893)

At first, the frontier was the Atlantic coast. It was the frontier of Europe in a very real sense. Moving westward, the frontier became more and more American. *As successive terminal moraines result from successive glaciations, so each frontier leaves its traces behind it, and when it becomes a settled area the region still partakes of the frontier characteristics.* Thus the advance of the frontier has meant a steady movement away from the influence of Europe, a steady growth of independence on American lines. And to study this advance, the men who grew up under these conditions, and the political, economic and social results of it, is to study the really American part of our history. . . .

But the most important effect of the frontier has been in the promotion of democracy here and in Europe. As has been pointed out, the frontier is productive of individualism. Complex society is precipitated by the wilderness into a kind of primitive organization based on the family. The tendency is anti-social. It produces antipathy to control, and particularly to any direct control. The tax-gatherer is viewed as a representative of oppression. Professor Osgood, in an able article, has pointed out that the frontier conditions prevalent in the colonies are important factors in the explanation of the American revolution, where individual liberty was sometimes confused with absence of all effective government. The same conditions aid in explaining the difficulty of

instituting a strong government in the period of the confederacy. The frontier individualism has from the beginning promoted democracy. . . .

From the conditions of frontier life came intellectual traits of profound importance. The works of travellers along each frontier from colonial days onward describe for each certain traits, and these traits have, while softening down, still persisted as survivals in the place of their origin, even when a higher social organization succeeded. The result is that to the frontier the American intellect owes its striking characteristics. That coarseness and strength combined with acuteness and inquisitiveness, that practical, inventive turn of mind, quick to find expedients, that masterful grasp of material things, lacking in the artistic but powerful to effect great ends, that restless, nervous energy, that dominant individualism, working for good and for evil, and withal that buoyancy and exuberance which comes with freedom – these are traits of the frontier, or traits called out elsewhere because of the existence of the frontier. Since the days when the fleet of Columbus sailed into the waters of the New World, America has been another name for opportunity, and the people of the United States have taken their tone from the incessant expansion which has not only been open but has even been forced upon them.

119 THEODORE ROOSEVELT

FROM "The Strenuous Life" (1899)

In speaking to you, men of the greatest city of the West, men of the State which gave to the country Lincoln and Grant, men who preeminently and distinctly embody all that is most American in the American character, I wish to preach, not the doctrine of ignoble ease, but the doctrine of the strenuous life, the life of toil and effort, of labor and strife; to preach that highest form of success which comes, not to the man who desires mere easy peace, but to the man who does not shrink from danger, from hardship, or from bitter toil, and who out of these wins the splendid ultimate triumph.

A life of slothful ease, a life of that peace which springs merely from lack either of desire or of power to strive after great things, is as little worthy of a nation as of an individual. I ask only that what every self-respecting American demands from himself and from his sons shall be demanded of the American nation as a whole. Who among you would teach your boys that ease, that peace, is to be the first consideration in their eyes – to be the ultimate goal after which they strive? You men of Chicago have made this city great, you men of Illinois have done your share, and more than your share, in making America great, because you neither preach nor practice such a doctrine. You work yourselves, and

you bring up your sons to work. If you are rich and are worth your salt, you will teach your sons that though they may have leisure, it is not to be spent in idleness; for wisely used leisure merely means that those who possess it, being free from the necessity of working for their livelihood, are all the more bound to carry on some kind of non-remunerative work in science, in letters, in art, in exploration, in historical research – work of the type we most need in this country, the successful carrying out of which reflects most honor upon the nation. We do not admire the man of timid peace. We admire the man who embodies victorious effort; the man who never wrongs his neighbor, who is prompt to help a friend, but who has those virile qualities necessary to win in the stern strife of actual life. It is hard to fail, but it is worse never to have tried to succeed. In this life we get nothing save by effort. A mere life of ease is not in the end a very satisfactory life, and, above all, it is a life which ultimately unfits those who follow it for serious work in the world.

In the last analysis a healthy state can exist only when the men and women who make it up lead clean, vigorous, healthy lives; when the children are so trained that they shall endeavor, not to shirk difficulties, but to overcome them; not to seek ease, but to know how to wrest triumph from toil and risk. The man must be glad to do a man's work, to dare and endure and to labor, to keep himself, and to keep those dependent upon him. The woman must be the housewife, the helpmeet of the homemaker, the wise and fearless mother of many healthy children. In one of Daudet's powerful and melancholy books he speaks of "the fear of maternity, the haunting terror of the young wife of the present day." When such words can be truthfully written of a nation, that nation is rotten to the heart's core. When men fear work or fear righteous war, when women fear motherhood, they tremble on the brink of doom; and well it is that they should vanish from the earth, where they are fit subjects for the scorn of all men and women who are themselves strong and brave and high-minded.

120 STUDS TERKEL

FROM "Jay Slabough, 48" (Interview with a Corporate Executive, 1980)

I sometimes think of myself as a hired gun. I come into a company and correct the problem, then go on to another company. . . .

You must be aggressive. I've always had the feeling that if you don't go up, you go down. Nothing ever stays the same. You get better and bigger, or you go the other way.

My feeling is everybody in business is against you. Everybody in the world is against you. Your people are against you because they want

more money for less hours than you can afford to pay them. Your suppliers are against you because they want more money for the product than you can afford to give them. Your customers are against you because they want your product for less money than you can afford to sell it. The city is against you because they want to tax you more. The federal government is against you because they want to control you more. The parent company is against you because they want to take more cash out of your operation and don't want to put the cash investment into it. When anybody gets in the way of your being a vital, growing force in the economy, they're hurting themselves and everybody around them.

Let's face it. If we don't grow and get more profit, there isn't more money for raises, there aren't promotions for people. If you don't grow, you don't buy more products from your suppliers. You don't have new machines, so you don't give more and better products to your customers. There's not more income for the government to tax. I can make a case of hurting God because there isn't more money for the collection plate. (Laughs.)

The American Dream is to be better off than you are. How much money is "enough money"? "Enough money" is always a little bit more than you have. There's never enough of anything. This is why people go on. If there was enough, everybody would stop. You always go for the brass ring that's always out there about a hundred yards farther. It's like a mirage in the desert: it always stays about a hundred yards ahead of you.

If I had more, if the company had more, I could accomplish much more. I could do more good for the economy. You must go for more – for faster, for better. If you're not getting better and faster, you're getting worse.

(Reflectively) Growth – better – faster. I guess that's my one big vice. I feel a very heavy sense of compulsion, a sense of urgency. When I get in a car, I also feel it. I drive much too fast. I'm always moving.

121 RONALD REAGAN

FROM Address on the State of the Union, 1986

I have come to review with you the progress of our nation, to speak of unfinished work, and to set our sights on the future. I am pleased to report the state of our Union is stronger than a year ago and growing stronger each day. Tonight we look out on a rising America, firm of heart, united in spirit, powerful in pride and patriotism. America is on the move! But it wasn't long ago that we looked out on a different land: locked factory gates, long gasoline lines, intolerable prices, and interest

rates turning the greatest country on Earth into a land of broken dreams. Government growing beyond our consent had become a lumbering giant, slamming shut the gates of opportunity, threatening to crush the very roots of our freedom. What brought America back? The American people brought us back with quiet courage and common sense, with undying faith that in this nation under God the future will be ours; for the future belongs to the free.

Tonight the American people deserve our thanks for 37 straight months of economic growth, for sunrise firms and modernized industries creating 9 million new jobs in 3 years, interest rates cut in half, inflation falling over from 12 percent in 1980 to under 4 today, and a mighty river of good works – a record $74 billion in voluntary giving just last year alone. And despite the pressures of our modern world, family and community remain the moral core of our society, guardians of our values and hopes for the future. Family and community are the costars of this great American comeback. They are why we say tonight: Private values must be at the heart of public policies.

What is true for families in America is true for America in the family of free nations. History is no captive of some inevitable force. History is made by men and women of vision and courage. Tonight freedom is on the march. The United States is the economic miracle, the model to which the world once again turns.

122 RUSH H. LIMBAUGH, III

FROM *See, I Told You So* (1993)

You hold in your hot little hands, my friends, America's next great publishing milestone. Soon, *See, I Told You So* will eclipse all publishing records known in the English-speaking world – most of which, by the way, were set by my first tome, *The Way Things Ought to Be*.

But this book was never supposed to be. In fact, the conventional wisdom was that after the 1992 election, I was just going to fade away into obscurity – a relic of a Republican era of greed and selfishness. They said there would be no room for me in the Age of Compassion that would assuredly be dawning come January 20, 1993.

Well, once again, the "experts" were wrong. Dead wrong. Not only did the Rush Limbaugh radio program soar to new, previously uncharted heights in the annals of Marconi's invention, but my television show also became the nation's hottest new late-night program. *The Limbaugh Letter*, my stellar journal of opinion, became what is arguably the most successful start-up publication in history. . . .

Our country is inherently evil. The whole idea of America is corrupt. The history of this nation is strewn with examples of oppression and genocide. The story of the

United States is cultural imperialism – how a bunch of repressed white men imposed their will and values on peaceful indigenous people, black slaves from Africa, and women.

No, don't worry. Rush has not become a commie-lib. The paragraph above, though, does summarize what is being taught today about American history on the average college or university campus. Why? What makes the education establishment so hostile to America? Because, in the last twenty-five years, a relatively small, angry group of anti-American radicals have bullied their way into power positions in academia. And while they preach about the evils of "cultural imperialism," they themselves are, ironically, the ultimate practitioners of it.

The indoctrination taking place today in American academia is disingenuously disguised as "multiculturalism" by its academic purveyors. A more accurate description would be "politically motivated historical and cultural distortion." It is a primitive type of historical revisionism. . . .

Let's start at the beginning with America's first important dead white male – Christopher Columbus. The politically correct view of old Chris today is that the Italian explorer did not actually discover America, because people were already living here. And, more important, he brought nothing to the peaceful New World "paradise" but oppression, disease, brutality, and genocide.

First of all, let me state something unequivocally: **Columbus really did discover America**. By making that claim, I am obviously not suggesting that no human being had set foot on the continent before 1492. But there can be no denying that Columbus was the person who brought America to the attention of the technologically advanced, civilized world and paved the way for the expansion of Western civilization (what a horrifying thought). . . .

This brings us to our Founding Fathers – the geniuses who crafted the Declaration of Independence and the U.S. Constitution. These were men who shook up the entire world by proclaiming the idea that people had certain God-given freedoms and rights and that the government's only raison d'être was to protect those freedoms and rights from both internal and external forces. That simple yet brilliant insight has been all but lost today in liberalism's relentless march toward bigger, more powerful, more intrusive government.

Don't believe the conventional wisdom of our day that claims these men were anything but orthodox, Bible-believing Christians. They were. And they were quite adamant in stating that the Constitution – as brilliant a document as it is – would work only in the context of a moral society.

"Our Constitution was made for a moral and religious people," stated second president John Adams. "It is wholly inadequate for the governance of any other."

George Washington, the father of our country, was of like mind. He said: "Of all the dispositions and habits that lead to political prosperity, religion and morality are indispensable supports."

James Madison, primary author of the Constitution, agreed: "We have staked the whole future of the American civilization, not upon the power of government, far from it. We have staked the future . . . upon the capacity of each and all of us to govern ourselves, to control ourselves, to sustain ourselves, according to the Ten Commandments of God." . . .

You can't fully appreciate how screwed up modern liberalism is without contrasting its vision (or lack thereof) with the broad view of our nation's founders. Americans throughout history – from the earliest settlers to the generation that fought World War II – have always understood and accepted sacrifice. They intuitively knew there were things worth dying for.

The early pioneers tamed a wilderness. Nothing was handed to them. And they sought only freedom and a better life for their children. Today, government is taking away our freedom and mortgaging with debt the future lives of our children. But not to worry. Government is more than willing to provide you with food stamps, welfare payments, unemployment benefits, day care, socialized medicine, free condoms, subsidized abortions – you name it. Can't you see how the vision has been turned upside down?

The founders knew they were bestowing upon us only an ingenious political system of checks and balances, limited government, and a legacy of human and civil rights. It would be up to future generations to make it all work. But it would only work, they warned (reread the quotes from Adams, Washington, and Madison . . .), if the society was girded on a bedrock of solid values and Judeo-Christian principles.

Where and how did we lose our moorings? With such a great start, why did we allow liberalism, moral relativism, and secular humanism to poison our nation's soul? And what can we do to recapture the original American spirit of freedom and individualism?

123 EARNEST ELMO CALKINS

FROM "Business Has Wings" (1927)

The three forces, then, which are injecting into the conduct of business a new hazard are fashion, new ideas, and changing habits; but what makes them formidable is the speed with which they spread and the unanimity with which they are adopted. Advertising is responsible for both the speed and the unanimity. The continuing body of advertising has produced a receptive state of mind. Advertising is accessory before the fact as well as after. It has created a public, almost coextensive with the population of the country, that reveals an amazing willingness to adopt

anything, or, to put it more emphatically, a determination not to be left behind – a sort of mad scramble to have, do, and be whatever is popular at the moment. The individualist is apt to be lonely.

The manufacturer, whatever he may make, however basic and staple, however well entrenched in the homes of the country, can no longer settle down and let things take their course. He must now hold himself ready to act and act quickly, interpret the signs, anticipate the new attitude of the public, analyze each new invention or discovery for its effects, immediate or ultimate, on his own business. He must sleep like a fireman, fully dressed, ready to dash out at a moment's notice. . . .

The fluid condition of business, the possibilities it offers of new combinations, the promptness with which the public accepts and applies everything offered to it, from filling stations to nonfiction books, – creating a new social structure as it drifts from camp to camp in its flivver, but making a best seller of a book about philosophy, – invite and tempt the new type of advertising man. Advertising in its narrow sense is but the door through which he enters a world where anything may happen, and no dream seems too fantastic to be realized. No wonder all the sad young men are deserting literature to become advertising experts.

Consider the discussion that has gone on for years about those periods of depression known as hard times. It was believed that they were inevitable, that business moved in cycles, that the pendulum must swing back, that action must produce reaction. Yet it has been realized for a long time that such periods are due to states of mind, when for some mysterious reason everyone becomes apprehensive, stops buying, ceases to act as one who believes in the continuance of prosperity. The thought spreads from mind to mind, weak businesses fail, banks call their loans, sales fall off, and everybody gives and receives the impression that business is not good – and it is not.

Today the most pessimistic cannot ignore the signs of prosperity. The business world is saying, "Every day and in every way business is growing better," and paying to say it. At the close of 1926, Cyrus Curtis employed a page advertisement in numerous newspapers to announce that more space has been booked for 1927 in his three publications than ever before in their history. A manufacturer has stated that he will spend in advertising, this year, the stupendous appropriation of twenty-five million dollars. Such incidents as these are more than indices of prosperity. They are guaranties that prosperity will be produced. They are causes rather than effects, but they reflect the belief of men who back their belief with their money, and by so doing make their belief come true. We have realized at last that prosperity is not merely wealth, or goods, or high wages. It is money in action, exchanged for goods. Securing prosperity by advertising for it is at least as certain as securing

any other concerted action by the same means. When everybody is pessimistic, business is bad. When everybody is optimistic, business is good. Business continues to be good as long as people think it is. If they can be made to continue to think it is, as they have been made to think

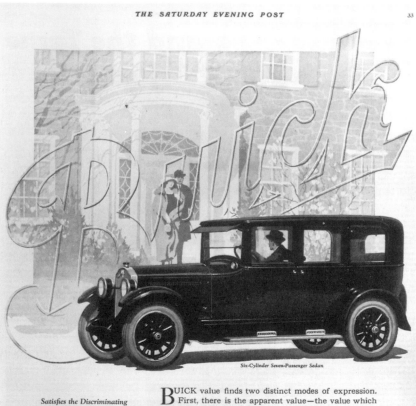

Figure 13.3 Advertisement for Buick motor cars, 1924
Reprinted by permission of the General Motors Corporation

they want motor cars or silk stockings, then business cycles of alternating good and bad times are as obsolete as bicycles.

124 DALE CARNEGIE

FROM How to Win Friends and Influence People (1936)

Actions speak louder than words, and a smile says, "I like you. You make me happy. I am glad to see you."

That is why dogs make such a hit. They are so glad to see us that they almost jump out of their skins. So, naturally, we are glad to see them.

An insincere grin? No. That doesn't fool anybody. We know it is mechanical and we resent it. I am talking about a real smile, a heartwarming smile, a smile that comes from within, the kind of a smile that will bring a good price in the market place.

The employment manager of a large New York department store told me he would rather hire a sales girl who hadn't finished grade school, if she had a lovely smile, than hire a doctor of philosophy with a sober face. . . .

You don't feel like smiling? Then what? Two things. First, force yourself to smile. If you are alone, force yourself to whistle or hum a tune or sing. Act as if you were already happy, and that will tend to make you happy. Here is the way the late Professor William James of Harvard put it:

"Action seems to follow feeling, but really action and feeling go together, and by regulating the action, which is under the more direct control of the will, we can indirectly regulate the feeling, which is not.

"Thus the sovereign voluntary path to cheerfulness, if our cheerfulness be lost, is to sit up cheerfully and to act and speak as if cheerfulness were already there. . . . "

Everybody in the world is seeking happiness – and there is one sure way to find it. That is by controlling your thoughts. Happiness doesn't depend on outward conditions. It depends on inner conditions.

It isn't what you have or who you are or where you are or what you are doing that makes you happy or unhappy. It is what you think about it. For example, two people may be in the same place, doing the same thing; both may have about an equal amount of money and prestige – and yet one may be miserable and the other happy. Why? Because of a different mental attitude. I saw just as many happy faces among the Chinese coolies sweating and toiling in the devastating heat of China for seven cents a day as I see on Park Avenue.

"Nothing is good or bad," said Shakespeare, "but thinking makes it so."

Abe Lincoln once remarked that "most folks are about as happy as they make up their minds to be." He was right. . . .

Franklin Bettger, former third baseman for the St. Louis Cardinals, and now one of the most successful insurance men in America, told me that he figured out years ago that a man with a smile is always welcome. So, before entering a man's office, he always pauses for an instant and thinks of the many things he has to be thankful for, works up a great big honest-to-goodness smile, and then enters the room with the smile just vanishing from his face.

This simple technique, he believes, has had much to do with his extraordinary success in selling insurance. . . .

IN A NUTSHELL

Six Ways to Make People Like You

RULE 1: Become genuinely interested in other people.

RULE 2: Smile.

RULE 3: Remember that a man's name is to him the sweetest and most important sound in any language.

RULE 4: Be a good listener. Encourage others to talk about themselves.

RULE 5: Talk in terms of the other man's interest.

RULE 6: Make the other person feel important – and do it sincerely.

125 MALVINA REYNOLDS

"Little Boxes" (1962)

Little boxes on the hillside, little boxes made
 of ticky tacky
Little boxes on the hillside, little boxes all the
 same
There's a green one and a pink one and a blue
 one and a yellow one
And they're all made out of ticky tacky and
 they all look just the same.

And the people in the houses
All went to the university,
Where they were put in boxes
And they came out all the same,
And there's doctors and there's lawyers,
And business executives,
And they're all made out of ticky tacky
And they all look just the same.

And they all play on the golf course
And drink their martinis dry,
And they all have pretty children
And the children go to school,
And the children go to summer camp
And then to the university,
Where they are put in boxes and they come
 out all the same.

And the boys go into business
and marry and raise a family
In boxes made of ticky tacky
And they all look just the same.

126 DAVID WATSON

"Civilization is Like a Jetliner" (1983)

Civilization is like a jetliner, noisy, burning up enormous amounts of fuel. Every imaginable and unimaginable crime and pollution had to be committed in order to make it go. Whole species were rendered extinct, whole populations dispersed. Its shadow on the waters resembles an oil slick. Birds are sucked into its jets and vaporized. Every part – as Gus Grissom once nervously remarked about space capsules before he was burned up in one – has been made by the lowest bidder.

Civilization is like a 747, the filtered air, the muzak oozing over the earphones, the phony sense of security, the chemical food, the plastic trays, all the passengers sitting passively in the orderly row of padded seats staring at Death on the movie screen. Civilization is like a jetliner, an idiot savant in the cockpit manipulating computerized controls built by sullen wage workers, and dependent for his directions on sleepy technicians high on amphetamines with their minds wandering to sports and sex.

Civilization is like a 747, filled beyond capacity with coerced volunteers – some in love with the velocity, most wavering at the abyss of terror and nausea, yet still seduced by advertising and propaganda. It is like a DC–10, so incredibly enclosed that you want to break through the tin can walls and escape, make your own way through the clouds, and leave this rattling, screaming fiend approaching its breaking point. The smallest error or technical failure leads to catastrophe, scattering your sad entrails like belated omens all over the runway; knocks you out of your shoes, breaks all your bones like egg shells.

(Of course, civilization is like many other things besides jets – always *things* – a chemical drainage ditch, a woodland knocked down to

387

lengthen an airstrip or to build a slick new shopping mall where people can buy salad bowls made out of exotic tropical trees which will be extinct next week, or perhaps a graveyard for cars, or a suspension bridge which collapses because a single metal pin has shaken loose. Civilization is a hydra. There is a multitude of styles, colors, and sizes of Death to choose from.)

Civilization is like a Boeing jumbo jet because it transports people who have never experienced their humanity where they were to places where they shouldn't go. In fact it mainly transports businessmen in suits with briefcases filled with charts, contracts, more mischief – businessmen who are identical everywhere and hence have no reason at all to be ferried about. And it goes faster and faster, turning more and more places into airports, the (un)natural habitat of businessmen.

It is an utter mystery how it gets off the ground. It rolls down the runway, the blinking lights along the ground like electronic scar tissue on the flesh of the earth, picks up speed and somehow grunts, raping the air, working its way up along the shimmering waves of heat and the trash blowing about like refugees fleeing the bombing of a city. Yes, it is exciting, a mystery, when life has been evacuated and the very stones have been murdered.

But civilization, like the jetliner, this freak phoenix incapable of rising from its ashes, also collapses across the earth like a million bursting wasps, flames spreading across the runway in tentacles of gasoline, samsonite, and charred flesh. And always the absurd rubbish, Death's confetti, the fragments left to mock us lying along the weary trajectory of the dying bird – the doll's head, the shoes, eyeglasses, a beltbuckle.

Jetliners fall, civilizations fall, this civilization will fall. The gauges will be read wrong on some snowy day (perhaps they will fail). The wings, supposedly defrosted, will be too frozen to beat against the wind and the bird will sink like a millstone, first gratuitously skimming a bridge (because civilization is also like a bridge, from Paradise to Nowhere), a bridge laden, say, with commuters on their way to or from work, which is to say, to or from an airport, packed in their cars (wingless jetliners) like additional votive offerings to a ravenous Medusa.

Then it will dive into the icy waters of a river, the Potomac perhaps, or the River Jordan, or Lethe. And we will be inside, each one of us at our specially assigned porthole, going down for the last time, like dolls' heads encased in plexiglass.

SOURCES

1 NATIVE AMERICANS

1 Thomas Jefferson, "Confidential Message to Congress" (1803). *Encyclopaedia Britannica, The Annals of America*, IV, Chicago, *Encyclopaedia Britannica*, 1968, pp. 158–60
2 Tecumseh, "We All Belong to One Family" (1810). J. D. Hunter, "Memoirs of a Captivity among the Indians of North America" (1924), in P. Nabokov (ed.), *Native American Testimony*, 1978. Reprinted in *The Harper American Literature*, Vol. 1, New York, Harper and Row, 1978, pp. 723–4
3 Tecumseh, "Sell a Country? Why Not Sell the Air?" (1810–11). Frederick W. Turner, III (ed.), *The Portable North American Indian Reader*, New York and London, Penguin, 1977, pp. 245–7
4 Seattle, "The Dead are Not Powerless" (1854). Frederick W. Turner, III (ed.), *The Portable North American Indian Reader*, New York and London, Penguin, 1977, pp. 251–3
5 Helen Hunt Jackson, "A Tale of the Wrongs." *A Century of Dishonor: The Early Crusade for Indian Reform* (1881). Extract reprinted from Diane Ravitch (ed.), *The American Reader: Words That Moved a Nation*, New York, Harper Collins, 1990, pp. 167–9
6 John Collier, "Full Indian Democracy" (1943). "Commissioner Collier's Views," in Edward H. Spicer, *A Short History of the Indians of the United States*, New York, D. Van Nostrand, 1969, pp. 247–8.
7 Buffy Sainte-Marie, "My Country." *The Buffy Sainte-Marie Songbook*, New York, Grosset and Dunlap, 1971. Reprinted in H. H. Høyrup and I. N. Madsen (eds), *Red Indians: The First Americans*, Copenhagen, Munksgaard, 1974, pp. 62–3
8 Leslie Silko, "The Man to Send Rain Clouds" (1969). Kenneth Rosen (ed.), *The Man to Send Rain Clouds: Contemporary Stories by American Indians*, New York, Random House, 1975, pp. 3–8
9 Studs Terkel, "Girl of the Golden West: Ramona Bennett." *American Dreams: Lost and Found*, New York, Ballantine Books, 1980, pp. 189–96

2 IMMIGRATION

10 Emma Lazarus, "The New Colossus" (1883). Inscribed on the base of the Statue of Liberty, 1886
11 Henry James, "The Inconceivable Alien" (1883). Christopher Ricks and

William L. Vance (eds), *The Faber Book of America*, London, Faber and Faber, 1992, pp. 44–5

12 Owen Wister, "Shall We Let the Cuckoos Crowd Us Out of Our Nest?" *American Magazine*, 91, March 1921, p. 47

13 Madison Grant, "The Mixture of Two Races" (1917). *The Passing of the Great Race or The Racial Basis of European History*, London, G. Bell and Sons, 1917, pp. 14–16

14 Arthur M. Schlesinger, Jr., "E Pluribus Unum?" *The Disuniting of America*, New York, Norton, 1992, pp. 11–13

15 Abraham Cahan, "The Meeting." *Yekl* (1896). Extract reprinted in *The Heath Anthology of American Literature*, Vol. 2, Lexington, Mass., D. C. Heath and Co., 1990, pp. 878–81

16 Ole E. Rølvaag, "The Power of Evil in High Places." *The Giants in the Earth: A Saga of the Prairie* (1927), New York, Harper and Row, 1955, pp. 305–14. Extract reprinted in Jay B. Hubbell, *American Life in Literature*, New York, Harper, 1936, pp. 694–702

17 Michael Lee Cohen, "David." *The Twenty-Something American Dream: A Cross-Country Quest for a Generation*, New York, Penguin, 1993, 279–88

18 Joan Morrison and Charlotte Fox Zabusky, "Premier Nguyen Cao Ky: From South Vietnam, 1975." Joan Morrison and Charlotte Fox Zabusky (eds), *American Mosaic: The Immigrant Experience in the Words of Those Who Lived It* (1980), Pittsburgh, University of Pittsburgh Press, 1993, pp. 417–18, 420–3

19 Al Santoli, "Mojados (Wetbacks)" (1988). *New Americans: An Oral History* by Al Santoli, New York, Penguin USA, 1988.

3 AFRICAN AMERICANS

20 Moses Grandy, "The Auction Block." Charles H. Nichols, *Many Thousand Gone: The Ex-Slaves' Account of Their Bondage and Freedom*, Leiden, Germany, E. J. Brill, 1963. Extract reprinted from Julius Lester (ed.), *To be a Slave*, New York, Scholastic Inc., 1968, p. 43

21 Joseph Ingraham, "A peep into a slave-mart." Christopher Ricks and William L. Vance (eds), *The Faber Book of America*, London, Faber and Faber, 1992, pp. 189–90

22 Sojourner Truth, "Ain't I a Woman?" (1851). Sharon Donovan (ed.), *Great American Women's Speeches*, Caedmon Cassette, CDL 52067, New York, Caedmon Records, 1973. The speech is rendered in dialect in *The Health Anthology of American Literature*, Vol. 1, Lexington, Mass., D. C. Heath and Co., 1990, pp. 1911–12

23 Abraham Lincoln, Final Emancipation Proclamation (1863). *Abraham Lincoln: Speeches and Writings 1859–1865*, Selection and Notes by Don E. Fehrenbacher, New York, Library of America, 1989, pp. 424–5

24 William DuBois, "Of the Faith of the Fathers." *The Souls of Black Folk*, Chicago, A. C. McClurg and Co., 1903, pp. 190–6

25 William DuBois, "This double-consciousness." *The Souls of Black Folk*, Chicago, A. C. McClurg and Co., 1903. Extract reprinted from Christopher Ricks and William L. Vance (eds), *The Faber Book of America*, London, Faber and Faber, 1992, pp. 199–200

26 Gwendolyn Brooks, "We Real Cool" (1960). *The World of Gwendolyn Brooks*, New York, Harper and Row, 1971

27 Martin Luther King, Jr., "I Have a Dream." SCLC Newsletter, I, 12, September 1963, pp. 5–8. Reprinted in J. M. Washington (ed.), *A Testament*

of Hope: The Essential Writings of Martin Luther King Jr., San Francisco, Cal., Harper, 1991, pp. 217–20

28 Malcolm X, "The Ballot or the Bullet." George Breitman (ed.), *Malcolm X Speaks*, New York, Grove Press, 1966, pp. 26, 40–1

29 Malcolm X, "The Black Man." *The Autobiography of Malcolm X*, New York, Penguin, 1965, pp. 424–6

30 US Congress, The Civil Rights Act of 1964. Reprinted from Anders Breidlid and Øyvind Gulliksen (eds), *Aspects of American Civilization*, Oslo, NKS-Forlaget, 1983, pp. 220–1

31 Septima Clark, "Teach How Change Comes About." [Written pre-1987.] Eliot Wigginton (ed.), *Refuse to Pass Silently By: An Oral History of Grass Root Activism in America, 1921–64*, New York, Doubleday, 1991, pp. 396–9

4 WOMEN IN THE UNITED STATES

32 Alexis de Tocqueville, "The Young Woman in the Character of a Wife." *Democracy in America* (1848), trans. 1862. Extract reprinted from Phillips Bradley edition, Vol. II, New York, Vintage Books, 1959, pp. 212–14.

33 Thomas R. Dew, "Differences between the Sexes." "Dissertation on the Characteristic Differences between the Sexes, and on the Position and Influence of Woman in Society," *Southern Literary Messenger* (Richmond, Va.), I, May 1835, pp. 493–512. Extract reprinted from Aileen S. Kraditor (ed.), *Up from the Pedestal: Selected Writings in the History of American Feminism*, New York, New York Times Book Co., 1968, pp. 45–7.

34 Seneca Falls Convention, Declaration of Sentiments and Resolutions (1848). Elizabeth Cady Stanton, Susan Anthony and Mathilda Joslyn Gage (eds), *The History of Woman Suffrage*, Vol. I, Rochester, N.Y., pp. 67–71.

35 Kate Chopin, "The Story of an Hour" (1894). Susan Cahill (ed.), *Women and Fiction: Short Stories by and about Women*, New York, Mentor Books, 1975, pp. 3–5.

36 Charlotte Perkins Gilman, *Women and Economics*, New York, Harper and Row, 1966, pp. 313–17. Extract reprinted from David Nye, Carl Pedersen and Niels Thorsen (eds), *American Studies: A Source Book*, Copenhagen, Akademisk Forlag, 1989, pp. 236–7

37 Meridel LeSueur, "Women on the Breadlines." *The New Masses*, January 1932, pp. 5–7. Reprinted in *The Heath Anthology of American Literature*, Vol. 2, Lexington, Mass., D. C. Heath and Co., 1990, pp. 1650–5

38 Betty Friedan, "That Has No Name." *The Feminine Mystique*, New York, W. W. Norton, 1963. Published by Penguin 1965, pp. 13–17.

39 Adrienne Rich, "Think through the Body." *Of Woman Born: Motherhood as Experience and Institution*, New York, W. W. Norton, 1976, pp. 290–2

40 Studs Terkel, "Just a Housewife: Therese Carter." *Working*, New York, Pantheon Books, 1972.

41 Merle Woo, "Letter to Ma" (1980). Cherríe Moraga and Gloria Anzaldua (eds), *This Bridge Called My Back: Writings by Radical Women of Color*, New York Kitchen Table, Women of Color Press, 1983, pp. 140, 141–3, 146–7. Extract reprinted from Ruth Barnes Moynihan, Cynthia Russett and Laurie Crumpacker (eds), *Second to None: A Documentary History of American Women*, Vol. 2: *From 1865 to the Present*, Lincoln, University of Nebraska Press, 1993, pp. 326–9

42 *National NOW Times* (Editorial), "Abortion Is Not Immoral" (1989). Ruth Barnes Moynihan, Cynthia Russett and Laurie Crumpacker (eds), *Second to*

None: A Documentary History of American Women, Vol. 2: *From 1865 to the Present*, Lincoln, University of Nebraska Press, 1993, pp. 343–4

43 Barbara Newman, "Postmodern Patriarchy Loves Abortion." *Sisterlife* 13, No. 1, Winter 1993, Washington DC, Feminists for Life of America, 1993.

5 THE STRUCTURE OF GOVERNMENT

44 Founding Fathers, The Constitution of the United States (1787). Reprinted from Anders Breidlid and Øyvind Gulliksen (eds), *Aspects of American Civilization*, Oslo, NKS-Forlaget, 1983, pp. 344–50

45 James Madison, "How a Republic Will Reduce the Evil of Faction" (1788). *Federalist Papers*, No. 10, New York, New American Library, 1961, pp. 77–84

46 E. L. Doctorow, "A Citizen Reads the Constitution." *The Nation*, February 21, 1987

47 Thomas Jefferson, "The Roots of Democracy" (1816). *Encyclopaedia Britannica, The Annals of America*, IV, Chicago, *Encyclopaedia Britannica*, 1968, pp. 422–6

48 John Marshall, *Marbury* v. *Madison* (1803). *Encyclopaedia Britannica, The Annals of America*, IV, Chicago *Encyclopaedia Britannica*, 1968, pp. 165–70

49 Andrew Jackson, Proclamation to the People of South Carolina (1832). *Encyclopaedia Britannica, The Annals of America*, V. Chicago, *Encyclopaedia Britannica*, 1968, pp. 585, 590–3

50 John Kenneth Galbraith, "The American Presidency: Going the Way of the Blacksmith?" *International Herald Tribune*, December 13, 1988

6 PARTIES AND POLITICS

51 George Washington Plunkitt, "Honest Graft and Dishonest Graft" (1905). William L. Riordon (ed.), *Plunkitt of Tammany Hall*, New York, E. P. Dutton and Co., 1963, pp. 90–3

52 Joe McGinnis, *The Selling of the President* (1969), Harmondsworth, UK, Penguin, 1970, pp. 56, 65–8

53 Studs Terkel, Interview with Congressman Philip M. Crane. Studs Terkel (ed.), *The Great Divide: Second Thoughts on the American Dream*, New York, Avon Books, 1988, pp. 364–8

54 Studs Terkel, Interview with Ex-Congressman Bob Eckhardt. Studs Terkel (ed.), *The Great Divide: Second Thoughts on the American Dream*, New York, Avon Books, 1988, pp. 360–3

55 Hedrick Smith, *The Power Game: How Washington Works* (1988), Glasgow, William Collins Sons and Co., Fontana Paperbacks, 1989, pp. xiii–xxv

56 The Republican Party, The Republican Party Platform 1992. Party Press Release, 1992

57 The Democratic Party, The Democratic Party Platform 1992. Party Press Release, 1992

7 ENTERPRISE

58 Benjamin Franklin, *Autobiography* (1785). *The Works of Benjamin Franklin, 1731–57*, I, New York, Putnam's, 1904, pp. 188–95, 199–200

59 Francis Grund, "To Americans, Business is Everything." *The Americans*, New

York and London, Augustus M. Kelley, 1837, reprinted 1971, pp. 2–9, 74–7, 158–9

60 Andrew Carnegie, *The Gospel of Wealth* (1900). *The Gospel of Wealth and Other Timely Essays*, ed. Edward C. Kirkland, Cambridge, Mass., The Belknap Press of Harvard University Press, 1962, pp. 6–49

61 Bruce Barton, "Christ as a Businessman." *The Man Nobody Knows* (1925), in Richard N. Current, John A. Garraty and Julius Weinberg, *Words That Made American History: Since the Civil War*, New York, Harper Collins, 1979, pp. 379–91

62 Studs Terkel, Interview with George Allen, Football Coach. *Working*, New York, Pantheon Press, 1972, pp. 386–9. Reprinted from Anders Breidlid and Øyvind Gulliksen (eds), *Aspects of American Civilization*, Oslo, NKS-Forlaget, 1983, pp. 336–7

63 Henry Ford, *My Life and Work*, Garden City, N.Y., Doubleday, 1922, pp. 2, 3, 6–7, 10–12, 176 and 188–9

64 Andrew Jackson, "The Power of the Moneyed Interests" (1837). *Encyclopaedia Britannica, The Annals of America*, VI, Chicago, *Encyclopaedia Britannica*, 1968, pp. 308–9

65 Franklin D. Roosevelt, "Organized Money." Samuel I. Rosenman (ed.), *The Public Papers and Addresses of Franklin D. Roosevelt: 1936, The People Approve*, New York, Random House, 1938, pp. 2900–03

66 Dwight D. Eisenhower, "The Military-Industrial Complex." *Public Papers of the Presidents of the United States. Dwight D. Eisenhower, 1960–61*, Washington, D.C., US Government Printing Office, 1961, pp. 1035–40

8 CLASS STRUCTURE

67 Thomas Jefferson, "Property and Natural Right" (1785). J. A. Leo Lemay (ed.), *An Early American Reader*, Washington, D.C., United States Information Agency, 1988. pp. 726–7

68 William Graham Sumner, "The Forgotten Man" (1883). Ernest J. Wrage and Barnet Baskerville (eds), *American Forum: Speeches on Historic Issues, 1788–1900*, Seattle, University of Washington Press, 1960, pp. 239–40

69 Upton Sinclair, *The Jungle*, New York, New American Library, 1960, pp. 101–2, 137. First published New York, Doubleday, 1906.

70 Sinclair Lewis, *Babbitt* (1922), New York, New American Library, 1980, pp. 6–8, 14–15, 62–3

71 Emily Moore, "Marie Haggerty" (1939). Ann Banks (ed.), *First-Person America*, (1980) New York, Norton, 1991, pp. 170–4

72 Studs Terkel, "Mike Lefevre" (Interview with a Steel Mill Worker, 1974) *Working*, New York, Avon, 1975, pp. 1–3, 6, 10

73 Lyndon B. Johnson, "The War on Poverty" (1964). *Encyclopaedia Britannica, The Annals of America: 1964*, Chicago, *Encyclopaedia Britannica*, 1968, pp. 212–13

74 Steven VanderStaay, "Hell" and "Joe." *Street Lives: An Oral History of Homeless People*, Philadelphia, New Society Publishers, 1992, pp. 14–15, 23–4

75 Peter Baida, "Confessions of a Reluctant Yuppie." *American Scholar*, Vol. 55, No.1, Winter 1985/86, pp. 45–6, 48–9

9 RELIGION

76 Jonathan Edwards, "Personal Narrative" (1739?–1742?). George McMichael (general ed.), *Concise Anthology of American Literature*, 2nd edition, New York, Macmillan, 1985, pp. 139–43

77 Ralph Waldo Emerson, "The Manifesto of 1838." H. Shelton Smith, Robert T. Handy and Lefferts A. Loetscher, *American Christianity: An Historical Interpretation with Historical Documents, Vol. II.* New York, Charles Scribner's Sons, 1963, pp. 137–40

78 James Cardinal Gibbons, "The Catholic Church and Labor" (1887). H. Shelton Smith, Robert T. Handy and Lefferts A. Loetscher, *American Christianity: An Historical Interpretation with Historical Documents, Vol. II.* New York, Charles Scribner's Sons, 1963, pp. 378–83

79 Will Herberg, "The Religion of Americans." *Protestant Catholic Jew*, New York, Doubleday, 1955. Extract reprinted from Anders Breidlid and Øyvind Gulliksen (eds), *Aspects of American Civilization*, Oslo, NKS-Forlaget, 1983, pp. 292–6

80 Anonymous, "Swing Low, Sweet Chariot" and "Go Down, Moses." Cleanth Brooks, R. W. B. Lewis and Robert Penn Warren, *American Literature: The Makers and the Making*, Book B, New York, St. Martin's Press, 1974, p. 1176

81 Billy Graham, "The Unfinished Dream." *Christianity Today*, July 31, 1970. Reprinted from Anders Breidlid and Øyvind Gulliksen (eds), *Aspects of American Civilization*, Oslo, NKS-Forlaget, 1983, pp. 296–9

82 Pat Robertson, "The New World Order," 1991. *The New World Order*, Word (UK) Milton Keynes, UK, 1992, pp. 233–46

10 EDUCATION

83 Robert Coram, "The Necessity of Compulsory Primary Education" (1791). Fredrick Rudolph (ed.), *Essays on Education in the Early Republic*, Cambridge Mass., The Belknap Press of Harvard University Press, 1965, pp. 112–27

84 John Dewey, "My Pedagogic Creed" (1897). Daniel Boorstin (ed.), *An American Primer* (1966), New York, Penguin, 1985, pp. 631–6

85 US Supreme Court, The 1954 Supreme Court Decision on Segregation. Supreme Court, 347 US.483. Reprinted from Anders Breidlid and Øyvind Gulliksen (eds), *Aspects of American Civilization*, Oslo, NKS-Forlaget, 1983, pp. 266–7

86 US Congressman "Protest from the South" (1956). Congressional Record, 84th Congress, 2nd Sess., p. 4460. Reprinted from Anders Breidlid and Øyvind Gulliksen (eds), *Aspects of American Civilization*, Oslo, NKS-Forlaget, 1983, pp. 267–9

87 Jonathan Kozol, "The Grim Reality of Ghetto Schools." *Death at an Early Age*, Boston, Mass., Houghton Mifflin Co., 1967. Extract reprinted from Anders Breidlid and Øyvind Gulliksen (eds) *Aspects of American Civilization*, Oslo, NKS-Forlaget, 1983, pp 269–72

88 Peter Schrag, "Savage Equalities: The case against Jonathan Kozol." *New Republic*, December 16, 1991, pp. 18–20

89 Allan Bloom, "The Closing of the American Mind." *The Closing of the American Mind*, New York, Simon & Schuster, 1987, pp. 62–7

90 Elizabeth Loza Newby, "An Impossible Dream" (1977). Maxine Schwartz Seller (ed.), *Immigrant Women*, revised 2nd edition, Albany, State University of New York Press, 1984, pp. 235–9

91 Studs Terkel, "Public School Teacher: Rose Hoffman." *Working*, New York, Pantheon Books, 1972. Extract reprinted from Anders Breidlid and Øyvind Gulliksen (eds.), *Aspects of American Civilization*, Oslo, NKS-Forlaget, 1983, pp. 272–7

11 MASS MEDIA AND POPULAR CULTURE

92 *New York Herald*, Review of *Uncle Tom's Cabin* (1853). Montrose J. Moses and James Mason Brown, *The American Theatre as Seen by Its Critics 1752–1934*, New York, W. W. Norton and Co. Inc., 1934, pp. 72–6
93 Bessie Smith, "Empty Bed Blues." Cleanth Brooks, R. W. B. Lewis and Robert Penn Warren, *American Literature: The Makers and the Making*, Book D *1914 to the Present*, New York, St. Martin's Press, 1974, p. 2769
94 Woody Guthrie, "This Land is Your Land" (1944). Diane Ravitch (ed.), *The American Reader*, New York, Harper Collins, 1990, p. 275
95 Mikal Gilmore, "Bruce Springsteen." *Rolling Stone*, November 5–December 10, 1987, 23–7
96 Studs Terkel, "Jill Robertson: Fantasia." *American Dreams: Lost and Found*, London, Granada, 1982, pp. 83–91
97 Stanley Kauffmann, "*Little Big Man*" (1970). *Living Images: Film Comment and Criticism*, New York, Harper and Row, 1975, pp. 31–4
98 Martin Scorsese, Paul Schrader and Robert de Niro, "*Taxi Driver*." Mary Pat Kelly, *Martin Scorsese: A Journey*, London, Secker and Warburg, 1992, pp. 89–93
99 Neil Postman, "The Age of Show Business." *Amusing Ourselves to Death: Public Discourse in the Age of Show Business*, New York, Elizabeth Sifton Books, Viking, 1985, pp. 83–93

12 THE UNITED STATES AND THE WORLD

100 George Washington, Farewell Address (1796). James D Richardson (ed.), *A Compilation of Messages and Papers of the Presidents 1789–1897*, Vol. I. Published by Authority of Congress, Washington D.C., Government Printing Office, 1895, pp. 213–24
101 James Monroe, "The Monroe Doctrine" (1823). *Encyclopaedia Britannica, The Annals of America*, V, *Encyclopaedia Britannica*, Chicago, 1968, pp. 73–5
102 Charles A. Beard, "The Case for Isolation" (1940). Richard N. Current, John A. Garraty and Julius Weinberg (eds), *Words That Made American History: Since the Civil War*, 2nd edition, London, Harper Collins, 1991, pp. 449–56
103 Harry Truman, "The Truman Doctrine" (1947). Congressional Record, 80th Congress, 1st Sess., pp. 1980–1. Anders Breidlid and Øyvind Gulliksen (eds), *Aspects of American Civilization*, Oslo, NKS-Forlaget, 1983, pp. 55–6
104 George C. Marshall, "The Marshall Plan" (1947). Richard Hofstadter and Beatrice K. Hofstadter (eds), *Great Issues in American History: From Reconstruction to the Present Day, 1864–1981*, New York, Vintage Books, 1982, pp. 408–12
105 Joseph McCarthy, "The Wheeling Speech" (1950). Allen J. Matusow (ed.), *Joseph R. McCarthy*, Englewood Cliffs, N.J., Prentice-Hall, 1970, pp. 20–6
106 John F. Kennedy, First Inaugural Address (1961). Richard Hofstadter and

Beatrice K. Hofstadter (eds), *Great Issues in American History: From Reconstruction to the Present Day, 1864–1981*, New York, Vintage Books, 1982, pp. 545–9

107 Lyndon B. Johnson, "American Policy in Vietnam" (1965). Richard Hofstadter and Beatrice K. Hofstadter (eds), *Great Issues in American History: From Reconstruction to the Present Day, 1864–1981*, New York, Vintage Books, 1982, pp. 556–9

108 George Bush, "The Launch of Attack on Iraq." *Public Papers of the President, George Bush, 1991*, Vol. 1, "Address to the Nation Announcing Allied Military Action in the Persian Gulf," Washington D.C., US Government Printing Office, 1992, pp. 42–5

109 E. L. Doctorow, Open Letter to the President. *Nation*, January 7–14, 1991, pp. 1, 6

13 IDEOLOGY: DOMINANT BELIEFS AND VALUES

110 Thomas Jefferson, with Amendments by the Continental Congress, The Declaration of Independence (1776). Reprinted from Anders Breidlid and Øyvind Gulliksen (eds), *Aspects of American Civilization*, Oslo, NKS-Forlaget, 1983, pp. 341–3

111 Abraham Lincoln, The Gettysburg Address (1863). Robert H. Fossum and John K. Roth (eds), *American Ground: Vistas, Visions and Revisions*, New York, Paragon House, 1988, p. 110

112 John Marshall Harlan, Dissenting Opinion in *Plessy* v. *Ferguson* (1896). Richard Hofstadter (ed.), *Great Issues in American History: A Documentary Record*, New York, Vintage Books, 1958, pp. 57–8

113 Learned Hand, "The Spirit of Liberty" (1944). *The Spirit of Liberty: Papers and Addresses of Learned Hand*, ed. Irving Dillard, New York, Knopf, 1952, pp. 190–1

114 William James, *Pragmatism* (1907). Daniel J. Boorstin (ed.), *An American Primer*, New York, Penguin, 1985, pp. 712–15

115 Jane Addams, *Twenty Years at Hull House* (1910), New York, Macmillan, 1938, pp. 124–7

116 Woodrow Wilson, First Inaugural Address (1913). *Encyclopaedia Britannica, The Annals of America: 1913*, Encyclopaedia Britannica, Chicago, 1968, pp. 412–14

117 William J. Clinton, Address on the State of the Union, 1994. *Weekly Compilation of Presidential Documents*, Vol. 30, No. 4, Washington, D.C., Office of the Federal Register, National Archives and Records Administration, 1994, pp. 151–3

118 Frederick Jackson Turner, "The Significance of the Frontier in American History" (1893). Martin Ridge (ed.), *Frederick Jackson Turner: Wisconsin's Historian of the Frontier*, Madison, State Historical Society of Wisconsin, 1993, pp. 28, 43, 47

119 Theodore Roosevelt, "The Strenuous Life" (1899). Roderick Nash (ed.), *The Call of the Wild, 1900–1916*, New York, George Braziller, 1970, pp. 79–81

120 Studs Terkel, "Jay Slabaugh, 48" (Interview with a Corporate Executive, 1980). *American Dreams: Lost and Found*, London, Hodder and Stoughton, 1980, pp. 34, 37–8

121 Ronald Reagan, Address on the State of the Union, 1986. Public Papers of the Presidents of the United States, *Ronald Reagan, 1986, Book I: January 1 to*

June 27, 1986, Washington, D.C., Office of the Federal Register, National Archives and Records Administration, 1988, pp. 125–6

122 Rush H. Limbaugh, III, *See, I Told You So*, New York, Pocket Books, 1993, pp. xxiii, 66–7, 73, 76–7

123 Earnest Elmo Calkins, "Business Has Wings." *Atlantic Monthly*, 139, 1927, pp. 312, 315

124 Dale Carnegie, *How to Win Friends and Influence People* (1936), New York, Pocket Books, 1940, pp. 72, 74–5, 110

125 Malvina Reynolds, "Little Boxes" (1962). Diane Ravitch (ed.), *The American Reader: Words That Moved a Nation*, New York: Harper Collins, 1990, p. 339.

126 David Watson, "Civilization is Like a Jetliner" (1983). John Zerzan and Alice Carnes (eds), *Questioning Technology: Tool, Toy or Tyrant?* Philadelphia, New Society Publishers, 1991, pp. 69–70

SUGGESTED FURTHER READING

GENERAL

Bailey, T. A. and Kennedy, D. M. (eds) (1994) *The American Spirit*, 5th edn, Lexington, Mass.: Heath and Company.
Bradbury, M. and Temperley, H. (eds) (1989) *Introduction to American Studies*, 2nd edn, London and New York: Longman.
Bromhead, P. (1988) *Life in Modern America*, London and New York: Longman.
Crunden, M. (1990) *A Brief History of American Culture*, Helsinki: Finnish Historical Society.
Dinnerstein, L. and Jackson, K. T. (eds) (1995) *American Vistas*, 7th edn, Lexington, Mass.: Heath and Company.
Fiedler, E., Remier, J. and Norman-Risch, M. (1990) *America in Close-Up*, London and New York: Longman.
Gidley, M. (ed.) (1993) *Modern American Culture: An introduction*, London and New York: Longman.
Luedtke, L. S. (ed.) (1992) *Making America: The society and culture of the United States*, Chapel Hill: The University of North Carolina Press.
Maidment, R. (ed.) (1995) *The United States in the Twentieth Century: Democracy*, Sevenoaks: Hodder & Stoughton/Open University Press.
Maidment, R. and Dawson, M. (1994) *The United States in the Twentieth Century: Key Documents*, Sevenoaks: Hodder and Stoughton/The Open University.
Mauk, D. and Oakland, J. (1995) *American Civilization: An introduction*. London and New York: Routledge.
Mitchell, J. and Maidment, R. (eds) (1994) *The United States of America in the Twentieth Century: Culture*, Sevenoaks: Hodder & Stoughton/Open University Press.
Nye, D. (1989) *American Studies: A sourcebook*, Copenhagen: Akademisk Forlag.
——— (1993) *Contemporary American Society*, Copenhagen: Academic Press.
Nye, D. and Pedersen, C. (eds) (1991) *Consumption and American Culture*, European Contributions to American Studies, xxi, Amsterdam: VU University Press.
Sirevåg, T. (1994) *American Patterns: The Open Society in myth and reality*, Oslo: Ad Notam Gyldendal Norsk Forlag.
Welland, D. (ed.) (1987) *The United States: A companion to American studies*, 2nd edn, London: Methuen.

HISTORY

Brogan, H. (1986) *Penguin History of the US*, Harmondsworth: Penguin.

Boyer, S. et al. (1995) *The Enduring Vision: A history of the American people. Vol. I, to 1977, Vol. II, from 1865*, concise 2nd edn, Lexington, Mass.: Heath and Company.

Jones, M. A. (1995) *The Limits of Liberty: American history 1607–1992*, 2nd edn, New York and Oxford: Oxford University Press.

Degler, Carl (1984) *Out of Our Past: The forces that shaped modern America*, 3rd edn, New York: Harper Torchbooks.

Foner, E. (ed.) (1990) *The New American History* (American Historical Association), Philadelphia: Temple University Press.

Kammen, M. (1988) *A Machine That Would Go of Itself*, London: Random House.

Lynd, R. S. and Lynd, H. M. (1929) *Middletown: A study in modern American culture*, New York: Harcourt, Brace and World.

Noble, D. W. and Carroll, P. (1988) *The Free and the Unfree: A new history of the United States*, 2nd edn, Harmondsworth: Penguin.

Norton, M. B. et al. (1994) *A People and a Nation: A history of the United States*, 4th edn, Boston: Houghton Mifflin.

O'Callaghan, B. (1990) *An Illustrated History of the US*, London and New York: Longman.

NATIVE AMERICANS

Bancroft-Hunt, N. (1991) *Native Americans*, New York: Mallard.

Caitlin, G. (ed.) (1989) *North American Indians* (introduction by P. Matthiessen), Harmondsworth: Penguin.

Hagan, W. T. (1993) *American Indians*, 3rd edn, Chicago, Illinois: University of Chicago Press.

Nichols, R. L. (1992) *The American Indian: Past and present*, 4th edn, London and New York: McGraw-Hill.

Olson, J. S. and Wilson, R. (1984) *Native Americans in the Twentieth Century*, Urbana, Illinois: University of Illinois Press.

Waldman, C. (1988) *Encyclopedia of Native American Tribes*, New York: Facts-on-File.

IMMIGRATION AND ETHNICITY

Commeyer, H. S. (ed.) (1961) *Immigration and American History: Essays in Honor of Theodore C. Blegen*, Minneapolis, Minnesota: University of Minnesota Press.

Daniels, R. (1991) *Coming to America: A history of immigration and ethnicity in American life*, London, Harper Collins.

Dinnerstein, L., Nichols, R. L. and Reimers, D. M. (eds) (1990) *Natives and Strangers: Blacks, Indians and Immigrants in America*, 2nd edn, New York and Oxford: Oxford University Press.

Dinnerstein, L. and Reimers, D. M. (1988) *Ethnic American: A history of immigration and assimilation*, New York: Harper & Row.

D'Innocenzo, M. and Sirefman, J. P. (1992) *Immigration and Ethnicity: American society "melting pot" or "salad bowl"?*, Westport, Connecticut: Greenwood Press.

Fuchs, L. H. (1990) *The American Kaleidoscope: Race, ethnicity and the civic culture*, Hanover, New Hampshire: University Press of New England.

Handlin, O. (1961) "Immigration in American Life: A reappraisal," in H. S. Commeyer (ed.), above.

Maldwyn, A. J. (1992) *American Immigration*, 2nd edn, Chicago: Chicago University Press.

Schlesinger Jr., A. (1992) *The Disuniting of America: Reflections on a multicultural society*, New York: Horton.

Takiki, R. (1993) *A Different Mirror: A history of multicultural America*, Boston: Little, Brown and Company.

Thernstrom, S. (ed.) (1980) *Harvard Encyclopedia of American Ethnic Groups*, Cambridge, Mass.: Belknap Press of Harvard University Press.

AFRICAN AMERICANS

Aldon, D. (1984) *The Origins of the Civil Rights Movement: Black communities organizing for change*, New York: Free Press.

Berry, M. F. and Blassingame, J. W. (1982) *Long Memory: The black experience in America*, New York and Oxford: Oxford University Press.

Franklin, J. H. and Moss, A. A. (1993) *From Slavery to Freedom: A history of African Americans*, 7th edn, New York and London: McGraw-Hill.

Franklin, V. P. (1992) *Black Self-Determination, a cultural history of African-American resistance*, 2nd edn, Brooklyn, New York: Lawrence Hill Books.

Hornsby Jr., A. (1991) *Chronology of African-American History, significant events and people from 1619 to the present*, Detroit: Gale Research.

Lee, G. L. (1989) *Black American History Makers*, Jefferson, North Carolina: McFarland.

WOMEN

Chafe, W. H. (1991) *The Paradox of Change: American women in the twentieth century*, New York and Oxford: Oxford University Press.

Degler, C. (1981) *At Odds: Women and the family in America from the revolution to the present*, New York and Oxford: Oxford University Press.

Goldin, C. D. (1992) *Understanding the Gender Gap, economic history of American women*, New York and Oxford: Oxford University Press.

James, E. T. *et al.* (eds) (1971–8) *Notable American Women*, 4 vols, Cambridge, Mass.: Belknap Press of Harvard University Press.

Kerber, L. K. and De Hart, J. S. (1991) *Women's America*, 3rd edn, New York and Oxford: Oxford University Press.

Rosenberg, R. (1993) *Divided Lives, American women in the twentieth century*, New York: Hill and Wang.

Woloch, N. (1994) *Women and the American Experience*, 2nd edn, New York and London: McGraw-Hill.

——— (1992) *Early American Women, 1600–1900*, Belmont, California: Wadsworth.

GOVERNMENT, POLITICS AND FOREIGN POLICY

Cummings, M. C. and Wise, D. (1993) *Democracy Under Pressure*, 7th edn, New York: Hbj College & School Div.

De Conde, A. (1978) *A History of American Foreign Policy*, 3rd edn, New York: Macmillan.

Denenberg, R. V. (1992) *Understanding American Politics*, 3rd edn, London: Fontana.

Grant, A. (1994) *The American Political Process*, 5th edn, Brookfield, Vermont: Dartmouth.

Hinckley, B. and Goldman, S. (1990) *American Politics and Government: Structure, processes, institutions and policies*. Glenview, Illinois: Scott, Foresman/Little, Brown and Company.

Kelly, A., Harbison, W. A. and Belz, H. (1993) *The American Constitution: Its origins and development* (2 volumes), 7th edn, New York: Norton.

La Feber, W. (1989) *The American Age: United States foreign policy at home and abroad since 1750*, New York: Nortoh.

McKay, D. (1993) *American Politics and Society*, Oxford: Blackwell.

Maidment, R. and Tappin, M. (1991) *American Politics Today*, Manchester: Manchester University Press.

Schlesinger, Jr., A. M. (1973) *The Imperial Presidency*, Boston: D. C. Heath.

Skidmore, M. and Tripp, M. C. (1993) *American Government: A brief introduction*, 6th edn, New York: St Martin's Press.

Sullivan, M. (1985) *The Vietnam War*, Lexington, Illinois: University of Kentucky Press.

Welch, S. *et al.* (1991) *Understanding American Government*, St Paul, Minnesota: West Publishing.

Williams, R. (ed.) (1990) *Explaining American Politics: Issues and interpretations*, London and New York: Routledge.

CLASS

Fussell, P. (1983) *Class: A guide through the American system*, New York: Ballantine.

Gilbert, E. and Kahl, J. A. (1993) *The American Class Structure: A new synthesis*, 4th edn, Belmont, California: Wadsworth.

Rossides, D. W. (1990) *The American Class System. Social Stratification. The American Class System in Comparative Perspective*, Englewood Cliffs, New Jersey: Prentice-Hall.

RELIGION

Carmody, D. L. and Carmody, J. T. (1990) *Exploring American Religion*, Mountain View, California: Mayfield.

Gaustad, E. S. (1976) *Historical Atlas of Religion in America*, New York: Harper & Row.

McNamara, P. H. (1984) *Religion American Style*, 2nd edn, Belmont, California: Wadsworth.

Marty, M. E. (1984) *Pilgrims in their Own Land: 500 years of American religion*, Boston: Little, Brown and Company.

MASS MEDIA AND POPULAR CULTURE

Barnouw, E. (1990) *The Tube of Plenty, the evolution of American television*, 2nd rev. edn, New York and Oxford: Oxford University Press.

Becker, S. and Roberts, C. (1992) *Discovering Mass Communications*, New York: Harper Collins.

Belton, J. (1994) *American Cinema/American Culture*, New York and London: McGraw-Hill.

Bluestein, G. (1994) *Poplore, Folk and Pop in American Culture*, Amherst, Mass.: University of Massachusetts Press.

Castleman, H. and Podrazik, W. J. (1982) *Watching TV: Four decades of American Television*, New York: McGraw-Hill.

Chase, G. (1987) *America's Music*, rev. edn, Urbana, Illinois.

Dean, J. (1992) *American Popular Culture (La culture populaire américaine), anthologie critique en anglais*, Nancy: Presse Universitaire de Nancy.

Lazere, D. (ed.) (1987) *American Media and Mass Culture, left perspectives*, Berkeley, California, University of California Press.

McQuade, D. and Atwan, R. (eds) (1985) *Popular Writing in America*, 3rd edn, New York: Oxford University Press.

Maltby, R. (ed.) (1989) *Dreams for Sale: Popular culture in the twentieth century*, London: Harrap.

Marchant, R. (1985) *Advertising the American Dream: Making way for modernity, 1920–1940*, Berkeley: University of California Press.

Scheurer, T. E. (1991) *Born in the USA: The myth of America in popular culture from colonial times to the present*, Jackson, Mississippi: University of Mississippi Press.

Schudson, M. (1984) *Discovering the News: A social history of American newspapers*, New York: Basic Books.

Turnstall, J. (1994) *The Media are American: Anglo-American media in the world*, 2nd edn, London: Constable.

IDEOLOGY

Bellah, R. *et al.* (1985) *Habits of the Heart: Individualism and commitment in American life*, Berkeley: University of California Press.

Bloom, A. (1988) *The Closing of the American Mind*, Harmondsworth: Penguin.

Curti, M. (1982) *The Growth of American Thought*, 3rd edn, New Brunswick: Transaction (originally published in 1964, New York: Harper & Row).

Kammen, M. (1990) *People of Paradox: An inquiry concerning the origins of American civilization*, Ithaca: Cornell University Press.

Lipset, S. M. (1990) *Continental Divide, the values and institutions of the United States and Canada*, London and New York: Routledge.

Marx, L. (1964) *The Machine in the Garden*, New York and Oxford: Oxford University Press.

Shafer, B. E. (ed.) (1991) *Is America Different? A new look at American exceptionalism*, Oxford: Clarendon.

Smith, H. N. (1950) *Virgin Land*, Cambridge, Mass.: Harvard University Press.

Tallack, D. (1991) *Twentieth Century America: The intellectual and cultural context*, London and New York: Longman.

Wilkinson, R. (1988) *The Pursuit of American Character*, New York: Harper & Row.

ENTERPRISE

Chandler, D. (1977) *The Visible Hand: The managerial revolution*, Cambridge, Mass.: Harvard University Press.

Cochran, T. C. (1972) *Business in American Life: A history*, New York and London: McGraw-Hill.

DiBacco, T. V. (1987) *Made in the USA, The history of American business*, New York: Harper & Row.

Dobson, J. M. (1988) *A History of American Enterprise*, Englewood Cliffs, New Jersey: Prentice-Hall.

Grayson, C. J. and Grayson, C. O. (1988) *American Business*, New York: Free Press.

Pusateri, C. J. (1988) *A History of American Business*, 2nd edn, Arlington Heights, Illinois: Harlan Davidson.

Watts, E. (1972) *The Businessman in American Literature*, Athens, Georgia: University of Georgia Press.

Zunz, O. (1990) *Making America Corporate 1870–1920*, Chicago: University of Chicago Press.

EDUCATION

Kozol, J. (1991) *Savage Inequalities: Children in America's schools*, New York: Harper Collins.

Sowell, T. (1993) *Inside American Education: The decline, the deception, the dogmas*, New York: Macmillan.

Spring, J. (1985) *American Education. An introduction to social and political aspects*, 3rd edn, New York and London: Longmans.

—— (1990) *The American School, 1642–1990, Varieties of history, interpretation of the foundations and development of American education*, 2nd edn, New York and London: Longman.